A General Theory of Visual Culture

A General Theory of

PRINCETON UNIVERSITY PRESS Princeton and Oxford

Visual Culture WHITNEY DAVIS

Copyright © 2011 by Princeton University Press

Published by Princeton University Press, 41 William Street,
Princeton, New Jersey 08540

In the United Kingdom: Princeton University Press, 6 Oxford Street,
Woodstock, Oxfordshire OX20 1TW

press.princeton.edu

Library of Congress Cataloging-in-Publication Data
Davis, Whitney.
 A general theory of visual culture / Whitney Davis.
 p. cm.
 Includes bibliographical references and index.
 ISBN 978-0-691-14765-9 (hardcover : alk. paper) 1. Art and society.
2. Art—Historiography. I. Title.
 N72.S6D37 2011
 701'.03—dc22 2010021905

British Library Cataloging-in-Publication Data is available

Epigraph on page vii from Ludwig Wittgenstein, *Remarks on the Philosophy of Psychology*, vol. 2, ed.
G. H. von Wright and Heikki Nyman, trans. C. G. Luckhardt and M.A.E. Aue (Oxford: Blackwell,
1980) 79e, no. 433.

This book has been composed in Garamond Premier Pro
Printed on acid-free paper. ∞
Printed in China
10 9 8 7 6 5 4 3 2 1

In Memory of Richard Wollheim

There could be people
who recognize a polygon
with 97 angles at first glance,
and without counting.

—Ludwig Wittgenstein

Contents

Illustrations

Preface

I began to plan this book at the Getty Research Institute in Los Angeles while taking part in its seminar on "Reproductions and Originals" in 1999 and 2000. My thanks to the staff at the GRI for support, and especially to Michael Schreyach, my assistant, for help with technical matters. Teaching a graduate seminar in the spring of 2003 at the University of California at Berkeley on the later philosophy of Ludwig Wittgenstein as "cultural criticism" suggested further lines of thought. Chapter Eight derives from my presentation at a symposium on visual culture that I co-organized with Martin Jay at UC Berkeley in April 2004. A preliminary draft of the book was prepared with support from the Humanities Research Fund at UC Berkeley.

Jeremy Melius and Justin Underhill made many useful suggestions about the penultimate draft, and Eva Jaunzems provided a careful and insightful editorial scrutiny of the final text. Earlier, Richard Neer offered astute comments on preliminary versions of several chapters. Even earlier, Michael Baxandall, T. J. Clark, Todd Cronan, James Elkins, Michael Golec, Brian Kane, George Kubler, Alexander Marshack, Patrick Maynard, Michael Podro, Michael Schreyach, Dan Sperber, and Richard Wollheim responded to materials that appear in print here. I owe special thanks to Hanne Winarsky of Princeton University Press for her

enthusiastic support of the project. Two anonymous readers for the press provided thoughtful reports that have helped steer my final revisions of the text. Jennifer Mahoney expeditiously produced the illustrations for the "parable of the builders" that appear in Chapter Nine; they are based on photographs of a conceptual experiment carried out at the Getty Research Institute in 1999 in cooperation with the artist Sherrie Levine.

A few sections of this book have been previously published in *Current Anthropology*, *The Encyclopedia of Aesthetics*, the *Journal of Aesthetics and Art Criticism*, *Representations*, and *Res*. I thank the editors and publishers for permission to reuse these materials. All previously published parts of the text have been extensively revised and substantially augmented here.

Occasionally I refer the reader to *Visuality and Virtuality*, a book of essays on imaging and picturing from ancient Egypt to contemporary "new media" that will be published soon after this book has appeared. *Visuality and Virtuality* contains historiographical and critical discussions that complement the chapters that follow. But in the present book I do not systematically pursue historiography and intellectual history, nor do I comprehensively assess the complete theoretical systems of other writers. I engage them only so far as they allow me to advance my own arguments.

I wish to dedicate this book to the memory of Richard Wollheim. I was introduced to Richard in the autumn of 1986 when I began a post-doctoral fellowship at Berkeley. Richard died suddenly in the autumn of 2005, the beginning of the academic year in which I had hoped to discuss a draft of much of this work with him. Fortunately he had already commented on many of the ideas that have made their way into it. In fact, *A General Theory of Visual Culture* was prepared in part as a response to Richard's writings on art and its objects, on pictorial representation, and on the vicissitudes of formalism in art criticism. Over a period of nearly twenty years we had many conversations about shared interests in art, art history, philosophy, and psychology. Richard taught me, for example, that Ludwig Wittgenstein's account of aspect-seeing (I use it in my own way throughout this book) and Sigmund Freud's theory of the distortions of imagination (a matter I have addressed elsewhere) can be congruent and complementary. These and other perspectives shaped by Richard's advice and criticism have shaped my seeing as an art historian.

London and San Francisco
December 2009

The Successions of Visual Culture **PART ONE**

Chapter 1

Vision Has an Art History

■ I

The American painter Barnett Newman once said that an artist gets
from aesthetics what a bird gets from ornithology—nothing. The editor
of *The Encyclopedia of Aesthetics*, Michael Kelly, has extended Newman's
observation to include art historians, archaeologists, and other students
of culture in its widest sense. Aesthetics must be as useless to all of these
scholars as ornithology would be to a bird unless, Kelly went on to say,
"their research involves art created in periods when aesthetics was still
considered relevant." According to *The Encyclopedia of Aesthetics*, the
period when aesthetics was considered relevant began in the eighteenth
century and as "a European development that has not been duplicated
anywhere else."[1]

Aesthetics in this sense emerged when ancient Greek theories of
poetic aptness (to single out Aristotle's main concern) and Roman and
Renaissance practices of rhetoric and decorum were absorbed into Alex-
ander Baumgarten's specification, in his *Aesthetica* of 1750, that aesthet-
ics should be "the science of the beautiful." Nineteenth- and twentieth-
century writers inherited this synthesis of ancient and modern interests.
For them the wide problems of *aisthesis* or "animal and human percep-
tion" (problems not limited to the interpretation of art in the modern
Western sense) became a philosophical study of the particular *aisthesis* of

"art in its natural and cultural contexts," to use Kelly's phrase. At the beginning of the twentieth century, as we will see in Chapter Three, a high formalist ideology of art attributed aesthetic aspects to a particular class of man-made things, albeit a wide swathe of them; the aesthetic ideology of high formalism did not limit itself to artifacts made in the period during which its terms for aesthetic aspects had been created. But in recent years philosophical aesthetics has tended to endorse Newman's point and Kelly's elaboration. Backing away from the universal application of aesthetics promulgated by high formalists, it takes aesthetics to be relevant to Euro-American artists in the later modern era (and perhaps *only* to those artists) because their work can be explained in aesthetic terms.

Such explanation is warranted, in turn, because aesthetic ideologies have constituted part of the specifically visual-cultural context within which later modern Euro-American arts have been made, and within which they could be understood to be beautiful, worthy, illuminating, or challenging. To be aware of aesthetics or to have a philosophy of art has been a substantial aspect of what it has meant to be a later modern artist. Outside this particular context, however, visual and other modes of culture arguably do not have a specifically *aesthetic* aspectivity. Except in the cultural tradition rooted in the eighteenth-century European development of aesthetic philosophy, aesthetics does not seem to have constituted an aspect of formality, stylisticality, or pictoriality in visual culture in the senses to be developed in the chapters of this book. In other words, it has not been a historical visuality. For most makers of paintings, sculptures, and other items of visual and material culture outside the European tradition, aesthetics has been, as Newman said, as ornithology to the birds: though the birds might well be studied ornithologically, *they* do not see themselves ornithologically. And it remains an open question what they *do* see when, for example, they interact with objects in their visual world—even objects that they themselves have made.

I will not try to defend this line of thinking—an arguable and much-argued one—in substantive terms. This is not a book about art and aesthetics. I begin instead by noting a foundational consideration, perhaps quite an obvious one, about the very fact that if *The Encyclopedia of Aesthetics* is correct in its history (and let us assume that it is) aesthetics provides the cultural context of *art*. Strictly speaking it is true that art must have culturally-recognized aesthetic aspects; culturally-constituted aesthetic aspects make art. For this very reason, however, we might feel we have learned little analytically about art *or* aesthetic aspectivity in identifying this cultural context. Certainly the cultural context of art is the art-context. But effectively this statement is vacuous.

Again, I will not try to decide substantively whether art should be defined in terms of culturally-constituted aesthetic aspects. Provisionally it might be said that aesthetic aspects must be necessary for art but are not sufficient for it insofar as things *other* than art can be aesthetic, even (indeed especially) within the ideology of the aesthetic developed in European philosophy since the eighteenth century. For the concept of a visual-cultural context—in this case, of an aesthetics that defines art—seems to need further analysis as well. So far it might seem that we have not learned much (beyond the crushingly obvious) about how art looks or what it looks like, aside from being able to say that "this work looks to be art . . . it looks like art; it has aesthetic aspects."

Still, in an important sense this last statement is *not* tautologous. It addresses a substantive self-evidence—something materially visible and recognizable—in the particular things in question. It does not amount merely to adding the obvious analytical label "aesthetic" to "art." Evidently there are things that art looks like in our context (even or especially if it is a "European development that has not been duplicated anywhere else") that we can readily recognize. More important, there are things in our context that we readily recognize to be art because they are sufficiently like it in relevant respects—even though they may not "look like art" in every respect.

What is this form of life in which this likeness can be seen? Setting aside the question of art, how do we move from situations in which certain aspects of things (here the aspect we call "aesthetic") have not dawned on us to the different situation in which they *have* dawned on us? Is it necessary to make a new kind of thing? Or simply to see the same old things anew? Because aspects of any kind are constituted in perceptual awareness, these must be aesthetic questions in the ancient etymological sense. They are questions of the animal and human sensory awareness of things in the world, and this even if the European aesthetics of art since the eighteenth century has dealt only with a particular swathe of objects in terms of a particular kind of aspect that they have come to possess. When applied to such objects as paintings, sculptures, and so on, they are questions, that is, of the history and cultivation of vision.

■ 2

The notion that "vision itself has its history," to use the words of Heinrich Wölfflin (Fig. 1.1), has been one of the longest-lasting and deepest-seated principles of art history, even if it has sometimes been somewhat subterranean. As Wölfflin went on to say, "the revelation of these visual

Figure 1.1.
Heinrich Wölfflin
(1864–1945) in 1930.
Photograph by F. Wasow.
Private Collection,
San Francisco, California.

strata must be regarded as the primary task of art history."[2] According to this proposal, styles of depiction—culturally located and historically particular ways of making pictorial representations—have materially affected human visual perception. They constitute what might literally be called *ways of seeing*.

If it is correct, this hypothesis implies that art history should occupy a central place in virtually any study of human forms of life. For any such study will be likely to address the role of human visual perception. Certainly the principles of art history, as identified by Wölfflin himself or by later art historians like Erwin Panofsky and Ernst Gombrich, would have immediate relevance for research in arenas as diverse as anthropology, psychiatry, and ophthalmology. (Here and throughout I do not conflate art history and *aesthetic* inquiry, even though art historians are often interested in the art in the artifacts they study and many of the questions addressed in this book are problems of *aisthesis*—that is, of perceptual awareness and judgment. By art history I simply mean historical investigation of the interrelations of configuration, style, and depiction in artifacts, regardless of their origin or status as art in a modern Western sense.)

Stated this way, however, the implausibility of the claim that vision has a history seems equally clear. Psychiatry and ophthalmology have little to do with art history, even though they have occasionally used art and pictorial representations in their investigations. For its part anthropology has often criticized art historians for their overreliance specifically on Western aesthetics. It seems reasonable to suppose that human visual perception affects pictorial representations made by human beings. After all, human observers must be able to see pictures in order to use and interpret them. But it is more difficult to demonstrate that these depictions, the historical modes and media of their configuration and their cultural forms and styles, organize the seeing itself.

We can eat foods prepared in many different ways according to the canons of taste and the styles of preparation developed in different cuisines. But has digestion been shaped historically by these styles? Does it work in different kinds of ways when we eat different kinds of cuisine? In treating disorders of digestion (ulcers, say) must we know what culinary styles have been ingested in each case? We might conceive a circuit that interconnects natural human digestive processes and particular cultural styles of preparing food in a recursion or feedback loop of some kind. Indeed, a recursion or feedback loop seems to operate when we use pictures, for in seeing a picture we must see it as having configurative, historical, representational, and cultural styles, what I will call "forms of likeness." But does this mean that the seeing itself has been pictorially

stylized or becomes stylized in the activity of seeing the picture? What would it mean to suppose that seeing has styles—styles reflected in con-figurative practices (that is, in ways of making and arranging the elements of an artwork or a picture) if not actually derived from them?

Questions along these lines have been asked ever since art history achieved its theoretical definition in the early twentieth century, and they continue to occupy me in this book. They have been especially pointed when the conceptual models of art history have been associated (by writers including Wölfflin, Panofsky, and Gombrich) with discoveries in anthropology, psychology, and biology about the nature of vision.

Oddly enough, however, a recent shift of art history into the study of so-called visual culture (best regarded as an *expansion* of art history into the study of visual culture) seems to presume that the questions have been settled. According to visual-culture studies, it is true *prima facie* that vision has a cultural history. Therefore the historical dimension of vision—and particular histories *of* vision—must become our object of inquiry whether we are art historians or ophthalmologists. In turn (at least according to some accounts of this matter) typical art-historical interests, that is, interests in the configuration of artworks, in the style of artifacts, and in the iconography of motifs, should apply to *all* of the domains of human life that involve vision, entirely regardless of the activities or artifacts in question. For all domains supposedly have a cultural history of vision or ways of seeing. Conversely, our art-historical understanding of the constitution of vision in culture (that is to say, our understanding of visual culture) must be applied to specifically art-historical objects such as artistic styles, even though some styles (as we will see in Chapter Four) are not wholly cultural entities. In these respects the study of art history and the study of vision equally dissolve into the investigation of visual culture. Or so we might be led to think.

But despite the emergence of visual-culture studies as a categorical solution to a long-standing theoretical problem, the question of the relation of vision and culture (a definite relation seems to be assumed in the very term *visual culture*) has not been settled. With the expansion of art history into visual-culture studies, the question has simply become more urgent. It concerns a greater range of objects and their attributes than would have been addressed by an art historian like Wölfflin, though Wölfflin's famous dictum, quoted at the outset, must count as a founding proposition of visual-culture studies.

As I see it, the question of vision and culture requires art historians to adopt something like the general theory sketched in this book. Properly stated, and despite the anti-art-historical rhetoric of some propo-

nents of visual-culture studies, the general theory of visual culture *fulfills* long-standing art-historical interests rather than just replaces them with entirely different concerns. To be sure, much of what passes for visual-culture studies is simply a sociology of multifarious technological practices and cultural productions in the domain of human activities and artifacts meant to be seen. Its general theory, if any, is simply a sociology of culture that happens to be visible. I am interested here, however, in a general theory of visual culture as such—in the intrinsic relation between vision and culture, if any there be, that is implied by the very term *visual culture*. That term must needs be vacuous unless it can be explicated in substantive terms.

Therefore I address the concept of *visuality*, or what I will call the "culturality of vision." If it is not to be vacuous, the concept of visuality, the specific theoretical basis of a visual-culture studies that makes good on the claim implied in its own name, cannot simply *assume* the culturality of vision. It must give substance to that concept—biological, psychological, social, and historical substance. At the very least, it must address two questions that are complementary, though analytically quite distinct. First, what is cultural about vision (Part Two)? Some things are cultural about vision. But not everything. And second, what is visual about culture (Part Three)? Clearly some things are visual in culture, or visible as culture. But again not everything—even when the "visual dimension" of an artifact and a way of seeing it seem to be involved.

As we will see, it is for these very reasons that the intersection of vision (and visibility) and culture (and visible culturality) must be treated as a historical phenomenon. Stated another way, vision is not inherently a visuality. Rather vision must *succeed* to visuality through a historical process. The recursions of this succession are not well understood analytically, let alone neurologically, as actual or functional operations of the visual cortex and of higher (cognitive) processing. But a general theory of visual culture should attempt to map them in a way that might guide further investigation into the salient material processes. This investigation must (and will) be conducted by neurologists, psychologists, and anthropologists rather than art historians. But if art historians cannot guide it, then the theory of visual culture is empty.[3]

In this book I make several interrelated proposals about visual culture and the historical succession of vision to visuality. Given what I have said, and despite the foundational neurological and psychological explorations that must be waiting in the wings, it is not surprising that my proposals are partly art-historical propositions—that they rely on art-historical concepts.

The most important proposal modifies Wölfflin's claim. Vision can sometimes succeed to culture in the full sense implied in the theoretical notion of visuality. But it need not *always* do so. The succession occurs in complex relays and recursions of recognition in the kind of circuitry or feedback loop that I have already mentioned. These relays are inherently historical. They vary in an agent's experience. They differ between agents. They take time. They require work. And they are not inevitable: they can fail. Sometimes, in fact, they can *only* fail. Strictly speaking, then, there is no such thing as visual culture, at least if that term designates an agent's fully achieved horizon of commonality with members of his or her social group. Nonetheless we must accept that the unpredictable work of partial succession to visuality (and parallel cultural successions in other sensory channels) is the main activity of social life as it interacts with human proprioception (see Chapter Ten). Indeed, the recursion of sociability in proprioception might be *defined* as culture. One succeeds to visual culture in the course of one's history: one is not endowed with it. But what is this history? How does it take hold in proprioception?

To summarize the overall argument laid out in the next nine chapters of this book, vision is surely the chief natural context in which we encounter and experience the fine arts of painting and sculpture, the so-called decorative arts, and so on—visual culture in a strictly tautologous sense. Virtually by definition, visuality, as we will see in the succeeding chapters, must meet and match the perceptual—the aspective—face of visual culture. And sometimes it also *makes* it. What is visible becomes cultured in visuality; as we will see, an appropriately educated Egyptian beholder, for example, saw apposite differences between hieroglyphs and portraits (see Fig. 7.2) even though they often deployed the same outlines and shapes. And visuality has usually cultured what becomes visible; despite what could be their identical outlines and shapes in many cases, the hieroglyphs and portraits have been assigned—have succeeded to— recognizable respects of notation and depiction respectively. The history of the succession of vision to visuality—its relays, recursions, resistances, and reversions—is my main topic. But this topic requires me to investigate a set of analytically distinct successions that constitute the feedback loop of vision and visuality just mentioned; that is, the complex relay or recursion of vision *into* visuality and vice versa. In particular, the formal, the stylistic, and the pictorial aspects of sensuously configured things, as I will put it, are mutually "interdetermined." Within a form of life, people can use the formal aspects of configuration to see its emergent stylistic aspects. They can use these stylistic aspects to see emergent depictive aspects. And they can use these depictive aspects to see emergent formal

and stylistic aspects—and so on, in recursion after endless recursion. For this very reason the succession of vision to visuality can be described, at least in part, as the history within which formality, style, and pictoriality come to be recognized in artifacts—to be seen or *visibilized*. I will consider the vicissitudes of these successions (including their disjunction, resistance, and failure) in the following chapters: formality (the apprehension of sensuous configuration in artifacts) in Chapter Three, style and what I will call "stylisticality" in Chapter Four, and pictoriality (the emergence of depiction in what I will call the "iconographic succession") in Chapters Six, Seven, and Eight.

In the domain of artifacts meant to be seen, form, style, and depiction are visual phenomena; they are visible in those artifacts. But culture does not require visual or visible manifestations. In the end, then, the culturality of vision, or true visuality, is not—or at least not exclusively—a visual phenomenon. Certainly it is not wholly visible. This result (explored in some detail in Chapters Nine and Ten) may seem paradoxical to some readers, art historians not least. The visualist prejudices of art history have been carried into visual-culture studies, and they encourage us to believe that its primary object of study must be *visual* artifacts and ways of *seeing* them in the past and present. But one of the most striking and consequential propositions of the general theory of visual culture is that forms of likeness in my sense are not entirely a matter of sensuously apprehended morphology, of the visual and visible "look" of things. Forms of likeness that go beyond the visual and the visible (indeed, that go beyond the sensuous in *any* sensory modality or medium) constitute the historical identity of form, style, and depiction, even as the visible vicissitudes of form, style, and depiction constitute the culturality of vision, or visuality. This succession is the most general recursion that I will explore in this book. It explains why vision has an *art* history, as Wölfflin probably should have said.

Chapter 2

Vision and the Successions to Visual Culture

■ I

"The eye is not historical," Arthur Danto has written, "but we are."[1] According to Danto, vision has a history only in the particular sense that "visual representations," by which he means depictions and other visible configurations, "belong to forms of life that are themselves related to one another historically."[2] If we use Wölfflin's famous classification of modes of pictoriality, two "linear" artists, such as Sandro Botticelli and Lorenzo di Credi (Fig. 2.1), were more similar to one another in configurative vision in the sense that Wölfflin intended ("a common visual idiom [in making representations] which cuts across national and religious boundaries at a given time"[3]) than they were to two "painterly" artists, such as ter Borch (Fig. 2.2) and Metsu. As Danto has put it, "the forms of life to which the two [painterly] artists respectively belonged overlapped in ways in which neither of them overlapped with the forms of life the linear style expressed."[4]

But the very fact that the two pictorial idioms seem to have been detached from particular communal (e.g., national or religious) traditions might imply that they constituted different ways of seeing. It suggests, in other words, that they were natural derivations of depictive styles available to anyone who painted in those styles *regardless* of cultural affiliation. People who looked at pictures made in these styles—and

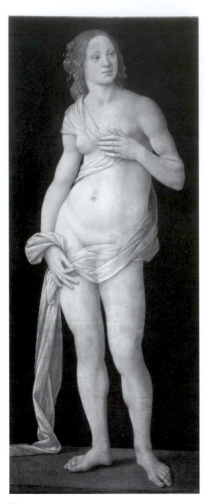

Figure 2.1.
Lorenzo di Credi
(c. 1459–1537), *Venus*,
c. 1490. Uffizi, Florence.
Photo courtesy Scala/Art
Resource, NY.

people who observed the rest of the world in terms of these pictures—might share this vision too. On this account, we would have to identify at least two available ways of seeing in Western Europe at the time of Botticelli, Lorenzo di Credi, ter Borch, and Metsu (that is, in the late fifteenth century and the sixteenth century), namely, the linear way of seeing and the painterly way of seeing. Both ways were historical in the sense that both emerged in human history. And both might be specifically *style*-historical in the sense that they emerged as late fifteenth-century and sixteenth-century European styles of pictorial configuration.

The last intuition would be familiar to art historians. Indeed, it typifies an art-historical theory of vision that has often been implied in the writing of art historians about the history of art. Stating it explicitly, the philosopher Marx Wartofsky wrote in 1979 that "modes of our visual cognition change with changes in the modes of our pictorial representation."[5] According to Wartofsky, human vision has a history that "goes beyond the biological evolution of the hominid visual system and is part of that activity of self-creation and self-transformation which we call cultural evolution."[6] Therefore "human vision is largely a culturally and historically developed capacity, an artifact created by our own visual activity which emerges with the development of visual practices and changes with fundamental changes in these practices."[7]

These sweeping claims could be coordinated with natural history in Danto's sense if "cultural and historical development" simply refers to the evolution of human perception and if "fundamental change in visual practices" simply refers to the emergence of depiction. But Wartofsky went on to add that visual practices are "any practices which order or affect our ways of seeing," including "the various modes of pictorial representation" and "the wide range of architectural, dramatic, and technical practices which orient our ways of looking at things, or what I would call our visual postures." When visual practices effect fundamental change in visual perception by constituting visual postures, Wartofsky calls them "visual scenarios." As he put it, these scenarios "prescribe or suggest how we ought to see, what we ought to look for, etcetera."[8]

There is an obvious risk of self-serving definition—of mere tautology—in Wartofsky's distinctions and in the analogous theoretical intuitions (often considerably more vague) employed by many historians of

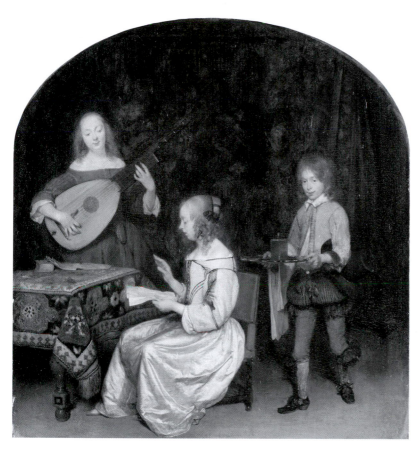

Figure 2.2.
Gerard ter Borch
(1617–1681), *The Concert:
Singer and Theorbo
Player*, c. 1657. Louvre,
Paris. Photo courtesy
Réunion des Musées
Nationaux/Art Resource,
NY.

art and visual culture. According to Wartofsky, seeing (visual perception) is fundamentally changed by any seeing (a visual practice) that fundamentally changes it (visual postures and a visual scenario). In a trivial sense this must indeed be true. But what is the evidence for Wartofsky's baroque ontology? Have we described any real differences, whether analytic (logical) or substantive (neurological), between visual perception, visual practices, visual postures, and visual scenarios?

Picture making surely qualifies as a visual practice and often it creates distinctive visual postures. By the terms of Wartofsky's model, then, it might be identified as an activity that fundamentally changes human visual perception. Again, however, have we identified the fundamental changes introduced into human life (and specifically into human vision or seeing) by the presence of pictures? It is logically possible that pictures might make no difference. Some of the most successful trompe l'oeil pictures, for example, seem to *preserve* the mundane postures of visual perception rather than to modify them. We can go about our lives without attending to the pictoriality of these pictures. They can appear to us

simply as objects in our world—not as pictures of it, and certainly not as envisionings of another world. In Wartofsky's terms, does this mean that our visual perception of these kinds of trompe l'oeil depictions does not attain the status of a visual scenario? That would be an odd conclusion in light of the fact that trompe l'oeil has usually been counted among the most advanced and specialized visual practices that have emerged in human cultural history.

In his most concrete historical proposal, in 1984 Wartofsky suggested that "canonical styles of representing the seen world change . . . and introduce transformations of vision."[9] Wartofsky carefully specified "canonical" or cultural-traditional styles as the source of transformations in vision, as distinct from the personal styles of individual makers in certain phases of their careers. Like vision (or *as* vision), canonical styles are widely shared; they are infraculturally stable constructions. They help us to define a human culture as such. Indeed, we know cultures as much by their traditional, canonical styles as we know styles by their cultures. Because of his preferred definition of style, Wartofsky's historical epistemology of vision grounded itself in a specifically cultural history. In the end, an "art-historical theory of style-change" entailing accounts of changes in particular canonical styles should underwrite the theory of human visual perception.[10] At the least, the *agents* of change in human vision have been culturally emergent canonical styles of pictorial representation. As an example, Wartofsky suggested that the "dimensionality of visual space" in visual perception (that is, our human ability optically to apprehend and to interpret ambient space as three-dimensionally coordinate and infinitely extended) was a consequence of the "pictorialization of visual space" acquired through "practices and conventions of pictorial representation" that had been developed in classical Greek and Renaissance Italian styles of depiction, notably the invention of linear perspective.[11]

In his *Primer in the Social History of Pictorial Style*, Michael Baxandall took pictorial style to derive from the socially-conditioned visual perception involved in making and interpreting pictures. According to Baxandall, this primary visual conditioning must occur in *non*pictorial social contexts, such as military or mercantile practices—a tuning of certain recognitional abilities, orientations, interests, and attentions brought to bear both on making pictures *ab novo* and in making sense of existing pictures.[12]

Like Wartofsky's historical epistemology of vision, Baxandall's "social history" of seeing gives elegant expression to the theoretical intuitions of many art historians. It differs from Wartofsky's conceptions insofar as Baxandall wanted to consider how styles of seeing the world (for ex-

ample, measuring, counting, and sizing-it-up visually) condition styles of depicting the seen world rather than the other way round. But Wartofsky's style-historicism allows that styles of depicting the world might vary according to "changes in modes of social, technological or economic practice," such as the mercantile practices that created the social history of pictorial style (according to Baxandall) in fifteenth-century Italy.[13] (In Chapter Nine, I will return to the question of how building or painting might be like cooking meals, pricing goods, or other social practices that may not always strike us as entirely visual or specifically visual-cultural.) In other words, whereas Baxandall considered how visual practice becomes a mode of representation (from seeing the world to depicting it), Wartofsky considered how a mode of representation becomes a visual scenario (from depicting the world to seeing it). But either way, in principle the full circuitry—from pictures to world to pictures to world and so on—is always up and running. Wartofsky called it a "spiral."[14] And so it is, though it is not (or at least not only) a spiral of canonical depictive styles (and therefore of ways of seeing) that succeed one another in the history of human vision. It is rather the spiral of pictures becoming present in it, which is to say *any* pictures that can be recognized by us in part in terms of their stylistic identity.

■ 2

Human visual perception, says Danto, "has *evolution* rather than a history."[15] For hundreds of millennia, hominid and human development has taken place in a biocultural mosaic that has included the emergence of spoken language and other kinds of symbolism, as well as (presumably) the effects of spoken language and other kinds of symbolism. According to Danto, however, there has been "no human evolution in the past one hundred thousand years" and "certainly none in the bare six hundred years from Giotto to Ingres."[16] Still, he has waffled on the precise chronology, and thus on the underlying evolutionary issue. Elsewhere he has written, for example, that "perception itself undergoes relatively *little* change over the period in question—let's say from about 1300 to 1900."[17] As *any* change in the physiology or function of the eyes and the visual cortex could have consequences for human seeing, Danto's acknowledgment of *some* change, however little, could be taken rhetorically to admit the historical possibility that in theory he had hoped to deny.

What is the evidence, then, that in the evolution of the eyes there has been no change that has affected practices of picture making, at least

since anatomically modern human beings replaced Neanderthals or other premodern humans? It is no easier to answer this question than it is to prove that there *has* been some such change. There are few if any surviving Mousterian pictures (though there appear to be a good number of surviving Mousterian marks, possibly made intentionally *as* groups, sets, or series of marks) to compare to our own pictures. And if these pictures were entirely different in their natural basis or function from our pictures—pictures made by the most modern hominids—would we even be able to recognize them?

Upper Paleolithic paintings, engravings, and reliefs from caves in southern France and northern Spain (Fig. 2.3) suggested to Danto that "the eye as the eye has no further history of speak of" since the time such pictures began to be made, about twenty-five thousand years ago (give or take several thousand years). Regardless of what the images were intended to symbolize, the astonishing resemblance of many motifs in the pictures to certain natural objects presumably involved all those capacities of the human eyes that we could suppose to be implicated in *later* practices of depiction, including the highly naturalistic pictures produced in modern human culture in the last few millennia. (The resemblances might have created pictorial illusion, true trompe l'oeil, especially under the lighting conditions that we now understand to have been instituted in the environments of the decorated caves. Indeed, some of the figurations made use of natural rock formations that might have struck the original makers as looking like the objects depicted.[18]) Thus, Danto concludes, the eyes as we find them now had already been evolved, physiologically and cognitively constituted, by the time these pictures were produced, and probably much earlier.

Danto's interpretation of the historical evidence of Upper Paleolithic depiction might well be correct. But the evidence seems to be consistent with an evolutionary-historical assessment as well as Danto's invariantist conclusion (*non*evolutionary in its stated historical purview) of the past hundred thousand years of history. The cranial capacity of some documented Mousterian populations lies within the range of variation found in modern human populations. For this and other reasons, the replacement of Neanderthal populations by modern human beings has often been held to be due to advantages conferred by cultural practices of the modern humans that were not shared by (or with) the Neanderthals who competed with them for resources. A highly flexible spoken language might be one such modern human cultural advantage; modern human language is founded in soft-palate and associated buccal and vocal morphology that might not have evolved in the earlier hominids. Some ar-

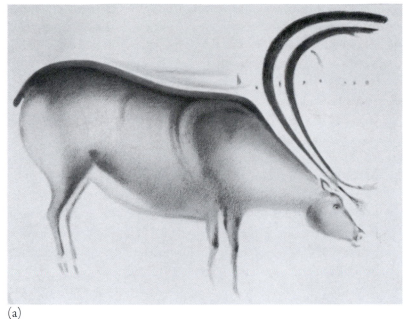

(a)

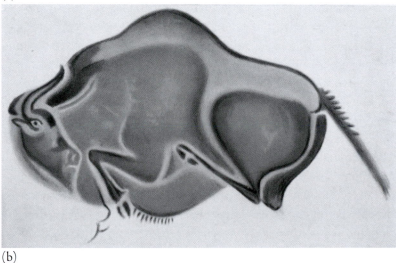

(b)

Figure 2.3.
(a) Painted polychrome reindeer in the Cave of Font de Gaume, Dordogne, France, Magdalenian, c. 17,000 BC. (b) Engraved and painted polychrome bison in the Cave of Altamira, Santander, Spain, Magdalenian, c. 16,000–14,000 BC. From Louis Capitan, Henri Breuil, and Denis Peyrony, *La caverne de Font de Gaume* (Monaco 1910) pl. 28 (a). From Émile Carthailac and Henri Breuil, *La caverne d'Altamira à Santillane près Santander* (Monaco 1906) pl. 25.

chaeologists have even suggested that specifically depictive activities (as well as practices of "gesturing" that might be evolutionarily antecedent to them) contributed to the emergence of spoken language in the modern human line.[19] We need take no firm position on this issue to note that representational practices (such as using marks to count and notate or to depict and diagram) became a causal factor in hominid biocultural evolution, just as toolmaking had been for millions of years.

In light of all this, Danto might find himself in the odd position (indeed, the highly implausible position) of accepting that *fifty* thousand

years ago Wartofsky might have been right: certain representational practices (specifically the making of pictures) might have reorganized the eyes, the hand, and possibly the cortex insofar as natural selection favored those populations that preserved the mutations which enabled these practices. But *today* those very same forces have supposedly ceased utterly to operate in human evolution. According to Danto, in the recent neurobiology of vision "there has not been a generational change, as in computers." But, as already noted, the transition from Neanderthals to modern human populations might be just such a change; and its history lies within the evolutionary timespan when, supposedly, "the eye has no history." And who is to say that an alien anthropologist might not someday take the emergence of writing (around 3,000 BC) or the electronic information-processing revolution (around AD 2,000) as later watersheds in the history of vision?[20] According to Danto, the evolution of the eye has "stopped." But there is neither theoretical nor empirical reason to think that evolution by natural selection ever comes to a stop with respect to any anatomical or physiological characteristics of any organisms under any ecological conditions or in any environmental contexts. That would be equivalent to saying that mutation in genetic replication no longer occurs, that chromosomal reshuffling in reproduction has ceased, or that the bombardments of cosmic radiation, as well as other causes of mutation (including human interventions in the ambient environment) to which hominids and human beings must adapt bioculturally, have come to an end.

What Danto probably meant to say is that the evolution of the anatomy and physiology of the human eyes has been so modest in the past fifty thousand years as to be inconsequential in its effect on the cognitive function that interests him; namely, the capacity of the eyes to interpret depiction. But this is an empirical claim for which he provides no evidence beyond pointing to the putative stability, the tranhistorical and cross-cultural persistence, of virtuoso effects of naturalism (even trompe l'oeil) in human picture making since the Magdalenian period in Paleolithic Europe.

If Danto believes that human visual perception ("the eye") has no history, nonetheless he considers that there *has* been historical change in the "hand," that is, in our motor habits, techniques, and skills in the making of pictures. Invoking Gombrich's history of supposed progress in the objective adequacy or optical correctness and fidelity of naturalistic depiction, Danto has written that "the schematisms intended to be matched against the seen [world] were prompted by discrepancies [between the schematisms and the things seen], which [the schematisms] were intended to overcome." And for the discrepancies to be noticed at

all, Danto suggests, seeing itself "had to have been the same from one end to the other of the history" of constructing and then correcting the schemas. It could only be in stable seeing relaying a stable seen that the making and matching (that is, the supposed pictorial relation itself) could have been historically constituted.[21]

This is an ingenious and powerful argument. But it is narrower than the argument that the evolution of the eyes has stopped. It need not entail that a stability of seeing relative to the world seen dates from the beginning of human history (or even from the time of the earliest depictions made by human beings) to the present day. It might entail only that the history of seeing acquires stability specifically *relative to* the history of certain enduring depictive functions, notably the narrative or "storytelling" that Gombrich took to be one basis of naturalism in pictorial art. These functions might be long-lasting, but they are not immutable. Indeed, this was precisely Gombrich's art-historical point (its accuracy can be set aside for the sake of argument) in urging that naturalistic depiction first appeared in realizing the needs of storytelling in archaic and early classical Greek society in the eighth, seventh, and sixth centuries BC, at least in the visual domain, and that it has been progressively refined ever since, especially in the revival of Greco-Roman pictorial naturalism in Europe in the later Middle Ages and the early Renaissance. In other societies and traditions, other functions of depiction might have led to comparable long-term stability in pictorial art. The millennia-long invariance of ancient Egyptian canons of pictorial representation, for example, might be attributed to their continuous role in legitimating the social and cosmic order, especially as embodied in the institution of Egyptian kingship—an order that was taken, perhaps even *seen*, to be immutable and eternal not least because invariant pictures and other images and symbols seemed to prove it. Certainly it is difficult to find examples of canonical Egyptian depiction that served to *de*legitimate the kingship or to question standard cosmology—kingship and cosmology that would have been known to many beholders principally, or perhaps solely, by way of pictorial representations.

Whether there is a relationship between the history of evolutionary variation in human visual perception and the kinds of history of cognitive and cultural change and difference in depiction noted in the previous paragraph—of changes and differences between, say, ancient Egyptian and Classical Greek "forms of life"—remains an entirely open question. It is unlikely on the face of it, however, that the latter order or register of historical process simply succeeded the former—that it entirely replaced it as the sole mechanism of configurative, stylistic, and iconographic

transformation in depiction. Indeed, there is nothing to be gained by distinguishing biological, cognitive, and cultural levels of evolution and somehow sequencing them temporally.

For the very same reason that Gombrich and Danto could take the hands to have acquired new habits, skills, and techniques in making pictures—habits and skills that for all we know may have in certain respects altered the natural functions and competences of the organism—we can take the eyes to have done so as well. (Gombrich believed that picture making evolved in human life as a way of accepting "substitutes," a behavior that ethologists have observed in many nonhuman creatures. But he could not entirely reduce specifically naturalistic picture making to the occasional acceptance of substitutes: the naturalistic picture is not simply a substitute for the thing it depicts but also a deliberately refined "illusion" of that thing.[22]) In fact, there is little reason for art historians to distinguish hand and eye, or to look in detail into any differences between the neurocortical operations that guide the hands and those that guide the eyes, even though some selective pressures that affect the two organ systems might differ. Picture making requires the use of both hand and eye in complex and constant coordination.

■ 3

Danto has noted one exception to the transhistorical and cross-cultural identity or invariance of "the eye," human visual perception, as he has conceived it—that is, as essentially nonhistorical though naturally evolved.[23] As this exception will turn out to be quite important to the general theory of visuality and pictoriality presented later (see Chapters Six, Seven, and Eight), we must attend to it here. What would happen if a Bronze-Age Minoan encountered a picture of an automobile? (How such a picture could have been made is another question; but let us imagine that a Bronze-Age Leonardo da Vinci imaginatively projected a pictorial design for an automobile, and that a Bronze-Age observer came across it.) The Bronze-Age Minoan would not have been able fully to recognize the object in the picture, simply because cars did not exist for him to recognize. Transplanted to our own day, however, the same Minoan, having seen enough automobiles, would be able to see the (object in the) picture.

Obviously the success of shape-recognition varies with the very existence of things, whether real or fictive, whose shapes can be depicted. In this restricted sense, as Danto says, shape-recognition is historical, and trivially so; it is, he thinks, an inconsequential exception to his ba-

sic claim that Minoan seeing was the same as our own, even though the Minoan could not have recognized automobile-pictures and we can. (Indeed, Danto thinks that it proves the basic point, for Bronze-Age Minoans *could* recognize automobile-pictures once they had recognized automobiles, just as we can.) But shape-recognition likely depends on a more complex feature of a beholder's visual experience. Once someone has encountered a thing, perhaps only in imaginative projections (including in previous pictures), its depicted shape can only be recognized in a configuration in which recognizable resemblances to that thing also denote it. The history of the presence of the object for the beholder is necessary for the history of the presence of the *picture* of that object for the beholder. But it is not sufficient. (As we will see in more detail in Chapter Six, the resemblance of things seen in pictures to objects in the world does not always entail that the painting or other artifact depicts those objects.)

Moreover, shape-recognition might sometimes be blocked not only because we cannot recognize something that does not (yet) exist for us. It can also be blocked because we can fail to recognize something that *does* exist. Danto's Bronze-Age Minoan observer might fail to recognize a porpoise or a shield (objects commonly depicted in Minoan paintings in the Bronze Age) even though he had seen plenty of porpoises and shields before (and even though he had seen Bronze-Age Minoan *pictures* of porpoises and shields before). Instead, he might see an altogether unrecognizable configuration—a blob, patch, or blur rather than a pictorial presentation. Or he might see a recognizable shape (for example, a porpoise-like ship) that is not taken by him to be what the painting actually depicts but rather to be something he simply happens to see in the configuration. In either case, for him the configuration—whatever it is—is not a picture at all, even though its shapes might resemble something in the world that he can and does recognize.

The failure of shape-recognition, then, must entail the failure of depiction. But the equation is not transitive. The success of shape-recognition does not simultaneously entail successful depiction. If depiction occurs at all—if a picture is present at all for the observer—then seeing the picture involves more than the visual processes of shape-recognition. It must also enable processes of motif-identification and image-interpretation. As we will see in much greater detail in Chapters Seven and Eight, a theory of what I will call the "iconographic succession" seems to be needed—that is, a theory of how pictoriality is recognized in shapes that resemble objects.

Let us imagine two object-resemblant shapes that are visually identical or, as I will put it, indiscernible: two red squares painted on wooden board.

(In ordinary English discourse, we describe something that cannot be seen as "indiscernible"—as something that cannot be discerned or made out visually. In this book, however, I will use the term in a more technical sense to refer to two or more objects, or representations of them, that cannot be visually distinguished one from the other, or more exactly *are* not so distinguished in the successions of vision and visuality, without visual recursions that must occur for any visible distinctions between the erstwhile indiscernibles to be descried—recursions that might or might not be possible or might or might not occur and that I will describe in terms of the recognition of analogy.) Both configurations are perfectly recognizable to us as resembling certain objects. But only one of them is a *picture* of the objects. For example, imagine that Painter Z has produced a painting he calls *Barn Door*, a red square painted on barn boards portraying (and resembling) a red barn door. Painter Z's *Barn Door* is indiscernible from (perhaps it is materially identical with) a red square of paint used by a barn painter to cover the bare wood of a barn door. The latter square resembles a red-painted barn door because it *is* one. Indeed, we might even suppose that the barn painter had deliberately replicated this very resemblance: imagine, for example, that he had *re*painted the door the same red color after the previous coat of red paint had entirely peeled away.

Danto's Painter J, whose productions and predicaments were described in *The Transfiguration of the Commonplace* (published in 1982), helps us to understand Painter Z's quandary. Or, perhaps more to the point, Painter J's situation helps us to understand the difficulty facing beholders of Painter Z's *Barn Door* in the context of indiscernible red-painted barn doors. Painter J has also painted a red square, and he hopes to have *his* red square, *Untitled*, accepted as a work of art in an exhibition along with such artworks as Sören Kierkegaard's *Israelites Crossing the Red Sea*, a red square that is indiscernible from Painter J's *Untitled*, as well as several other similarly subtle paintings. (*Israelites Crossing the Red Sea* depicts the fact that the Israelites have already passed through the sea and the Egyptians pursuing them have been inundated and drowned.) All of them—Painter J's *Untitled*, Kierkegaard's *Israelites Crossing the Red Sea*, and the other works—consist in painted red squares that appear identical although each of them depicts a different real object or state of affairs. In preparing to hang the exhibition, we could easily mix them up, mistake any one of them for any other, an error that might cause considerable consternation to Painter J, Kierkegaard, and the other artists, each of whom naturally would want to see his own creation take the prize.

In persuading the jury to accept his work in this context, Painter J can be asked what distinguishes *Untitled*, like Kierkegaard's *Israelites*

Crossing the Red Sea, from a mere red square—say, a red square painted by the barn painter. As Danto laid out the conditions of this situation, Painter J could not give the answer that we might expect; namely, that his red square depicts a red square (such as the square painted by the barn painter) while the mere red square resembles a red square (because it *is* a red square). This is because *Untitled*, in Danto's scenario, was made by Painter J to be "void of picture" (it is an "abstract" painting) precisely in order to diverge from *pictorial* red squares such as Kierkegaard's *Israelites Crossing the Red Sea*, which have already been accepted as valid and viable artworks (possibly on the basis of their peculiar and maybe witty pictoriality) and to which Painter J hopes to add his own work (i.e., *Untitled*).

Of course, the question of the presence of art in Painter J's *Untitled* is logically independent of the question of the presence of pictoriality in it, even if the presence of pictoriality has seemingly assisted Kierkegaard in getting his *Israelites Crossing the Red Sea* accepted as a work of art. In solving Painter J's problem, Danto specifically addressed the issue of (indeed devoted himself to) the presence of art; his thought experiment stipulates the absence of pictoriality in *Untitled* in order to dramatize the aesthetic puzzle of *Untitled*. Despite the indiscernibility of Painter J's painting and the barn painter's painted square—their seeming visual identity or lack of such discernible features as would distinguish them—the barn painter's red square derives from and belongs to a form of life to be described as painting barns and other buildings. By contrast, Painter J's painting putatively derives from and belongs to a form of life to be described as making artworks. It belongs to what Danto has called an "artworld."

According to Danto, this artworld should not be characterized analytically as an arbitrary convention or a social institution, though descriptively it is both of these things. Painter J's painting is not a work of art because a certain institution calls it "art" ("This painted red square here—it's art!"). In Danto's view, it seems, that would be to put the cart of a language-game before the horse of a form of life. Rather, an activity of calling certain objects works of art, a *use* of these objects, has emerged in a form of life. It is a practice of accepting certain objects *as* works of art. And this practice is not to be found in every domain, most notably (for Painter J's purposes in his situation) the domain in which we paint barns and other buildings to protect the bare wood from the elements. Because painting barns and making artworks are recognizably different practices in our form of life (that is, in the form of life shared by Painter J and his critics and buyers), configurations that devolve from each practice and continue to inhere in them can be recognizably distinct despite their indiscernibility in any number of respects. In the red-painted barn

door, we might notice such aspects of the configuration as the seeming toughness or imperviousness of the layers of paint. In the red-painted square displayed as an artwork, by contrast, we might notice such aspects of the configuration as the brightness of the hue or the evenness of the brushstrokes. All these aspects might well be visible to us in *both* configurations. But *each* configuration can be seen as having been replicated specifically for *some* of its aspects to be acknowledged and attributed to the causes and contexts of the work: its origin and maker, its place and time, its use and function, and its media and history of replication and variation. (In this regard we can say that *Untitled* and a red barn door have different *styles*.) Adapting Ludwig Wittgenstein's slogan about language-games, Danto says, "To imagine a work of art [Wittgenstein had said 'language-game'] is to imagine a form of life in which it plays a role."[24] (Wittgenstein's notion of language-games in a form of life and my application of it to the problems of visual culture, especially to what I call the "cultural succession," will be considered in Part Three.)

We can transpose this line of argument from artworks such as *Untitled* by Danto's Painter J to pictures such as our Painter Z's *Barn Door*. Depiction emerges in a form of life as that practice in which we accept certain object-resemblances to be found in configurations as portraying the objects. This practice cannot be found in every domain, including many domains in which we recognize configured shapes to be something-or-other or to look like such-and-such. For example, a triangle in a geometric demonstration in a textbook is not usually a *picture* of a triangle. It is a triangle drawn in a particular way for the purposes of the demonstration, namely, not really as a triangle at all in the strictest sense of the geometry of triangles—for triangles in themselves have no visible width to their three "lines." (Painter Z is working on a new project, however, in which he will *portray* the geometric demonstrations in a particular textbook in his possession in such a way that the width of the lines is so great as to make it difficult to understand the geometric proof in question.)

On this understanding, and considering that he might simply have painted a barn door red, Painter Z must get us to see that he has depicted a red barn door in his *Barn Door*, however he manages to do this. In part, he can depend on a specification relayed in a fuller title: *Red Barn Door*. Moreover, in the catalog of the exhibition he might include a photograph of the actual red barn door that he used as his model. In turn, these specifications can recursively affect pictoriality in the red square that is *Red Barn Door*—a square that recognizably resembles a red barn door. Now the square portrays as well as resembles. And new questions about it must arise. We might begin to look more closely at the painting to see if we can

find details in *Red Barn Door* that might match particular features of the actual red barn door painted by the barn painter or alternately might differ from them. When the barn door and *Red Barn Door* are put side to side in the same perceptual context, that is, the artificial context imagined in the thought experiment, they seem to be indiscernible—they appear to be visually identical. But indiscernibility is not objective; it is an aspect of things—an aspect of the relation between two or more perceived objects—in a visual situation. And might not the red barn door in its context on the farm and *Red Barn Door* in its context in the gallery look different? Perhaps the hue of red in *Red Barn Door* looks rather orange in the artificial light of the gallery; perhaps the slick of rain on the red barn door on the farm looks rather slippery to the touch.

Painter Z's operations resolve a case of what can be called "depictive disjunction," a horizon of perceptual and interpretive ambiguity that surrounds recognitional and iconographic relays in the succession of pictoriality itself. Indeed, these relays are inherently embedded in pictoriality. In this primordial sense depictive disjunction stands outside, and prior to, the iconographic succession of visual culture (Chapters Seven and Eight); it subsists entirely in the pre-iconographic domain and possibly outside or before culturality as such (Chapter Ten). For obvious reasons we can usually set the disjunction aside in considering the vicissitudes of pictoriality *in* the succession: in considering the vicissitudes of pictoriality, we must have already assumed or determined that a picture is present, and we want to ask how people see it, namely, what they see in it and what it looks like. But in many areas of art history and visual studies, resolution of the depictive disjunction must be the *sine qua non* of our more narrowly oriented investigations of the visual and noetic successions and recursions that specifically constitute visual culture. Did any pictoriality whatsoever inhere for someone in a configuration or part of a configuration that to us looks like it resembles something-or-other? In other words, was a picture present?

For the immediate purposes of this chapter, we can proceed from the conclusion that human shape-recognizing abilities in the visual field (however they evolved in the long span of hominid and human phylogenesis) might have tranhistorical and cross-cultural stability or constancy. Or they might not; they might be subject to pressures recursively introduced to vision by human technology and representation. But the issue is broader than the question of visual culture as such, even if implicated in visual culture in its constitutive successions and recursions. What counts for the general theory of visual culture is the way in which shape-recognizing abilities, even when constituted recursively as visual-

cultural functions, must succeed to picture-interpreting abilities despite the depictive disjunction. Precisely because of depictive disjunction, in fact, shape-recognition (however practiced or skilled in the discrimination of one shape from another shape) cannot suffice for the characteristic ability of cultured vision to resolve perceptual ambiguity by making distinctions between visible things, however indiscernible at the visual level, in terms of their analogies. I will return to this capstone of the general theory of visual culture (it is equally the *platform* of the general theory of visual culture) in the final two chapters.

■ 4

According to Danto, the interaction between human visual perception and historical styles of depiction, if there is any, must be one-way. It runs from seeing to style and not from style to seeing.[25] As already noted, Danto has reached this conclusion in part because he thinks the evolution of the eye has "stopped" in recent human history—a notion that I take to be incorrect. More plausibly, he has appealed to the supposed neuropsychological modularity or compartmentalization of perception and cognition and to the putative impermeability of the perceptual modules to the cognitive modules. But impermeabilist modularism cannot be fully maintained, in my view, when it comes to non-natural (cultivated) object recognition—and this for reasons already broached in the immediately preceding section of this chapter and to which we will return in subsequent chapters. My arguments will not depend essentially on a neuropsychology of visual perception. But I suspect that they are likely to be more compatible with a neuropsychology that emphasizes the plasticity and pluripotency (and in particular the transreflexive recursions) of the cortical circuits involved in recognition and representation rather than their impermeable modularity.

To use Danto's example (an homage to J. J. Gibson), in flying an aircraft a Chinese pilot can see moving blots and blurs of color all around him as edges, holes, and surfaces, much as they would be depicted in Western perspectival pictures. Therefore the pilot will land successfully on a Western airfield. An episode like this suggests to Danto that the Chinese pilot's seeing remains impervious to his traditions of depiction. (We must assume in this thought experiment, as Danto makes clear, that the Chinese pilot would always *depict* the airfield, and anything else, according to traditional conventions of classical Chinese pictorial representation in which such features of the world as the precise length of

the runway or the height of the plane from the ground would not be rendered or at least would not be rendered with the kind of geometrical exactitude—an exactitude that enables accurate measurement of the projected space—required by the pilot in flying his plane. None of this is to say that classical Chinese representation lacked methods for the pictorial configuration of deep, atmospheric spaces. Nor is it to say that classical Chinese pictorialists did not engage with or failed to understand Western linear-perspective projections when they became familiar with them in the later seventeenth century, or that later Chinese art did not incorporate aspects of linear-perspective configuration into its repertory of effects.) As recounted by Danto, the episode seems to be readily imaginable. But our questions about it must be quite narrow.[26]

We need not evaluate the general perceptual abilities of a pilot, Chinese or otherwise. But we must determine the role of different depictive skills, habits, expectations, and cultural traditions in his piloting. For Wartofsky, the landings could occur at least partly because the pilot has a depictively organized mastery of airfields (and everything else), implying a world in which there are as many world-adapted forms of life as there are differing canonical styles in representational traditions. For Danto, the landings would occur *despite* the canonical styles of the representations, implying a world in which there is one world-adapted human form of life (at least in the domain of seeing, of visual perception) regardless of representational tradition.

But it would be difficult, perhaps impossible, to design a test that could adjudicate this artificial dispute. If the pilot were not Chinese in the sense required (Chinese in the sense that if asked he would always depict the Western airfield using pictorial conventions of Chinese art), then whatever he would do would not be direct evidence for what people who *do* depict airfields in conventional Chinese fashion would do in flying the airplane. We can imagine an analogous person who employs different canonical styles of depiction, such as a Chinese pilot who always draws airfields (and everything else) according to spatiometric techniques of Western perspectival projection. But exactly the same problem must arise. To show that his depictive practice has no impact on his piloting, we would have to know whether he could pilot without it. It is safe to assume that it would not be easy to find such a person in any existing form of life in the human world: virtually all people have habits, skills, expectations, and cultural traditions in styles of depiction.

We can set aside the perennially fascinating question of "wolf children" (that is, feral human beings), very young children, traumatically disturbed or deprived adults, and other creatures whose form of life (albeit

human) might seem to be situated somewhere outside pictorial habits, skills, expectations, and traditions. If were to grant, for the sake of argument, that pictures are not present for such a person (a point it might be difficult to prove), then obviously we could discover what he could do *without* picturing. Such cases may seem far-fetched, but they are not completely irrelevant to the cultural history of style and depiction. John Ruskin asked modern painters to strive for what he called the "innocence of the eye" by inventing "a sort of childish perception."[27] Western art theory since the late Middle Ages has repeatedly cast up versions of the idea that in painting or sculpture an artist might register simply what he sees or just and only what he sees, as it were pre-pictorially and non-stylistically. But to know whether picturing and pictorial styles would have any effect on the perception of these innocent creatures, we would have to introduce them to pictures. We would have to make pictures present for them. And then they would be constituted as nothing more or less than "Chinese pilots." Rarely if ever can we find people for whom no pictures have ever been present in their seeing, for their seeing, and, arguably, *as* their seeing. (Notice that picturing need not require painting or other media; it could be carried out in gestures with the fingers.) None of this tells against the possibility that there really might be invariant visual processes that are utterly impermeable to pictorial styles. But the trained seeing of the Chinese pilot, which enables him correctly to interpret moving blurs as edges, holes, and surfaces, to interact with them using his skills, habits, expectations, and traditions in representing such features of the world, is not likely to be found in a pre-pictorialized or non-stylized domain.

To take another challenging case, Danto claims that a famous optical illusion, the Müller-Lyer grapheme (Fig. 2.4), cannot be overridden by higher-order cognitive processing or (as Danto would surely have to claim) within a representational practice. An artist who carefully and de-

Figure 2.4.
The Müller-Lyer
grapheme.

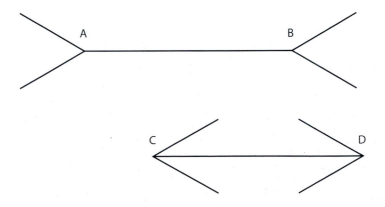

liberately measures and draws the two interior lines (the horizontals AB and CD) to be exactly the same length (so far as the ruler says) will still find himself subject to the visual impression—the powerful illusion—that they are *unequal* in length when the different angular extensions have been added to the lines. (Stated the other way around, although line AB appears to be longer than line CD in the configuration of two arrow-like forms, the horizontals are equal.)

Again, however, does this refute the historicist? A form of life in which illusions simply deceive us must differ profoundly from a form of life in which an illusion can also be known (cognitively represented) and graphically projected as such. Employing deliberately honed skills and traditions in depiction and precise graphic calibration, an artist could configure the apparently unequal lines of the Müller-Lyer illusion within a grid that shows the lines to be equal, thus presenting the illusion *and* showing the fact that it is an illusion. We can *see* the illusion. (The work of twentieth-century artists and graphic philosophers as diverse as Josef Albers, Victor Vasarely, and Bridget Riley routinely plays with such paradoxes.) When we consider a person who has been deceived by the illusion, we are not investigating someone who sees the illusion in virtue of recognizing a certain style and understanding certain conventions in the grapheme—for example, the convention that each side of each square throughout the grid has equal length, something that can only be *represented* imperfectly. What we want to know about him is whether the illusion has been perceptually experienced despite his representational ability or, alternately, because of it.

As a final and even more specifically art-historical example, consider the configurative similarities between wash paintings by classically-trained Chinese painters (Fig. 2.5) and the black-and-white blot-and-wash drawings of Alexander Cozens and other artists in Britain in the eighteenth century (Fig. 2.6). According to the twentieth-century Chinese painter Chiang Yee, who admired the British works, these similarities encouraged him to suppose that "there is really no boundary between English and Chinese art at all."[28] However the similarity was understood by Chiang Yee, Danto can explain it in noncultural terms. As a result of invariant mechanisms of visual perception, the human eye—whether it be "Chinese" or "English"—tends to construe shapes in blots of color in the same way. Typically it detects (it sees) objects of some kind. In this respect perhaps there is transcultural similarity in visual perception between China and England.

But perhaps the similarities noted by Chiang Yee were generated in a depictive practice in Wartofsky's sense, albeit a transcultural one. In

Figure 2.5.
Chiang Yee (1903–1977),
*Mountains in Rain
Looking Through the
Window of a Bus from
Seatoller to Keswick*, c.
1936. From *The Silent
Traveller: A Chinese
Artist in Lakeland*
(London 1936), pl. 5.

Figure 2.6.
Alexander Cozens (1717–
1786), blot painting, c.
1785. British Museum,
London. Photo courtesy
British Museum.

world art history there have been several widely approved styles of making visually suggestive patterns that solicit beholders to see the shapes of objects in what might appear to be amorphous blots of color. After all, Cozens was born in Russia and throughout his later life in Britain remained involved with fashionable Orientalisms. He was familiar with Near and Far Eastern arts: Persian and, we might suppose, classical Chinese calligraphic and pictorial styles. His experiments in landscape, then,

can reasonably be regarded at the circumstantial historical level as mediated replications of Chinese styles.

In fact, Chiang Yee himself might also be said to have had an historically situated "eye," derived in part from his life as a traveller and expatriate. In his several books and in the paintings he produced to illustrate them (Fig. 2.7), he evinced disinterest in clear-cut cultural boundaries between ways of seeing or traditions of depiction, sometimes to the point of expressing a kind of moral objection to them. He was interested in intercultural accommodation and exchange. And "art," he opined, "knows no narrow national or racial boundaries."[29]

Danto has suggested that in his seemingly hybrid pictures (e.g., Fig. 2.7), Chiang Yee "internalized a western idea of novelty as the concomitant of originality."[30] But if this is so, Chiang Yee would not be an example of the kind of schema-bound artist that Gombrich once took him to be; that is, a Chinese painter depicting (if not actually *seeing*) the world of the British Isles according to the conventions of the "relatively rigid vocabulary of the Chinese tradition."[31] (According to Gombrich, Chiang Yee in Britain was gripped by the "schemas" of Chinese painting, though it is not clear from Gombrich's discussion whether Chiang Yee *in China* was a highly schematic painter—a "conceptual" artist.) And at any rate, whether Chiang Yee preserved a traditional Chinese pictorial style or modified it in light of Western aesthetic ideology, we might suppose that his visual recognition of similarities between Chinese and English art was historical and cultural. It might have been based as much on his Chinese and his English training and travels, and on his interests in intercultural exchange, as on invariant tendencies of his human eyes to see

Figure 2.7.
Chiang Yee (1903–1977),
Cows in Derwentwater,
c. 1936. From *The Silent Traveller: A Chinese Artist in Lakeland*
(London 1936) pl. 8.

stylized pictorial patterns (let alone depicted objects) in colored washes and blots. It is hard to know how we could settle this point without taking Chiang Yee's training and travels away from him. But if he had not had this history and culture behind him, would he even have noticed the similarity between Chinese and English blot paintings, a similarity that he saw *as* a trans- or intercultural phenomenon—let alone have pointed to the importance of that very value?

■ 5

In the examples considered in the previous section, the Chinese pilot saw blurs of color as the edges of an airfield or holes in a runway, and in the similarity of Chinese and English blot paintings Chiang Yee saw the lack of a hard-and-fast boundary between Chinese and English art. The pilot and the painter saw certain salient *aspects* of things (visible in the pilot's case, intangible in Chiang Yee's case) in the raw perceptual data, if such a term has any real meaning when we consider the processes of recognition involved in the pilot's and the painter's seeing.

Following philosophical psychologists in the wake of the later work of Ludwig Wittgenstein, I take *seeing-as* and what Richard Wollheim has called *seeing-in* (as well as the aspectivity of things with which these mental actions are intrinsically correlated) to be the heart of visual perception considered from the sensuous point of view of the sentient human being. That is, visual perception is at its core an activity of recognizing and sometimes representing things in a partly visible world, whether or not that activity is specifically cultural or cultivated.[32] Indeed, it is because visible things have sensuous aspects for sentient human beings (aspects that *can* be recognized as such but need not be) that vision can sometimes be cultured and cultivated. For aspects can be compared one to the next morphologically and they can be likened one to another analogically. The pilot not only can see certain relevant edges, holes, and surfaces in (and as) the airfield, a process that might be defined by Danto or Gibson as wholly natural. He also sees them as looking like a landscape picture, Chinese or Western as the case might be; this aspect of things precipitated in his seeing could be described as a cultural recognition. And Chiang Yee not only can see Chinese aspects in English painting and English aspects in Chinese painting, a natural recognition of cultural facts in which the painter sees the Chineseness and Englishness of the paintings (albeit in a way inverse to that in which beholders of these particular objects might commonly recognize such aspects). He also sees these aspects as mani-

festing the essential identity of English and Chinese painting, a cultural interpretation of his natural visual-cultural recognition.

There is a complex relay and recursion in these recognitions when they are fully integrated; that is, when the Chinese pilot sees the airfield like he sees a Chinese or a Western painting (namely, visually alert to the visible phenomena rendered in Chinese traditions of depiction) and when Chiang Yee sees the Chinese and English paintings as like one another and presumably like he sees his own paintings. Although perhaps spontaneous and near-instantaneous, then, the salient recognitions are neither simple, primitive, nor unitary. They are not a kind of primal or pure object-seeing, even though they are, of course, addressed to objects (namely, airfields and paintings). The Chinese pilot is not Chinese in the sense intended (despite his Chinese pictorial education, he can land on Western airfields) if he has not seen *both* airfields and paintings. And Chiang Yee cannot see the requisite similarity between the paintings (despite their Chinese and English origins, the same images appear to him) if he has not seen *both* Chinese and English examples. For this reason the place of culture in these relays of recognition is not localized in seeing aspects of any *particular* object, even though particular seen objects can be seen culturally—that is, not only visually but also in a visuality.

Nonetheless we should not assume that culturality suffuses each and every relay and recursion of the circuit of recognitions that enable an agent to navigate his world, including the pictures it might contain. The Chinese pilot might see the airfield as looking like a Chinese painting because of his cultural education, or he might see it looking that way simply in response to its Chinese look for him. It has certain (and in his form of life crucial) Chinese-painting-like aspects for him. And while Chiang Yee can see a cross-cultural identity between Chinese and English painting when he compares certain artifacts derived from far-flung sources, he could just as well see the Chinese and English paintings as visually similar without any cultural points of reference. They have certain (and in his form of life crucial) look-alike aspects for him.

In the end, it is much less important to quantify the ratio of "nature" to "culture" in these relays (we can usually expect them to have a measure of both) than it is to track their historical vicissitudes. Vision succeeds to visuality (or it does so partially, or not at all) in many ways. The history that determines the Chinese pilot's ability to land on Western airfields and the history that determines Chiang Yee's identification of Chinese and English paintings are discriminably different. In both histories, depictions and depictive styles have a specifiable place and play a definable role, whether it be negligible (according to Danto) or substantial (ac-

cording to Wartofsky). The examples were intended by their authors to dramatize this very point. But in the one history we are concerned in the end with the pilot's ability to recognize *airfields*, regardless of their resemblance to pictures and even if that ability is partly the result of their resemblance to pictures. In Chiang Yee's history, on the other hand, we are concerned in the end with the reason the painter recognizes *artistic style*, regardless of the paintings' resemblance to one another and even if the painter's recognition is partly caused by that resemblance. We are concerned with different aspects of visible things in different visual *and* nonvisual interactions—different histories of recognitional relay and recursion, including different kinds of resistance and risks of misrecognition and failure. While the pilot sees moving blots and blurs because he is flying over the airfield at high speed, he sees the edges of the runway and other features below him and he is able to land on it (we hope) because he is a pilot: he sees the relevant edges, holes, and surfaces. And while Chiang Yee sees the paintings to be visually alike because he sees similarly suggestive blots and blurs in them, he sees them as artistically and perhaps spiritually akin (he believes) because he is a painter: he sees a method of making images in them.

With a great deal of ingenuity, we could probably map these aspective networks onto one another or even adduce them as psychological variants of an underlying type or mode of seeing. Arguably, for example, the pilot and Chiang Yee embody two variants of a specifically Chinese "eye," as Gombrich would have insisted despite Chiang Yee's skepticism about the real difference between Chinese and English depictive styles (or certain highly particular examples of them, at any rate). Certainly the situations of the Chinese pilot and Chiang Yee are not wholly incommensurable. Indeed, for some artificial analytic purposes they can be identified, as Danto did when he tried to isolate the specifically natural dimension—pre- or non-cultural or uncultivated—of the pilot's *and* the painter's aspect-seeing. (As noted, this may be a point of abstract philosophical interest. But it has little anthropological relevance because neither the pilot nor Chiang Yee, nor virtually anyone else for that matter, actually lives in such a compartmented way and certainly does not fly airplanes or paint pictures in that way.)

There is, however, sufficient disjunction between the pilot's situation and Chiang Yee's to require different histories of the causal contexts involved in the recognitions that each agent must make (what I will call "forms of likeness") in order to navigate his world; that is, in order to fly or paint in the particular way that he does fly or paint. These disparate recognitional circuits or forms of likeness have precipitated from differ-

ent forms of life, and in the recursion of culturality in what I will call the "cultural succession" they can help to *constitute* different forms of life. What is truly important in the pilot's form of life is that he can land on Western (and Chinese) airfields regardless of his Chinese aesthetics. And what is truly important in Chiang Yee's form of life is that he can see diverse pictures to be transculturally akin regardless of their English (or Chinese) derivation.

In fact, and given the admittedly tendentious terms of the original examples, it might even be possible to say that the pilot does not and cannot see the Chinese and English paintings as Chiang Yee sees them. He does not have Chiang Yee's way of seeing; supposedly he sees everything according to the canons of classical Chinese depiction. And Chiang Yee does not and cannot see the airfield as the pilot sees it. He does not have the pilot's way of seeing, for supposedly he sees no essential distinction in Chinese and English depiction. The forms of likeness of airfield and paintings are different for the pilot and Chiang Yee, even though *both* of them can see *both* airfields *and* paintings, and can see visual similarities and differences between them, with the same kind of eyes. (To show how this might be so—the deepest finding, I believe, of visual-culture studies—will be the burden of Chapters Nine and Ten.)

Despite their common national background and partly shared cultural history, then, the pilot and Chiang Yee arguably can be said to inhabit markedly different visual cultures or visualities. We might call these "classical" and "cosmopolitan" visualities respectively, though the terms could be somewhat misleading: the ostensibly classical pilot is cosmopolitan, of course, when landing on Western airfields, and cosmopolitan Chiang Yee is typically classical in painting with a calligrapher's brush. To be sure, this difference may have little or no practical consequence in most areas of their lives, even in those areas that involve focused exercises of visual perception. If asked to pilot an aircraft, Chiang Yee, like the pilot, could land on the kind of Western airfields encountered by the pilot, in part because their specifically Chinese or Western "look" is inessential to him. And if asked to paint a picture, the pilot, like Chiang Yee, could paint the kind of English-seeming pictures produced by Chiang Yee, in part because they "look" specifically Chinese to him.

Nonetheless the two different forms of life and the forms of likeness that sustain and devolve from them might show their true colors, as it were, when the agents are called upon not only to see the world *simpliciter* but also to see pictures *in* the world and to make pictures *of* the world. (Of course, this is the recursion—the pilot is likely unaware of it, while Chiang Yee is fully aware—that makes the two examples interesting as

complex cases of seeing.) For to see pictures and certain other man-made artifacts, as I have mentioned, is inherently to see them as having configurative, historical, representational, and cultural styles—aspects that can be recognizable or recognized and represented or replicated as such. Regardless of the pilot's ability to land on Chinese or Western airfields, he distinguishes essentially between Chinese and Western depictions. And regardless of the painter's ability to produce Chinese and English paintings, he would not distinguish essentially between the very same pictures. The forms of likeness of these objects are clearly distinct for the two agents *even if the objects themselves look exactly the same*—indeed, even if the objects *are* the same. The same objects can have many forms of likeness, possibly disjunct and even incompatible forms of likeness, depending on the visual-cultural history of the agents who see them; that is, who recognize the same, overlapping, or wholly different aspects.

■ 6

In seeing man-made artifacts, we do not only recognize the objects *simpliciter*. (The definition of man-made artifacts must be elastic. The term usually refers to such material objects as tools, shelters, and works of art, but it can be applied to natural phenomena, human persons, and social activities.) We also tend to apprehend their configurative, stylistic, representational, and cultural aspects, what I will call their "formality" and "representationality" (Chapter Three), their "style" and "stylisticality" (Chapter Four), their "pictoriality" (Chapters Six, Seven, and Eight), and their "culturality" (Chapters Nine and Ten). Indeed, our recognition of an object in the anthropological sense—as something that is used, usable, and useful in our form of life—depends on accessing a substantial proportion of these interacting aspective horizons in substantial and substantially appropriate ways, or, as I will put it, on *succeeding* to them. We must recognize their forms of likeness. This is a perceptual episode, an aesthetic event in the broadest sense (as well as in the original etymological sense). But in successfully integrated and complete successions it is really a perceptual *conversion* that takes place. Somehow we see the same things in different ways. Because the things have not materially changed as physical stuff (or so I will need to assert for the sake of advancing the fundamental argument), the seeing itself must have shifted somehow *qua* seeing. Like many conversions, the visual-cultural successions addressed in the chapters of this book usually have a social matrix. It is important to realize, however, that they do not *require* sociability or social relations.

The successions require only that "light dawns gradually over the whole," to use Wittgenstein's metaphor; that is, that an object, or even the world, comes to be seen anew—as having new aspects.[33]

How does this light dawn? By what relays or recursions in recognition do people come to see new aspects in things? The general answer is simply that the aspects of things are *interdetermined* in multiple ways; new aspects build on and thread through aspects that have already been accepted. To be specific in terms of the objects and artifacts that occupy historians of visual culture, within a form of life people can use the configurative aspects of things to see the stylistic aspects, the stylistic aspects to see the depictive aspects, the cultural aspects to see the configurative aspects, stylistic aspects, and depictive aspects, and so on.

The recursive relations between the aspective successions (the interdetermined configurative, stylistic, and representational aspectivity of objects in our recognition of their identity, use, and value) will occupy me throughout this book. In the end the fact of interdetermination entails that in theory it must be nonsensical to isolate the purely formal, the purely stylistic, the purely depictive, or the purely cultural aspects of something. We do not see discrete thing-aspects. We see the aspects of something as a whole, the integral thing it is for each and every seer. Analysis of the separate aspective successions can provide heuristic starting-points. But only starting-points. And the substantive *reifications* of aspective successions that typify extreme or high formalism (Chapter Three), stylistic typology (Chapter Four), the iconography of motifs (Chapters Seven and Eight), and culturology (Chapter Nine) involve a severe—in fact, a fatal—theoretical error.

In theory the full circuitry of aspective succession and interdetermination is open and endless. But it constitutes the "meaning" of an object or artifact for the agent who apprehends it. (I put the term "meaning" in quotation marks because in the end it will not do much psychological or historical work; as we will see in Chapters Nine and Ten, it suffices for us to identify the forms of likeness that sustain and devolve from aspect-seeing.) Needless to say, not everyone (and perhaps no one in a later period or at a different location) can recognize all of the aspects of an object or artifact that were apprehended by its original users. But at every time and place in history an object or artifact must have an overall aspectivity recognized by the people who use it. This overall aspectivity can be entered at any point (probably at many points) and tracked to other points, allowing new aspects to dawn according to the same principle of aspective succession and interdetermination that rendered the artifact recognizable (even visible) for its original users in the very first place.

Thus the present-day historian might be able to say a great deal about the pictoriality of an artifact without being able to say much about—that is, without being able to "see"—its original formality, the sensuous configuration apprehended by original users as having been produced to effect such visual awareness. Still, because the pictorial aspects of the artifact originally might have grounded its formality, if the historian can grasp the pictoriality of the artifact it might be possible to gauge its original formality. This method of entrance into historical visualities has been preferred by iconography (see Chapters Seven and Eight). By the same token, if the historian can apprehend the formality of the artifact it might become possible to grasp its stylistic, pictorial, and cultural aspects. This method of entrance into historical visualities has been preferred by formalism (see Chapter Three). In general, all of the methods of *Kunstwissenschaft* are means of entering the overall aspectivity of man-made artifacts of the past (or artifacts produced in sociocultural contexts that are not natively inhabited by the art historian) by way of their aspectivity in the present. (The most influential and tendentious version of this notion, usually called "formalism," will launch my inquiry in Part Two.) These methods have made possible, continue to realize, and help to justify a general theory of visual culture. I will not undertake systematic historiographical exposition of this point, though a survey of the *Aspektwissenschaften* in the hermeneutic and historical disciplines would be useful, and in subsequent chapters I will devote attention to classic (and in my opinion still valid) art-historical formulations of salient forensic problems. The overarching point is that the successions and interdeterminations of aspectivity, such as the way in which formality can reveal pictoriality and pictoriality can reveal formality, must suggest particular methods of hermeneutic and historical investigation, whether or not these methods have always been fully developed and consistently applied in art history or in any other discipline that purports to deal with visual culture.

In our historical and hermeneutic investigations we must proceed with caution through the aspective successions and interdeterminations. The way is not as smooth and well marked as many historians have supposed. For example, although the configurative aspects of an artifact should not be wholly divorced from its stylistic and representational aspects, they might be substantially *disjunct* from them. In fact, this must be true by definition in some arenas. When a connoisseur points to the "form" of an artwork (say, the configuration of its principal conventional motif), he might identify aspects that are distinct from the aspects he would identify in specifying its authorial style. For authorial style in the connoisseur's sense, as we will see in Chapter Four, can never be conven-

tional. And it need not—indeed it usually does not—inhere in the principal motif. Again, when an iconographer identifies the motif of a picture (regardless of its configuration), he might point to aspects that are distinct from the aspects he would identify in specifying its culturality. For cultural significance in the iconographer's sense, as we will see in Chapter Seven, requires a succession from visible motif to conventional intelligibility. Moreover, despite the fact that all artifacts must have an overall aspectivity (there is no such perceptual phenomenon, no such visible thing, as an object without aspects) there might be more or less "formless" or "styleless" artifacts of all kinds (under certain conditions, as we will see in Chapters Three and Four, some agents do not recognize any formal or stylistic aspects in artifacts that have been made to be visible to them; that is, as artifacts of visual culture). There is no absolute quotient of "real" aspectivity in an object to be recognized by all of its observers and users. There are simply the aspects that *are* recognized in each context of observation and use. In each context it might be easier to recognize aspects that might also be apprehended in other contexts, or it might be more difficult. In some contexts, aspects recognized in other contexts cannot be seen at all—aspects as fundamental, for example, as the very presence of pictoriality in an artifact known to be made to be a picture.

Thus in some contexts the apparent stylelessness of an artifact (for example) might serve to accentuate its formality rather than to diminish it. To take a familiar case, sometimes a museum will display a beautiful ancient artifact as an isolated masterwork, as if it were unique. Such exhibitions tend to impose excessive formality on the object. This is because its original "stylisticality," as I will call it in Chapter Four, that is, its rhetorical replication of a stylistic tradition that would be visible in the ancient context, cannot readily be recognized in the museum. It is perfectly possible that the ancient artifact had a high degree of formality for its ancient beholders, as it does for us. But without access to the interdetermination of formality and stylisticality in the artifact, an interaction that is occluded in the museum, we cannot say its formality for the ancient beholder was the *same* formality that we apprehend in the museum setting as an avowedly visual experience (and supposedly an aesthetic one to boot). Indeed, a distinctive aspective succession might be entirely lacking for us in the museum that was fully available to ancient beholders, and vice versa. In the museum, the stylisticality of the ancient artifact might be wholly invisible.

Conversely, to use an example that I have already mooted in this chapter and to which I will turn in detail in Chapters Six and Seven, because an artifact might look like a picture (insofar as it has the visible

form of object resemblance for us) does not mean that it *was* a picture, that is, that it had any depictive aspects or pictoriality for its makers. This assertion might sound strange. How could what we take to be a picture not depict anything at all for its makers? But at the theoretical level explored in this book, the assertion does not differ from the finding that our seeing of the formality of an ancient artifact in a museum sometimes has nothing at all to do with the maker's vision of it. Everything turns on the aspective successions and interdeterminations and on their completion and integration—or lack thereof—for each and every observer.

As the examples broached in the previous paragraphs might suggest, *resistances* and incompletions in the aspective successions and *disjunctions* in their interdetermination, not to speak of their oscillation and fluctuation, are as much a part of the history of artifacts as the full, smooth, continuous *integration* of all aspective horizons that might be constituted in an ideal recognition of the artifact as totalized, as a kind of holomorph. It is easy to see how these resistances and incompletions occur in the afterlife of an artifact, which can survive as a physical thing long after its original makers and users (and all who learned their seeing from them) have died off, that is, long after its visuality has disappeared. The obvious fact that today we cannot completely see what makers in the past might have seen in the artifacts they made, or what they might have seen them as, motivates art-historical research in the first place.

In theory, however, the dynamics of the *Nachleben* of an artifact and its eventual inevitable anachronism are entirely secondary. Even at the time and in the place of its making and first use, an artifact has often solicited (and sometimes secured) complete aspective succession and integrated aspective interdetermination. But equally it must have encountered resistances and incompletions in recognition. Sometimes, in fact, it *created* such resistances and incompletions. The anachronistic aspectivity at any point in the life history of the artifact might or might not have been recognized by makers and users at that time, and if recognized, it might or might not have been fully integrated into the forms of likeness of the thing. As a specifically visual-cultural dynamic, then, anachronism fades in and out of view, in and out of visuality, even if it is a constant or enduring archaeological parameter of the artifact.

Whether the archaeological reality of anachronism or its aspective recognition creates new integrations or instead leads to resistance and disjunction in the aspective successions and their overall integration is another matter. And the persistence of once-recognized significances into times and places in which these significances are *less* recognized, less integrated, is not the only cause of resistance and disjunction in the aspective

successions, or even the prime cause, though it might well characterize the situation in which *art historians* find themselves. The most likely and most common cause of resistance and disjunction is not the persistence of fading significances or the imposition of novel significances (two ways of describing anachronism). It is rather ambiguity. Admittedly ambiguity can sometimes be caused by conflict between fading aspects and novel aspects of an artifact, that is, by its temporal disjunctiveness. But it can be created in many other ways as well, notably by *spatial* and *social* disjunctiveness—the out-of-placeness of the artifact in certain contexts. At any rate, resistance and disjunction is not so much a contingent part of aspect-seeing as an inherent part, even a necessary part, regardless of the temporal or spatial situation and the aspectivity thereof.

Advanced aesthetic criticism has sometimes been sensitive—perhaps overly sensitive—to this consideration when it is pleased to describe avant-garde modern arts as arts *of* resistance and disjunction. Indeed, resistance and disjunction have become easy, positive terms in the language of art criticism, largely with the goal of validating the cultural claims of the arts in question. This brand of art criticism, an academic outgrowth of the modern artworld, has become as routine as it is implausible and sometimes reaches tautological or vacuous extremes. More exactly, it only has substance when it can show resistance and disjunction to be histories of aspective succession and interdetermination that somehow did not simply lead to aspective incoherence—to the wholesale unrecognizability of an artifact putatively made to promote certain *definite* aspective successions. To distinguish the visibility of resistance and disjunction from mere visual nonsense, we need to know that "resistance" and "disjunction" were produced to be visible as such. But what enables this recognition? This problem will occupy me at the end of Chapter Seven.

Another shortcoming of the criticism in question is that it has not always faced up fully to the implications of its own finding. If an artifact resists or decomposes aspective integration—full recognizability in terms of available forms of likeness—then it fails fully to belong to visual culture, to the coherent worlds that people see. And if this is so (and though there is no one-to-one correlation between being a genuine work of art and fully belonging to visual culture) any of the claims made by a work of art (*qua* work of art) to change peoples' worlds must be suspect. The artwork turns out to be inert or "wooden" rather than revelatory and transformative. This problem will occupy me at the end of Chapter Ten.

But let us set aside the gyrations embedded in the world of modern art criticism. In general the methods of *Kunstwissenschaft* have been ill-suited and ill-prepared to deal with the *essential* instability of aspective

succession, recursion, and interdetermination. Art history tends to seek such static and totalized aspective horizons as the ostensibly visible form, style, and pictorial or cultural meaning of an artifact instead of tracking aspective successions such as formality, stylisticality, pictoriality, and culturality for each of the agents who use the artifact. For this reason, when I outline a general theory of visual culture as an immanently *critical* theory of visual culture—a theory maintaining the impossibility of a fully-attained visual culture as such—I will highlight what might be called aspective nontotalization. But whether we decide that an aspective succession has somehow failed a holomorphic ideal or simply that aspect-seeing has not natively succeeded to full culturality (by far the most economical analysis in most cases), we can state with certainty that the circuitry of vision and visuality does not work like clockwork. We do not immediately succeed to culturality in vision—to visuality. We do so only when we literally *see* what life is like.

What Is Cultural about Vision?

PART TWO

Chapter 3

What Is Formalism?

■ **I**

There have been many kinds of formalism in art history. All deal with the sensuous configurations of artifacts and artworks—with their formal aspects or what I call their "formality," or apparent configuratedness. Formal analysis would seem to be inherent in art history and in the study of visual culture all around the world given that all artworks (as well as many other artifacts) have some degree of formality. And this is true whether or not that formality is intentional and stylized, that is, recognized and manipulated as such. Of course, the apparent configuration of carving knives (what might seem to us to be their sleek and elegant formality) is less important to those using them than their actual substance (hard and impervious) and conformation (long and sharp-edged). But things that look like carving knives have been made that are neither hard nor sharp. If something has the style of a carving knife and if it represents a carving knife, then formally, at least, it more than likely *is* a carving knife, even if it cannot carve anything at all.

Partly for this reason, formalism sometimes seems to be virtually the same thing as the study of style and stylisticality (the representation of style) in artifacts. (On the succession of style and stylisticality, see Chapter Four.) Indeed, the most focused mode of stylistic analysis, in connoisseurship, is often described (though largely by its critics) as formal-

ist. Stylistic analysis certainly does take account of formality: it looks at the configured aspects of artifacts. Unlike formalism, however, stylistic analysis investigates the *causes* of an apparent configuration. What formalism identifies as formed (or configured) will be specified in stylistic analysis as made (and sometimes deliberately stylized) by a particular agent who can be identified by that style.

In many cases formalism and stylistic analysis address the same configurative phenomena in an artifact—properties of the artifact that, in being formed, had to have been made. But there is one kind of style that is *not* formed in the sense implicitly preferred by one kind of formalism in art history. Certain stylistic properties of an artifact are not configured under the sentient self-control of a maker in a display of configurative artistry. Produced outside the maker's awareness or unintentionally, these stylistic attributes have been called *Grundformen* by Giovanni Morelli, the connoisseur who first described them. (As the term might suggest, *Grundformen* are basic or grounding forms.) The theory of *Grundformen* decisively detaches stylistic analysis from formalism, at least in this dimension, and I will return to it in Chapter Four. Here it suffices to say that so far as connoisseurship is Morellian it cannot be entirely formalist. Indeed, extreme formalism must be the reverse of Morellian connoisseurship. Failure to appreciate this point has created much confusion.

Iconography also offers a causal analysis of form: it identifies what configurations mean, usually by way of determining what they depict. (On the iconographic succession from configuration to motif and symbol, see Chapter Seven.) Rightly or wrongly, iconographers usually imply that the meaning motivated the configuration, not the other way around. In fact, as we will see in Chapter Eight, iconography emerged as an art-historical method in the 1920s partly as a refutation of formalism. Nonetheless, there must be an intimate relation between formalism as an identification of the configuration *of* artifacts and iconography as an identification of figuration *in* artifacts.

Of course, formalism and iconography have sometimes been polarized. We routinely hear, for example, that formalism deals with form whereas iconography deals with "content" or meaning. But a dichotomy of form and content corresponds to nothing whatsoever in our actual sensory experience of whole artifacts or whole artworks. If formalism and iconography must be distinguished at all, they should be ranged as positions on a continuum or, better, as way-stations in a circuit or loop. As we will see in more detail in Chapter Eight, both theorists of formality such as the formalist Heinrich Wölfflin and theorists of pictoriality such

as Erwin Panofsky, an iconographer, were acutely aware of this loop in methodological and substantive terms.

All formalisms deal with the sensuous configurations of artworks. But the stylistic and representational aspects of artifacts must be sensuously apprehended as well. On the face of it, then, it would make no sense to separate the stylistic and representational aspects from the purely formal aspects of configuration—to say, for example, that this dab of color in a portrait painting depicts the painted subject's eye while that dab displays the painter's characteristic makership and yet another dab exhibits a "formal" artistry of painting. Usually we can see that the subject's eyes have a particular painted configuration that is characteristic of the artist. Our recognitions of style and depiction, then, must be formal: they use our sensuous awareness of the configuration of the materials of the paint or other medium of the artifact to identify its style and its pictoriality, if it has any. We see the painter's identity in and through the way he paints, and as the way he paints; we see the painted subject's identity in and through the way he has been painted, and as the way he has been painted. Conversely, we see the way the painting has been painted when we see what has been painted and which painter has painted it.

Thus it is odd to discover that a species of formalism has emerged in art history and the study of visual culture that encourages the categorical segregation of formality from the other visual aspects of the configuration or visible features of an artifact. According to a high or extreme formalism, in looking at artifacts we can cleave formality from style and representationality and apprehend it as such—as the configured aspect of an artifact independent of its visible style and representational projection. If this approach has any theoretical validity, its primary warrant must be that formality, style, and representationality are not simply analytic classifications but distinct psychological domains. That is, they must be different routes of, or different moments in, the complex relays of integrated aspect-perception. Because integrated aspect-perception does involve recursions, even a looping, of recognitions (a general point to which I recur throughout this book), this view is not incredible; despite severe criticisms that have been leveled over the years, formalism is a defensible hermeneutic method in the historical project of tracking the vicissitudes of integrated aspect-seeing in the past and in the present.

But the theoretical argument underlying this method needs to be applied evenhandedly. If formality can be partly discerned outside style and representationality, then it must follow that stylisticality can be discerned outside formality and representationality, and that representationality

can be discerned outside formality and stylisticality. In other words, it should be possible to educate our seeing to attend *differentially* (perhaps even to attend discretely and disjunctly) to putative form, to style, and to depiction. If we could do this, the great methods of professional art history—formalism, stylistic analysis, and iconography—could be said to correspond analytically or in their epistemology to the natural ontology, to the orders, relations, and differentiations, of integrated aspect-perception in the visual field. But I doubt that we *could* do this without visual artifice, disorientation, or confusion. Dis-integrated aspect-seeing is not seeing at all.

High formalists have rarely made the requisite argument for the autonomy of formality. They are loathe to admit that the stylistic and representational aspects of an artifact or artwork might dominate people's awareness, assessment, and use of it, asserting that formality, "form," is the primary aspect of an artifact—indeed its very *raison d'être*. (As we will see, to advance this view with any credibility our selection of artifacts must be a narrow one.) In many cases this claim goes hand-in-hand with the notion that formality is *closer* to visual perception than style or representationality, and that our attention to it in highly refined "close looking" will provide a more thoroughly visual or a more purely visual understanding of the artifact than our attention to style or iconography.

But this notion must be utterly wrong, and pernicious. No sensuously apprehended aspect of something is any closer to the object, or any further away from it, than any other such aspect. As sensuously apprehended aspects of configuration, style and depiction—the aspective successions of stylisticality and pictoriality considered in the next four chapters—are just as rooted visually in our apprehension of the artifact as formality, and they are just as visible in it; like formality, they inhere closely in many artifacts as their visual aspects. Like formality, they seem to us to be "of" the artifact—to be its essence and its identity.[1]

In fact, it is not at all clear that there really *are* any formal aspects of artworks (or any other kinds of objects) that can somehow be identified apart from or outside of stylistic and iconographic successions. "Post-formalist" art historians have urged that nothing would be lost (and considerable clarity gained) by dispensing entirely with form at the ontological level and with the formalism that identifies it at the methodological level.[2] I will not try to settle this controversy here. In a sense the apparent configuratedness of artifacts, their formality, must be the aspective basis of stylistic and representational aspectivity (for it is only in man-made objects that we see style and representation in the art historian's sense of those terms), whether or not this formality can be taken to be vested

in *different* aspects. But at the very least, the popular notion that hermeneutic and historical analysis must *begin* with formal analysis—with close looking at the formality of artifacts as distinct from their style and representationality—has little to recommend it in a general theory of visual culture.

■ 2

We can phrase these considerations in another way. Stylistic analysis and iconography are plainly historical in object and method. But formalism seems to *deviate* from historical inquiry: if historical inquiry is supposed to be objective, formal analysis is plainly subjective. Still, the true formalist, like the student of style or the iconographer, aims to build from the subjective formal description of artifacts toward a more objective historical understanding of them. Why does attention to formality often seem, then, to be inherently more subjective than stylistic analysis and iconography?

As historical method, formalism starts from the visible evidence of apparent configuration. Its difficulty lies not in this starting point, which it shares with stylistic analysis and iconography. Instead it lies in the tendency of formalism to *end* with its starting point—to generate a closed, circular confirmation of the formalist's own observations, relating how the artifact appears to him to be shaped and colored, but providing little or no account of the formality produced by makers and perhaps recognized by observers in the past. By contrast, seeing style and seeing figuration in an artifact inherently involve objective orientations that are immanently historical. To see style in an artifact is to sense its attributability to a maker who existed before and outside us, even though *we* see the affiliation. And to see representationality in an artifact, or to see its pictorial aspects, is to sense its resemblance to things (to states of affairs and objects) outside us, in a virtual world beyond us, even though *we* see the correspondence. But when we see pure formality in an artifact we seem to see *in* the artifact just and only what we see it *as* (namely, this shape, that color, these edges, those surfaces, and so on). Lacking the traction of attribution and the translation of figuration, our recognition of pure form seems to have no objective correlate: it is colors and shapes seen *as* colors and shapes, and colors and shapes seen *in* colors and shapes. Despite its claims to unfold the visual richness of configuration, then, formalism might be said to approach the "zero degree" of aspect-seeing. In a sense it attends to itself *in* sensation instead of the objective correlates *of* sensa-

tion; if it sees anything at all, it sees *itself* rather than the object. This is not a theoretical paradox: high formalism artificially fails to enter—in fact it deliberately avoids entering—the successions, recursions, and interdeterminations of the integrated aspect-seeing of our natural vision. But it is a philosophical error.

In practice, we find a continuum between the more subjective formalisms that always return to the present-day observer's apprehension of formality within the frame of his own form of life and formalisms that are more objective, that use our sensuous awareness of configuratedness as a means to the understanding of forms of life, not limited to our own, within which configuration has stylistic and representational aspects as well. Close looking cuts both ways here. Therefore it is a red herring as a supposed criterion of formalism, of formal analysis as a supposed independent method of inquiry. A casual, distant inspection might tend to be the most purely formalistic because it has not done the recognitional work that reveals stylisticality and representationality. Here close looking would enable us to *escape* pure formalism; it could reveal stylistic and representational aspects of the artifact that we had overlooked. Conversely, however, close looking can reduce stylisticality and representationality to brief grace notes in self-absorbed sensual delectation, even to mere detours. Here close looking could *reinforce* pure formalism, virtually calling it into being.

Given this range of possibilities, the categorical criterion of pure formalism is not that it looks closely. It is that it only looks at what it sees, and what it sees is only what it looks at—a visual array or visible pattern. It asks how things look, not what they look *like*. On this account of the matter there is, consequently, an intimate analytic relation (manifest in the work of many formalists) between pure formalism and vision science, and this even though the pure formalist might be regarded as highly subjective in his procedures while the vision scientist might provisionally be regarded as objective. As noted, pure formalism often advertises itself as closer to vision or to "the visual," whatever that might be, than other methods of investigating the coherence of visual culture. And so it is, if the vision in question is nothing more and nothing less than the seeing of the formalist.

■ 3

At the subjective end of the continuum of formalisms, we find an art criticism that came into being largely in order to describe modern (and often the specifically modernist) arts in the Western tradition. This high

formalism has sometimes achieved extraordinary heights of critical and literary sophistication. And there is an obvious and good reason to suppose that it has been one of the best guides, if not *the* best guide, to an understanding of modern and modernist arts in the West, and at any rate the most appropriate. Produced in highly formalist terms, these arts are understandably susceptible to high-formalist scrutiny because they deliberately subordinate many of the recursions of stylisticality and representationality to a dominant formality—namely, to an ideology of art. Here, formality would appear to constitute the whole identity of art. As Clive Bell put it in a famous definition, form is comprehensively significant in art. Indeed, according to Bell a work of art simply *is* "significant form."[3] By "significant," Bell did not mean representational, semiotic, or symptomatic. He meant visible to us aesthetically as an independent aspective value coextensive with the meaning of the work.

But the real object of attention in formalism is not art and artworks. It is the formality in artifacts. Therefore high formalism in Bell's terms, which has global aspirations, has not always stopped at its description of artifacts culturally-made and recognized as art. It proposes to extend its recognition of art to many other and conceivably to all possible artifacts. One influential version of high formalism accordingly asserts that whether or not an artifact was produced as an artwork, notably in the modern Western form of life within which putative formality has been used for culturally-recognized aesthetic purposes, it can be said to be essentially significant in its purely formal aspect.

As Roger Fry urged, a sensitivity to pure formality (what he called "sensibility") might be recognized in the production of many kinds of artifacts by ancient and modern civilizations all around the world.[4] These traditions likely did not develop a theory of art as significant form in anything like Bell's sense. If they recognized and endorsed formality for cultural purposes, they did so in their own terms of judgment. To Fry it was obvious, however, that they produced artifacts that must have been significant at the level of shape and color, that is, of configuration seen as autonomous form. For all intents and purposes, then, they made art in their artifacts. This notion has not been limited to the specific "aestheticism" that is identified with the intellectual, cultural, and artistic world of Fry's "Bloomsbury" and with preceding aesthetic movements in Britain and elsewhere. It has recurred, for example, in much more recent calls for the constitution of a "world art studies" predicated on the putatively global phenomenon of art—art often defined in highly formalist terms.

Fry's own claimed sensitivity to formality was shaped in the context of his partisan encouragement of modernist artifacts, works produced

and intended to be recognized as art (though their status as such was not universally acknowledged at the time). Most notably he championed the work of Post-Impressionist painters in France. But Fry's sensitivity to formality enabled him to attribute sensibility to the protodynastic Egyptians and the pre-Columbian Americans. The artifacts made by these people were not historically intended as art in any recognizable discursive or ideological sense in their own forms of life, but this fact does not inherently disable Fry's notion that many, and perhaps all, human civilizations display formal sensibility and sensitivity to formality. It simply suggests that formality can be culturally organized in various ways in different historical contexts, perhaps sometimes as art and sometimes as other forms of artifactual and visual culture. This thesis warrants art-historical formalisms (perhaps of the kind incarnated in present-day world art studies) that need not be specifically affiliated with the high-formalist art criticism of modernism. On the one hand, despite high formalism's claims about art, it is possible that artworks in our own form of life are not produced exclusively with a view to their formality. And on the other hand (and despite high-formalist interpretations of protodynastic Egyptian or pre-Columbian American artifacts), it is equally possible that formality can be achieved and recognized in wholly nonartistic ways. Regardless of the high formalism advanced by Bell and Fry, genuine formalism, despite its severe theoretical and methodological difficulties, need not be troubled by these historical and cultural possibilities.

Needless to say, high-formalist art criticism has had considerable (and probably disproportionate) influence because it addresses artifacts that historians reared in the modern Western world have been culturally prepared to accept as art, regardless of their origins. Stripped of its art-critical rationale, however, this kind of relatively pure formalism can be useful even when applied to objects produced outside the modern aesthetic ideology of the West. Often we know little about the significance of an artifact in its original historical use. We might perceive style in it and yet be unable to assign it a historical identity. We see the madeness of the thing but not its maker. This is a point to which I will return in Chapter Four. In much the same way, we might apprehend representationality and yet remain unable fully to identify the objects or state of affairs represented by the configuration. We see the thingliness of the configuration but we do not know what this thing is that it depicts, or we see the pictorial motif but not what it signifies. To this point I will return in Chapters Six and Seven. In such cases, our formalistic reversion of the artifact's configuration might be our only (and in this sense our best) guide to its identity and history.

Faced with such cases, of course, pure formalism must explicitly propose what it takes for granted when it addresses modern arts produced in full expectation of art criticism—namely, that formality was produced as a recognizable aspect of the artifact by its makers and might have been seen as such by its beholders and users or (to use a shorthand) that it was culturally constituted. In other words, when formalism breaks out of its closed, self-fulfilling loop it has to find a way to identify the objective correlate—namely, the formality produced in the past as a recognizable aspect of an artifact—for the formality that the formalist claims to see in the artifact. According to Aloïs Riegl and the historical formalists of the Vienna School of *Strukturforschung* ("structural research"), this correlate might be the *Kunstwollen*, a kind of "will to art." Art in the modern Western world is one historical formality, a *Kunstwollen* in the most literal sense—a motivation to "artify" an artifact. (It is worth noting that Riegl's professional occupation as a curator consisted in the study of textiles and other so-called art industries, or *Kunstgewerbe*.) But there have been *Kunstwollen* other than art. And the invocation of *Kunstwollen*, whether it refers to the "will to artify" or to other configurative intentions, such as the will to stylize or the will to pictorialize (questions that Riegl and the Vienna School addressed in considerable depth), could simply be an objective excuse for formalist subjectivity.

Formality is not an inherent property of artifacts or works of art. Rather, formality is an aspect of an object recognized by the human subjects who perceive it: it is their subjective perception of the shape and color of a configuration *as* shaped and colored. Properly speaking, then, formalism is not an intensive study of "the object," as we are often told, just as it is not the only mode of close looking. If anything, formalism should be an intensive study of the *subjects* who look closely at artifacts or works of art. As already noted, it remains subjec*tive* to the degree that it remains within the loop of the formalist's recognition of formality. We can say that formalism becomes objective, however, when it identifies a formality that was subjectively constituted and recognized as the sensuous aspect of a configuration by the people who constructed the artifact. In brief, formalism becomes objective when it recognizes the constitutive *historical* subjectivity of formality. For this reason, and despite its tendency to remain at (or to return to) its subjective starting-point, high formalism likes to suppose—indeed it needs to suppose—that it can convert itself into an objective identification of formality. This conversion must be secured, however, not despite the formalist's subjectivity but *because of* it. High formalism at its best hopes to effect a psychological communication, virtually a transference, between two subjects who have

both addressed a single object—the *formalist* subject in the present day and the *form-making* subject in the past.

■ 4

Richard Wollheim has identified two variants of formalist method, which he called Manifest and Latent Formalism.[5] Both methods can be associated with high formalism, which has encouraged them as a salve for its subjectivity: as we will see, both try to address pure formality objectively. They are, at bottom, formalist methods for objectively describing pure formality as it appears directly to us, whenever and wherever formalism seeks to do this. In the end these methods are defeated by the defect of their theory. Because of the complex, recursive nature of aspective succession and interdetermination, there is no such thing as pure formality. Or if there is such a thing, it is a rarified product such as the modernist art that might have been made only to exemplify something like Bell's or Fry's aesthetics. To be fair, there are many high formalists, including Fry, who have not used the methods of Manifest or Latent formalism. On the other hand, both methods can be found in the historical formalism of the Vienna School, despite its claims to present independent (extraformalist) evidence of *Kunstwollen*.

Figure 3.1.
Erle Loran (1905–1999), diagram of Paul Cézanne's *House and Farm at Jas de Bouffan*, 1889–90. From *Cézanne's Composition*, 3rd. ed. (Berkeley and Los Angeles: University of California Press, 1963) 53. Courtesy University of California Press.

According to Wollheim, Manifest For-
malism attempts to diagram the essential
form of a work of art and as it were to pic-
ture its pure formality. Its procedures have
been embodied, for example, in Erle Loran's
dissection of Paul Cézanne's still life compo-
sitions and landscapes (Fig. 3.1) and in such
complementary efforts as Rudolf Arnheim's
analysis of Cézanne's portrait of his wife (Fig.
3.2).[6] An art teacher, Loran was influenced by
the painter Hans Hofmann's doctrine of *Ge-
staltung*, or form-creation, which Loran knew
in part from personal contact with Hofmann.
Arnheim was a perceptual psychologist
trained in the traditions of Gestalt theory.
Like Loran, he valued pictorial modernism
and abstraction in painting. In their artistic
tastes both writers were beholden to formal-
ist aesthetics in the writings of Bell and Fry,
and both evinced disdain for historical for-
malism, stylistic connoisseurship, and documentary iconography even
when they engaged in art-historical debates about the technical bases and
the social significance of the masterworks they addressed formalistically.
They did not regard themselves as art historians. In turn, and given the
prominence of historical formalism, connoisseurship, and iconography in
art history at the time they were writing, their work was neglected, even
dismissed, by art historians. It was popular, however, with artists, educa-
tors, and psychologists. And its standard for an ideal formalist method
was adopted by a broad general culture of art appreciation, teaching, col-
lecting, and publication that has continued to have wide appeal.

In their diagrams Loran and Arnheim claimed to identify the "forces"
and "centers," the visual "relations" and "structures," that can be seen in a
configuration (and that it should supposedly be seen *as*) insofar as these
phenomena can literally be extracted from the configuration and dis-
played in an independent image. They were providing, as it were, a literal
picture of the formality. Of course, the very fact that we can extract such
an illustration putatively serves to confirm the existence of formality in
the configuration as well as the partial independence of that formality
from other visible aspects of the configuration. And once extracted from
the configuration, the illustration encourages us to see the configuration
as this supposed image of its formality, even if we had not hitherto no-

Figure 3.2.
Rudolf Arnheim
(1904–2007), diagram of
Paul Cézanne's *Madame
Cézanne in a Yellow
Chair*, 1888–90. From
Art and Visual Perception
(Berkeley and Los
Angeles: University of
California Press, 1964)
25. Courtesy University
of California Press.

ticed any forces, centers, relations, or structures. In one sense, then, Manifest Formalism substitutes a surface or superficial illustration of certain visible aspects of the complete image *for* that image. This substitute image is simply called "form." In another sense, however, Manifest Formalism claims to make the *image* manifest to us—to specify the image at the visual level by showing us what form it can be seen to have.

Though compelling, this enterprise is peculiar and paradoxical. Wollheim declared that it is nothing short of nonsensical. As the previous paragraph may have implied, it is certainly tautologous or circular. It seems to be biased as well, and incomplete in that it proceeds from assumptions it has not defended.

Consider the famous duck/rabbit drawing (Fig. 3.3).[7] If we see a rabbit in the drawing—that is, see it as a rabbit—we can draw a rabbit to show someone what we see. If we see a duck in the drawing—see it as a duck—we can draw a duck to show what we see. Our rabbit-drawing and our duck-drawing might look different from the duck/rabbit configuration, for one of *its* aspects would seem to be perceptual ambiguity, doubleness, or oscillation, which we might *not* see in our duck and our rabbit drawings. And these might—probably must—look different from each other. In any case, however, they will be depictions, attempts to picture what we see in the configuration, namely, the object(s) we recognize: either the duck or the rabbit in the way we see that duck or rabbit in the grapheme, as having a certain outline shape and shading.

Loran's and Arnheim's diagrams are likewise depictions of pictures. But paradoxically they do not really depict, or they depict only incidentally, the *representational* identity of the configurations, that is, the objects depicted—in this case, a rabbit or a duck. Using various lines, arrows, shapes, and borders, they supposedly depict the formal forces, centers, relations, and structures of the (representationality of) the configuration of duck or rabbit, its formality. It is as if I were to find a way to draw the visual impression that the formalist takes me to be experiencing when I see the rabbit in the duck/rabbit drawing: upness, rightness, and blackness, for example; or, by contrast, downness, leftness, and whiteness when I see the duck in the drawing. When I see these qualities I am seeing a rabbit or a duck respec-

Figure 3.3.
The duck/rabbit grapheme. From Joseph Jastrow, *Fact and Fable in Psychology* (London 1900) 295.

tively. But when I illustrate the pure formality of duck or rabbit as such, somehow I present the upness, rightness, and blackness or the downness, leftness, and whiteness in themselves. Various diagrammatic conventions (arrows for directionality, hatching for color differentiations, etc.) serve to represent my image, what I see when I am attending only to the formal aspects in view, as I must when making the diagram.

This disaggregation of the pure formality seen in the configuration can occur diagramatically or discursively; that is, in a graphic illustration or in a verbal description of the supposed form. Loran and Arnheim employed both means of representation. Still, it is fair to say that the techniques of painterly abstraction in the modernist arts of the twentieth century are probably more closely kin to the dynamics of Manifest Formalism than the techniques of verbal description that have been applied to the fine arts since the eighteenth century. An abstract painting by Wassily Kandinsky or Hans Hofmann might well succeed aesthetically as a relay of—a construction of—a virtual visual world. Moreover, the artistic and ideological power of modern painterly abstraction surely conferred plausibility on Loran's diagrams of Cézanne's still lifes and landscapes; there is a significant sense, explored by Loran himself, in which Cézanne can be historically understood to have used something like the technique (or at least the ideas) that Loran deployed to diagram his paintings.

But of course the diagrams of Manifest Formalism, such as Loran's diagram of Cézanne's *House and Farm at Jas de Bouffan* of 1889–90 (Fig. 3.1), are *not* abstract paintings. Or if they are, they do not belong to the same order of abstract painting as their points of reference in Cézanne's painting, which is not abstract. Manifest Formalism tries to diagram the formal relations *of* abstract paintings as well as those of figurative paintings; Manifest Formalism would make a second-order Kandinsky, as it were, in order to illustrate formally how a Kandinsky looks to us. One could say that this diagram illustrates what the painting looks *like* if it were not for the fact that the diagram does not propose that the painting really looks like the diagram. For clearly it does not; we do not say, or at least we are not supposed to say in this formalism, that "this Kandinsky looks just like this formalist diagram," even if it does. On the contrary, it is the *diagram* that is supposed to look like the painting. Needless to say, it is hard to know in exactly what way the second-order Kandinsky (the formal diagram of one of Kandinsky's paintings) would differ from the Kandinsky it illustrates, considering (among other things) that Kandinsky's paintings might themselves have suggested an illustrative technology to the Manifest-Formalist maker of the second-order Kandinsky. But we are not likely to suppose that the modernist painter Kandinsky actu-

ally made his painting in order that it look like a formalistic diagram of the very same painting. Such recursions are far more likely to be found in later artistic practices that could be described as *post*modernist precisely because they attempt something of the kind.

Latent Formalism, as Wollheim describes it, treats a work of art as if it had a linguistic identity or at least a language-like identity. The method identifies the *system* within which a configuration was generated: form is constituted within the system in the same way as a well-formed sentence might be spoken by someone who knows the grammar of a language. Needless to say, the rise of linguistic sciences in the twentieth century provided a vocabulary for Latent Formalism and conferred plausibility on it. As a method, it has been embodied in many art-critical and art-historical projects. Some of them can be identified with semiotics. But not all semiologies consider artworks to be like natural language (that is, to have an actual grammar), though they must consider them to be significant or symptomatic and to be or to make signs. And not all theories of the language-like structure of art or artifacts are specifically semiological. At any rate, then, and whatever its systematic basis, Latent Formalism takes form to be rule-governed. It hopes to discover the recipe (as we might put it) or to write the algorithm (to choose another analogy) that generated the form of an artwork and that allows it to be recognized by us *as* formality—an algorithm that might generate or actually has generated other possible (and systemically related) formalities in other possible (and systemically similar) artworks.

Here the basic error is simple. Aspect-seeing is not rule-governed, even if it is organized and even if it is (as I put it) internally interdetermined. Nothing whatsoever *makes* us see anything in or anything as anything else.[8]

More narrowly, even if there is such a thing as form and formality that can be cleaved from integrated aspect-seeing and apprehended as such, there probably is no such thing as a language or grammar of formality. Precisely because formality is ineluctably bound (supposedly) to the particular conditions of our visual perception—our image—of the configuration of a particular artifact, it is unlikely that it can be codified with anything like the precision and particularity required by a grammar. If it *could* be codified this would be possible only within the frame of an entire artistic practice, an ideology of configuration, that sets out to do just this—especially a practice and ideology (what I have called "high formalism") in which style and representationality can be deliberately subordinated to the artistic construction of a putative dominant formality. Again, we might well find such practices in the history of later modern

arts in the West. In these contexts Latent Formalist theory might be historically apposite to the object of study, in part because of the wide circulation in modern Western culture of linguistic and semiological sciences and, more recently, of image-making methods derived from cybernetic, information-theoretical, and computational technologies. Beyond that, however, they are dubious. Their claims as *general* methods for the study of visual culture seem far less plausible than, for example, Fry's notions about the universality of sensibility.

Wollheim's defective formalist methods can overlap. A Manifest Formalist diagram of the pure formality of an artwork need not be incompatible with a Latent Formalist characterization of the system in which it was generated. Indeed, many formalisms in art criticism and history combine elements of Manifest and Latent Formalist methods in Wollheim's terms. For example, Loran focused on the configurations of particular paintings by Cézanne. But it is clear that he thought the painter had a general method of pictorial composition, a rule-book. And whereas Latent Formalism claims to reconstruct the system behind such methods, the recipes and rules, typically its main evidence for their very existence lies only in particular works.

In other respects, however, Manifest Formalism and Latent Formalism sometimes pull in different directions. Manifest Formalism tends to identify the formal aspects of a work with the maker's intentions and with his artistic invention and control: what the maker more or less consciously put in to the work. By contrast, Latent Formalism tends to identify formality in terms of the conventions of competence, performance, and communication deployed by users and observers of the artifact; that is, the rules of the game accepted by all who come into contact with it, including the maker of the artifact. Latent Formalism need not presume that the maker *invented* these rules, for they might have had a wholly traditional basis. In this respect, Latent Formalism emerged (for example, in structuralist and semiotic studies in art history and criticism) in part as a critique of the very artistic originality admired by Manifest Formalism in its myths of artistic creation and command.

Nonetheless, the nuances of difference between Manifest and Latent Formalism might not be salient for the deepest purposes of art theory. In Wollheim's view, both Manifest and Latent Formalism commit a basic error that his own philosophy of art sought to avoid. They detach art from its material object (namely, the artwork) by seeking to identify its supposed form in independent illustrative or grammatical terms. According to Wollheim, this alienation of form and its material object overlooks the aesthetic identity of art as such—the identity of art and its material ob-

Figure 3.4.
(Right) Photograph
of Paul Klee (1879–1940),
The Laden, 1929,
reproduced by Fry;
(Left) Tracing of the
reproduction by Roger
Fry (1866–1934). From
Roger Fry, *Last Lectures*,
ed. Kenneth Clark
(Cambridge 1938)
Figure 1.

ject. For Wollheim, then, Manifest and Latent Formalism actually *deter* genuine aesthetic analysis despite their self-anointed claims to advance it. Indeed, their art-critical error rides on an even deeper philosophical error that Wollheim's general philosophy of mind sought to avoid. In detaching art from its object, they must traduce its aspective identity—the aspective identity, that is, of the sensuously apprehended object that art is. For once pure formalities have been read out of this object, its aspective coherence is no longer sufficiently represented.

This defect will be painfully evident when a formal diagram or description occludes what Wollheim has called "representationality," or alternately when it covertly exploits representationality by coming up with a diagram or description that seems to capture the representations that we see as form. So far I have used the term representationality without explicitly defining it. But I have used it in Wollheim's sense. Representationality is the tendency of most two-dimensional configurations, pictorial or not, to have a *three*-dimensional or spatializing configuration in our visual apprehension of them, our image. This spatiality suggests or projects the presence of a virtual visual world. (This world need not, of course, be a virtual world of recognizable real-world objects.) Of course, the occlusion of representationality promoted by formalism will be especially

palpable when the two-dimensional configuration is specifically *pictorial*, when the virtual visual world suggested by a configuration, its representationality, includes depicted things; that is, particular objects that can be recognized.[9] Even when Manifest Formalist analysis two-dimensionally illustrates the *pictoriality* of the two-dimensional array (as both Figs. 3.1 and 3.2 are constrained to do despite the fact that they really try to diagram *formality*), it does not adequately capture the representationality of that image for us—the fact that the picture is usually apprehended as a spatialized virtual visual world rather than as a flat pattern. And this even though materially (as a painted surface) it often *is* a flat thing.

In his Slade lectures at Cambridge University in 1933 and 1934, Roger Fry produced a diagrammatic representation of the formality of a 1929 painting by Paul Klee, *The Laden* (*Der Beladene*), which has the graphic character typical of Klee's work and can be described as a drawing (Figs. 3.4, 3.5).[10] Fry's diagram is simply a tracing assisted by a straight-edge ruler of almost all of the lines that Klee himself (who evidently also used a straight edge to guide him) can be seen to have laid down. Fry made the copy, however, specifically in order to draw attention to the way in which the artwork itself escapes such analysis. Compared to the ruled copy by Fry, the drawing by Klee (Fry suggests) presents an entirely different as-

Figure 3.5.
Paul Klee, *The Laden*, 1929. From Carl Einstein, *Die Kunst des 20. Jahrhunderts*, 3rd ed. (Berlin 1931) 551.

pect to us. Some of Klee's lines were drawn freehand, or if not freehand were ruled with a bold, even pressure and show subtle changes of direction, for example in the descending line that establishes the right-hand side of the man's torso and right leg. Thus they possess a palpable tremor that might motivate us to see emotional drama and psychological intensity in the depicted figure (Fry did not give Klee's name for it) that Fry's ruled copy of it does not suggest to us at all. We do not simply say that Klee's *lines* look anxious or agitated, though they wobble a bit; we say that the whole configuration looks like an anxious or agitated man laden with packages, if we take the title and the visible geometry of the drawing literally, and perhaps burdened with worry and cares. (The picture is ambiguous; the slightly jumpy, jerky figure could also be seen as a marionette on a stage.) Even if Fry's diagram had preserved the distinctive pressure and wobble

of Klee's lines (that is, even if it were an exact transcription of the two-dimensional array presented by the image) there could be no guarantee that we would see in it the liveliness expressed by Klee's little man.

Moreover, and obviously enough, Fry's ruled copy has configurative aspects in its own right. We might see something in the depicted figure (or see something about it) in the copy as such, for the very reason that it has ruled straight lines. We might, for example, take Fry's copy of Klee's drawing to depict a stiff and lifeless figure, somewhat anemic and uncertain. Such a figure would stand in striking contrast to Klee's lively little man. But if we diagram or describe *that* recognition, we must take a step back in order to say something more complex: If wobbly lines in Klee's figure express lively character, then the straight lines in Fry's diagram could be seen as stiff and anemic because Fry's diagram can be seen as *not* showing—as having been made by him to be discernibly *different from*—the character of the little man represented in Klee's drawing.

But obviously the diagram cannot be its *own* formal analysis in exactly the same way that Klee's drawing is not its own formal analysis. As a formal analysis, Fry's straight-ruled-line diagram of Klee's wobbly-ruled-line figure purportedly explains *Klee's* drawing formally, not its own straight-ruled-linedness. For this, yet another formal analysis would be required, say, a ruled-line copy of Fry's ruled-line copy of Klee. But what would prevent this diagram from running up against the very same roadblock (it is really an endless detour) that we have already noted in the case of Fry's copy? The straightness of its lines might not function for us as representations of stiffness. Instead they might be seen merely as a material feature of the technique we used (as Fry did also, following Klee) to make the diagram. The aspect of the straight lines in Fry's ruled copy (a poor and partial representation of the liveliness of Klee's drawing) and in our ruled diagram of Fry's ruled copy (an accurate tracing of that misrepresentation) might be quite different: Klee's drawing is lively, Fry's drawing is stiff, our drawing is straight.

Of course, that is just the point in Fry's construction of this example: in its somewhat wobbly lines Klee's original drawing seems to have a subtle expressive quality that Fry himself appears to have wanted to notice. But it is the constitution and apprehension of certain aspects particular to each drawing that makes the difference. In Fry's diagram we must see what Fry wanted to represent as absent in a simple ruled-line tracing of the array of lines in Klee's drawing. If we do not see this in Fry's diagram, we cannot see how it might be a revealing (mis)representation of the configuration of Klee's drawing. To get to this point, either we must offer a formal analysis of a formal analysis of an artwork *or* we must return to the

original image. As the example of Klee's drawing, Fry's formal diagram of it, and our formal diagram of Fry's diagram suggests, the formalist effort sets in motion an infinite regress—a regress leading us ever *further away* from the artwork even as it tries to achieve an ever-more-precise characterization of the artwork, as seen by us. And it is just this characterization that high formalism claims as the goal of its close looking.

To capture representationality in its analysis of formality, formal analysis would have to reproduce the object for us as the configuration we see. But presumably formalism does not want simply to *copy* a painting, a sculpture, or a building, nor does it just offer the actual thing to us as the formal analysis of the work. (Though this, of course, is precisely what Fry did in the example just discussed in order to make his point.) High formalism, however, has long been associated with the notion that it *should* offer the object to us, whatever else it might do. Important collections of paintings, such as the Phillips Collection in Washington, DC and the Barnes Collection in Merion, Pennsylvania, have been created expressly to support high formalist responses—what their founders and devotees liked to call "learning to look." According to the high formalist rhetoric that prevails in these and other institutions, formal analysis is best conducted in front of the real thing. Albert Barnes wrote in 1925 that the method incarnated in his collection and promoted in his books "stipulates that an understanding and appreciation of paintings is an experience that can come only from contact with the paintings themselves."[11] Setting aside whatever concrete gain accrued to Duncan Phillips or Albert Barnes as a result of the tourism this philosophy generated, this is innocuous enough. But if formalism really believed that it had nothing to show us *in* the painting beyond simply showing us the painting, it would not exist. This is not because it would be logically peculiar to show us the actual work. In some ways that simple gesture would fulfill high-formalist aspirations. Still, formalism would have no point if we could simply go and look at the work without the formalist having to *re*show it to us.

Formalism does not—or at least it should not—just say, "Go and look," or "Here it is." By way of its diagram or description, formalism says "Go look at *this*." The injunction is probably most useful, and certainly can only be tested, when the configuration is right in front of us. It does not depend, however, on the immediate availability of the work. Indeed, and perhaps paradoxically, art criticism emerged as a literary genre in the eighteenth century in part as a means of introducing works of art to people who could not see them in the flesh. To be sure, early art criticism did not trade exclusively in identifications of putative formality in the sense

adumbrated by later formal analysts like Loran and Arnheim or high-formalist collectors like Phillips and Barnes. It included extensive consideration of the stylistic, depictive, functional, and cultural identities of the works in question, and recognized that it is possible, and sometimes necessary, to secure stylistic, iconographic, or anthropological understanding of a work without direct visual inspection of it but by working with prints, photographs, and other reproductions. But when art criticism becomes highly formalistic, such mediations become impossible. Although works of art do not need to be immediately available for inspection, high formalism instructs us to go look at the work at some point; for this is in the end the final aim of our interest in it. And why? To see its form, of course: "what it really looks like." Paradoxically, though, this form, as noted, cannot just be the work itself, even though what it really looks like, so far as high formalism is concerned, is entirely and only itself.

In all of this, the general problem, to reiterate, is that conventional formal analysis—whether Manifest or Latent and whether inside or outside high formalist art criticism—inevitably tends to obscure the overall integrated aspectivity that configurations intrinsically have for us. "Go look at *this*" in the painting or sculpture or building, it insists. We must go and look at something *in* the work, at certain features *of* it. But even as formalism recognizes aspectivity (as I have put it, formalism is the zero degree of aspect-seeing), aspectivity, which can never be less than full for us, undermines formalism. When the formalist tries to tell us how a configuration looks the way it does to us, telling us about its specifically shaped and colored "look," he often fails to enlighten us about something far more important—what it looks *like*.

▪ 5

As I have already noted, high-formalist criticism has not typically felt a need for independent documentation of the recognition of style and representation, and of the reciprocally or recursively determined formality, that was achieved by the beholders and users of an artifact in the past. Indeed, such documentation often cannot be found. Ancient Egyptian or pre-Columbian Mesoamerican artists did not write about the sensibility that Fry later employed to detect the formality he observed in their artifacts. Nor did they say anything about the identity and history of the "significant forms" constructed in their paintings or sculptures. The mere absence of such documentation does not imply, of course, that they were insensitive to the look of configuration (and to what it looked like) or

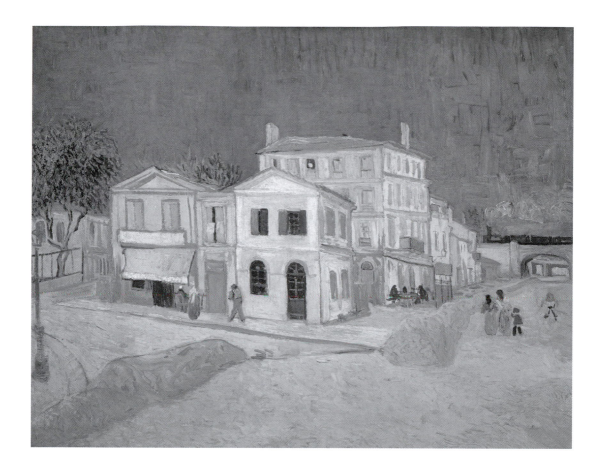

Figure 3.6.
Vincent Van Gogh
(1853–1890), *Yellow
House at Arles* or *The
Street,* 1888. Van Gogh
Museum, Amsterdam.
Photo courtesy Van
Gogh Museum (Vincent
Van Gogh Foundation).

that they did not recognize representation in its apparent conformation or assign a style to it. But its absence does make it difficult for us to identify this formality in objective terms.

In this regard it is a peculiar achievement of the most successful formalist criticism that it seems to open wide our window onto the past maker's and past beholders' supposed constitution of form. We feel translated or transported from the formalist critic's to the past beholders' ways of recognizing the configurative aspects of the artifact. Consider, for example, Fry's description of Vincent Van Gogh's *Yellow House at Arles* (as the picture is usually known), painted in the autumn of 1888 (Fig. 3.6):

> Nowhere else did he express so fully the feeling of ecstatic wonder, the intoxicated delight with which he greeted the radiance of Provençal light and colour. Here he shrank at nothing in order to find a pictorial phrase in which to sing of the violence of the sun's rays upon red-tiled roofs and white stone walls. To do this he has saturated and loaded his sky, making it, not indeed the conventional

cobalt which is popularly attributed to Mediterranean climes, but something more intense, more dramatic and almost menacing. . . . Here all is stated with the crudity of first impressions but also with all their importunate intensity—and they are the first impressions of a nature that vibrated instantly and completely to certain dramatic appeals in the appearances of nature. . . . The artist's interest was entirely held by the dramatic conflict of houses and sky, and the rest has been little more than an introduction to that theme.[12]

If we use Wollheim's terms, in this passage Fry to some extent practiced both a Manifest Formalism and a Latent Formalism. On the one hand, he attends to color values and contrasts. On the other hand, he recalls the sensuous conventions in which this story had been and could be presented, that is, "pictorially phrased" and "sung." Certainly we encounter Fry's patently subjective formalism, his unapologetic assumption of the representationality of the array for him—as he sees it. But Fry's description of his impressions turns into what would seem to be its opposite. It becomes virtual historical psychology—a statement not of Fry's but rather of *Van Gogh's* aspect-perception in painting and presumably in seeing the yellow house, Van Gogh's residence in Arles (located at 2, Place Lamartine, where the painter took up residence on September 16, 1888).

In part this transference has been achieved through Fry's selection of examples. In *Yellow House at Arles*, Van Gogh's cobalt pigment is so saturated (as Fry points out) that the sky in the painting, we seem to feel, could remain just this cobalt no matter who looks at it and in what way. How could anyone *not* see this peculiar cobalt as "intense, dramatic, almost menacing . . ."? But in principle Fry could recognize an artist's sensibility regardless of the artist's particular uses of his medium, and in no way depending on the use of saturated colors or other eye-catching effects. (Indeed, elsewhere Fry described how the special sensibility of mid-eighteenth-century French painters was manifested in the muted, gray shadowing of light and airy pastel colors in their pictures—delicate, barely palpable visual effects at the opposite end of the spectrum of coloristic possibilities from Van Gogh's strong primaries and bright saturations.) Although buoyed by Van Gogh's signature painterly procedures, and more dependent on stylistic considerations than it admits, Fry's description of Van Gogh's formality achieves plausibility through a characteristic rhetorical feature of his formalism. Fry can certainly be described as a high formalist. But he did not conduct *all* of his business as

a Manifest or as a Latent Formalist in Wollheim's sense. In the sample of criticism quoted above, he tried to ground the painting's formal aspects in the painter's artistic personality and his intentions in the painting. In theory, if we know what original makers intended to represent, then our formal analysis of their work (whatever else we might see in it) can try to describe the configurative organizations that are compatible with said intention (and perhaps only with it).

As it happens, in the case of Van Gogh's painting we *do* know something about what the artist intended to represent. In a now-famous letter that he sent to his brother Theo from Arles, dated by its editors to September 29, 1888, Van Gogh enclosed a sketch of the painting he wanted to make (or was in the process of making at the time), as well as a description of it:

> Also [included is] a sketch of a size 30 canvas representing the house and its surroundings in sulphur-colored sunshine [*literally*, under sulphur sun], under a sky of pure cobalt. The subject is frightfully difficult, but that is just why I want to conquer it. It's terrific, these houses, yellow in the sun, and the incomparable freshness of the blue. And everywhere the ground is yellow too. I shall send you a better drawing than this rough improvised sketch out of my head.[13]

Fry knew the painter's letter perfectly well; his own description of the painting echoes it. But he did not mention or cite it, and for the sake of argument (and in order to appreciate the rhetorical force of his criticism), we can suppose that he did not mean simply to reproduce Van Gogh's own comments on his painting. For Fry's reader, at any rate, it is as if the critic's identification of the representationality of the painting—Fry's analysis of its formality—springs fully formed out of his own apprehension: it is Fry's identification of the painter's intended formality in representation transferred to Fry (and then on to us) not so much by Van Gogh's letter as by Van Gogh's *painting*. Or so Fry maneuvers to suggest.

To accomplish this, Fry needs his reader to remain unsure whether it is formality (for example, the white-yellow slashes) or representationality (the violent sun) that is hot and bright. Indeed, Fry uses the same epithets (radiance, intensity, importunateness) for both formality (what the painting arrays for us sensuously) and representationality (what the picture depicts to be sensuously apparent in this virtual world). Thereby he effects their coincidence. If one were to ask why the roof of the house as formed

by Van Gogh in the painting should be said to be hot and bright (again setting aside the documentation, not cited by Fry, that is provided by the painter's letter), Fry's reply would be that the Provençal sun is represented to be hot and bright. And if one questioned why the Provençal sun as Van Gogh represents it can be said to be hot and bright, Fry's reply would be that the roof of the house is formed to be hot and bright. In Fry's phrasing this correlation seems so tight and natural that we tend to overlook its self-serving circularity. As Fry understands it, the painting relays Van Gogh's intentional equation between the color and brightness of materials or environments (as configured formally) and such facts as latitude, locale, season, and time of day (as represented by that configuration).

The rhetoric succeeds in part because Fry's description of the yellow house in the *Yellow House at Arles* subordinates the question whether Van Gogh always employed the equation supposedly represented in *this* painting. If he did, we might regard this aspect of the painting's supposed formality as a manifestation of Van Gogh's *style*, even as a stylisticality of the painting; that is, a representation of a certain style. In fact, in many paintings—some of them mentioned by Fry in his essay—Van Gogh showed no direct correlation between the represented latitude, locale, season, or time of day and the seeming heat or brightness of colors; his colors tend toward high heat and great brightness *regardless* of the particular climatic correlation assumed by Fry to be represented in *Yellow House at Arles*. Because the direct correlation of color and location in *Yellow House at Arles* cannot be confirmed to be an intrinsic stable feature of Van Gogh's style (at least within the purview of the formal analysis proffered by Fry), it might be said to be intended in this painting. But in his formal analysis of the painting Fry mounted the requisite argument from style to formality and pictoriality in an indirect fashion barely registered in his prose: as Fry puts it, "nowhere else" in Van Gogh's painting was the equation of light and color so fully expressed as in *this* painting. We cannot confirm this assertion on the basis of Fry's criticism; in this essay Fry's analysis of the painter's style is neither comprehensive nor comparative. But true or not, the claim grounds the formality of the painting in an intended representationality: a "yellow house," yes—but "at Arles."

In other words, Fry moved from the formality of the painting to its putative representationality and from the representationality of the painting to its formality. His contribution as a critic lies in seizing the rhetorical possibilities of this relationship and in extracting a kind of history from it. Addressing stylistic considerations indirectly or in a negative statement only ("nowhere else . . ."), this circuitry is inserted into the

painting in Fry's accounting of its formal identity in his own assumption of its putative representationality. Needless to say, Fry had some warrant in the conventional title of the painting, specifying a yellow house at Arles, even though that title (which was not Van Gogh's) could be taken to indicate that the intended yellowness of the house is not, or is not only, a condition or consequence of its location at Arles (it is this house and not another house at Arles).[14] For Fry, intended Arles-ness gives and grounds configured yellowness, and vice versa.

But we might see in Van Gogh's painting a more ambiguous or contradictory mediation between the sensuous aspect of the house and its represented identity at Arles. Fry's descriptive epithets, insistently pointing to the "violent," "menacing," "importunate" aspects of the scene, hint at the possibility that the representational intentions or motivations of the painting do not lie simply in the "dramatic appeals in the appearances of nature" in Provence or in the "dramatic conflict of houses and sky" at Arles. Indeed, Fry asserts that the representation of the environment and the house that Van Gogh intended in the painting goes beyond—is palpably, even dramatically, different from—what is "popularly attributed to Mediterranean climes" in more "conventional" painting. But the measure of this distinction, this difference, is stated in terms that likewise trade on ambiguity between formality and representationality: the cobalt/the sky has peculiar "intensity." And the actual nature, history, causes, and consequences of this intense, importunate drama go entirely unsaid. Fry leaves it to his reader (perhaps to his reader's awareness of the misspelling in the painter's letter, even though it is not quoted) to remember that the painter killed himself in the house a few months later.

A crucial direction of likeness supposedly constituted in the painting, at least according to Fry's very own rhetoric, thus remains unidentified in this example of Fry's criticism. The criticism might be suggestive and satisfying, of course, for some purposes of aesthetic appreciation. And it could be regarded as judicious and tactful to the extent that it reserves explicit judgment (or seems to reserve explicit judgment) on certain speculative questions of motivation and context—on the relation, for example, between Van Gogh's depiction of the house and his states of mind while living there. But Fry's criticism is still a long way from being historical despite the way in which its subjectivity appears (in the transference that I have reconstructed here) to become objective—to report or retrieve not only what Fry sees in Van Gogh's painting but also what the painter put into it and what he took from it, what *Van Gogh* saw in the yellow house at Arles and his painting of it.

Fry made persistent efforts to come to formalist terms with ancient Egyptian, classical Chinese, and other visual cultures in premodern or non-Western contexts. As noted earlier, he imagined a global formalism. By the mid-twentieth century, this had become an influential notion in art museums and art collections: it helped motivate them to add many archaeological and ethnological artifacts to their exhibitions. In the end, however, Fry failed to identify essential aspects of likeness assumed by the makers and observers of formality in the visual-cultural traditions of ancient and non-Western worlds.[15] Falling back on platitudes about the spiritual significance of the alien artifacts, his essentially projective and empathetic method did not allow him to bridge the gap between present-day and premodern or non-Western cultures of formality.

In particular, Fry neglected to defend his stylistic and iconographic identifications, even though he often enfolded these aspective specifications (albeit indirectly) into his formalistic analysis of modern arts in the West. Of course, in the case of such works as Van Gogh's *Yellow House at Arles* these specifications were known in advance; they were more or less self-evident in the motif. Thus they could simply be assumed as secure aspects of the work in any description of its putative formality. Although the eponymous specification of the representational identity of *Yellow House at Arles* was not Van Gogh's, Fry knew that it was a painting of Van Gogh's house at Arles, whether the house was yellow or not and whether or not it was yellow because it was a house at Arles. Hence Fry's indirect rhetorical allusions to the dramas in the house, to Van Gogh's supposed tragedy and suffering, could animate his high-formalist description of the painting with portentous psychological implications. But we can have no such confidence when dealing with visual cultures in societies far removed from our own.

For this reason, it is surprising on the face of it, and certainly worth noting, that historical formalists in the Vienna School of *Strukturforschung* (structural research) produced lasting forensic and interpretive studies of ancient Egyptian and many other ancient and non-Western artistic traditions.[16] For example, Riegl contrasted the supposedly haptic configurative consciousness of the ancient Egyptians with the partly optic style he identified in classical Greek art and early imperial Roman art (these arts highlighted such optical effects in sculpture as the shadowing that creates the impression of volume and foreshortenings, establishing an aura of surrounding atmosphere). In turn, he contrasted these partly optic classical-naturalistic arts with the *highly* optic or virtually "Impres-

sionist" style of later Roman art (its deep undercutting and other techniques created coloristic and spatialized effects).[17] Like Fry, Riegl elaborated little if any Manifest or Latent Formalism in Wollheim's sense. And like Fry, he pursued the reciprocal determination of formality and representationality in our integrated aspect-perception. But *unlike* Fry's formalism, *Strukturforschung* in the Vienna School could escape the strongest strictures on formalist subjectivism because it required the historian to produce objective evidence for the constitutive historical subjectivity of formality. The "evidence" of his *own* eyes was not sufficient.

In part, *Strukturforschung* turned to documents of various kinds to identify the formal intentions of original makers, what Riegl called their *Kunstwollen* as if to suggest that the motivations in question were independent of (and somehow prior to) the artistic activity, the making as such. As already noted, however, independent evidence about intentions (evidence of the kind that Fry had in his possession but did not explicitly cite in his formal criticism of Van Gogh's *Yellow House at Arles*) will likely be difficult to find. The ancient Egyptians might have had a haptic consciousness in configuration. But our evidence for its natural and social basis and for its ontological and epistemological parameters can only be sought in the configurative activity itself and possibly in other cultural activities that we might take to be cognate with it, to be *like* it in the sense to be developed in Chapter Nine: the Egyptians wrote very little about their intentions in configuration and depiction in terms that we can understand specifically to explicate these activities.[18] In *Spätrömische Kunstindustrie*, Riegl's evidence for the ideological orientations of the makers of the less optic style of the early Roman empire and the more optic style of the later empire could not always be extraformalist evidence. (The less optic style was identified with the "pagan" state religion or imperial cult and the more optic style with Christianity and in particular with the conversion of Constantine and many of the emperors who succeeded him.) In fact, the religious and political affiliations of the artisans, patrons, and viewers in question were often unknown to him *except* by way of the works of art and architecture they had produced and used.[19] In the end, then, Riegl's evidence for originating intentions, for *Kunstwollen*, could not be wholly independent of formality, especially insofar as he treated formality as interdetermined by the stylistic and iconographic successions. Rather, in Riegl's art history the hypothesis of the *Kunstwollen* served as an account *of* formality based on what he took to be general principles of human perception—namely, the criteria of distant, normal, and near views that he used to define relatively haptic and relatively optic styles in contexts ranging from ancient Egypt to the modern West.

For precisely this reason, historical formalism of the kind proposed in the Vienna School was not a documentary history of art or even a descriptive sociology of art. (Indeed, in Riegl's hands historical formalism emerged in a *critique* of the document-based or philological approaches that had dominated German art history in the second half of the nineteenth century.) Riegl deliberately remained *within* the circuit of formalism: like all formalisms, historical formalism hopes to offer the formal history of society as much as the social history of form. Like high formalism, then, historical formalism—regardless of independent documentation—addresses the historical subjectivity of formality by locating it in the network of aspective interdeterminations. It therefore proceeds from the formalist's visual inspection of the configurative aspects of the work as he sees them—just like high formalism. But unlike high formalism, historical formalism does not rest content with this starting-point. It does not depend covertly, as Fry did, on the ways in which the supposedly secure historicity of *other* aspects of style and representationality will serve (though tautologically) to translate formalist critical observations into virtual historical psychology. Rather historical formalism *tests* its formal observations of configuratedness in artifacts against a comparative range and a variable series of morphological likenesses among artifacts seen to have similar formality.

In publications ranging from Riegl's *Stilfragen* to George Kubler's *Shape of Time* (that is, from the 1890s to the 1960s), historical formalism tracks configurative practices through time (often long periods of time), in cultural space (often including many locations and regions), and in many artifacts (often in many instances of many artifact types). In doing so it offers explicit typological, statistical, and seriational models of historical variation in configuration, all of which involve laborious analysis of large groups of artifacts (an analysis assisted nowadays by statistical methods and computers) as well as careful inspection of individual artifacts (an analysis that still uses the "close looking" of the individual formalist's unaided human eyes). In the process, it tends to become clear what is proper to the historian's aspect-perception (to his observation of apparent formality in the artifact) and what might have been proper to the original making and use of the artifact. A high formalist such as Fry is like a person caught in a psychological transference between himself and another person, the original maker. In high formalism, it is not clear whether the analyst or the object analyzed has inserted the salient formality and representationality into the scene of analysis. It is likely, in fact, that formality relays a projection of the formalist critic's history and

sensibility (though I cannot say if Fry's suffering found its partly fictitious or fantastical objective correlate in Van Gogh's). By contrast, a historical and structural formalist is like a psychoanalyst who interprets his transference with another person, the maker of the artifacts, to have objective etiologies of aspect-seeing in *both* himself *and* the maker.[20]

Of course, an archaeologist (professionally, many historical and structural formalists have been archaeologists) routinely applies his or her own sensibility to the study of comprehensive assemblages and immense arrays of artifacts—the very same sensitivity to formality that might be brought to any particular single artifact in looking closely at its supposed form. But the sheer quantity and variability of archaeological source material tends to discourage excessive concentration on configurative detail in any single artifact, let alone the reduction and reification of such detail. (An exception would be a case where it could be scientifically demonstrated that a particular artifact ought to be treated as representative or symptomatic of original configurative processes in integrated aspect-perception and aspective interdetermination.) In this sense historical formalism is not *high* formalism, which is defined by the reification of pure formality, the promotion of close looking at individual objects, the dubious methods of Manifest and Latent Formalism, and the decontextualization of "the object," its disaggregation from the archaeological and architectural assemblages in which artifacts are usually found. It is, rather, a historical hermeneutics of integrated aspect-seeing in the past that proceeds methodologically from the formalities we can see when we organize artifacts according to explicit morphological typologies and series.

Whether it is rather simple and impressionistic (as in *Strukturforschung* in art history) or sophisticated and rigorously controlled (as in the seriational procedures of modern analytic archaeology), formalist archaeology promotes a shift from avowedly subjective to putatively objective procedures. Most important from the point of view of the present book, its methods can suggest to us that an artwork or artifact likely possessed a certain configurative aspect for its past makers and observers *even if the historical formalist cannot initially see it with his own eyes.*

Indeed, the strongest variant of historical formalism might want to claim that initially we *cannot* see formality in artifacts constituted and recognized by people in the past. The formality in question belongs to an original visuality, not to our vision. Or at least it does not belong to our vision until we have learned to "see things in the way they did." And contrary to what high formalism tends to suggest, this is not, or not only, a subjective visual activity on our part, however refined and attentive it

might be. It is, rather, a historical project in which formality must be located in the visuality within which it could have been seen by other people—within which it was *made* by other people. Because it was visible, we might come to see it too, for we have the same human eyes as people in the past or in other societies. But this recursion—it moves from a past visuality to our vision—is the very opposite of the procedure of high formalism when it moves from our vision right now to a visuality in the past.

Chapter 4

The Stylistic Succession

■ I

In art history we often find the terms "formalism" and "stylistic analysis" used interchangeably. Indeed, sometimes we hear one method praised or criticized for procedures or results that actually belong only to the other. The conflation of the two, although not surprising for reasons that I will explore in this chapter, has been debilitating to the discipline. It is thus well worth being clear about the arenas of absolute disjunction, of categorical difference, between formalism and stylistic analysis.

Formalism does not inherently require, nor does it exclusively look for, style, though it might do so. And stylistic analysis does not require, nor does it exclusively look for, formality, though again it might. In fact, the extreme or high formalism described in Chapter Three sits as far away from ordinary stylistic analysis as it can settle itself: it tends to imagine *styleless* artworks—artworks whose configured identity and sensuous *raison d'être* can supposedly be found entirely in pure formality. High formalism typically addresses the style of artworks, if it does so at all, as a merely background consideration, and not comprehensively. It follows that this kind of formalism cannot offer a connoisseurship of style; that is, a dedicated cultivation of the seeing that sees style. Oddly enough, however, connoisseurship has often been said to be formalist.

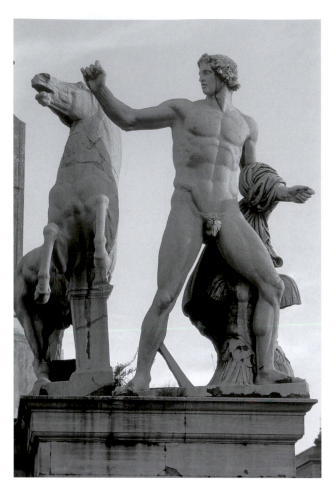

Figure 4.1.
"Castor," one of the
"Horse Tamers." Piazza
del Quirinale, Rome.
Colossal Roman marble
copy, c. AD 300/350, of a
Greek original identified
as either Alexander and
Bucephalus [?] or Castor
and Pollux [?]. Photo
copyright Scott Gilchrist,
Archivision, Inc.

Stylistic analysis aims to attribute an artifact to its historical origin on the basis of its sensuous configuration, and in particular to assign it to the set or sequence of artifacts in which it was made, what elsewhere I have called its production system.[1] In theory we should be able to *see* this stylistic configuration. Like the formalist, then, the historian of style uses the evidence of his own eyes. But the style of an artifact derives not only from its own apparent configuration. As noted in the last section of the previous chapter, it also derives from similarities between the perceived conformation of an artifact and the conformations of many *other* artifacts that seem to possess (and therefore can reveal to us) a common origin in their making, a style in analytic and historical terms—a similarity that we can see in the artifacts or that we can see the artifacts as having. Similarity between artifacts *seen as* caused by their having a common origin is an aspect of each of the artifacts in which this similarity is seen, whether or not they really have this common origin or only something that looks like it. I will call this phenomenon *stylisticality*. In stylisticality we apprehend an artifact's seeming similarity to other things. These other things are seen as putative replications of the artifact, and their putative replicatedness can be seen in the artifact. These visual and morphological similarities in the configurations are visible to us whether or not we are grasping the real cause, in the actual history of making, of these apparent likenesses.

At first sight my distinction between style and stylisticality might seem abstruse. But it is really quite simple and straightforward. Just because two things look to be and to have been made alike, a feature of stylisticality, does not mean that they meet the criterion of style in an important art-historical sense: namely, that they actually have a common historical origin in the production of one maker or group of makers. Though of course they *might* have such an origin. Yet stylisticality is just

as visible as style; it is an aspect of configuration as we see it. And regardless of visual facts, of "look," it would be risky to presume that two artifacts that look alike have the same date or were made in the same place or by the same people. Some of the most secure styles (or stylistical replications) in the history of art were made by many different people in many different times and places.

The classical style in figurative sculpture and the International Style in architectural design are good examples. Rooted in ancient Greek and modern European cultural traditions respectively, they became transcontinental and transhistorical when the classical style was transmitted from the Greeks to Hellenistic rulers, to the Romans, and to the East and when the International Style was transmitted from Central Europe to North America and elsewhere. Of course, there were many visible differences between the classicizing statues set up around the Periclean Parthenon and those found in towns

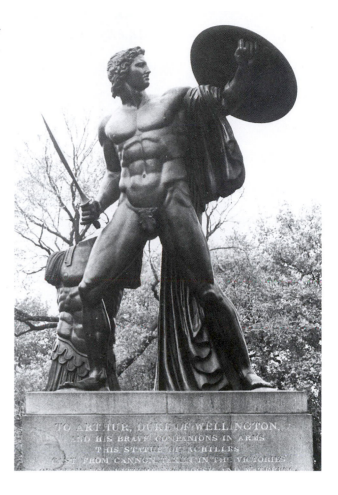

Figure 4.2.
Richard Westmacott (1775–1856), *The Wellington Monument* ("*Achilles*"), unveiled 1822. Hyde Park, London. Photo courtesy Courtauld Institute of Art, London.

and capitals of the Hellenistic kingdoms or in the imperial city of Rome (Fig. 4.1) or, for that matter, in the parks of London and other European and American cities in the nineteenth century (Fig. 4.2). Likewise, there are visible differences between International Style buildings erected in Soviet satellite countries in the 1950s and in North American cities at the same time.[2] In context, the formality and pictoriality of these different works, despite their stylistic commonality, was disjunct from one replication of the style to the next. In terms of overall aspective interdetermination, they probably had different cultural aspects because they probably looked like quite different things to their respective beholders in ancient Athens or Rome and modern London or in capitalist North America and the Communist Soviet Union. (As we will see in Chapters Nine and Ten, looking-like-something defines *culturality* as distinct from the archaeological fact, the mere datum, of the thing's having been produced in one particular cultural system.)

The relation between ancient classicism and modern Georgian, Victorian, and Edwardian neoclassicism in sculpture or between Soviet and North American architectural modernism was probably in part stylistical. Despite the visible likeness between the ancient and modern works, even if explicitly intended on the part of the modern sculptors, the modern works could not be attributed to the same material cause—the agency identified in the analysis of style carried out by art historians—as, for example, the original Attic, Alexandrian, or Roman works. The ancient and modern works could be seen in London in the nineteenth century as produced in different ways by different agents in different conditions. In turn, the primal visible likeness could be recognized as something configured (at least in London) to be seen as *representing* the artifact's cause regardless of its real cause. In this case the visible likeness, the classicism visibly shared by certain Greek or Roman sculptures (whether found in Britain or elsewhere) and certain Georgian, Victorian, or Edwardian sculptures made in Britain, indexed a system of production that was *fictively* common—in London intended to be seen as common—to the ancient and modern works.

It is quite possible, of course, that some people in London in the nineteenth century, perhaps many people, *failed* to see the stylisticality of classicizing Victorian sculptures. If a sculpture looked Greek, for these people it *was* Greek; after all, it had Greek style. But we should not take the stylisticality that deceived them to be any less real in their *seeing* of the artifacts in question (though they saw it as style) than the style that might have showed them where, how, and by whom the artifacts were really made. (Presumably they had seen classicizing *Greek* sculptures, which they saw as Greek style, and they saw the same Greekness in the Victorian sculptures; so far as their visual-cultural horizons permitted, this was quite correct.) Indeed, the representationality of style, what it *appears* to mean about the real causes of the visible likenesses between artifacts, can feed back into the ways in which they *are* made. Some Victorian sculpture was explicitly made to look Greek.

As the example just described suggests, in many circumstances style and stylisticality might be indistinguishable. This can be due to the fact that the real causes of likenesses in replication were disguised, or to the fact that the beholder does not have enough information to distinguish these causes, or to both. (As we will see, this is not a phenomenon confined to visual cultures, to visualities, in the past; it also occurs in present-day histories of past visual cultures.) Both style and stylisticality are visual aspects of artifacts that might or might not have been recognized by the makers and users of the artifacts, and they might or might not be seen by

us. But for analytic purposes in the historical study of style, especially in the activity of *attribution*, it is crucial to keep them apart.

The observation that two artifacts are "stylistically close" or that they are "close stylistic parallels" (to use common terms of stylistic connoisseurship) does not mean that they had to have been made in the same time and place or by the same people. Indeed, it could mean quite the opposite—namely, and as already noted, that artifacts made by different people in different times and places nonetheless display similarities that devolved from a replicatory procedure common to the different makers in the entire sequence, or at least to those later makers who (re)produced the original style. (Replication often jumps techniques and media; regardless of technique and medium, it depends on the preservation of perceived resemblance and on substitutability defined in that context.) When different artifacts are described as "close-looking" in stylistic analysis, then, it is we who have seen them—on careful comparative inspection—to appear highly alike *as* replicated. That is, we have seen them to be very similar in both the circumstances and the appearance of their generation. But as yet nothing at all has been said or even implied about the historical status—the real material ground—of this observation.

The relation of "looking close" (looking-very-like) that we might discover in our inspection of a group of artifacts can be contrasted with the "close looking" advocated in high formalism. As we saw in Chapter Three, high formalism typically approaches the sensuous configuration of each artifact, its formality, regardless of its similarity to *other* artifacts and their formalities. Both methods of inspection usually call for intensive, direct engagement with the objects—that is, with "the object" (singular) in formalism (typically with the object of art) and with "the objects" (plural) in stylistic analysis (typically with artifacts not limited to artifacts of art). But in looking closely at objects (plural), stylistic analysis *corrects* formalism. Moreover, high formalism reifies aspects of sensuous configuration that were supposedly constructed and recognized by the makers of the artifacts, even if each of these supposed formalities was actually produced only once in history (that is, even if it was only produced in one artifact). By contrast, as we will see in more detail later in this chapter, connoisseurship reifies aspects of the sensuous configuration of artifacts that supposedly went entirely *unrecognized* by their makers, even though these aspects were constituted repeatedly. Any close looking at these phenomena in visual culture must be looking at two different things: the formality of one artifact or the style and stylisticality of an entire group.

When we see artifacts to be "stylistically close," we do not have to mean that they were historically close. We mean that they were actually

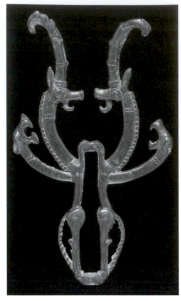

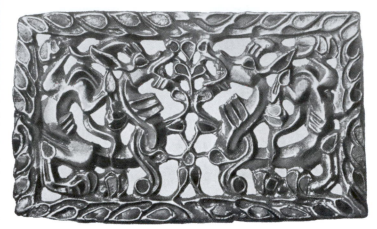

Figure 4.3.
Bronze finial from Luristan, western Iran, probably second half of first millennium BC. British Museum, London. Photo courtesy British Museum.

Figure 4.4.
Large gold buckle, Scythian workmanship, probably first century BC. From Gregory Borovka, *Scythian Art*, trans. V. Gordon Childe (London 1928) pl. 52(b).

made in closely similar ways in replication. Or at least they were made, in the case of what I call "stylisticality," in ways intended to (make them) look closely similar. Thus we can say that two sculptures or two buildings are "close parallels" in their replications of classical style or the International Style. We might know nothing about the makers of the sculptures or the buildings, or about the dates, locations, or other circumstances of their production. Nevertheless we can see that a high degree of similarity was somehow achieved in the making of the products—a similarity we see as replication, and can attribute to it. And this stylistic aspectivity promotes our historical knowledge *of* replication. In turn, of course, this heightens our impression of style, our awareness of it as an aspect of configuration putatively made and manipulated by people in the past.

For this very reason, however, stylisticality is not so much our awareness of the shared historical derivation of artifacts (although it can flow from this knowledge if we happen to have it) as it is our visual impression of an historical derivation that is likely shared. If this awareness can be trusted, it has obvious and sometimes immense forensic implications: things that look alike tend to imply to us that they have a common cause. If we want

to determine what *really* happened in the making of artifacts and their apparent styles, of course, eventually we will need independent information about the process of production of apparent replicated similars, including (for example) its dates, locations, participants, and techniques. Even so, style as we see it in artifacts can be a placeholder for circumstantial material history, and in particular for the history of stylisticality in replication.

In identifying the Animal Style or the Style of the Boucicault Master, we do not need to know whether they were recognized by the makers of the Animal Style or by the Boucicault Master, whoever they were—that is, that they recognized that they were working in the style that we identify in their artifacts as replications of their style. In fact, the makers of the Animal Style in Luristan (western Iran) in the first millennium BC (Fig. 4.3) or in Scythian lands in the first century BC (Fig. 4.4) could have known nothing about the productions of makers of the Animal Style in northern Europe in the second half of the first millennium AD (Figs. 4.5, 4.6).[3] Therefore they could hardly have reproduced them directly and deliberately. Conversely,

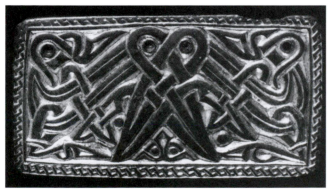

Figure 4.5.
Gilded bronze brooch from Noerre Sandegaard, Bornholm, Denmark, seventh century AD. National Museum of Denmark, Copenhagen. Photo Lennart Larsen, the National Museum of Denmark.

Figure 4.6.
Gilded bronze plaque from Skabersjö, Sweden, seventh century AD. From Bernhard Salin, *Die altgermanische Tierornamentik* (Stockholm 1904) Figure 586.

it is unlikely that the Scandinavian carvers and Hibernian illuminators at the end of the first millennium AD knew what the stonecarvers and metal-workers of the Near East or the Caucasus had made as much as two or more millennia earlier, though both historical groups were practitioners or exponents of the Animal Style. (It is worth noting that *our* recognition of the Animal Style is not an effective platform for the attribution of artifacts to ancient Near Eastern or medieval Scandinavian contexts of making, if we are interested in discovering them. But it might well be a valid medium by which we can detect historical patterns of long-term, complex cultural transmission between ancient Near Eastern and medieval Scandinavian so-cieties.) The Boucicault Master might never have seen the work of some of his followers, and some of his followers might never have seen the master's work. Strictly speaking it would have been impossible for all these histori-cal parties in the replication of their own supposed styles to have recog-nized these styles—at least in the comparative, sequential, and statistical terms that we can survey in our art history. But this does not mean that the makers of the Animal Style, despite its vast extent and great duration, did not see the stylisticality in what we see as their long-term, stable style. It is possible that they produced configurations that they recognized as their own *for* apprehension as such by different observers—observers, it turns out, who include people throughout history all the way down to the mo-ment of stylistic analysis in the present.

■ 2

Where there is observation of style, there can be replication of style. And where there is replication of style due to observation of it, there is stylisticality. Where there is stylisticality, there must be observation of style. And where there is observation of style, there can be replication of style . . . From this loop (and *because* of this loop) we can derive not only the possibility of so-called stylistic development. (Stylistic development is not always simply a sequence of mutations in replication, as Aloïs Riegl proposed in *Stilfragen* in 1893; sometimes it can be a history of revisions through recognition, as Riegl realized in *Spätrömische Kunstindustrie*, published in 1901.) We can also warrant the forensic possibility that when we see style we can see what things looked like to people in the past. In this respect, stylistic analysis *supplements* formalism. As we have seen in Chapter Three, formalism risks seeing only how things made by people in the past look to us. Stylistic analysis, at least when it identifies stylistical-ity, might be able to see what the material likenesses between things made

by people in the past looked like to them, the people who had replicated these aspects of configuration and had done so in order that they be seen *as* replicated. And this must tell us what each thing looked like in at least one of its dimensions of likeness: how its configuration had an apparent replicatory cause in common with similar configurations.

These are deep hermeneutic equations at the very heart of art history and the study of visual culture. Despite their suggestiveness and power, however, their delicacy and difficulty should be obvious. Stylisticality not only sees style in an artifact as the configured visibility of the artifact's putative origin—a recognition of style. In a circuitry of identifications, stylisticality also *constitutes* style in our sensory awareness of a similarity among artifacts seemingly due (we believe) to their common origin. It is *our* sensuous awareness that an artifact seems to have been produced in a way that has also been used to produce similar artifacts. Whether or not the artifacts were actually made in the same way, to us they "look like" one another. As we might say, "This painting—yes, it looks like Van Gogh's, like a Van Gogh."

Correct or not in actualist terms, this awareness might well have been shared by the original makers and observers of the artifacts. After all, we attribute to them the making of things in a style—in *their* style. This style that we see, then, might also be the stylisticality that they apprehended. In one of its ordinary applications in art history, stylistic analysis seeks to find this equivalence. But not *only* this equivalence. The aspectivity of a style in the past or in the present, or in the past *and* the present, cannot be taken for granted. As noted, style is not always a recognized original aspect of artifacts even if it is always an attribute of artifacts, a set of identifiable traits that have an objective cause and that *we* can see on making a comparative inspection and forensic investigation—an inspection and investigation that people in the past could also have conducted, though presumably not in exactly the same way as we do.

Because of all this, the *stylistic succession*, as I will call it, is not always smooth, continuous, or complete. Though both are "made" by the makers and can be attributed to them by us, style that is unrecognized (what I will henceforth simply call *style* for the sake of economy) and stylisticality have different kinds of cause; that is, different routes and relays in the aspect-seeing of the makers in question (though both deserve to be described as *styles*, as I will perforce continue to do). One succeeds to the other only in a recursion in aspect-seeing that need not occur, and often does not occur.

On the one hand, we might fail to see historical styles that had full stylisticality for their makers. The history of visual culture around the

world must be replete with *stylistical styles*, past and present styles recognized by their makers or by observers as such—styles made to be seen as styles. But present-day art historians and archaeologists have probably recognized only a handful of these. Despite the fact that our sensory comparison can often discover likenesses among artifacts, it is unlikely on the face of it that we have seen *all* of the likenesses that were seen by people in the past or in situations remote from our own as stylistical. Art-historically unrecognized stylisticality must be a blank space in the landscape of art history.[4]

On the other hand, the historical makers of a style might not have observed it as stylisticality. Many art historians suppose that the history of art has been replete with such styles, recognized by us but *un*recognized by the makers. Indeed, one kind of connoisseurship, explored below, requires this: in order for connoisseurs to identify the handiwork of the individual makers of (their own) styles in the production of artifacts, these makers must have been entirely unaware of their stylistic behavior (as we might call their habits in making), or else they could have manipulated it in ways that would now defeat this very kind of style-historical apprehension. (Of course, they might well have done so, thus defeating this kind of connoisseurship without leaving any trace of the fact.) Anthropological models of style typically translate this connoisseurship from the individual and habitual plane to the communal and conventional plane. But like the connoisseurship of individual makers' styles, of the "hands" of artists or artisans, anthropological models of communal style often do not assume—and sometimes cannot assume—that the style produced by a community was recognized as such by the members of the community.

Many technical methods for identifying style have been advanced by modern archaeology, beginning in the 1880s with the comparative researches of Riegl and the roughly contemporary invention of seriational procedures by archaeologists, notably Sir William Matthew Flinders Petrie.[5] Obviously these methods were unknown to anyone before the end of the nineteenth century. In due course, twentieth-century archaeology consolidated a massive transregional and transcontinental corpus of comparative evidence. It has made possible sophisticated typological and seriational approaches to the physical and the sensuous properties of all sorts of artifacts. Styles identified by archaeologists on these grounds could not have been *stylisticalities* for their makers, at least not before the end of the nineteenth century. Although the makers might have had other grounds for recognizing a style inferred by us on the basis of technical, comparative, typological, or seriational analysis, it is equally possible that they had *no* grounds for recognizing the style. Of course, when com-

parisons became available to them, a stylisticality could emerge. In the accumulation of like-looking artifacts known to them to be made by them they could recognize their own stylisticality. But according to the theory of connoisseurship (when applied to individual or communal styles) the makers' recognition of their style as stylisticality would change the way that the style could continue to be made. In fact, it would no longer *be* the same style—though it might *look* the same.

The *attribution of stylisticality*, then, is not the same thing as *stylistic attribution*—a fundamental difference that has often been overlooked in technical and cultural studies of style. *Looking like* other things (or more exactly looking like how other things are made) is not the same thing as *being* like other things (or more exactly being made like them). Whereas stylisticality projects from looking-like to being-like, style arises because being-like produces looking-like. To be sure, these twinned dimensions of making and observing artifacts tend to support one another in a ramified network of identifications and recursions in stylistic successions. We tend to assume being-made-like on the basis of evident looking-like; and actual being-made-like encourages us to assume looking-like. But these assumptions sometimes undermine each other. It goes without saying that complex relations of imitation, citation, appropriation, and, of course, counterfeiting and forgery—complex interanimations of style and stylisticality—have long been part of the making and remaking of artifacts. Indeed, these relations constitute and define the very possibility of replication (substitutability relative to a perceptual context and context of use) as a sensuous property of artifacts—a property, that is, that can be observed. For this reason they can be culturally deployed in surprisingly recursive ways; there is no single, given order to the ramified identifications that are inherent in stylistic succession. In the artworld today, for example, citation and appropriation can be used legitimately to augment authenticity and originality or perhaps to "critique" it, but never simply to plagiarize or to forge the work of other people—as would often have been the case in previous centuries.

As these considerations suggest, style and stylisticality constitute one of the most slippery forms of likeness that historians investigate. It has been all too easy to overlook the stylistic successions in artifacts—the continuous, recursive, and sometimes self-reflexive historical succession from style to stylisticality and vice versa. Conversely, it has been all too easy to discover stylistic succession when it did not actually take place. And it has been all too easy to mistake its actual cause. Stylistic succession can occur in replicatory production by one group of makers. But it can also occur in one maker's own work. It can even occur in the making of one artifact or

artwork. All style, of any scale and duration and having any cause or origin, can succeed to stylisticality; all stylisticality can revert to style.

■ **3**

Among art historians, the best-known variant of the analysis of style in the sense that I have adopted is the connoisseurship founded by Giovanni Morelli in the 1880s.[6] Morellian connoisseurship identifies attributes (not aspects) of configuration that supposedly were produced without configurative deliberation of any kind in any respect. In theory, then, this style must be outside formality constituted to be recognized as such—outside configuration that has been constructed by a painter or sculptor to be seen, for example, as *his* signature ear or hand (i.e., the ear or hand to be seen as painted or sculpted by him) (Fig. 4.7). And in complementary fashion, this style must be outside iconographic specifications acknowledged by the maker, and indeed outside pictoriality constituted to be recognized as such—outside configuration that has been constructed by the maker to be seen, for example, as his *ear* or his *hand* (i.e., painting or sculpture to be seen as his painted or sculpted ear or hand). These *Grundformen*, basic forms or foundational forms in Morelli's terminology, subsist in a kind of no-man's-land that nonetheless reveals *each-man's-land*. It is a space between configurative making as such, which has many material causes and agents, and formality and pictoriality manifestly promulgated by the maker to be seen as such.

Grundformen, then, are styles entirely without stylisticality—*pure unstylistical style*. They have not succeeded to any stylisticality, and per-

Figure 4.7. Morelli's diagrams of characteristic ears and hands (*Grundformen*) of Italian painters of the Renaissance. From Giovanni Morelli (1816–1891), *Italian Painters: Critical Studies of Their Works*, trans. Constance Jocelyn Ffoulkes (London 1892) 77, 78.

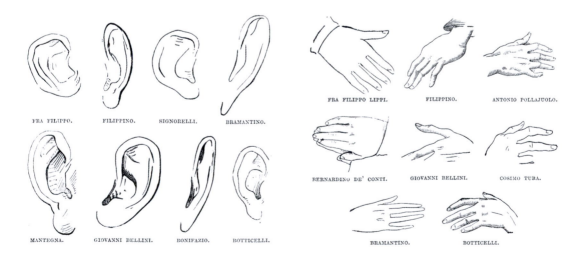

Chapter 4

haps never will; they have not passed into self-reflexive replication. Perhaps, in fact, they went *unseen* by their makers, even if they were visible to other people. But this possibility need not be resolved by Morellian connoisseurship. The most important thing about Morellian style is that it can be seen *by us*.

One often hears that Morellian *Grundformen* individuate an artist's identity throughout his career—that they are characteristic of an artist as a spatiotemporally continuous human individual. In certain statements of his method, Morelli sometimes might have encouraged this notion. But a careful reading of his *Kunstkritische Studien* shows that *Grundformen* do not always individuate artists as continuous human persons. For one thing, an artist's *Grundform* (his "typical" hand or ear) (Fig. 4.7) can change over the duration of his career. In a mere two pages of analysis in Morelli's text, for example, the *Grundformen* of hands painted by Sebastiano del Piombo changed their likeness from Giorgionesque to Raphaelesque to Michelangelesque; the first phase is illustrated, for example, by the form of the hand in Sebastiano's drawing of a faun (Fig. 4.8[a]) and the last phase by the Michelangelesque bend of the second finger in Sebastiano's *St. John the Baptist* (Fig. 4.8[b]), now in the Louvre. The painter's landscape backgrounds and his painted ears (Fig. 4.8[c])—also considered *Grundformen* by Morelli—were said, however, to remain relatively stable over time. (According to Morelli, the vintage of Sebastiano's landscape backgrounds lay in his Giorgionesque period and the vintage of his painted ears lay in his Raphaelesque period.)

As this implies, the configuration of *Grundformen* can be acquired by one artist or artisan from another. In other words, *Grundformen* (like other orders of configuration) can become "academic." In one painting,

Figure 4.8.

(a) Morelli's sketch of Sebastiano del Piombo's drawing of a faun;
(b) Morelli's sketch of Sebastiano del Piombo's *St. John the Baptist*;
(c) Morelli's sketch of the characteristic ear painted by Sebastiano del Piombo. From Giovanni Morelli, *Italian Painters: Critical Studies of Their Works*, trans. Constance Jocelyn Ffoulkes (London 1892) 42, 44.

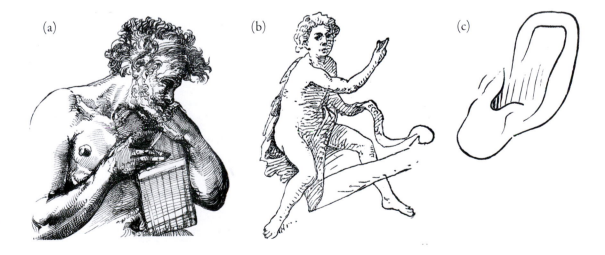

(a) (b) (c)

as Morelli put it, Sebastiano's typical painted hand was "*nothing but* the transition from Giorgione to Raphael."[7] More exactly, when making paintings Sebastiano was *this* painterly "nothing but"—namely, Sebastiano del Piombo, a stylistic character or agent who incarnated "the transition from Giorgione to Raphael" precisely in virtue of not knowing it, at least when he painted hands. Of course, all the developments and relations of his style, its ramifications and recursions, belong to Sebastiano as a human subject: his painted hands were produced by Sebastiano simply being himself, the painter he was, when studying Giorgione, when admiring Raphael, and when emulating Michelangelo. But insofar as these relays of his painterly subjectivity were not self-consciously recognized by Sebastiano *as* a subject, they were radically *other* to him in the very fact that they were radically *of* him or radically *in* him.

It lies beyond the scope of this chapter to investigate the counter-Hegelian nature of Morelli's conception of human subjects. As Peter Fenves has emphasized, according to Hegel it is the *whole of the other* that must be recognized by the subject in order for the subject to attain full self-consciousness in the first place. It was the Hegelian project, in other words, "to secure self-knowledge and self-recognition by showing that knowledge and recognition are mediated by the whole"[8]—that they are constituted, that is, in relation to the whole of the world that the subject takes to be outside itself, to be other to it, when that whole is grasped as a product of the subject's own consciousness. By the same token, but conversely, we might say that it was the Morellian project to recall that—and to discover where—self-knowledge *cannot* be fully attained when the whole of the other has mediated part of the subject without its recognition. (Recall Sebastiano del Piombo, "nothing but" the mediation of Giorgione, Raphael, and Michelangelo.) This is surely the ordinary condition of subjectivity in human forms of life, at least insofar as they have not attained absolute self-consciousness in Hegel's terms.

To some extent Morelli's system was self-taught, though fellow-travellers in the development of connoisseurship (notably Bernard Berenson) saw a connection between it and contemporary psychophysiologies and philosophies of the reflexes, habits, irritations, and pleasures of the human body that had been developed more formally by such writers as Vernon Lee and George Santayana; I will return to these at the end of this chapter. Here it suffices to note that it is not surprising to see Morelli's method frequently likened to Sigmund Freud's doctrine of unconscious repression and its symptoms. Indeed, Morelli's method has sometimes been said to have played some kind of role in the formulation of Freud's method. But it is best to see Morelli's project as a distinct one, as *sui ge-*

neris. Certainly it presents (or at least implies) a theory that must be seen as *inverse* to Freud's in a central respect. The Morellian *Grundform* is not a *symptom*, what Freud's psychophysiology would define as the reflex of a reflex (i.e., the distorted derepression of a defensive repression). It is primal habit or reflex itself. Whatever might be true about the self-awareness of symptoms that can be attained by the subject in psychoanalysis, the *Grundform* cannot be recognized self-consciously by the subject without disappearing *as* reflex and passing into what I have been calling stylisticality. *Grundformen* have no cure; they are essential alterities of human makers. When they disappear, something original to the subject must be wholly lost.

At any rate, and whatever his philosophical presumptions might have been, Morelli's method has deep theoretical interest. It focuses primal hermeneutic intuitions about historical likeness among artifacts and, equally important, about our own sensory capacity to identify their origins and reconstruct their affiliations—to *see* their history. In principle Morellian connoisseurs can make substantial empirical discoveries. Their findings can be confirmed by conservators and other scientists on independent forensic grounds, and often have been, though no doubt they must seem to be most potent when they have no other forensic grounds but Morellian inspection—the art-historical magic, as it were, of a connoisseur's trained "eye" at work.

Nonetheless, the application of Morelli's method has often fallen short of its theoretical formulation. In attributing artifacts to makers, Morellian connoisseurship depends not only on its founding tautologies, that is, on its ability to distinguish pure unstylistical style from self-reflexively constituted formality and pictoriality and their attendant stylizations. It also depends on a crucial qualification, openly admitted, about reflexive, habitual style. If reflexes or habits in making artifacts are common to a *group* of makers, then, of course, any pure style does not individuate *individual* human agents as makers of the artifacts. Rather, it individuates groups of makers or traditions of making. Because it has individuated them at the level of pure style, it can, of course, attribute artifacts to these groups or traditions. But this was not Morelli's usual intention or the aim of Morellian connoisseurs. They have aimed specifically at the attribution of works of art to individual agents—to Old Masters and commonly to particular phases in the career of *each* Old Master. The fact that Morellian connoisseurship must often content itself with attributions of a work to a "workshop," "studio," "school" or "tradition" must be counted a shortcoming of the method, for the method is predicated on a theoretical hypothesis about *individual* stylistic behavior. At

the very least, further Morellian stylistic analysis of the pure style of the group or the tradition would still seem to be required. It would reveal different styles *within* the workshop or school, or perhaps identify a stylistic succession in the situation that accounts for the attributive clump.

But in turn this points to the sense in which Morellian connoisseurship is endless. Until we reach the lowermost threshold of minimum reflexive habituation, whatever it might be, it will always be possible to find style nested in styles. And whenever we have *not* reached the threshold of minimum reflexive habituation, it will always be possible that style is partly stylistical. These are valid, indeed essential, theoretical points; they contribute to the interest and power of Morellian connoisseurship. But Morellian connoisseurship has frequently resisted them. And regardless of their theoretical significance, they pose severe methodological problems: often there is simply not enough visual evidence, or our forensic methods are not penetrating enough, to pursue Morellian analysis all the way down. Instead of discovering and analyzing a stylistic succession, and finding the Morellian styles embedded in stylistical recursions, too often we simply end up with an inaccurate—an overgeneral—identification of a supposed style. (These overgeneralities can be descriptively useful as part of an overall classification, but they often lack specifically *historical* and explanatory force; if I am interested specifically in a feature of the physiology of dogs, but not wolves and jackals, it does not help me to know that dogs belong to the genus *Canis*.)

Group-traditional reflexes or habits in making artifacts, which have been said to characterize the "diagnostic style" of "analytic individuals," have typically been the object of stylistic analysis in archaeology, though Morellian connoisseurship frequently identifies the same phenomena.[9] Style-diagnostic archaeology invents groups like the "A-Group" of Neolithic Lower Nubia at the end of the fourth millennium BC or the "Beaker Folk" of Bronze Age Europe (Fig. 4.9) as the exact equivalents (at the collective, communal, or even continental scale) of Morelli's great individual Old Masters of drawing and painting.[10]

Archaeological diagnosticians sometimes sneer at art-historical connoisseurship, as if archaeological diagnostics (often carried out with the aid of sophisticated seriational and statistical tools) were incompatible with connoisseurship or refuted it. By the same token, connoisseurs often deride diagnostics. But all this is simple confusion and professional posturing. Like Morelli's connoisseurship of an individual Old Master, archaeological diagnosis of a group-traditional style requires that the style has not, or has not yet, succeeded to stylisticality: it has not yet become self-reflexively replicated. If and when the diagnostic style of a

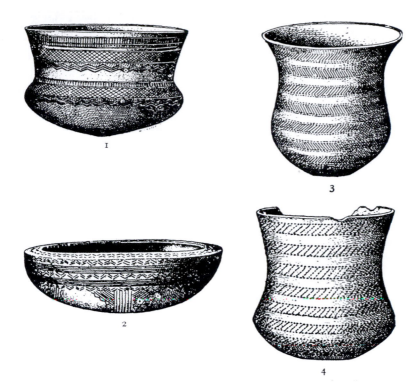

Figure 4.9. Early Bronze Age pottery of the "Beaker Folk": (1) and (2) from Palmella, Portugal; (3) and (4) "Classical" or "Pan-European" beakers from La Halliade, southern France, and Villafrati, Sicily. From V. Gordon Childe, *The Dawn of European Civilization* (London 1925) 222, Figure 112.

group tradition succeeds to stylisticality, of course, it might not be the same group that continues to make it. And even if it is the same group, its members can no longer be said to have quite the same tradition of making. Like Morellian connoisseurship, the style-diagnostic approach hits a roadblock when style succeeds to stylisticality. That is the end of the line for the method.

The real difference between art-historical (Morellian) and archaeological (diagnostic) connoisseurship lies in their accounts of the reflexive, habitual origins of pure unstylistical style. Morelli's connoisseurship ventured the plausible claim that reflexive behaviors, or habits, characterize the activity of individual human beings, for they belong materially to— they inhere in—the bodies of discrete organisms. To recognize a habit, then, is to identify its human agent or agents. Group-traditional stylistic diagnostics, however, must assume that all members of a group of makers, such as the A-Group or the Beaker Folk, unknowingly acquired identical reflexes and habits in common. How this might happen remains unclear. Perhaps the habits were transmitted by inculcation, imitation, and indoctrination in something like the academicism of the Morellian workshops or schools. But the A-Group potters of neolithic Nubia or the Beaker Folk in the European Bronze Age probably did not always associate in

workshops or schools. More likely, many of them did not know each other at all, and it is even conceivable (recall the case of the Animal Style) that some had never even *seen* any artifacts made by their fellow A-Groupers or Beaker Folk. Indeed, the very historical existence of the A-Group or the Beaker Folk must be approached cautiously insofar as we know these putative communities largely by the styles that have been attributed to them. If we took away the style, there might be no material reason to ask how the members of the group interacted with one another.

Some archaeologists seem to suppose that common use of a particular technique *of* making bespeaks shared habits *in* making. And in fact it seems reasonable to assume that reflexes can be technologically habituated and socially homogenized when different individuals use the same materials and the same tools or machines. In circular fashion, the apparent existence of a group-traditional style leads us to suppose that a common technique was habitually used by all makers in the past in making the artifacts that we take to be similar. This might well have been so. But the technique might have been habitually deployed by some makers—intersecting here with their pure style—and self-reflexively stylized by *other* makers. If so, the strict diagnostic approach will not work. It will identify some but not all of the actual makers it is looking for, or perhaps identify too many. And it will fail to recognize important distinctions in the real psychological and social interactions of the group-makers, the analytic individuals, that it does happen to find.[11]

Whether applied to Old Masters or to group-traditional production, the connoisseurship of pure style offers a theory of the manifestation of habits in human making: at least some identifiable habits of making, whether individual or group, were manifested *in* style (where we can find these habits) although they were not seen *as* style. Nothing requires that the analytic individuals identified by stylistic analysis had real-life historical identity either as individuals or as groups. Connoisseurship remains open to the historical possibility that a pure style could have been made by an individual *or* by a group. In some cases, in fact, pure style was made by an individual *and* a group, as in the case (of special interest to Morelli) of individual masters and their unself-conscious, reflexively imitative followers. Here the foundational theory must assume an interpersonal and sociopolitical history in which habits were transmitted from one maker to other makers without stylization in the process of reproduction, that is, without the succession of stylisticality. (Even if the original maker's configuration was stylistical, it could still be transmitted to others as their pure style; conversely, as we have seen, what was pure style for one maker could become stylistical for others.)

Such historical patterns of interpersonal and sociopolitical interaction might be difficult to identify in any other way. Social relations are not preserved, at least not wholly, by material things; they do not fully fossilize like the material artifacts that index their histories (in pure style) and relay and represent them (in stylisticality). Stylistic analysis, however, can make it possible for us literally to see interpersonal and sociopolitical histories in the making of things—histories that might have no other manifestation and no other record or fossil than style. Whether *other* people, people in the past, also saw these histories is a question of the stylistic succession and often has no easy answer.

■ 4

In pure style, we see individual action and interpersonal, sociopolitical interaction that was reflexive and habitual. In the analysis of stylisticality, by contrast, we see making (and the action and interaction that determined it) that was *rhetorical*. What was made was seen as the deliberate, probably self-conscious style of some person or some group, now possibly (re)understood as stylistical—as having been seen *as* a style earlier or all along, and even if it was at some point pure style.

In the literature of stylistic analysis in specifically forensic disciplines like art history, rhetorical style—the stylisticality of style—has received less systematic attention than reflexive style. Indeed, the distinction between style and stylisticality has rarely been made systematically, even though connoisseurship (whether Morellian or archaeological) requires it. In particular, the stylistic succession, the emergence of stylisticality in style and vice versa, has not been comprehensively understood to be the historical dynamic that constitutes the overall identity of a style. At this point in our consideration, the term "style" can be taken to denote both reflexive *and* rhetorical styles that are copresent and interact in the succession and styles that are either reflexive *or* rhetorical, these dimensions being somehow disentangled and purified *despite* the succession. But when we observe the stylization of artifacts, we do not usually see pure style *or* stylisticality. We see their interpenetration and transition. Conversely, when we see the stylistic succession—ordinarily what we see in an artifact of visual culture with respect to its cause—we see the historical complexity of style, the visual (and material) interactions of its reflexive and rhetorical origins.

As will be obvious from previous sections of this chapter, I use the term "rhetorical" in a limited (and to some degree an artificial) sense

to designate making that self-reflexively recognizes and self-consciously obeys canons of configuration—that conforms itself in deliberate action, in self-aware conventionalization, to certain configurative possibilities that have been made available to it. On this narrow understanding, there is no such thing as a rhetorical habit. More exactly, when rhetorical conventionalization becomes habitual, stylisticality has been succeeded by, or has lapsed into, stylistic behavior in the connoisseur's diagnostic sense. Stated the other way round, if we were to find "rhetorical habits" in a particular style (as is theoretically possible), this would signal one of the real historical movements of stylistic succession; namely, the passage from relatively habitual to relatively self-reflexive activities of making, a transition from unrecognized to recognized aspects of what has been made *as* being so made. Of course, in some cases we can speak of *habitual self-reflexivity*—of patterns of self-recognition and self-conventionalization in making that have become practiced and routine, perhaps even subliminal or preconscious. But these patterns pose no problem for the theory of the stylistic succession. They are ordinary recursions of style and stylisticality in the stylistic succession that we should probably expect to find in any material history of stylization in the making of artifacts.

As in high formalism and its reification of pure formality, which we considered in Chapter Three, the methods of stylistic analysis in forensic art history tend to reify pure style. Pure style seems to permit attributions that are not contaminated, or seem to be least contaminated, by the original maker's rhetoric. For rhetoric creates the possibility that imitative configuration and conventionalization might deceive us about the historical identity of the maker or makers of the style even as it was probably intended to persuade others in the past that the style had been properly replicated *regardless* of its maker or makers. The stylistic succession inherently contains such imitative possibilities; it is the history of their emergence, interaction, and ramification. But from our point of view as connoisseurs and historians, the historical possibility of stylisticality complicates and sometimes confuses the forensic history of style. Stated another way, whereas the original makers of the style passed from stylisticality, ways of making that they *recognized* as their ways of making, to pure style, we must enter the loop of the stylistic succession at the opposite end. We must pass from pure style, which enables us to recognize the makers, to stylisticality and the ramifications of self-recognition that it involved.

Needless to say, then, the forensic analysis of pure style, whether conducted by Morellian connoisseurship or archaeological diagnostics, tends to exclude a full consideration of recursions of self-reflexion and

self-recognition in stylistic behavior. It characterizes stylisticality in a maker's style as a kind of debased self-repetition or self-forgery, if not actual historical counterfeiting. By the same token, when a master's stylistic behavior was reproduced by *someone else* as an entirely stylistical recursion, the duplication, if detected by us, can be set aside as an instance of defective attribution and excluded from any canon of his work. Although the attribution identifies an emergent stylistical tradition generated in the replication of pure style, it fails to explain the *origin* of this tradition even though the relatively reflexive and relatively rhetorical moments might betray a coherent social interaction, that is, a particular historical event or process (for example, a student "following" a master artist as they are working together on the same project at the same time). For reasons like these, the history of the stylistic succession tends to be set aside (even while being worked through) in the basic task of an initial attribution, even though the relatively reflexive and the relatively rhetorical moments of a maker's production, as just noted, might not actually belong to disjunct historical phases (as they would, for example, in the work of a student "following" a master artist at one point and paying homage to or parodying him at a *later* point). This is merely a forensic and hermeneutic convenience for us. It does not fully grasp the historical reality of styles as emergent stylistic successions. In particular it tends to downplay the likelihood that a great deal of pure habitual style itself originated in stylistical replications. In fact, regardless of the actual causes and correspondences, the *visual-cultural* origin of style is neither reflex nor rhetoric. Style is constituted visually in an artifact when people see reflex and rhetoric to be interacting in a particular fashion in the way it was made.

For that very reason, when past makers saw style, there is every chance that they saw some degree or quotient of stylisticality precisely because such configuration, a rhetorical tradition and its manifestation in artifacts, had likely been made among them *to be seen* from the very beginning. The stylistical aspectivity of artifacts could certainly be attributed by them to makers. But these makers could not have been regarded as essentially endowed with stylistic habits in the sense assumed in Morellian connoisseurship and archaeological diagnostics. Instead, they would have been seen as exponents of replication achieved, more or less successfully, in accord with established models or more or less differing from them for recognizable rhetorical ends. In other words, probably people often saw the makers of artifacts to be less like bundles of reflexes and more like "public speakers" in our sense, just as the theory of rhetoric (founded in Cicero's and similar Roman treatises on oratory) would tend

to suggest. Most important, rhetorical stylization implies the presence of others, the *recipients* of a configuration contrived to impress them, to persuade or move them. Whether or not made in a group, stylisticality is inherently the making of style that is configured to be recognized *by* a group. Needless to say, the presence of others plays little or no role in the analysis of pure style in the Morellian or diagnostic sense, even when it attributes styles to groups: if not entirely excluded, it is irrelevant to the identification of the pure style of analytic individuals. Whether or not anyone else or a group recognized it, the maker himself supposedly did not recognize his pure style.

In a sense, in the connoisseurship of pure style the people who recognized stylisticality—its "audience"—become the person of the connoisseur himself. The *art historian* comes to occupy the role once assumed by past observers of the aspects of things to be seen by them as attributes created by a particular maker or makers. But in this conversion the primary feature of stylisticality, its recursive self-reflexive self-recognition, has been suppressed. The connoisseur sees style as belonging entirely to the body and habits of the maker rather than as configurative rhetoric addressed by the maker to other people—people possibly including the connoisseur himself. Of course, usually the connoisseur does not belong to the community within which style communicated in this way—within which stylisticality was recognized. In the end, then, his exclusion from the original aspective horizons of the stylistic succession would seem to have been converted into the putative behavioral isolation of the makers (for no one else has their style) and the supposed invisibility of their style (for not even they can see it).

▪ 5

To be fair, we must go at these matters the other way around as well. Stylistic attribution in art history and archaeology has not *always* proceeded as a forensics of reified pure style, even though the forensics of pure style was developed largely to improve attributions. In practice, most working connoisseurs, including Morelli, could not and cannot now entirely avoid addressing stylisticality even when they explicitly claim to be looking methodically for pure unstylistical style. Indeed, attribution in art history and archaeology—broadening the methods of the most strict Morellian and diagnostic connoisseurship—often pursues stylisticality in my sense.

Why? In part because the theory of the stylistic succession simply does not encourage an absolute differentiation between pure style and

stylisticality. And it is this theory, as much as the methodological reification of pure style, that founds connoisseurship. The inescapable conditions of the stylistic succession constantly confront and frequently confound Morellian connoisseurs in their efforts (for example) to distinguish the identity of master artists from the identities of co-makers or assistants, apprentices and studios, imitators and followers, and, in some cases, duplicators and counterfeiters—distinctions that have long been the main business of conventional art-historical connoisseurship, especially when it subserves the needs of museums and the art market.

In fact, the historical phenomena of stylisticality, such as the replication of "authentic" unstylistical styles by imitators and forgers, has often motivated a Morellian search for pure style in the first place. Even when successful in Morellian terms, this connoisseurship did not *only* generate lists purportedly identifying the genuine works of particular artists (that is, discrete pure styles), although it has certainly claimed to discover the hands of many individual artists and artisans in many traditions of material and visual culture around the world, and such cataloging, though not strictly limited to Morellian method, is comparatively strict in its application of it.[12] In distinguishing the stylistical imitations of a follower from the stylistic gestures of a master (or, conversely, the stylistical flourishes of a master from the stylistic mimicry of a follower), connoisseurship *also* discovered (to take one example) irreducible overlaps between individual masters and some of their followers working together on the same artifact. Such an artifact might best be seen as a complex coproduction of the reflexive and the rhetorical activities of *all* the makers contributing to its configuration. Strictly speaking, of course, we can attribute one part of the making of the artifact to the master and one part to the followers, insofar as we can identify the Morellian style of master and followers. But we want to be able to consider the entire artifact as a configurative whole—including its stylistical inventions and recursions, if any—at the level of its use, its visual reception. And why? Precisely because it was likely seen to be such by its original makers and observers. That is, it was seen as a configurative whole, even if it is the work of several people. Discoveries like these must cut against both the reification of pure style and its attendant search for the authentic identity—the bodily, habitual originality—of individual artists *and* against the reification of pure stylisticality and its attendant reduction of making to something like public speaking or social performance. By the same token, they reinforce the more fundamental theory of stylistic succession.

Equally important, interactions between the stylistic succession on the one hand and interleaved formal and iconographic successions on the

other hand ensure that styles are often known to us by way of their formal and pictorial aspects. But these aspects of artifacts involve reflexive and rhetorical histories that do not always neatly align with the distinctions of style and stylisticality. For example, when a connoisseur uses *pictorial* evidence to effect an attribution, he is likely to appeal to configurations that should be described as stylistical, that is, as relatively self-reflexive and rhetorical in the making. Conversely, when the connoisseur appeals to *formal* evidence, he might sometimes appeal to features of configuration that could be identified with pure style, that is, with making unrecognized by the artist as subject to his own configurative control. But as I have noted in Chapter Three, formality in an artifact can be highly rhetorical: it can involve a communication of recognized configurative aspects from the original maker to an anticipated group of recipients. And as we will see in more detail in Chapters Six and Seven, pictoriality need not always be rhetorically self-conscious: *stylistic* pictorialities rooted in bodily habits (or what might be called "pure forms of depiction") subsist at one notional end of the iconographic succession, albeit an extreme end.

For these reasons, the object of connoisseurship at its most sophisticated tends to be, and should be, the full ramifications of stylistic succession, as well as its formal and pictorial interactions, not the consolidation of moments of pure style *or* stylisticality. If pure style can be attributed to one kind of historical identity (namely, the body and habits of a maker) and stylisticality can be attributed to another kind of historical identity (namely, a tradition of recognizing cultivated replication), then their succession must be attributed to *both* kinds of identity interacting with one another, as they ordinarily do among actual human agents, whether individuals or groups. To map out a stylistic succession is, in the end, to propose an historical recursion, an involution, of bodily habit and rhetorical performance. It is this involution that is picked out, or should be picked out, in realistic stylistic attributions, and it is unique to the stylistic analysis of visual and other culture.

■ 6

Let us consider an example of this involution and its interactions that Morelli himself confronted. The National Gallery of Art in Washington, DC, attributes the painting it calls *Bindo Altoviti* (Fig. 4.10) to the great painter Raphael Sanzio, then in his mid-thirties, working in Rome in the years before his death in 1520. The actual dates given for the painting in

Figure 4.10. Raphael Sanzio (1483–1520), *Bindo Altoviti*, c. 1518. National Gallery of Art, Washington, DC. Photo courtesy of the Board of Trustees, National Gallery of Art, Washington, DC.

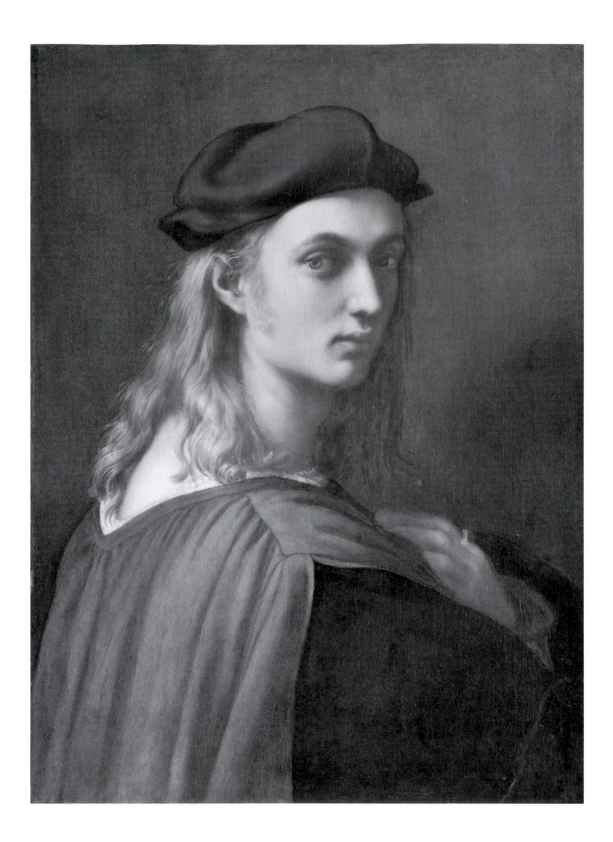

recent National Gallery publications range from 1515 to 1518/19. In the Gallery's official *Catalog of Italian Paintings*, published in 1979, Fern Rusk Shapley cited parallels in the oeuvre of "late Raphael" for characteristics found in the "*Bindo*" by "Raphael."[13] But I use the quotation marks advisedly. It is possible that neither pole of the attribution—neither the identity of the painter nor of the pictorial subject—is quite as secure as the Gallery's version, and its imprimatur, might suggest.

In his *Life of Raphael*, Giorgio Vasari, the chief near-contemporary historical source for the life and career of Raphael, seems to tell us that in Rome Raphael "made his portrait when he was young" for Bindo, a wealthy younger friend (*E a Bindo Altoviti fece il ritratto suo, quando era giovane, che e tenuto stupendissimo*). But it is not fully clear that the phrase *il ritratto suo* grammatically denotes a portrait of Bindo; the phrase *il ritratto lui* might be more usual. In 1880 Morelli took it to be perfectly intelligible idiomatic Tuscan denoting Raphael's portrait of Bindo. But "la phrase amphibologique de Vasari," as J. D. Passavant had already put it in 1860, permits several interpretations: that the portrait depicts the young Bindo; that the portrait was made by Raphael when he was young; that the portrait depicts the young Raphael. Some of these interpretations are mutually exclusive, but not all of them.[14] Could it be that at the time of the production of the painting an essential uncertainty about the identification of its sitter—perhaps even a deliberated ambivalence in portraying him—had been registered by Raphael's and Bindo's contemporaries? In about 1518, Bindo, born in 1490, would have been noticeably older than the youth pictured in the painting, who is clearly an adolescent in bloom. The depicted color and texture of the sitter's skin (though possibly restored, and probably seeming brighter, if not paler, after cleanings) has a lot to do with our judgment of his depicted age, along with what seems to be the painter's stress on the sitter's wispy sproutings of light blond facial hair, as if newly grown. (The picture appears to have been heavily restored at least once; in his examinations of the painting Morelli noted an "over-smooth violet-red tone of colouring in the face" that he attributed to an overeager picture-restorer in the eighteenth century.[15] And it is known to have been cleaned at least twice, in the 1880s and in the 1940s. Such treatments likely altered the appearance of the painting, even if it is hard to correlate them with its attribution at any point in the history of the relevant connoisseurship.)

Dispute about the sitter's depicted age might seem to be a strictly pictorial consideration. But it has characterized virtually the entire history of the *stylistic* attribution and interpretation of the painting. What seems to be the most natural construction of Vasari's meaning, that the

painting by Raphael portrayed Bindo at an age younger than he really was when he sat for the painter, raises no art-historical problems; there are contemporary portraits picturing sitters at ages younger than their age at the commission.[16] We know Bindo's much older (sixty-year-old) likeness in the form of a bronze bust by Benvenuto Cellini, now in the Isabella Stewart Gardner Museum in Boston, made about 1550. When it was completed it was said to be a strikingly faithful portrayal. Presumably Vasari knew both Bindo himself and Cellini's bust as well as the painting, though the last possibility, oddly enough, was denied by Morelli, perhaps because of a lack of resemblance between Cellini's Bindo and the painting's sitter, even granting changes in likeness caused by aging. Morelli himself did not cite this visible dissimilarity as the reason for his claim that Vasari lacked first-hand familiarity with the painting. But it did explicitly motivate one of the leading Raphael scholars of the early twentieth century, Oskar Fischel, to doubt that the painting portrays Bindo. Reasonable within its purview, this scepticism in turn could feed into the long-popular view that the painting was a *self*-portrait by Raphael of himself aged about fifteen years younger (i.e., c. 1500). This interpretation is allowed by the grammar of Vasari's initial statement; it was proposed by seventeenth-century readers after Vasari; and it was even perpetrated by assorted Altovitis in the eighteenth century. The self-portrait was putatively commissioned from Raphael by Bindo for reasons that remain unknown.[17]

Would it be too much to suppose that a real physiognomic likeness between the youths had captivated their interest at the time, an interest relayed in Raphael's portrait of Bindo (or in Raphael's portrait of himself for Bindo)? The sitter in the painting does look somewhat like the known self-portrait of the artist in his twenties, namely, the likeness included in the *School of Athens* (Fig. 4.11) and replicated in what seems to be a reverse-copy of that figure, possibly by a student of the master, now in the Uffizi. It even looks somewhat like portraits of the more mature artist by *other* painters, such as the Louvre *Double Portrait* (the so-called *Raphael and His Fencing Master*) (Fig. 4.12) perhaps painted by Raphael's follower Sebastiano del Piombo, as some scholars have thought, or by Giulio Romano, Raphael's assistant in Rome—if this painting is not *also* by Raphael.

Indeed, perhaps we do not have to choose between Bindo imagined as a young man by Raphael and Raphael imagined as a young man for Bindo. Both of these historical identities could be partly in the image pictorially if it is simply a *Bildnis eines jungen Mannes*, a portrait of a young man, as the painting had come to be described in Munich when Morelli exam-

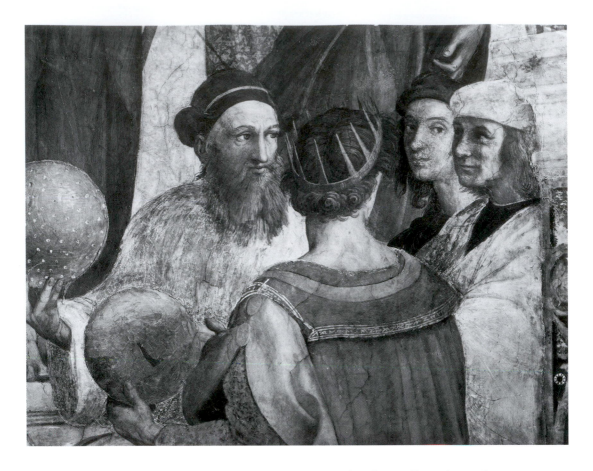

Figure 4.11.
Raphael Sanzio
(1483–1520), detail with
self-portrait in *The School
of Athens*, 1509–10.
Stanza della Segnatura,
Vatican, Rome. Photo
courtesy Alinari/Art
Resource, NY.

ined it. It is certainly curious, and perhaps telling, that in their representa-
tions of the identity of the painter and the sitter the eighteenth-century
Altovitis confused (or deliberately replaced) their own famous ancestor,
Bindo, with his even more famous supposed portraitist, Raphael. At any
rate, in the history of its connoisseurship the fact that the painting does
look like it could be Raphael's portrait of himself when young became
one main, if only indirectly relevant, reason why it has been attributed *to*
Raphael, though surely Vasari's "phrase amphibologique" licensed much
of the uncertainty, if it did not actually cause it. Stylistically the paint-
ing does not look quite like a Raphael. Indeed we could call it *Portrait
for Bindo Altoviti by Raphael*, an interpretation permitted by Vasari's
grammar whether or not we take Raphael to have made this hypothetical
painting—a peculiar recursion, made by Raphael or not, that involves
a stylistical replication of Raphael's style. For some scholars, past and
recent, have actually attributed the painting to Raphael's assistant in
Rome, Giulio Romano, because of its dramatic lighting, high and hec-
tic colors, metallic background, and brilliant finish, not to speak of the

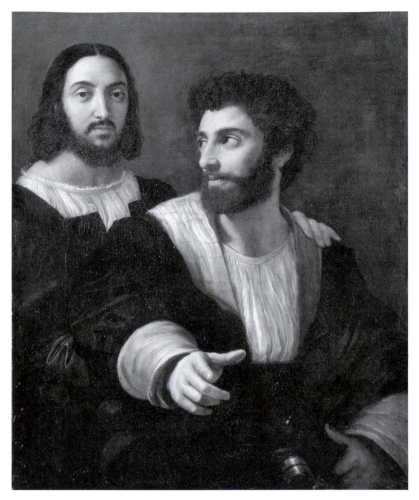

Figure 4.12.
Raphael Sanzio (?),
*Portrait of the Artist with
a Friend*, sometimes
called "*Double Portrait*"
or "*Raphael and His
Fencing Master*," c. 1518.
Louvre, Paris. Photo
courtesy Réunion des
Musées Nationaux/Art
Resource, NY.

neck-wrenching *contrapposto* of the sitter. All of these features—formal,
stylistic, and pictorial—have been linked with Giulio's innovations in the
Raphaelesque stylistic succession in which he had trained.

Naturally there was plenty of Raphael *in* Giulio. Indeed, the connois-
seur Sidney Freedberg (intimately familiar with the painting in his post
as curator at the National Gallery) concluded that the painting had been
"designed" by Raphael and "executed" by Giulio.[18] In Freedberg's explica-
tion of this curious proposal it appears that Raphael did not have to set
finger to the canvas. In strictly Morellian terms, then, the painting can
be attributed to Giulio because the habits of *his* hands actually marked
the surface somewhere and in such a way (as Freedberg would have to
have it) that they can be distinguished from Raphael's if *he* had touched
the surface (which supposedly he did not) and as he would have marked
the surfaces of other paintings (although supposedly not *this* painting).

Of course, the habits of Giulio's hands would have to be distinguished from Giulio's manual performance when working deliberately to imitate Raphael's, which he might well have done in this particular painting. But this is a point Freedberg did not have to decide in effecting his attribution because, strictly speaking, it is not a Morellian question at all.

Conversely, however, there might also have been some Giulio *in* Raphael working in Rome. To help account for its untypical-looking Raphael, the National Gallery explicitly invokes the notion of "Raphael's continued stylistic evolution in Rome," that is to say, the history of Raphael's assimilation of the configurative techniques and ideas of some of his own followers. Indeed, it is even possible that there was some *Sebastiano* in Raphael working in Rome. Fischel took the compositional "structure of the portrait," if not its Giulio-like use of color, to be "based on" Sebastiano's near-contemporary *Violin Player*.[19] He believed that our painting was not by Raphael but by Giulio, that is, by Giulio following Sebastiano. But the idea that *Raphael* could assimilate Sebastiano is invoked in the National Gallery's attribution to "late Raphael," possibly on the basis of a parallel with the *Violin Player*, but not, it seems, specifically a parallel with the compositional aspects described by Fischel; that is, with the "structure of the portrait." For Fischel that aspect of the painting betrayed *Giulio's* assimilation of Sebastiano, though if Sebastiano followed Raphael, as all agree, then Raphael's following Sebastiano in this respect might, of course, simply amount to Raphael being Raphael.

We must also note that Morelli had originally extracted the *Violin Player* from Raphael's oeuvre, where it had come to rest in the earlier nineteenth century. He assigned it specifically to Sebastiano as an imitator of Raphael, along with what Morelli thought was Sebastiano's portrait of Raphael (now in Budapest), which had been taken by scholars before Morelli to be *Raphael's* lost *Portrait of Antonio Tebaldeo* until plausible copies of that work actually turned up. Now that Sebastiano's *Portrait of Raphael*, as Morelli had it, has simply become the Budapest *Portrait of a Young Man*, it is at least theoretically possible that *it*—not the National Gallery's painting of a young man, supposed to be Bindo—might be Vasari's *Portrait of Bindo* (at Bindo's correct contemporary age of twenty-six or so) by Raphael or more likely a mediocre copy thereof (like the old copy of Raphael's *Tebaldeo*). In this interpretation of the matter, Vasari would have been referring to a portrait of Bindo "when he was a young man" because at the time Vasari inspected the painting its sitter, Bindo, still living, appeared to Vasari as Cellini had or soon portrayed him. What stands in the way of this attribution is mainly that the sitter for the Budapest picture, if he has to look like either of them, looks more

like Raphael than Bindo (especially if, on this hypothesis, the *Bindo* is not Bindo) and its painter looks more like Sebastiano than Raphael—especially if scholars want to base the supposed *Bindo* by Giulio partly on a Sebastiano that was once a Raphael.

Confronted with this network of interactions and replications and with the involutions of style and stylisticality at the heart of the history in question, the grounding of the relevant stylistic attributions has come pretty much full circle in formal and pictorial terms. Out of the range of pictorial possibilities briefly surveyed already, perhaps Bindo accepted that the painting was a portrait of him—"his portrait" (*il ritratto suo*) by Raphael, although it imagined him to be substantially younger than he was and at the same time to look a bit like Raphael himself as depicted in an earlier self-portrait. Perhaps, however, Raphael made *his* portrait of his friend, though this painting of the sitter recognized and communicated the stylistical idea that both Sebastiano and Giulio could have made it too—and even as a portrait of Raphael. Some interacting formal, stylistic, and pictorial aspects of the painting support both of these constructions of the historical attribution. In *both* cases, the painting can be attributed to Raphael as his *Portrait of Bindo Altoviti*. But at the level of fundamental aspective interdetermination, they are very different paintings; despite stylistic similarity sufficient to attribute them to Raphael as his portrait of Bindo, they have different, disjunct valences. The former painting emphasizes Bindo's part-likeness to Raphael, captured in a style that resembles self-portraits painted by Raphael. The latter painting emphasizes Raphael's painting's part-likeness to paintings by Sebastiano and Giulio, captured in a style that enables the depiction of Bindo.

Everything depends on the weight we give to formal and pictorial aspects that are irreducibly interleaved in the stylistic succession of the painting and the images it conveyed to its original maker, patron, and beholders—including Vasari, possibly Cellini, and others (such as Bindo's descendants). The visual interpretations of the aspective networks that were visible to all of these beholders (for example, in comparing the painting and Cellini's later portrait) have continued to affect *our* seeing. If we make only the slightest shifts in emphasis in identifying and describing a handful of formal, stylistic, and pictorial aspects of the painting, its attribution could change dramatically. Instead of subsisting as Raphael's *Portrait of Bindo*, it might be seen as Raphael's *Self-Portrait* given to Bindo, or Giulio's *Portrait of Bindo* (supervised by Raphael), or Sebastiano's *Portrait of Raphael* (in the manner of the sitter himself) confused with a portrait of Bindo by Raphael . . . Some of these attributions might be inconsistent with strictly Morellian findings. But the Morellian findings

are not always consistent with the deeper history of stylistic succession. All of the attributions index notionally possible histories of painting in the visual culture in question—in painting in Florence and Rome in the first decades of the sixteenth century—even if attribution in Morellian connoisseurship has never yet discerned them in any other paintings.

■ 7

Why, then, has there long been little doubt, despite the documentary and the methodological uncertainties I have reviewed, that the painting now in the National Gallery is the *Portrait of Bindo Altoviti* by Raphael? It is fair to say that this attribution has been accepted not only by partisans of Raphael, such as his catalogers and biographers (including the pioneering Passavant, and later Lionello Venturi and Sir John Pope-Hennessy), a group of scholars who might naturally be keen to find another self-portrait of the master. It has also been accepted by connoisseurs whose taxonomy of sixteenth-century Italian painting has no special stake in finding another painting by Raphael (such as Bernard Berenson and Sydney Freedberg). The chief exceptions to this rule, of course, are to be found among the catalogers and biographers of Giulio. Naturally they tend to promote their artist as the portraitist of Bindo Altoviti. However good the arguments of this party might be, however, they have never been sufficient to demolish the attribution to Raphael.

Mid-nineteenth-century art historians like Franz Kugler, Jakob Burckhardt (the author of *Der Cicerone*), J. B. Crowe, and G. B. Cavalcaselle would have said that the most widely-accepted attribution (i.e., that the painting is Raphael's portrait of Bindo) is also the best in capturing the *geistige Gehalt*, the "spiritual content," of the cross-cutting intersections, ramifications, and fissions of identity displayed in the documented history and in the formal, stylistic, and pictorial configuration of the painting.[20] The sitter might not be the Bindo said by Vasari to have been portrayed by Raphael, and the picture might not be the Raphael said by Vasari to have portrayed Bindo. But the final guarantee that it depicts Bindo is that it is *by Raphael*, and the final guarantee that it is by Raphael is that it *depicts Bindo*. Implicitly, then, the attribution supposes both that Bindo would have recognized himself in the painting ("it's me, even if I look like Raphael") and that Raphael would have recognized himself in the painting ("it's mine, even if I paint like Giulio and Sebastiano"). In other words, the attribution *maximizes* the subjective or spiritual dimension of the painting—maximizes, specifically, the supposed mutual

recognition and understanding of the historical subjects Bindo Altoviti and Raphael Sanzio. At the same time, the attribution *minimizes* the objective dimensions of the painting, its merely or purely stylistic features, such as the quotient of Giulio's or Sebastiano's contributions to Raphael's work of painting and the possibility that the model (or a model) might be an unknown personage—someone not mentioned in any of our documents and maybe meant to be invisible in this representation of "Bindo."

By assuming this particular *geistige Gehalt* in the painting—Bindo's and Raphael's self-reflexive mutual recognition in the painting if not in other arenas of their association as well—we can go on to pursue well-defined circumstantial questions and to frame seemingly pertinent formal, stylistical, and pictorial questions. Why, for example, did the thirty-five-year-old painter portray his twenty-five-year-old friend and patron *quando era giovane*—as a sixteen- or seventeen-year old boy? Obviously this circumstantial question would not arise if the painting did not depict Bindo at all. And what should we make of the palpable eroticism of the portrait, of the robe gently slipped back revealing an extraordinary triangle of pale smooth skin framed by luscious curls swept back over the boy's right ear? This question could arise, of course, even if the painting did *not* depict Bindo; that is, if it depicted Raphael or another personage. But it acquires a particular weight and force in the attribution accepted as capturing the *geistige Gehalt*. Because we know (or think we know) Bindo to have been Raphael's friend and patron and to have been older than he is depicted in the painting, and because we know (or think we know) Raphael to have been the portraitist, Vasari's ambiguous phraseology acquires peculiar spiritual significance. It seems to speak to us of the states of consciousness and subjectivity of the painter and the sitter. In particular, the painting seems not only to index but also to portray an *identification* between sitter and painter that might be characterized as a mutual recognition of social affiliation, which we can plausibly assume, and possibly of sexual attraction, which we might now be able to see in the painting if we had not noticed it before. A subtle art-historical interpretation could readily proceed in these terms. Assuming this spiritual content, it might explore friendship in commercial patronage (relations in which artists and patrons were often not personally acquainted beyond such restricted encounters as portrait sittings), homoeroticism between older and younger men (does *Bindo* record such affection?), and strikingly sensual performances of self-presentation by elite young men in early sixteenth-century Italy (to whom does Bindo expose his skin, and why?). These are all salient topics that art history might investigate as so-called contexts of the painting. But they are all contexts that have been

primordially defined and circumscribed by adopting this *geistige Gehalt* as a basis for the attribution. And at the same time, the accepted *geistige Gehalt* obviously *assumes* certain contexts. For example, it assumes the circumstantial or contextual possibility that early sixteenth-century artists, patrons, and beholders would not have been completely flummoxed by a portrait depicting a well-known man in the city at an age that could be seen to be younger than his age at the time of the sitting. (In Chapter Seven I will consider a case of such "failure to signify" in visual culture.) Indeed, it would seem to assume the opposite: that the visible age disparity had recognizable significance, perhaps homoerotic, when relayed in the visual features of the portrait. But oddly enough *this* contextual requirement has rarely been defended explicitly, and never in the nineteenth century.

In the tautology or circularity just mentioned, content and context reinforce one another without independent grounds. In part for this reason, the *geistige Gehalt* of Bindo's hand or Bindo's ear—hand and ear specifically—returns us to the peculiar Morellian method of identifying a pure style embedded in the wider matrix that is the *geistige Gehalt* of the painting as a whole, a "spiritual content" in which the emergence of intersubjective social recognitions seemingly should take pride of place. As we have seen, Morellian connoisseurship would not really say that in the painting *Bindo's* ear spreads his hair. And *Bindo's* hand does not slide under his robe, parting it gently for an observer's gaze. According to Morellian connoisseurship, if the hand and ear in the painting belong to anyone at all they must be *Raphael's*. This is not, of course, because they are pictorial likenesses of Raphael's body parts, though the involuted circumstances and rhetorical configuration of this painting (a painting possibly *about* an intersubjective identification of artist and sitter) perhaps permitted such a pictorial "phrase amphibologique." Instead it is because they should be pure stylistic indexes of the fact that Raphael happened to be the painter of the portrait. To use terms Morelli directed against the impressionistic *geistliche* connoisseurship of his day (a connoisseurship both "spiritual," or about subjectivity, and "ghostly," or immaterial) Bindo's hand and ear are *Grundformen* of the *geistige Gehalt*.[21] Therefore they cannot really *portray* Bindo's hand and ear even if they belong to Raphael's pictorial representation of his sitter. For in order to serve as pure stylistic indexes of Raphael's production of the portrait, as Morelli urged, they must lack deliberate and intended portrait-pictorial specificity. They might betray Raphael painting or Raphael as the painter (certainly not someone else painting or as the painter), but not *painting Bindo*. And

as we will see shortly, this is exactly what Morelli finally said about the picture.

All this might be well and good in Morelli's terms. But if we subtract Bindo's hand and Bindo's ear from Raphael's highly self-reflexive, rhetorical portrayal of Bindo, what remains to the *geistige Gehalt*, the basic spiritual content of the painting? Is it not the case that its relay of subtle social relations of patronage, friendship, likeness, attraction, and identification ramifies above all in these particular painterly details? (It seems to be Bindo's hand, for example, that makes a gesture relaying an erotic significance.) If we have to set these details aside, do we not inevitably overlook the *geistliche* value of the work, its aesthetic, psychic, cultural, and social valence—what it actually looked like to its beholders and to Raphael and Bindo above all?

If Morellian connoisseurship has any irrefutable theoretical claim, the answer to these questions is plain. It was denoted in Morelli's term for the visual-cultural entity that is made visible by his method of inspection: *Grundformen* or grounding forms. Pure style, because of its purely reflexive nature, grounds the achievement of formality and pictoriality, the sensuous configuration of an image. Indeed, the purely stylistic causation of certain aspects of the image *proves* that its relay of such psychic and social relations as patronage, friendship, likeness, attraction, and identification has authentic grounds. Although unrecognized by its makers and beholders, pure style shows *us* that the painting is not merely a self-reflexive, rhetorical projection of a possible story, though in a high degree it is such an image and in large measure it probably was such an image for its maker and beholders. It is also the real, artifactual precipitate of an actual history.

The original psychic and social relations cannot simply be stylistical constructions, for a psychic and social history, like a painting, can be duplicated or counterfeited in other representations, including the documents (such as texts and paintings) that supposedly confirm its existence. In part, then, the psychic and social relations (if they have any historical ground) must have developed partly outside conscious, calculated human awareness and manipulation. (Indeed, the eroticism relayed in Raphael's *Portrait of Bindo Altoviti* should probably be understood in part as unconscious on his part, on Bindo's part, or on the part of both men.) If there is to be a documented history of the painting, these relations *must* appear to forensic observation as pure style as well as stylisticality or in addition to it. And only when they appear as pure style can they be attributed to human agents, whether defined as continuous human persons or

as persisting human communities—the agents that must be the real material relays of all psychic and social processes in history in the first place.

To revert to Morelli's terminology, the *Grundformen*, then, are not antithetical to the formality, stylisticality, and pictoriality configured in the aspective successions of the overall spiritual content of an artifact or artwork, its aesthetic, psychic, social, and cultural valences. They are the way *in* to these histories. In turn, working from the *geistige Gehalt* seen in a painting properly attributed on the basis of its pure style, we should be able to derive "truer knowledge" of the *Grundformen* themselves—what *they* mean in aspective history.

The methodological circle of connoisseurship moves from *Grundform* to *geistige Gehalt* and back again as one version of the stylistic succession. It is a logical and powerful circularity. But it is not infallible for all the reasons already enumerated in previous sections of this chapter, and it must be regarded as a special case in—a special theory within—the general theory of stylistic succession. Certainly it requires distinctions and discriminations, some of them quite paradoxical, that might lead the connoisseur to spiral further away from a real historical identity, rather than come closer to it, precisely to the degree that his forensic observations become increasingly painstaking and fine-tuned. In particular, the isolation and attribution of pure style tends to cleave one aspect of the stylistic succession from the interleaved formal and iconographic successions that probably constituted the chief aspects of the work for the people who made and used it—its original visuality. The discrimination of this style may enable us to determine which people made the work. But in itself it cannot enable us to see what they themselves saw in it, including what they saw its pure style as—for the pure style of an artifact was not inherently *invisible* to beholders just because the people who made it did not see it as evidence of their own agency.

We should not be surprised, then, that Morelli himself seems to have been led astray, or at least led to be uncharacteristically circumspect, in his own effort to attribute the painting now in the National Gallery. When he saw it in the Alte Pinakothek in Munich, the director of the collection had recently attributed it to Giulio. (As we have seen, this contravened tradition, even if the tradition was vulnerable to critical evaluation on philological and documentary grounds.) According to Morelli, if the painting, which he inspected more than once, was not a picture by Raphael (or by anyone in the *school* of Raphael) it was probably not a portrait of Bindo either. Morelli left himself a bit vague on the last score. He seemed to say that the depicted age of the person in the painting rules out Bindo as the sitter for the odd reason, pursued nowhere else in the criti-

cal literature, that the sitter is represented to be *older* in the painting than Bindo would have been at the supposed time of the commission (Morelli says that Bindo would have been twenty-two years old at most). Apparently, then, Morelli had judged that the painting had been made *before* Raphael's relocation to Rome, perhaps because he denied that there were any stylistic traces of Giulio, Raphael's assistant in Rome, in the work. But if the painting does not depict Bindo and it is not a Raphael, it is not relevant at all whether it was made before or after Raphael relocated to Rome. And the depicted age of the sitter—whatever else it tells us—does not pertain to any commission that Raphael received from Bindo.

Morelli's reasoning is difficult to follow. Despite the explicit claims of his method, evidently he could not help allowing a strictly *pictorial* consideration (namely, his judgment of the sitter's depicted age) to color his approach to the attribution of pure style. And in the end that attribution turns out to be no attribution at all. Although Morelli denied that the painting was made by Raphael or by any member of his school, in particular by Giulio, he left us in the dark as to who *did* make the painting. Disarticulated from the *geistige Gehalt* of the work, and distinguished radically from its rhetorical stylisticality and the interactions of the stylistic succession, the pure style of the painting has no recognizable history—even as the work of "Painter X." More exactly, although its pure style must have a history, we cannot see what it is.

In this case, then, pure style has not succeeded to the minimum condition of style itself, namely, that it be attributable. Until we actually know that the painted hand or ear in the painting actually relays the bodily habits of an identifiable historical agent, they might, of course, be understood to be perfectly intelligible *formal* or *pictorial* choices. If so, however, they cannot succeed to pure style in Morelli's sense: pure style cannot inhere in the deliberated choices of formality and pictoriality. In this case we simply do not know what the case might be. As it stands, Morelli's connoisseurship of this particular painting, his nonattribution of any pure style observed in its stylistic succession, cannot be disentangled from *nonstylistic* histories of formality or pictoriality in the work. Regardless of Morelli's special theory of *Grundformen*, however, and reverting to the larger theme of this chapter, this is perhaps just as it should be in the general theory of the stylistic succession.

As suggested in previous sections of this chapter, there is no reason why a sophisticated connoisseurship cannot address the full stylistic succession in its relations to interleaved successions of formality and pictoriality—address, that is, *both* the special Morellian succession from *Grundform* to *geistige Gehalt* and back again *and* the general succession

from pure style to stylisticality and vice versa. Morelli's nonattribution of pure style in the *Portrait of Bindo Altoviti* clearly took advantage of these relations in order to deny the recent attribution to Guilio, if not exactly to refute or replace it. Officially, Morellian connoisseurship reifies an impossible purity of style in order to get off the ground in finding the grounds of form. But there is little in the theory of the stylistic succession to warrant this reification, which restricts the connoisseur to Morellian pure style in effecting an attribution. And there is a great deal to suggest, quite conversely, that the successions of pure style—its passages in and out of stylisticality and its formal or pictorial interactions—*are* its history. At least Morelli went so far as to see this in the negative, as it were, in dealing with the painting in Munich, *la phrase amphibologique*. (We might recall Roger Fry seeing pictoriality in the negative in Klee's drawing and seeing style in the negative in Van Gogh's painting [Chapter Three].) In so doing Morelli discovered the possibility of stylistic succession—his lasting contribution to the study of visual culture even if he did not recognize it.

■ 8

In the early 1890s George Santayana, a young philosopher at Harvard, offered lectures in aesthetics to undergraduates who hoped to understand the fashionable "aesthetical" arts and letters with which their teacher, a poet and epicure, was locally identified. Santayana had completed his doctoral dissertation in 1889 at Harvard, supervised by William James and Josiah Royce, on the philosopher Herman Lotze's "naturalistic idealism." In *The Sense of Beauty*, a resume of his lectures at Harvard published in 1896, Santayana proposed a polemical and up-to-date thesis that owed a good deal to Lotze's immensely prestigious mid-nineteenth-century system. In the human "sense of beauty," he suggested, pleasure has been "objectified." It has been transferred, that is, from the human subject who feels pleasure to the object that appears to stimulate it, an idea originally suggested by Lotze.[22]

Cultural criticism written on Santayana's terms would attempt to reconstruct this process of objectification, and especially to trace its mediations. Certainly Santayana's thesis has found many echoes, often unacknowledged, in the work of twentieth-century scholars of art history and visual culture. Feminist art historians, for instance, have urged that male artists and viewers tend to project their desires for sexual gratification and social domination onto the bodies of the women they depict. The

resulting pictorial images can be said to "objectify" real women, perhaps the models or sitters for the pictures in question, in the sense that women have been constituted chiefly as the virtual objects of the men's feelings of erotic pleasure and possessive aggression in encountering their bodies. Santayana would not have been especially surprised by this conclusion, even though his own objectifications (and therefore his own tastes in art and culture) were predominantly homoerotic.

Santayana's approach was polemical because he wanted to integrate naturalistic and idealist accounts of the sense of beauty. These approaches had usually been held apart. Objectified pleasure transforms animal states of arousal or contentment, natural states of the organism, into cultural norms and traditions of happiness and beauty relayed in the images that ostensibly help to encourage and to represent these ideal states of being. But these canons cannot transcend their animal basis, Santayana argued. In a memorable phrase, he urged, for example, that it is "from the sexual passion that beauty borrows warmth."[23] In this regard Santayana's idealism responded to contemporary evolutionism instead of warding it off; Charles Darwin had rooted the sense of beauty in the dynamics of "sexual selection" in sexually reproducing species. It differed from Kant's idealism and from academic idealism among the Kantian aestheticians who had long required that the canonically correct and morally elevated "ideal of beauty," especially the perfected ideal of beauty in the fine arts, must divorce itself from the interested appreciation (let alone the sexual desire) that we might have for the sensuous charm of an object.[24]

Despite its background in idealist and evolutionary aesthetics of the mid-nineteenth century, Santayana's work was up-to-date because he took his formulations to be consistent with the advanced psychology of his day. For example, in identifying the types of intrinsically pleasurable organizations of formality to be found in the arts he followed Gustav Fechner's *Vorschule der Aesthetik* of 1876, an influential text of contemporary psychophysics. More broadly, he tried to integrate his aesthetics with the psychophysiological analysis of reflex response being conducted by scientists in the later decades of the nineteenth century. If Fechner's and similar aesthetics were correct, the typology of pleasurable configurations inherently reveals a typology of reflex—patterns of reflexive irritation or arousal, pleasure or hedonism, relaxation or attention, and so on.[25] Like other later nineteenth-century psychologists and philosophers, Santayana conceived reflex as an arc of pleasures and pains bound to mental representations (*Vorstellungen*) that mediate the brute sensory experience and awareness of the human organism, what Santayana later called "animal faith," and more or less self-conscious intentions and

ideals. As an idealist, Santayana hoped that the mediation could actually be attained—and that it could be attained naturally—in the aesthetic and ethical cultivation of instinctual awareness and preference.

This cultivation might allow the possibility that the subject could *escape* painful sensations and feelings by way of aesthetic experience, thus relieving human suffering, as Arthur Schopenhauer, too, had imagined in the 1840s.[26] But Santayana knew that sometimes "unpleasure," discomfort or even pain, would simply be delayed or distorted. (This approach also issued in Sigmund Freud's *Entwurf einer Psychologie* of 1895 and in Freud's psychoanalysis, though Santayana himself opined that Freud's method offered a "long way round to Nirvana."[27]) A naturalistic emphasis on the interruption or deflection of transcendence did not put an organic brake on aesthetic experience. Rather, it suggested to Santayana why aesthetic experience has a natural (a psychological and a social) history. Indeed, it suggested why aesthetic experience might be regarded in the first place as a reconstruction of natural feeling, though not a perfection of it, as idealists had typically believed—why it might serve as a lifeboat in the storm of vital life but perhaps not as a beacon to a safe haven. In this respect Santayana's aesthetics contrasted markedly with aestheticism, or the doctrine of "art for art's sake," with which it might superficially be (and often was) identified. In aestheticism, art could be regarded as making or generating its *own* life, its own autonomous world of values and pleasures. As Oscar Wilde put it, it should not be so much that art imitates life; properly, and in the aesthetical form of life promoted by Wilde and his followers, life should imitate art. In Santayana's aesthetics, however, if art does not exactly imitate life it follows from it, absorbs it, and reprojects it without falsifying it, without indulging in the "lying" that Wildean aestheticism took to be the very work of art, its function in improving banal or brutal nature.

Whatever his contemporary orientations, Santayana returned to the ancient understanding of *aisthesis*, including the pre-Socratic image of the pneumatic rhythm of animal perception. "It would be curious to discover," he wrote, "how much the pleasure of breathing has to do with our highest and most transcendent ideals The actual recurrence of a sensation in the throat and lung . . . gives those impressions an immediate power prior to all reflection on their significance."[28] (Similar ideas were explored by Vernon Lee in *Beauty and Ugliness*, published in 1912, and in other works, especially a long essay with the same title published in 1897. In her "Gallery Diaries," Lee kept a systematic record of her pulse, breathing, sweating, and the like, while studying artworks in the galleries of Florence and Rome. Like Santayana, Lee was well educated in con-

temporary psychophysiology and the psychology of perception; indeed, she made a number of technical contributions and was confident enough to dispute certain laboratory methods and findings.) Breathing, like digestion, and maybe like sexual arousal or like visual perception, just goes on. It recurs prereflectively. If it finds expression in artistic form, as Santayana seemed to suggest, then it must be possible for cultural practices somehow to replicate animal instincts, absorbing the configurations, rhythms, and structures of their vital recurrence and thus their pleasures into the work of art. We might say that such replications resituate the animal in a reflective relation to the newly perceived *form* of its form of life. The character of this transference and mediation was the subject of Santayana's next major project, his multivolume *Life of Reason*, as well as several of his later systematic works, including a second multivolume exposition of a philosophical system, *Realms of Being*—complex works that are not my topic here. To describe the processes in question was the challenge of a naturalist idealism that would update Lotze's and similar idealist systems in light of later-nineteenth-century psychological science and naturalistic philosophy.[29]

■ 9

The art historian Bernard Berenson, a fellow Bostonian, had been Santayana's friend at Harvard in the late 1880s, and the two remained aware of one another's work throughout their later careers as connoisseur of art and philosopher respectively. Certainly Berenson was familiar with the philosopher's early ideas in aesthetics and art theory in *The Sense of Beauty*, subjects that the older and more famous Harvard philosophers, including James and Royce, had not really addressed. Indeed, if Berenson had any academic grounding in philosophical aesthetics (which he later tended to deny) it was probably steered by his acquaintance with Santayana and later with Lee.

In 1896, Berenson published his *Florentine Painters of the Renaissance* with a long "Index to Their Works."[30] In this catalog Berenson applied, though he did not fully explain, the method used by Morelli (himself only five years deceased) to attribute dozens of fifteenth- and sixteenth-century Italian paintings, some of which had been attributed to other painters or had no accepted attribution at all. In the introductory pages of *Florentine Painters*, Berenson offered a short theoretical warrant for this connoisseurship. It was visibly influenced by Santayana's naturalistic explication of *Einfühlung* or empathy—of the beholder's recognition of the "objecti-

fied pleasure" of the artist as incarnated in his work of art. Through minute and painstaking observation, Berenson suggested, the art historian, a highly trained beholder, could detect the "tactile values" that had guided the artist's handiwork, the depiction of the world created by his habitual muscular rhythm-pleasures, the personal style of his graphic breathing—the *aisthesis* of his organism become the form of his art.

In the later 1890s, after his book appeared, Berenson became embroiled in a painful dispute with Lee, a friend and a neighbor in Florence, about academic priority in the invention of the concept of tactile values in its matrix of reflex, hedonic, and empathy psychology. It is probably fair to say that both Santayana and Lee knew far more about the psychological and philosophical basis of the model than Berenson, and that he derived a good part of his understanding of it from them, especially from Lee, who at the time was working out a sophisticated account of the "muscular image" constituted in our bodies in the course of an empathetic encounter or an aesthetic experience. Nonetheless his application was very much his own.

It is important to note that *Morelli's* explicit theoretical warrant for his method differed from Berenson's. Morelli had attempted to locate an artistic subjectivity, as we might now say, that is not always to be identified with the artist's persisting bodily identity and remains unknown to the artist himself at a self-conscious level. In Morelli's connoisseurship it was quite clear that the *Grundformen*, reflexive pure style, need not persist throughout an artist's human life. They are a function, or at least a feature, of his interactions with particular projects, with the work of other artists, and with contexts of living. Therefore they can change—or some of them can change—when the artist takes up new projects, acquaints himself with the styles and techniques of different artists, or alters his way of life or place of residence.

Berenson was less certain about this fundamental point. His "tactile values" resemble Morellian *Grundformen* in their analytic or *epistemological* status. But their nature or *ontology* seems to involve a habituation even deeper than the unself-consciousness identified by Morelli in the *Grundformen*. Tactile values are not only unself-conscious. It is possible that they should not even be described as belonging to *any* level of consciousness. To adopt the term preferred by Santayana, they are "animal." As such, questions about their sociability—of their communicability and reproducibility, of their academic status, of their visibility to beholders—were not easy for Berenson to answer. His uncertainties and inconsistencies on these points rendered his catalogs and indexes art-historically tendentious, sometimes effectively useless from the point of view of a later

social history of art. Indeed, Berenson's connoisseurship did not really enable him to individuate the works of discrete artists conceived as independent, individual organisms, even though this was the very task that he had set himself and that he claimed to accomplish in his "Index" insofar as it identified or invented agents thought to be real persons.[31] Instead he individuated bundles of tactile values, some of which (according to the terms of his theory) must belong to the *beholder*, not to the artist. Essentially he was identifying a relay of empathetic encounters.

If Berenson's forensic results were sometimes recalcitrant for ordinary art-historical purposes (that is, in identifying real agents in the past), nonetheless his *philosophical* instincts were creative and largely correct. As we have seen, Morelli's discriminations remained at least partly yoked to pseudo-Hegelian "spiritual" characterizations of human agents thinking human thoughts in human worlds. Berenson's catalogs, on the other hand, resembled zoological taxonomies. As such it was difficult to know what kind of human *Geist* they revealed, even if they revealed aspects of an artist's social life—his training, his travels, his experience of other pictures, and his participation in circles of production.

Strictly speaking, Berenson's approach involved an important recursion, at least in light of the grounding theory of an original objectified pleasure and its empathetic apprehension on the part of beholders. The *artist's* particular pleasures in making a representation of a depicted world, *his* objectified pleasures, become an object; and that object, by virtue of the "tactile values" that it relays, becomes visible to an *art historian's* aesthetic sensitivity. The former situation, the artist's, was Santayana's topic, and the latter, the connoisseur's, was Berenson's. And despite Berenson's term for the object of art-historical scrutiny, his art-historical *method* was not really tactile. It was specifically visual. The art historian, of course, does not actually handle the objects sensuously experienced in the *artist's* world—objects and experiences relayed into the artwork in its characteristic "tactile values." Instead the art historian *looks* at the results. The art historian's objectification, then, is a second-order analytic and critical objectification with a different target than Santayana's; namely, the artwork precipitated in the artist's aesthetic objectification rather than the world originally objectified in his artwork. Nonetheless the two different objectifications can be said to communicate because of their partly *shared* common medium, the artwork that *results from* the artist's objectifications and that *attracts* the art historian's objectifications. Thus they seem to be able to transfer something of the artist's bodily sensation of self and world to the art historian. In connoisseurship according to Berensonian principles, we come to see what it was like corporeally to be *this* artist

making a picture of the world, whether or not we take this embodiment to have been intended by the artist with the goal of effecting just such a transfer to beholders of his work.

In this sense Berenson's connoisseurship fulfilled the deepest ambition of formalism already described in Chapter Three, and this despite the erroneous conflations of formalism with stylistic analysis that I cited at the beginning of this chapter. It attempted to establish a virtual historical psychology, and to transfer the world-sensations of long-dead artists to later beholders of the fossils left behind by the original objectifications of pleasure. And it did so in terms of comparative stylistic analysis. By definition, the habits that Morelli and Berenson had in mind when they scrutinized the fossilized sensations of long-dead artists were recurrent ones; if they are plausibly to be regarded as reflexive, they must be found in more than one artifact. For this reason, Berenson, despite everything to the contrary that has been written about him (usually as severe criticism), was not really—or never deeply—a high formalist in the sense that I have developed in Chapter Three. He was a *historical* formalist who specified the objective correlate of formalist sensibility to be the reflexive hedonic objectifications of artists in the past. He found his historical evidence, his documentation, in the artworks themselves, in the ways in which they can be arrayed and interpreted by the connoisseur or historian on the grounds of stylistic distinctions achieved by individuating bundles of tactile values.

Of course, Berenson's approach did not lead to a formal history of society of the sort that *Strukturforschung* in the Vienna School claimed to have discovered; namely, a history of social ideologies or *Weltanschauungen* that motivated artistic configuration in the past (*Kunstwollen*). In part precisely because Berenson's catalogs were based on specifically stylistic analysis (here as distinct from formal analysis), they proposed a different kind of social history. It is the history that might be revealed to us when we individuate reflexive-hedonic agents and begin to discover their complex intersections and interrelations, whether or not this history (a history of feeling that can be distinguished from a history of ideation) can be translated in routine social-historical terms; that is, in terms of actual artists, schools, and traditions that might be known to us in the documents, let alone in terms of what these artists or traditions *believed* ideologically about the worlds they represented. And this history primally includes, it openly acknowledges, its hermeneutic recursion—its involvement of the body of the connoisseur as the instrument for detecting and discriminating the relevant embodiments of artists in the past when they were making representations of the world.

The procedure might be described as highly subjective. In Berenson's theory of it, the best connoisseurship must be subjective because it attempts to individuate a feature of the subjectivity of artists in the past (namely its basis in animal recurrences in perception and production, in *aisthesis*) that can only be grasped corporeally by us (namely in our visual recognition of its past "tactile" corporeality). But for all that Berenson's procedure has a good claim to be scientific. In his view, it departed decisively from the impressionistic characterizations of art that had been promulgated in the handbooks—characterizations that were subjective in the bad sense because their authors imagined that they could see, or empathetically replicate, the *Geist* of the artist in the work, not his animal identity. By comparison, Berensonian connoisseurship aimed to approach something like laboratory conditions. As Edgar Wind and Panofsky suggested of the iconographer (see Chapter Eight), the connoisseur's trained eye must be trained not only on the artworks but also on *itself* as an instrument inherently interacting with its objects—without which its objects are invisible. And therefore it is not only an appropriate observational device in the domain of visual culture considered objectively, as an object of study. That same trained eye also serves as the exact analog of the zoologist's microscope or the astronomer's telescope. It is an essential instrument in attaining knowledge of visual culture, and in the ideal case participates in it.

Chapter 5

The Close Reading of Artifacts

■ I

On the face of it, the notion that one must *read* an artifact is nonsensical. Usually one can *see* an artifact, and thus *look* at it. One can sometimes touch it and perhaps move it, sometimes smell it and even taste it. There are of course many artifacts (and certainly many parts of artifacts) that are not meant to be seen—the interior mechanics of a building, for example, or the reverse sides of drawings or paintings. While these are visible to be sure, and in certain situations can be seen, they might not have *visuality* in the sense addressed in this book.

Still, notions of reading an artifact—of such activities, for example, as "reading a painting" or "reading a teapot"—have become ubiquitous. Some of them derive from a loose metaphor deployed by aestheticist historians of material culture in order to convert it into *visual* culture—that is, into culture that can be said to be aesthetically intelligible in vision and as visual. Indeed, many scholars of material culture can be described as *art* historians (as behaving, methodologically that is, as art historians) rather than as archaeologists or materials scientists.[1] Their metaphor of reading material culture is an analog of the notion of close looking in formalist art criticism. In fact, it extended the aestheticism of high formalism into domains of visual- and material-cultural studies where modernist-

formalist art critics such as Roger Fry (see Chapter Three) had not yet ventured. In this school of thought, the aesthetic particularity of an item of material culture, such as a quilt, a teapot, or a pair of boots, can be secured by reifying its readability—its revelation of social significance not only to the ones who made and used its notation, its material "writing" of its symptomatic status, but also to present-day beholders who can adequately share in the understanding of this symptomatology, who can also "read" it.

When the matter is stated this way, however, we can readily see that in material-culture studies the metaphor of reading an artifact functions chiefly to elevate the inquiry to the plane of iconology (the subject of the two following chapters of this book). In particular it serves to identify "popular" or "vernacular" artifacts that hold a place in general historical method analytically equivalent to the artworks addressed by the high-formalist art criticism that is so often suspected of elitism or exclusionariness. But in doing all this, material-cultural studies runs the risk of abdicating or avoiding its most salient contribution to the general theory of visual culture *as* material: many of the artifacts that we use in our ordinary forms of life (including many artworks) do not possess full visuality in the general theoretical sense. Despite their materiality, they cannot always be interpreted to issue in the kind of visual readability and cultural intelligibility presumed to result from the iconographic succession (see Chapters Seven and Eight) in recursive interactions with the successions of formality and stylisticality (Chapters Three and Four). Indeed, in much of material-cultural studies the metaphor of reading material culture—reading artifacts—remains unexplicated. By and large it remains a metaphor—a convenient shorthand description, at best, for the complex interactions between vision, visibility, and visuality as constituted, configured, and coordinated in material artifacts. It is not, then, a general theory of material or visual culture. Rather, it *requires* a theory.

More interesting concepts and more important activities of the "reading" of artifacts derive from technical (and often quasi-linguistic) analysis of the semiotics of visual culture. In visual semiology, the concept of reading an artifact is sometimes more than a mere metaphor for the putative intelligibility of artifacts in an iconological horizon or for a putative method of discovering such intelligibility. It is a substantive doctrine—a theoretical claim. In principle it entails definite methodological prescriptions and distinctive analytic devices. (Some of these have been relayed in the methods of what Richard Wollheim has called Latent Formalism, discussed in Chapter Three.) Visual semiotics (that is, a semiology of visual culture) is certainly interesting and important. But if it leans too

heavily on a concept of reading signs (as analytically distinguished, for example, from *seeing* them) it can be misleading for the purposes of a general theory of specifically visual culture. Often visual culture is not something that has been made visible in order to be read in the strict sense, even if it has been made to be intelligible or significant within a visuality. There might be readable dimensions of the artifact, but they need not be visible; and what is visible in an artifact need not be readable. At the least, then, the relation between readability and visuality is more complex than a "pansemiotic" textualist approach to all visual and material culture might presume. (Such an approach was sometimes advocated in the heyday of visual semiotics in the 1970s and early 1980s; it has substantially abated since then.) In fact, a rigorous semiology of visual culture does not in all cases require a doctrine of *readable* signs (of sign-reading), even if it must invoke such a doctrine in some particular cases—namely, in all cases of visualities that are relayed partly or wholly in the reading of items of visual or material culture. Conversely, the general concept that *is* required within visual semiotics—a concept of *seeing signs*, or visuality—remains undeveloped. The linguistic and textualist biasses of general semiotics have inhibited it.

Obviously a general theory of *visual* culture, of artifacts produced in order to be visible and especially to be deliberately inspected in terms of the culturally intelligible aspectivity of visible morphology, must address activities of seeing and looking—perhaps, too, of touching, moving, smelling, and tasting. Virtually by definition, visual culture includes the activity of seeing (visible) culture. (As we will see in later chapters, however, it does not *only* include this activity, and merely visible things cannot simply be assumed to be *culturally* visible.) In turn, then, visual-cultural artifacts and activities might *also* involve activities of reading (often activities of seeing and looking as well) when the artifacts in question are readable or when they might be thought, at least provisionally, to be readable or to have certain readable aspects. One sometimes reads certain features of visual-cultural artifacts. And many readable artifacts, of course, must be visible.

Still, the very fact that some artifacts need *not* be visible in order to have readable features proves the underlying point that motivates this chapter. Even in artifacts of specifically visual culture, the readable dimensions of the artifact *might or might not* be visible. They might be something to be seen, to be looked at. Or they might not. Like the notion of "close looking" considered in Chapter Three, then, the attractive notion that we should conduct a "close reading" of artifacts of visual and material culture, including artworks, or even that we should read them

tout court—recommendations to that effect have become widespread, as I have noted, in art history, material culture studies, archaeology, and elsewhere—must be greeted cautiously. A general theory of visual culture cannot essentially depend on close reading. Like close looking, close reading is not an essential condition of visual culture. Indeed, readability *tout court* is not an essential condition of visual culture. For this reason it cannot be a categorical criterion of the *method* of art history or of visual-culture studies.

Within this frame, the problem of *readable* visual culture becomes newly visible. When does visual culture need to be read, or even read closely?

■ **2**

Of course, there are many partly-readable visual-cultural artifacts, even if we limit our consideration to the class of visual-cultural artifacts in which the element of readability is itself visible. These artifacts include not only material incarnations of texts, such as holograph manuscripts or printed books—inscriptions or imprintings of the spoken word or of a written language, whether or not the scripts or imprints deploy pictorial configurations (so-called pictographs or pictograms). Such artifacts as maps, coins, and heraldic emblems have certain readable aspects or dimensions, even if they were not always produced entirely for their readability and even if certain readabilities in the artifacts are effectively *in*visible (striations on the edge of a coin that designate its denomination might need to be read by touch; although they can be seen, they cannot easily be *read* by sight).

Even drawings and paintings sometimes contain readable inscriptions (this does not mean, of course, that the drawing or painting is pictorial) or pictures of readable inscriptions (here the drawing or painting *must* be pictorial, at least in this narrow domain). One of the most familiar tricks of trompe l'oeil pictorial illusion, for example, has been to depict a readable inscription such as a sheet of autograph script or typeprint. Here the painter (it often seems) has hoped partly to transfer the beholder's looking from the painterly form of the picture to an inscribed meaning (albeit *depictively* inscribed). The clear readability of the depicted inscription heightens the illusion that we are looking at an actual readable artifact, such as an autograph letter or the page of a newspaper, rather than a *picture* of it. Of course, the depicted readable artifact, such as the newspaper that we think we see pasted to the real surface of the painting, might have its own form (such as a choice of paper color) and style

(a particular typography). But the trompe l'oeil tries to get us to see *this* form and style—the putative or pictorially represented form and style of the depicted newspaper— rather than the painter's form and style of picturing it.

Painted pictures might have readable features or elements in other respects as well. They might, for example, have numerical or other notational features—cartographic, for example, or scalar-proportional. A linear-perspective pictorial projection might contain no inscriptions and no pictures of inscriptions. But an appropriately educated beholder will know that the transversals and orthogonals of the perspectival recession (the apparent virtual depth constructed by the picture) represent a unique set of metrical information about the height, width, and depth of the depicted objects and their distance from one another and from the implied standpoint and the apparent vanishing points or points. This information would seem to be "seen" and "read" at one and the same time. To see the perspective properly is effectively to read the numbers, even if the integers and ratios have not been counted out or spelled out as such, or laid out and marked off as discrete. It is an experience of seeing consistently proportioned *scale* in a depicted domain that has been perspectively projected. (This scaling need not be natural, and the projection need not be an illusion: we might be able to see, for example, that a depicted human figure in the pictorial world is larger than in any real world that the human body might inhabit. But the "readability" of this pictorial largeness will be given precise numerical identification in the linear-perspective projection of the figure placed in surrounding space and scaled in relation to other depicted objects.) And to read the numbers, correlatively, is to see exactly what the perspective picture sets out to show, namely, the metrical proportions of things in a certain virtual world when mapped perspectively, whether or not the proportions of these depicted things have the natural or "correct" proportions of things in the real visual world. Stripped of this correlation, the perspective picture might make much less sense. An ancient Egyptian observer, for example, might find it to look deeply distorted—to be an entirely *incorrect* representation of the world (that is, of the real heights, widths, depths, and distances of things in the world) at the visual level. He can see the painting perfectly well, but in one crucial respect he cannot read the picture.[2]

As these disparate examples suggest, there are many kinds and perhaps many degrees of readability—of readable features or elements—to be found in artifacts of visual culture. Readability as such calls for a general theory of reading, probably to be predicated in turn on a general theory of notation. There are several examples of the former. Unfortu-

nately, there are very few examples of the latter. And neither order of general theory is my topic in this book. But it is worth noting that such typologies as Charles Sanders Peirce's classification of signs in his theory of "semeiotic" and Nelson Goodman's classification of the phenomenal logic of "symbol systems" were intended specifically to describe the kinds of readability to be found in artifacts as diverse as maps, clocks, coins, pressure gauges, signatures, and pictures.

Neither Peirce nor Goodman assumed the essential *visibility* of sign modes (such as iconicity or indexicality in Peirce's model) or symbol schemes (such as sketching or scoring in Goodman's model) in their special senses of those terms. An icon (or hypoiconic sign) in Peirce's sense could be produced strictly to be interpreted by touch: what counts is that what is touched has been taken by the interpreter to resemble its referent, whether the resemblance is vested in a partly visual property inferred by touch or remains a strictly tactile property. A sketch in Goodman's sense could be produced as a gesture or motion in an entirely unilluminated space, creating no visible phenomenon for the agent or for any beholders. Nonetheless it could be recognized through the interpreter's sense of touch or simply in embodied self-sensation as a pictorialization of the referent. (In total darkness, one could, for example, trace the motions of another's finger describing the shape of an object or body in the "dense" and "replete" way that Goodman required of depiction as a symbol system. It is likely that many items of ostensibly *visual* culture in many traditions incorporate such tactile and other embodied or even self-sensate operations and recursions in the basic functions of pictorial interpretation.[3]) Certainly neither of these writers tried to build a typology of signification or symboling that was wholly predicated on the sensory medium of the reading. Rather they addressed logical and psychological gradients, differentiations, and intersections in readability. And they never excluded the possibility that some signs or symbol systems should not be described as readable in the first place. In Peirce's model, one does not "read" indexicality. Instead one infers it or (in Peirce's term) "abducts" the requisite causal relations. (By the same token, in reading one is not inherently inferring indexicality or iconicity—the causes or causal relations of the marks one sees, or their visual resemblances.) In Goodman's model, pictures are maximally *non*notational. Their capacity to symbol lies in their relative imperviousness to the reading of the marks that make them up. Yet indexicality in Peirce's sense or depictiveness in Goodman's constitute crucial parameters or thresholds of visible signification in all kinds of visual culture.

For the sake of argument, however, let us now assume that certain artifacts have readable aspects or dimensions. If these artifacts are items

of visual culture, we must ask, in turn, about the visual parameters, definition, and focus of the reading that is required, in the same way, for example, as we might examine how "close looking" might be needed in visually accessing—in recognizing—the visible formality of certain artifacts (Chapter Three). In particular, is "close reading" the required mode of "close looking" when visuality involves readability?

Some of the readabilities of visible artifacts are gross and immediate. Because they are, as it were, right on the surface, they do not really call for "close reading." In reading a printed text, for example, we do not usually conduct a close reading of the inscription as such; that is, a close inspection of the form or style of the characters. Rather we conduct a close reading of what it inscribes, namely, its "content"—the text. In such cases we might reasonably assume that the text *could* be written, that it could be inscribed or imprinted, in many different ways that would diverge from one another in formal and stylistic terms. (Indeed, Goodman took this possibility to be a criterion of what he called "allographic notation," the commonest kind of notation: allographs, such as this page of printed text, can be inscribed in many ways—using, for example, many different styles of font—and nonetheless write the same thing. By contrast, there is only one way to inscribe an "autographic notation" such as a signature used to authenticate a document; the autograph requires a reading of the specific conformation of the particular configuration, which is often unique. In philosophical terms, "type" and "token" are identical in the true autograph in Goodman's strictest sense.) But our assumption is not relevant to our usual reading of the text. Often we do not care whether the text is written allographically or autographically, or if written autographically that it could be written allographically (and vice versa).

Of course, we might sometimes need to inspect the characters more closely, especially if we think that we have encountered an ambiguity in the text or an unfamiliar feature or a defect in the inscription. But it is doubtful that we would call this inspection a close reading. What we are doing is *looking* closely at the inscription of the text in order to be able to read it, or to be able to keep on reading it—in the course of a reading that might or might not be especially close, that is, attentive to semantic ambiguities and appreciative of textual subtleties. Conversely, however, close reading does not always demand close looking. Indeed, close looking at the form or style of letters in the inscription of a poem would probably detract severely from our ability to *read* it closely.

Given all this, visual-cultural artifacts that call for the *intersection and integration* of close looking and close reading have special interest. Such artifacts may prove rarer than we might expect. We might be tempted,

for example, to consider that a specimen of fine calligraphy calls both for close looking and for close reading—that it synthesizes them. But this synthesis would have to be a feature of the particular specimen in question. It cannot be a criterion of calligraphy as such. The calligraphically rendered text might not demand close reading at all. Perhaps it is immediately intelligible. Perhaps it is even composed in order to mitigate or eliminate semantic ambiguity and textual subtlety. Conversely, the calligraphically configured characters might not demand close looking. Perhaps they too have been designed expressly for ease and immediacy in our recognition that they have an established form or a familiar style. If we take the metaphors embedded in the terms close looking and close reading at their literal value, we might not have to bring our eyes up close, inspecting fine details of the inscription, in order to read the text. Perhaps the specimen of calligraphy can be seen and read perfectly well from far away.

To take another example, consider again the workings of a standard linear-perspective pictorial projection. In order to *construct* the projection, the artist might well have to engage in a synthetic process of close looking and close reading. He must draw the transversals and orthogonals (or more exactly the objects that inhabit the space defined by them) *just so* in order to ensure that they represent the real dimensions and proportions of the depicted objects, matching the measures that would be specified in metrically exact plans and elevations of the objects. Indeed, he will probably have to fiddle extensively with the measures and the drawing in order to make the painted perspective look right; a metrically exact projection likely will seem optically unnatural to us. To do this he might well deploy reading-and-writing instruments, such as a ruler, in addition to his drawing-and-painting instruments, such as a pencil. And some features of the configuration (such as the "baseline" transversal in a perspective projection made according to the method recommended by Leon Battista Alberti) will function as much as notations (defining the module of scale to be observed throughout the projected space) as depictions (showing the leading edge of that space as seen from the implied standpoint).

Very little of this close looking-and-reading or reading-and-looking carried out by the painter needs to be rehearsed by the *beholder* of the finished pictorial perspective. It might be perfectly obvious—readily visible—that objects are foreshortened and proportioned in the projected space, the fictive depth, in a more or less optically natural way. In general, close looking at the conformation of depicted objects and close reading of the mensuration embedded in the perspectival construction will only be needed if the apparently pictorial array afforded to the observer seems

to present a difficulty or seems to contain a defect of some kind—if, for example, the foreshortened image of a depicted object creates ambiguity about its identity when no such ambiguity would seem to have *textual* salience. (The picture does not *represent* an ambiguous object but seems to represent an object ambiguously.) By and large Albertian pictorialists set out to avoid this outcome. They might want us to look closely, but at the depicted scene and not at the perspective mensurations as such. And they might want us to read closely, but only if the scene depicts inscriptions that demand it. Even close looking at a pictorial perspective is ordinarily an easy read.

■ 3

Close looking and close reading should be distinguished; they need not be correlated even in artifacts of visual culture that need to be read. In light of this it is noteworthy that some of the *earliest* notations in human history, if not *the* earliest notations, seem to demand very close looking in order to be read at all and, conversely, to demand a close reading in order to be seen aright.

I refer to the supposed lunar calendars and similar calculator-predictors or chronometers identified by Alexander Marshack in the archaeological record of the Upper Paleolithic, and perhaps even the Middle Paleolithic. These notations consist of scratchings and markings on the surfaces of bones and stones, such as the bone "plaque" from the rock-shelter of Blanchard in the Dordogne valley of France (Fig. 5.1).[4] If we agree that these artifacts really did serve the purposes that Marshack assigns them, then what we have here is an instance of *inscription* on tools. That is, the artifacts must be identified as implements (indeed, as inscriptional ones) rather than as some kind of activity *other than* the deliberate making of visibly readable notations. (Here I am less interested in the empirical plausibility of Marshack's claims about the artifacts than in the theoretical problems they raise about visuality and readability: problems that any appropriately constituted artifacts would raise if they functioned like Marshack's marks

Figure 5.1.
Schematic rendition of the incised marks on the Paleolithic Blanchard plaque. After Alexander Marshack, *Hierarchical Evolution of the Human Capacity: The Paleolithic Evidence* (New York 1985) Figure 11.

as he interpreted them.) Before Marshack, the markings on such objects had often been understood as "decoration," even as depiction, without specifically notational or readable aspects. Or if it was acknowledged that they had readable aspects, these were simple and obvious ones—perhaps counts or tallies of some kind. In Marshack's view, however, the decorative element (which he did not specifically deny), the depictive element (which is often obvious), and the element of logically simple notation in a straightforward tally (in which one mark equates to the integer "1") had been recombined to create a more complex inscription. It tracked the phases of the moon (that is, a *group* of mark-integers—a set of "1"s—designating a temporal *duration*, e.g., one full-moon-to-half-moon period) and its correlation with the movement or behavior of fauna (the fact that rutting, spawning, or foaling occurs after a *group* of lunar phases, that is, after a certain group of the groups marking the visible phases of the moon). (In Chapter Ten I consider this kind of representation for my own purposes.)

Since Marshack's research was published, other scholars have identified putatively deliberate man-made markings on a variety of artifacts initially unknown to Marshack, some of which precede the evolutionary emergence of anatomically modern human beings. To be sure, the claim—Marshack's claim—that some early arrays of marks were *notational* needs to be carefully distinguished from claims (widespread in the scholarship) to recognize "art," "geometric organization," "aesthetic order," "intentionality," and the like, in early marks, such as the cuttings made by *Homo erectus* on bones dated to c. 350,000 BC that were recovered in the mid-1980s at Bilzingsleben, Germany (Fig. 5.2).[5] These claims do not inherently presume that the patterns were notational. And indeed if the "art" in question is pictorial (in the earliest known cases it does not seem to be, at least to our eyes) it could *not* be notational in Goodman's terms. For my purposes, particular archaeological examples of early marks and questions of their evolutionary position and priority are less important than the wider questions of intentionality, notationality, readability, and visuality that they dramatize. In particular, archaeologists have used methods of close looking to identify pattern, agency, and intention-

Figure 5.2. "Artifact 1" (possibly made by *Homo erectus*) from Bilzingsleben, Germany, c. 350,000 BC. (a) Plan view. (b) Longitudinal side view. (c) Reconstruction of the "sequence of engraved lines." After Dietrich Mania and Ursula Mania, "Deliberate Engravings on Bone Artefacts of *Homo Erectus*," *Rock Art Research* 5 (1988) Figure 3.

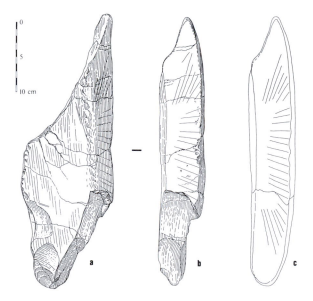

ality in early marks, and to conclude that they were items of visual culture correlated with a prehistoric visuality—perhaps one predicated on the notationality of visual aspects of the artifacts. But this is not in itself close reading.

As my qualifications will have suggested, controversy has stalked Marshack's proposal. For my purposes, the problems lie not so much with Marshack's conclusions as with his presumed *method* of analysis (which Marshack's critics in large part share with him): much of it can be reduced to the question of the relation between close looking and close reading. And this is true whether we speak of the looking and reading to be attributed to the original makers and users of the artifacts or of the looking and reading conducted by the modern archaeologist. A major weakness in Marshack's decipherment of the supposed Paleolithic notations is that his readings (especially his observation of supposed "sets" in the marks and of ostensibly visible differences between the sets) had to be secured by way of virtually microscopic inspection of the artifacts, in his case using a hand lens—a tool that the original mark-makers and the original beholders could not have employed. Scholars who have tested Marshack's forensic claims, and sometimes disputed them, have gone even further. Francesco d'Errico, for example, examined replications of Marshack's Paleolithic marks using a scanning electron microscope and concluded that Marshack's identifications of discrete mark types and sets of marks (as well as specific counts of the numbers and members of these types and sets) sometimes cannot be sustained. But d'Errico endorsed an even broader thesis—that some of the arrays of marks, such as the array to be found on the Upper Paleolithic antler bone from La Marche (near Les Eyzies in the Dordogne) (Fig. 5.3), "should be interpreted as an artificial memory system with a complex code based on the morphology and the spatial distribution of the engraved marks."[6] In Fig. 5.3(b), d'Errico's "schematic rendition of the marks on the two faces of the La Marche antler," "capital letters indicate groups of marks carved by the same point (sets), small letters indicate sub-sets which correspond to a turning of the antler within groups of marks produced by the same point; numbers in parentheses identify rows; arrows indicate the turning of the object; [and] patterns indicate sets of marks carved by the same point."[7]

For my limited purposes here, evaluating the differences between Marshack's and d'Errico's forensic results could be like debating the number of angels on a pinhead. What kind of visual and inscriptional culture could have produced, would have wanted to produce, a notation or an "artificial memory system" in which notational elements that should be eminently easy to read take the form of an inscription that is very difficult to see—

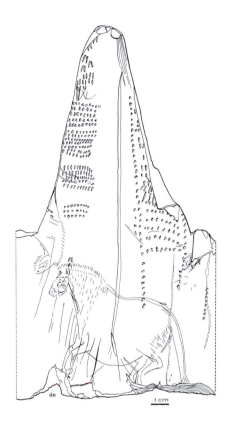

Figure 5.3.
(a) Drawing of the marks and engravings on an antler from La Marche, near Les Eyzies, Dordogne, France. Magdalenian, c. 12,000 BC.
(b) Schematic rendition of the marks on the two faces of the La Marche Antler. From Francesco d'Errico, "A New Model and Its Implications for the Origin of Writing: The La Marche Antler Revisited," *Cambridge Archaeological Journal* 5, no. 2 (1995) Figure 4 (a), Figure 19 (b). Reproduced by permission of Francesco d'Errico.

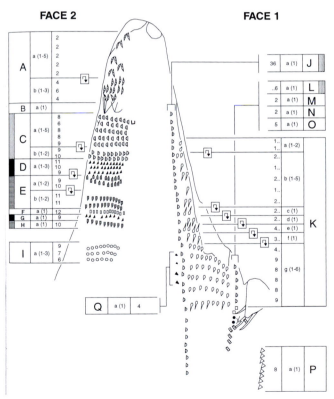

The Close Reading of Artifacts

that requires us to use a hand lens or electron microscope, for example, to identify salient morphological parameters of the inscription? Should we *see* readability in marking that must have contained many random variations that in turn might *look* like the syntactic and semantic differentiations between written characters required by a notational system or like distinctions within the phrasing (even the content) of a written text?[8]

Despite the rhetorical force of these questions, answering them is not easy. As my epigraph for this book has it, "there could be people who recognize a polygon with 97 angles at first glance, and without counting." Such people might have made the prehistoric marks that *we* must now study carefully with a handlens. But inquiry into this matter has probably not been helped by the fact that Marshack sometimes called his techniques of close looking at the Paleolithic artifacts a method of close *reading*. In the case in question, this rubric comes too close for comfort to assuming the consequent, namely, that the marks we are looking at were made to be read—the very fact that needs to be established. And there is an important difference between reading the Paleolithic marks (in deciphering their notation of certain kinds of texts, as Marshack claimed to do) and *looking* at the presence of readabilities that remain undeciphered—that depend upon recursions of visuality that we do not fully understand. (D'Errico's results might fit into the latter category; though he has claimed to have identified an "artificial memory system" in the marks, he has not said exactly what the system remembers, what it saw and "wrote.") It is not clear that any amount of close looking or *closer* looking and close reading or *closer* reading will resolve basic depictive disjunctions and recognitional disjunctions (for these, already broached in Chapter Two, see Chapters Six and Seven) as well as notational disjunctions (in this historical case). Indeed, as I have already noted, close looking or close reading might be *too* close: they might exacerbate the disjunctions.

What we need is not a looking or a reading that is close enough finally to see and to read everything, or conversely to discover that there is nothing to read in what can be seen. We need a looking and a reading that sees what is to be looked at (and perhaps to be read) *at a distance appropriate to the visuality*. Within that frame, closer and closer lookings and readings might be needed. But the very definition of the appropriate distance of inspection, degree of resolution, and fineness of discrimination will depend upon the frame of visuality. People who can recognize polygons with ninety-seven angles without counting are not necessarily looking closely. Further, because they are not counting they are not reading at all, even though *we* must look and count—look carefully and

count closely—in order to see what they do. And we cannot see what they do *as* they do: while we must set about to look carefully and count closely, they are simply recognizing a kind of polygon that can readily be seen by them.

▪ 4

In an elegant essay on Marshack's studies of Paleolithic mark making, James Elkins has written that Marshack's analytic methods were "among the most careful . . . in all of archaeology as well as in art history and criticism, visual theory, connoisseurship, and conservation."[9] By "careful analysis," Elkins means what he went on to consider as "close reading," though in the end he concluded that Marshack *failed* in reading closely (at least in the way that he claimed he needed) because such reading simply cannot be attained.

As already suggested, however, there might be careful analysis that is neither close nor reading. *Looking* might constitute such an analysis. Indeed, Elkins's comment closely aligns Marshack's analytic methods with such approaches as high formalism in art criticism (addressed in Chapter Three) and Morellian connoisseurship in art history (see Chapter Four). But in order to assess this alignment or equation we need a wider view of Marshack's work than the one Elkins has framed. Setting aside the question of the results claimed by Marshack and disputed by d'Errico and others, is it really true that Marshack's methods are "among the most careful . . . in all of archaeology as well as in art history and criticism, visual theory, connoisseurship, and conservation"?

Straight off it should be noted that Marshack's ostensibly close reading of prehistoric mark making (and its supposed compu-notational outcomes) was not especially unusual in archaeology. Nor was it necessarily all that careful. For example, Lewis Binford's scrutinies of Pleistocene archaeological landscapes tried to disentangle what I have called the "non-intentional," the "zero-degree intentional," and the "variable intentional" traces in a site that was traversed by human or hominid activity and affected by natural forces and animal behavior as well.[10] Sometimes Binford called this scrutiny "reading," as in decipherment.[11] Usually, however, he wanted to "take a reading," as if from a thermometer.[12]

In one of its most bravura performances, Binford and his collaborators' study of the Neanderthal "flaked bones" from Cueva Morín, this reading (intended to determine whether the bones really *were* flaked) probably involved more careful or close forensic analysis than did Mar-

shack's.[13] Of course, to determine whether the bones really were flaked might not be to engage in the reading of a *text*, despite Binford's terms. As Binford took care to insist, our analysis must leave itself open to the material possibility that the bones were not flaked by hominid agents at all. Therefore it cannot simply *consist* in a method of reading the flaking. It must investigate whether or not such reading is apposite by taking a reading of the very presence of flaking as such. (A similar recognition— an implied recursion—organized Marshack's research, but he was less explicit about it than Binford.) Still, in view of the fact that paleoarchaeologists have often seen hominid and early human techniques of making tools as rule-governed procedures, as chains of operations, flaking (if it occurred at all) might have parallels with some kinds of inscription. In Binford's metaphorics, then, our question really concerns the inscription of hominid intentionality in the activity at the site. To flake the bones was, as it were, to *write* them—to endow them with the functional usefulness specifically consequent upon conforming them inscriptively.

Again, analogy to a thermometer is helpful. A reading of temperatures that register *above* a certain degree can tell us that the patient is alive and well—that he could be intending, making, inscribing, and reading something. Below that degree, however, that patient cannot be doing any of this. Indeed, there might be no living patient at all. Binford's "readings" take the temperature of an archaeological landscape in this sense; they try to determine whether there was intentional human action at the site in the first place, action such as the making (or "writing") of certain tools, to be read (by original makers, users, and beholders of the artifacts and activities and by us). To some extent this reading depends on the ability to read the tools—to determine that certain apparently flaked or otherwise worked bits of stone and bone would have been used in a particular way, and thus "written." But it depends as well on our ability *first* to determine whether toolwriting is present, whether or not we can discern how the tools were used (that is, what they "wrote"). This reading could be obtained simply by determining that no other force could have produced this conformation of bits of stone and bone. Without being able to read them, we could tell that they had been written.

But there's the rub. If we cannot *read* the writing, can we be sure that it *is* writing? Might there be a writing that we cannot *see* because we cannot read it?

Marshack took it for granted that human intentionality was inscribed in the marks on Upper Paleolithic artifacts, whether as notation or not. (Clearly the marks were man-made; there is an immense difference between the Mousterian flakings and scratchings studied by Binford and

his collaborators, which might have had animal or other natural causes, and the considerably later markings, including depictions, that Marshack addressed.) By contrast, Binford proceeded from the more fundamental point that "inscriptiveness" as such, the quality of being inscribed, must be discovered—demonstrated to be present as an artifact—before it can be read. And in precisely this respect he always remained alert to the possibility that the mere *look* of inscriptiveness (like the mere look of depictiveness) is not enough to show that a mark *was* inscriptive.

For this reason Binford's forensics should be seen as careful, that is, as *cautious*. If and when inscriptiveness or depictiveness has been discovered by Binfordian readings, "taking their temperature," we can accept the result as more secure than Marshack's *a priori* assumption of inscriptionality in marked artifacts that might have lacked it. It is noteworthy, however, that Binford's methods, especially his investigation of taphonomic processes (the natural, animal, and human formation of sediments and deposits), often led him to results that foreclosed any question of reading at all. Stated most simply, Binford often read that there was nothing to read. Therefore he had no need for a method of reading *writings*, though he would not deny that Marshack's methods might be apposite within their purview so long as it could be established that Marshack's marks were inscribed.

To take an example of an equally careful forensics, Sir John Beazley attempted to identify a variety of what might be called "analytic individuals" in classical Greek vase painting—that is, to discover particular painters (for example, the "Berlin Painter"), their students and workshops, traditions of imitating their styles, and so on.[14] Beazley's looking and reading (if he read at all) was an individuating technique; it was like trying to discover the voice one wants to hear in a crowded, noisy room, and this whether or not the voice can be understood to be saying something—indeed, even if it was simply crying and coughing like an animal (think of the beasts that traversed some of the Pleistocene sites studied by Binford) rather than speaking intentionally as a human agent. Moreover, the voice in the crowded room—the agency to be identified in Beazley's connoisseurship—might be the voice of one person (coughing or speaking) or it might be the noise produced when *several* people sound together (coughing or speaking, or coughing *and* speaking, and this whether or not they intend to sound together or realize that they are heard by others as one). Indeed, it is possible that one kind of sound that we hear in the crowded room is simply an echo, whether it is an echo of coughs, speech, or chorus. But even the echo tells us that somewhere an agency—a person or a group vocalizing, intentionally or not—has made a noise, though we did not hear it in its first or primal sounding.

In order to individuate and differentiate these agencies, Beazley often employed the method of Morellian connoisseurship explored in Chapter Four. Seemingly he embraced Morelli's theory. But he did not limit himself to it. The voices to be individuated in Greek vase paintings (whether an individual painter, his school and workshop, or a continuing tradition) have reached us as fragments of pottery, sometimes tiny ones, distributed in collections all over the world. Attributing each fragment could help us to put the original painted vase back together, and Beazley pursued this possibility. But strictly speaking this Morellian method would only help us to find the painters who painted the vases, or their schools and traditions. It does not help us to find the vases themselves. And the vases, of course, must be found before they can be attributed. Here the Morellian method confronts a severe difficulty. The *Grundformen* that individuate an artifact as the product of a particular maker (discussed in more detail in Chapter Four) need not be found in every material part of the artifact. Therefore if the artifact is found in fragments it is likely, in turn, that some of them cannot be attributed in Morellian fashion. Fortunately a vase can be put back together and *then* attributed on other grounds as well—grounds that have nothing at all to do with close looking at what the vase depicts or inscribes or with any kind of reading. Beazley was perfectly happy, for example, to reconstitute a vase by realizing that the broken edges of two fragments fit together, or that part of a shape on one fragment could be completed by another part on another fragment. *Finding* a voice (as Beazley tried to do) does not equate to identifying the speaker (as Morelli hoped to do), let alone to hearing what he might be saying (as Marshack claimed to do). But Beazley worked from one end of this spectrum to the other, and often back again, in complex analytic circles.

As a paleoanthropologist, Binford was a rigorous evolutionist. He took it for granted that such intentional processes as configuring, inscribing, and reading cannot be found *throughout* the archaeological record of hominid and human activity. Rather they developed in particular historical situations of adaptation. As a connoisseur, Beazley was a rigorous reflexologist, at least insofar as he depended on Morelli's methods of stylistic attribution. In order to effect his attributions in Morellian terms, he had to take it for granted that when the Greek painters were inscribing some marks they were not aware of what they were doing. They were not writing in the ordinary sense. In fact, a painter might not even have been able to *see* the very features that we use to identify him. If Morellian theory is correct, it is likely that in many cases the *Grundformen* that link an artist's work to his hand (and from our point of view attribute the work to him) had not succeeded to visuality even though they might have been

visible. And the jagged edges of broken shards that we might fit together to identify discrete works would not even have been visible to the makers, the original potters and painters, when the pots were still whole—when no breaks existed. In other words, both Binford's and Beazley's forensics of possible readability in items of visual culture start considerably further back, or deeper down, than Marshack's. They begin with the fundamental horizons of visuality and even visibility. In visual culture, we must traverse the territory of making—its natural, animal, and human determinations—over the horizon of visibility to the further horizon of visuality to the yet further horizon of readability. (This project in theory might be identified with material-culture studies, mentioned at the outset of this chapter, if that enterprise did not usually short-circuit the analysis in question by prematurely assuming both the readability and the visuality of material configurations that possessed only visibility.)

Of course, as already noted, neither Binford's nor Beazley's definition of his analytic purview would *preclude* the possibility that the Mousterian bone-flakers or the Attic vase-painters were indeed writing something. If Binford's taphonomic forensics had been able to prove that Marshack's marks had been made intentionally by hominid or human makers, then the stage would be properly set to ask whether the mark-makers were *writing*—whether they were writing the text of a calendar or something else altogether. And Beazley was always happy to use the results of epigraphy and iconography, of essentially textual philology in the written and the pictorial domains, to supplement his reflexology of style. It is debatable, I think, whether painters were writing something when they painted pictures on the vases. As already noted, pictures are not easily analyzed as notational. More important, and as we will see in Chapters Six, Seven, and Eight, pictoriality itself often *resists* visuality. But when the painter affixed a name to a depicted character in the painted scene, when he praised the beauty of a boy who might see the painted vessel at a symposium (by adding a so-called *kalos*-name to the composition), or when he signed his *own* name on the pot, he certainly wrote something to be read. Binford's and Beazley's forensic methods simply sought to make the readings of any such written passages of flaking or painting entirely *relative to* the adaptive and reflexive contexts in which they were materially embedded.

Our ability to identify these contexts, in fact, should inform our readings of the writings made within them. If the marks on the bones of Bilzingsleben (Fig. 5.2), for example, were made deliberately by *Homo erectus* artisan-writers as patterns, decorations, or notations of some kind, what does it mean that they *look like* the ordinary scratches that can result from stripping meat and skin off the bone—which of course are no kind

of writing at all? Were the prehuman mark-makers trying to *represent* this process? And if the Attic Greek vase painters devised expressions of their painterly virtuosity that would stand out in a competitive marketplace, as Richard Neer has argued, what does it mean that some of the features of the painting that were most likely to individuate them definitively *as* the painters of the vases were least accessible to such display?[15] (If the painter deliberately showcased his typical ways of painting hands or ears, for example, his exhibition of these features would not actually permit the work to be attributed to him in the way required in Morellian connoisseurship. To use my terms, in showing off the virtuoso painter could end up producing stylisticality that need not specifically index *his* making—a result in part inimical to his desire to be uniquely credited with the style.) These are tricky questions of reading (perhaps close reading) that are at least partly outside the philological or iconographic question of *reading the writing*, whether it demands close reading or not.

With these points of reference in mind, we can now specify Marshack's contribution more exactly. Like Binford, Marshack was an evolutionist. But in reading the writing that supposedly was Upper Paleolithic calendrical notation, he claimed to be reading a *new* adaptation in hominid history, a new writing—one of the first material expressions, he thought, of the human "symbol making capacity." A Binfordian archaeologist might deny that Mousterian toolmakers had any such capacity, even if they could flake bone or stone according to a plan or by acting to optimize the efficiency of their labor and their use of material. And that is precisely the point: in his work Marshack claimed to be reading a writing that Binford (in dealing with earlier hominid adaptations) could not read to be read in the first place.

Like Beazley, Marshack was a reflexologist. In order to read the Upper Paleolithic notation that supposedly was a calendar, he had to determine that the marks were grouped into sets (and more important into groups of sets) as a function of the way in which the marking tools were handled, shifted, and changed over time, and especially that these sets and groups could be *seen*. But here he was not individuating *makers* in Beazley's sense (or Morelli's). Rather he claimed to find the individuations that constituted the putative texts inscribed by them. *This* group of marks was made at *that* time, supposedly because a certain tool that created their characteristic visual aspect can be seen to have been used in making the marks, or because in the marks it can be seen that the tool was handled in a certain way so that the marks could be distinguished.

In this respect it seems to be a defect of Marshack's method that the individuation of marks could easily be conflated with the individuali-

ties that constituted the *makers*—with the different ways, for example, in which tools were likely handled by different makers, or indeed by the same maker when marking at different times in the lunar month, as the putative notation would have required. Certainly it is peculiar that the individuations that supposedly constitute Upper Paleolithic calendrical notations seem to be found at the same level of visual resolution as the virtually invisible *Grundformen* that index the analytic individuals who made them, and not at the level of gross visual intelligibility; that is, of the ordinary material visibility of the artifact when picked up and held before the eyes. (Just as we cannot easily see *which maker* made the mark, we cannot easily see *what tool* made it *when*; as noted, the relevant distinctions must be observed with a handlens.) But this phenomenon characterizes a great deal of Paleolithic marking, depictive or notational or not. And it is not impossible that it has good explanations specifically at the level of visuality—of aspectively *seeing* the full significance of what is (also) materially visible. The generation, preservation, and transmission of knowledge (the "artificial memory system" that d'Errico finds in Marshack's marks) might have been guided in part by people who knew how to *touch* the marks properly—to feel by hand their material distinctions one from the next, and perhaps to count them manually. (Perhaps the little bone and stone chronometers were digital computers that required the *digits* to read the inscription, not the eyes.) In this sense Marshack's methods might actually have revealed a writing that required the very closest reading and little or no *looking* at all. Indeed, here readability perhaps *avoided* visibility, a possibility not theoretically surprising. It is in fact predictable. As noted at the beginning of this chapter, close reading and close looking do not subsist in constant coordination, let alone in one-to-one correlation. And what has sometimes seemed to be their constant conjunction or even identity in the earliest human marking behaviors might require more dynamic and recursive analysis: a certain distance of looking enables certain distances of reading that in turn motivate new distances of interdetermined looking and reading. A full analytic model of this interaction would require an entire book, conceived differently from the present book, on notation, computation, and depiction.

■ 5

According to Elkins, Marshack's close reading (whether or not it also involved looking or close looking) was "impossible." Because of the inherent "blindness" of all reading, close or not, it was, Elkins thinks,

doomed to fail to read what it claimed to be the writing it saw. Indeed, the closer the reading (or looking or touching for that matter), the more comprehensive or pervasive the blindness might said to be; that is, the more likely it will be that it involves our own sensuous interests, cognitive techniques, and canons of intelligibility. Presumably these occlude, if not contaminate, the objective or original form, style, representationality, and cultural status of the text or artifact in question. Elkins derived this objection (or his particular version of an objection that can take many forms) from the literary theory of Paul de Man. According to de Man, the blindness of reading devolves from the fact that in reading a text we cannot simultaneously read our inherent distance from it with sufficient critical reserve to realize that when we read we are partly *not* reading the text. ("Distance" refers here to our historical and cultural distance from objects made by others; more metaphorically, it also refers to the material divide between an object configured and projected in the consciousness of others that has become an object of attention and interpretation in our own.) This *mise-en-abyme* becomes more acute the more closely one reads precisely because this operation claims to be able to reduce our distance from the text to the absolute minimum, essentially to nothing, and therefore to read *everything* that possibly is there to be read in the text.

De Man's observations about reading (especially the kind of reading practiced in the criticism of romantic and modernist literatures) are apposite as far as they go. But he described a problem in the reading of writing that we can already see to *be* writing—to be the text, for example, of a poem. To use the technical terms that he developed toward the end of his career, he addressed the "hypogrammatic" context of the inscription, the context of reading the inscription (notably the context includes the "seeing" of the reader himself) that potentially disables the reading insofar as one usually hopes to read the "grammar" of the enunciations in the language of which the inscription is a notation (that is, to read clearly) rather than unwittingly to enact the natural and historical parameters of the act of reading itself (that is, read blindly).[16]

In the case of the reading practiced by Binford, Beazley, and Marshack, however, we are concerned not only with the hypogrammatic context of the inscription. We are also concerned (and concerned more primally and profoundly) with what might be called the holomorphic context of the hypogram—with the context within which *the very possibility of readable inscription in the marks* (as opposed to the very possibility of understandable text in the inscription) must be identified. As already noted, Binford was prepared to discover that putatively man-made marks (not to speak of written characters) actually are natural scratches, scars, or

stains. In an archaeological landscape (even a single artifact) man-made marks are often enmeshed with these scratches, scars, and stains in an overall apparent form. (In turn it would be easy to confuse this apparent form with deliberate formality—a risk underestimated in high formalism [see Chapter Three].) This holomorph likely must be seen and touched by us all at once as a field of marks, even though it is not readable as such and even though Binford sometimes applied the metaphor of "reading" to the forensic taphonomy involved in identifying its interlayered causes, only one of which can really be described as "writing."

In Beazley's archaeology, the holomorph, the entire painted vase, often must be reconstituted before the vase as a whole can actually be attributed. (As noted, some shards of the vase, once broken, might not display *Grundformen* that allow them to be attributed.) Thus one must not only read such features as inscribed letters, including the names of depicted characters, *kalos*-names, and painters' and potters' signatures. (These are not usual objects of the formalist criticism or the connoisseurship of inscribed *depiction*; indeed, they might well be rejected as marks too readily forged to be safely used in attribution by the Morellian connoisseur.) One must also "read" such things as pot-breaks or the presence of a scratch, scar, or stain that allows us to see how two fragments of a painted vase can be joined together as parts of the whole. Here again the holomorphic context is the *sine qua non* of our forensics, our "reading." Indeed, the hypogrammatic context (that is, the context in which the readability of depiction in a particular painter's inscriptional style must be investigated) did not much interest Beazley. Once the visibility of a particular inscriptional style has been read by a connoisseur in Beazley's tradition, the readability of what it was writing *about*, what it depicted in its characteristic fashion, could be handed off to iconographers, mythographers, and other specialists in the meaning of text.

Of course, as Elkins has demonstrated, any general problems of reading (including the *aporia* identified by de Man) must apply to Marshack's readings. But does this tell us anything about the peculiar content and particular intelligibility of Marshack's unique readerly object as he claimed to identify it? Even in the field of prehistoric art studies and even in his terms, Marshack's close reading was in fact no closer than the reading practiced (for example) by G.-B.-M. Flamand. In *Les pierres écrites*, published in 1921, Flamand paid close (and sometimes, it seems, literally microscopic) attention to the ways in which North African prehistoric engravings had been made (Fig. 5.4). Studying the depth, the direction, and the cross-section of incisions, he extracted information about the step-by-step procedures and tools of the engravers, just as Marshack set

out to do fifty years later.[17] Despite the title of his book, Flamand did not think he was reading, even though some of his objects had customarily been described as inscriptions; the metaphor had little currency in his presentation of his procedures. His interests in patination and superimposition put him instead closer to Binfordian concerns for processes of site formation and to Beazleyan concerns for chronosocial attribution (both initially holomorphic and then hypogrammatic and grammatological as warranted) than to philological and iconographic projects of decoding and interpretation (entirely grammatological). Nonetheless he aimed to reconstruct the canons of legibility and the writerly conven-

Figure 5.4.
Flamand's analysis of Neolithic petroglyphs form North Africa. (a) Outline engraving in a "Libyco-Berber" petroglyph. (b) Engraving in a "Libyco-Berber" petroglyph from Oued Dermel, South Oranais Region, Algiers. (c) Sections and profiles of incisions. From G.-B.-M. Flamand, *Les pierres écrites (Hadjrat-Mektoubat): Gravures et inscriptions rupestres du Nord-Africain* (Paris 1921) figs. 155, 156, and 147.

tions of the ancient engravers. Like Binford and Beazley, then, he ranged across the interdependent holomorphic *and* hypogrammatic contexts of inscription, though like Marshack he assumed that his material object was indeed inscriptive.

In Flamand's work, we can find a prototype of the analytic methods of reading employed by Marshack. The question is not really *how* Marshack read, however closely. It is *what* he read at the appropriate distance.

The prehistoric engravings studied by Flamand were readable because they were understood, at the time, to be pictures. (Fig. 5.5[a], for example, a petroglyph from the south Oranais region of Algiers, illustrates three

(c)

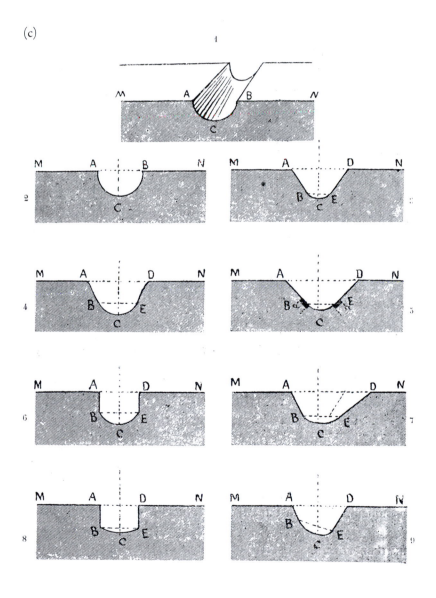

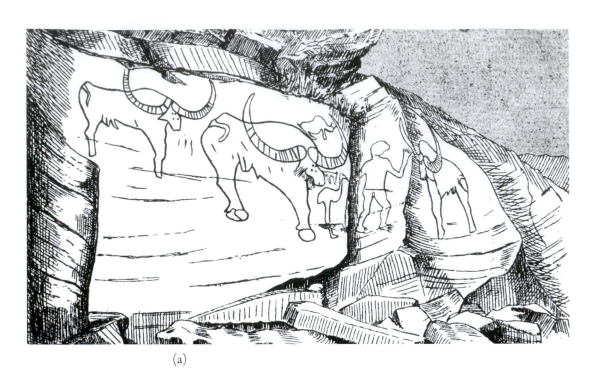

(a)

(b)

giant *Bubalus antiquus*, other animals, an ostrich, and what seems to be a human.) Although one might wonder what the pictures symbolized, a question to be explored in much greater detail in Chapters Six and Seven, their visible legibility *as* pictures was not in question. (I simplify for the sake of argument. Some of the seemingly pictorial engravings included *written* inscriptions in the ordinary epigraphic sense: Fig. 5.5[c], for example, illustrates an array of "Libyco-Berber" engravings—depictions and inscriptions—from the region of Aoulef in south-central Algiers. And some inscribed shapes in North African prehistoric engravings, writing or not, are not recognizable to us, such as Fig. 5.5[b], illustrating prehistoric and "Libyco-Berber" engravings from the south Oranais region; in other words, the status of the inscription as pictorial or scriptive, or possibly both, is not known, and might be moot if the inscription *qua*

Figure 5.5.
(a) Engraving from Ksar-el-Hadj-Ahmar, west of Géryville, South Oranais Region, Algiers. (b) "Libyco-Berber" engravings from El-Hadj-Mimoun, South Oranais Region, Algiers. (c) "Libyco-Berber" engravings and inscriptions from the region of Aoulef, South-Central Algiers. From G.-B.-M. Flamand, *Les pierres écrites (Hadjrat-Mektoubat): Gravures et inscriptions rupestres du Nord-Africain* (Paris 1921) 125, Figure 16 and Figure 26.

script is notationally pictogrammatic. Finally, some petroglyphs, such as "cupules," cannot always be readily distinguished from natural formations, which are neither pictorial nor scriptive.) Hence Flamand could not be credited with a cultural-historical discovery—a decipherment—like Marshack's. He simply advanced analytic methods for describing a cultural tradition understood to have made decipherable texts.

By contrast, the Upper Paleolithic markings studied by Marshack and his critics (Figs. 5.1, 5.3) were *not* deciphered. They were not even understood to be readable—to represent a text. Marshack proffered his decipherments of the marks as a possible (but purely hypothetical) explanation for the readability of something *else* that he had succeeded in reading. He was *reading readability* in the sense that one might read (or maybe simply *see*) that a sequence of marks is a marking of English (that it notates an English text, spoken or written) and yet remain unable to read that English. Marshack was reading the presence of visible Paleolithic-ese without inherently reading what it had written *about*. This was reading writing as an index-gauge of readability; Marshack was "taking a reading" of writing. The catch is obvious, as Binford's forensics remind us: although there is always a temperature to be taken anywhere a thermometer has been placed, there is not always a *writing* to be measured in the same sense. As a reading, then, Marshack's method was more like a weather balloon than a thermometer. The phenomenon to be gauged might or might not be there to be "read," depending not only on how close the balloon has managed to get to it but also on the vicissitudes of the atmosphere itself. A balloon cannot measure the temperature of a passing cloud if the sky is completely clear.

■ 6

According to Marshack's assessment of its holomorphic context, Paleolithic-ese (or the Paleolithic-ese that he read in the marks on the supposed chronometers and calendars) was written in what he called a "time-factored" way. The bone plaque from Blanchard, for example, was written by "following the waxing and waning of the moon" (Fig. 5.1). Speaking strictly and literally, it was written as *divided by time*: supposedly the inscription was written at several (or many) different points in time (presumably at the geographic place or places of observation correlated with them). Most important, this fact must be *visible in time-factored inscription* precisely because that is *what it is writing about*. Time-factoredness, then, was the constitutive hypogrammatic context of the visible inscription. It

is read by us by *inspecting the holomorph* (such as the way in which the marks were cut) as well as by *reading the inscription* (its correlation of sets and groups of marks with lunar days and phases). Put another way, holomorph, hypogram, and inscription seemingly cannot be separated in Paleolithic-ese, cannot be segregated as discrete and disjunct horizons of visibility, visuality, and readability. Indeed, they cannot be separated precisely because it was the inseparability and perhaps even the *indiscernibility* of holomorph, hypogram, and inscription that opened up the very possibility of notation—that enabled it cognitively. I will return to this topic in greater detail in succeeding chapters, especially in Chapter Nine.

Because Marshack primarily read the time-factoring of the hypogram (knowable if unread), not the inscription or the "meaning" it inscribed (readable but unknown), his methods and results have often confused unwary seekers of decipherment. The decipherment in Marshack's account remained strictly hypothetical: it was a "best fit" between the holomorph (the observed order of sets and groups of discrete marks in the engraving) and the *text*, the fact that lunar phases are grouped *analogously* to the sets, at least as a beholder of the man-made marks (held in his hand) and the lunar events (up in the sky) might be able to see it. In Chapters Nine and Ten, I explore the fundamental role of analogy in detail.

Of course, if Marshack's marks, as d'Errico has argued, do not in fact have the particular order of sets and groups of discrete marks that he reported, then the "fit" with the lunar phasing loosens considerably. Still, it is a theoretical strength of Marshack's decipherment that the *number* of discrete marks seems approximately to correlate with the actual count of days in a simple lunar calendar that would track a certain number of visible phases of the moon—whether or not these phases were recorded, as Marshack claimed, by marking each one in a *different* way; that is, by using different tools at different times in compiling the calendar. The number of marks does not have to be exact—one mark for one lunar day, for example, or more exactly *x* number of marks for *x* days in one phase of the moon. Indeed, d'Errico's results showed that Marshack's *counts* of the number of man-made marks on the artifacts, putatively characters in the readable inscription, were sometimes wrong: in other words, either there was no Paleolithic numbering going on at all, or it was inexact, or the marks were not counting lunar days and recording lunar phases, whether exactly or inexactly. But all these seemingly negative results can be accommodated by a suitably adjusted theory of lunar-time-factored compu-notation. As we will see in Chapter Ten, the marking need not be *counting* in our sense; it can instead *merely* track visible phenomena by discretely marking each iteration. If counting, it probably *must* be

inexact in order to average the variable counts of visible lunar phases—which are sometimes *not* visible—across multiple iterations, that is, over many actual lunar months. Only by inexactly tracking the (in)visibility of phases of the moon over many months could an exact numeration of lunar-month periodicity emerge recursively. And whether counting or not, exact or inexact, the compu-notation could well have been tracking something else—the primary visible object of visuality—that was analogous to phases of the moon (for example, the mating, foaling, or other behavior of animals) and with which moon-phases became recursively correlated in an "artificial memory system." What seem to be pictorial representations of flora and fauna on the antler from La Marche (Fig. 5.3), ostensibly a lunar-calendrical predictor-calculator, suggests as much: the calendar, though counting by the phases of the moon, could be a timeline of plant or animal life.

Stated another way, the visible analogy and its implied correlation, the seeming fact that holomorph (the material sediment of marks) fits a certain possible text (maybe *only* that text), seems to call both the hypogram and the inscription into being; that is, to motivate an interpretation of the fit and its disambiguation in certain particular aspects and its discrimination in certain particular respects—even if we had not seen any of these features and possibilities in the marks in the first place. Recall that in the case of Flamand's prehistoric markings, the hypogram and the inscription (that is, the "engraved inscriptions" and the supposed context of their engraving, namely that they be read as pictures or scriptings) were known in advance. Marshack proceeded inversely. Both the technological (even taphonomic) form of the holomorph (that is, the visibility of material marking and its configuration) and the logic of a certain possible textuality (that is, the readability of these marked configurations within a particular visuality) could, Marshack contended, be known (the former forensically and the latter notionally or hypothetically). If their numerical and notational *analogy* (their fit despite differences) can be accepted as having been intentionally replicated in the marking (the marks were made to realize the text relayed in the writing), then hypogram and inscription (the "calendars") automatically materialize.

But this direction of analysis can only work out fully in the special case of *visibly time-factoring and/or spatially distributing the holomorph, even if it seems to be* seen *all at once, as a field of marks*—that is, in emergent practices of tallying and counting for the purposes of time-tracking (or "calendaring") and space-mapping (or "cartographing"). Other kinds of writing, such as picturing and scripting, cannot be accessed in this way, or at least cannot be accessed in this way until we have (as I put

it) succeeded recursively to their readable features as aspects of visible artifacts. Pictures and scripts might write *about* time and space. But they are not themselves holomorphically constituted as visible temporal and spatial sediments. In a typical modern calendar, for example, the marks track blocks and stretches in time. But they do not usually do so as marks that are visually understood to have been made in different blocks and stretches *of* time. Instead, they are all in one sequence—a sequence made and seen as such; that is, as a passage of "writing" that is temporally identical with an episode of marking. And in a modern picture, the marks map places, passages, distances, and depths in space. But they do not usually do so as marks set up in different places and depths *of* space. Rather they are all in one plane.

Indeed, the fundamental noetic problem of picture and script is that we must already know both the hypogram (the context of inscription) and the inscription (the mode of textualization) in order to be able to read the marks in the first place. For this very reason one might, in turn, take the holomorphic prehistoric writings read (and unread) by Marshack and other paleoanthropologists to be the origin of the writings read by iconographers (such as art historians) and epigraphers (such as literary critics)—to be the technical, the conceptual, and the evolutionary origins of latter-day pictorializations and scriptivations.

Chapter 6

Successions of Pictoriality

■ I

A picture is a visual recursion of nonpictorial stuff, of matter or marks. It transmutes their like-lookingness into looking-likeness. More exactly, it replicates the unpredictable visual event of like-lookingness, the visual event in which matter or mark is seen *as* something-or-other, as looking-likeness, a visual event in which that something-or-other can be seen *in* the mark. As I will put it, we replicate *pictoriality*: we pictorialize the marks when we replicate what they have been seen-as in order to see just this thing in them. When we reproduce this pictoriality in order for others to see it as well (or even when we reproduce it in order to continue to see it ourselves in new contexts) we have produced depiction, a stable "picture" of the kind addressed by art historians and philosophers of reference, representation, and communication. The pictoriality of matter or marks pictorializes something *in particular* for us. For all intents and purposes we are now using the marks to stand for what they can pictorialize, for we have now *made* the marks specifically for that visibility. We try to see them in this particular way and to manufacture them in order to secure this particular visibility. And vice versa: we manufacture them in order to see them in this way.

It is evident, however, that the pictoriality of matter or marks need not *always* stabilize in the pictorialization relayed in a depiction—in the depictiveness of a particular picture. Rather, pictoriality must be resecured

throughout its stabilization as the particular pictorialization replicated in a depiction for our seeing. Here it is constantly enveloped (and it is sometimes undercut or blocked) by the emergence of *different* pictorialities that are aspectively interdetermined in relation to the same ground—with respect, that is, to the visible matrix of matter or marks continuously afforded to seeing. Put slightly differently, the particular recognizability of a pictoriality that emerges in matter or marks, an unpredictable event in human vision, can sometimes succeed to consolidated depiction in our intentional efforts of pictorialization—succeed to the recursion, that is, in which pictorialization provokes our visual ability to see something particular in the marks *whether or not* they were seen *as* that thing in the first instance. This is a fragile consolidation. It tries to transfer and transform a highly unstable visual occurrence into a stable visibility. All this is not to speak of the fact that the entire succession of pictoriality and depiction as just described remains embedded in the *non*pictorial visibility of the matter or marks that have been seen as something, and in which that something can be seen if we replicate them in a certain way—a visible feature of matter or marks that might have its own nondepictive legibility and significance (Chapter Five).

In distinguishing pictoriality (autonomic, reflexive, or what might be called "radical"), pictorialization (intended), and depiction (consolidated and communicated) as discrete moments in a succession, I have pulled away from the usual starting-point of art historians in order to identify a crucial operation of visual culture as such; namely, the recursion of vision and visuality. Ordinarily art historians content themselves with describing pictoriality as if it *is* a depiction (and conversely with assuming that depictions *do* have pictoriality for their beholders). They may even describe a visual image, a putative event in seeing, as if the depictive matter or marks before the beholder's eyes pictorialized only the visible aspects of things supposedly depicted by the marks. This is an unreliable platform, however. It is possible that (1) I might see a camel in a cloud, (2) might pictorialize the cloud for myself by looking out to see it as a camel wherever I can, and (3) might produce a depiction of this cloud-camel by replicating the pictorialization, seeking to preserve the cloud-camel as the camel it looks like. But none of this means that I cannot continue to see the cloud as something *other* than a camel, whether as a cloud or as something else. And it does not mean that even the camel-depiction could not be seen as something (a cloud or anything else) that pictorialization has *not* replicated to be seen in it. A painting usually has pictorialities other than the depiction it is *meant* to be, especially for beholders who cannot visually access the depiction in the full development and recursion of the iconographic succession (Chapter Seven). This is not, however, a defect of painting or of depiction

(though it might be a difficulty that some paintings and depictions must overcome). It is the very ground from which the intended depictiveness of the painting as pictorialized must arise.

Stated another way, depiction has pictorial aspects (obviously enough) in virtue of being the depiction it is. Ordinarily it is these aspects that we attend to— visually or analytically—when we speak of its pictorial meaning, its intended communicative significance or "iconography." But it also has pictoriality in virtue of being an array of marks that permit things to be seen in them—things that the depiction did not set out to replicate but that cannot be *prevented* from being seen in them. These features of the array can be just as visible to us as the depiction that seems to have been intended by the maker to be communicated to its beholders; new aspects—including new pictorial aspects—can always dawn on us, and often do. These pictorialities—horizons of radical pictoriality in the matter or marks—are perhaps *more* visible outside the visual culture or visuality within which a depiction fully attains its intended reference (that is, within which the pictorialities of a configuration wholly accede to a particular depictiveness). It might be, in fact, that for some beholders the depiction (the pictoriality we think that we see the marks to have been made to relay) is invisible regardless of its other pictoriality, and even *in virtue* of these visible horizons of likeness.

Depiction never enrolls all the pictoriality from which it succeeds, for it depends—depends in succession—on emerging from it, and on allowing it to continue to emerge recursively until a *particular* threshold has been achieved in replication; namely, the threshold at which a depiction can be seen to be the intended pictorialization of what the marks might be seen as. This open-endedness can be a burden, of course, for some purposes of representation and communication. There are, for example, depictions that depend on the constraint that the objects we see as pictorialized in them *cannot* be seen in the same marks as different objects as well, or at least should not be so seen. (Consider a traffic-marking system in which pictograms designate objects and activities that must not be conflated or confused visually with other objects and activities.) For other purposes, however, ambiguity confers richness and resilience, perhaps esthetic, on a depiction. It might be that our visual uncertainty about the identity of depicted objects, about divergent pictorialities in the marks, is pictorially intended—a common feature of figurative painting as an art.

By the same token, the pictoriality of things does not always succeed to depiction. I can always try to see the camel in the cloud that I saw it as, and to some extent I can pictorialize the cloud whenever I see it. However, if I cannot reliably replicate the cloud in my seeing as the camel that I have sometimes seen in it, and further if I cannot produce, reproduce, and se-

cure this visual event for other people (whether by pointing out the camel in the cloud for them to look at or by making something that enables them to image it), I have not really consolidated the cloud as a camel-picture for me or anyone else. Neither I nor anyone else can reliably use the cloud to stand for the camel I have seen in it. At best we can go on trying to make it possible to see the cloud as the camel.

For some intents and purposes, or in some contexts, the awareness of resemblance (the cloud looks like a camel) might well suffice for the possibility of reference (the cloud *means* camel or even *portrays* a camel). Why would I persistently try to envision the cloud as a camel, looking out for the camel in it, if I were not using the cloud as a camel-pictorialization, at least for myself and even if only to see whether this resemblance in the cloud might persist visually? And certainly the stability of the reference must ride on the awareness of the resemblance: it emerged recursively in it. Still, visual replication of the resemblance need not succeed to the reference that requires it. In pictoriality we are visually aware that we can replicate the cloud specifically for its camelness: we see that we can look out for it, that we can show it to others, that we can simulate it. But this is only one step in making that camelness out of the cloud or anything else—in preserving the resemblance noticed in vision as the *raison d'être* of looking at it, let alone as the *raison d'être* of the cloud envisioned in this way. Certainly it does not tell us *how* to take the cloud that looks like a camel and turn it into a cloud (or anything else) that can be used specifically to get us to see that camel in it. Put another way, we move from a visible morphology (what we see the marks to be when including things that we might see them as) to a visual analogy (what the marks make us visually aware of when we use them to see that morphology, including the things that might be seen in it). Analytically and psychologically, however, the morphology and the analogy are disjunct.

In all this, three fundamental points must be kept in mind. First, the question of depiction as visual culture is the question of its *particularity* in virtue of its replication of a certain pictoriality grounded in a given visual event. If I see the cloud as a certain camel, pictorialize that visible affordance in further activities of making and remaking that visual event, and eventually produce something that specifically *enables* that event (and sometimes in principle *only* enables it), then the depiction has the pictoriality that it does because it relays my seeing the camel in the cloud. Second, however, this succession of pictoriality—from seeing cloud as camel to making a cloud for the camel to be seen in it—need not be *singular*, even with respect to the cloud that I see as a camel and to the cloud that I might make for the camel to be seen in it. At any point, and in virtue of the radical

pictoriality of natural vision, that cloud could be seen as something else; that is, something other than the camel it was seen as by me. Other things could be seen in it, regardless of my best efforts in envisioning and replication. What steers me toward the particularity of the analogy in the relevant visible morphology is the *singularity* of the replication that delivers it: I am aware (or need to become aware) that the cloud has been made by me (or made by someone else *for* me and others) to see the camel in it, and not something else or nothing at all. And what steers me toward the singularity of the replication is the *particularity* of the visual events: I must be able to reproduce a seeing of the cloud as camel, at least by seeing the camel in it, aware that this is what the replication has been made to deliver.

Third, the successions of pictoriality and the recursions of depiction, however guided by intentional replicatory activity or pictorialization, remain surrounded by unintended uncertainties, ambiguities, multiplicities, and errors. Even when replicated with the intention of depiction, the non-pictorial matrix (what a beholder might see the depiction as) might yield nothing visually in the way of visible resemblance to anything beyond itself. It is possible that I or any beholders might *fail* to see the cloud-camel, my pictorialization of the cloud, in the configuration that intentionally tries to relay it. For that configuration must, of course, look like a cloud too, whether or not it is taken to be an intentional pictorialization thereof. Consider the case of drawing a single straight line across a sheet of paper. I could draw the line as a horizon; one of its radical pictorialities for me in that case would be its horizonality, intentionally pictorialized in my drawing in a certain way. And I could fully intend this topographical or spatial feature to be seen in the configuration as what it depicts. But it could be that a viewer, whether me or someone else, sometimes sees *nothing but* the line. "It's just a line," he might say, even if he might think that I intended that very line (drawn in the way that it is) to be seen by him. In this case, no visual analogy is being built from it by replicating the relevant aspects of morphology—pictoriality. Indeed, in this case it is hard to see how depiction *could* be built from it, regardless of the radical pictoriality—the horizonality—the line has for me. Probably I would need to modify the straight line to make it look more horizonal, or somehow show that it is the *horizonal* straightness of the line that I am replicating—say, by adding "sky" color above and "earth" below.

Moreover, when it does come specifically to visible resemblances of marks and their pictorial aspects, we will likely be enmeshed in an embarrassment of visual riches. Just as depiction is overdetermined by the pictorialities from which it extracts its envisioning of things (the theory of the iconographic succession addresses this dynamic [Chapter Seven]), so

pictoriality is overdetermined by the resemblances from which it extracts its visibility. We will always be able to see something as all kinds of things even when the thing itself has specifically been made (and we are specifically intended) to see only some aspects of some things in it. Or at least depiction and pictoriality must notionally be overdetermined in this way. It is an inherent function of our autonomic processing of visual affordances—processing governed by geometrical optics—that the successions and recursions of pictoriality can be overwhelmed by other orders of the visibility of things.

Nevertheless, and to focus on the matter addressed in the present book, in practice or in the real life of visual culture it seems that depiction can be more or less successfully *inter*determined as a visible aspect of the visual constitution of configuration. And it seems that this can often be more or less successfully communicated as pictoriality afforded to beholders by the configuration. A fuller account of the registers, routes, and relays of this interdetermination would therefore be desirable. If depiction, when successfully consolidated, is one of the hallmarks of human visual culture, even if it is not the sole province of visuality (see Chapters Seven and Eight), it seems to be equally clear that vision must be tuned or directed in certain ways—if not always cultured—to reach this threshold.

In this chapter, I pursue elements of this account. A general theory of visual culture requires only, however, that we treat pictoriality (for many purposes defined as the consolidated depictive aspectivity of configuration) as one of the aspectively interdetermined successions that constitute visual culture, especially in the context of the iconographic succession (Chapter Seven). Many technical problems of the visual psychology of depiction could be solved in a number of ways, including ways quite different from the ones I propose here, without changing the role I assign to pictoriality in my account of visual culture. Some readers might wish, then, to skip directly from here to Chapter Seven.

■ 2

As I have already intimated, to describe pictoriality as it is recursively consolidated as depiction requires us to address its occasionality, particularity, singularity, and intentionality in replication, as well as its conventionality and communicability. I begin with the primordial *occasionality* of pictoriality.

Pictoriality germinates in an event of seeing-as, an autonomic happening in vision. (It is an unpredictable occurrence, but not inexplicable or

ungovernable: there are many ways to provoke seeing-as and to guide it.) But *mere* seeing-as wholly precedes the succession of pictoriality, not to mention the recursions of depiction. Only the replication of an event of seeing-as by attending to it as a continuing visible horizon of something noticed in the visual field can inaugurate pictoriality.

To be specific, the mere visual event of visible resemblance between an array afforded to vision and a virtual object (a relation usually experienced visually as a brief sensation of fleeting identity—of *real* virtuality in the field of vision—that is immediately disambiguated in natural vision) must become the intentional object of visual orientation and attention. In the activity of pictorialization, the object can maintain itself only so long as *that* visual event (best defined as the intentional seeing *of* the virtual object unintentionally constituted in primary seeing-*as*) can be replicated, even in the particularized seeing-*in* ostensibly managed by consolidated depiction (that is, by iconography that recursively regulates vision in terms of its envisionings and that produces configurations materially afforded to natural vision for seeing-as [Chapter Seven]). Therefore pictoriality seems to be one-off: it happens anew with every look. And it is context-specific. In some contexts of looking at the array afforded to it, even in some *close* looking, it could devolve differently, or not at all. Despite iconography, then, the essential occasionality of pictoriality persists: persists, that is, throughout the succession from primary seeing-*as* (in the adaptive adjustments of natural vision) to the recursive seeing *of* seeing-as (in the intentions of pictorialized looking) to the retrodictive refinement of seeing-*in* in the replications of depiction. Depiction is ultimately nothing more (though also nothing less) than what you can see something *as* when you see *of* it that something has been seen *in* it (because it was seen *as* that thing . . . and round and round again, interminably). And that complex visual event, however consolidated in subtle psychological recursions, will always be susceptible to many vagaries. Regardless of iconography, I can never get beyond or get away from the way in which a configuration looks to me. By definition, as we will see in more detail in the second part of Chapter Seven, this would seem to entail the possibility that I might visually miss—fail to be able to *see*—some of the primary depictions created in visual culture for itself (its iconology). But so what? Visual cultures constitute themselves *because of* this occasionality: cultures try to reduce it. Indeed, they are constituted *despite* it—leaping over it.

The occasionality of pictoriality has a relevant parallel in natural language, that is, in speech and to a lesser extent in writing, even if it is only a partial one. Building on Wittgenstein's ideas about language-games (see Chapter Nine), H. P. Grice asserted that his analysis of linguistic meaning

should apply "to any act or performance which is or might be a candidate for non-natural meaning" in the sense defined in his essay "Meaning," published in 1957.[1] By "natural meaning" Grice denoted the sense of "meaning" in sentences like "These spots mean measles" or "Those spots didn't mean anything to me, but they meant measles to the doctor." To use terms developed by such theorists as Charles Sanders Peirce and Alfred Gell, the spots were natural signs or indexes of (my having) measles. In contrast, by "non-natural meaning" Grice denoted the sense of "meaning" in sentences like "Those three rings on the bell of the bus mean that the 'bus is full,'" that is, conventional or arbitrary "symbolic meaning."[2] Grice occasionally considered non-natural meaning in gestural signalling and other nonverbal activities.[3] As he once proposed, "any human institution, the function of which is to provide artificial substitutes for natural signs, must embody, as its key-concept, a concept possessing approximately the features which I ascribe to the concept of utterer's occasion-meaning."[4] A picture would be an "artificial substitute for natural signs" insofar as appropriately configured spots of paint on a surface might represent the measles that would indicate someone had the disease if the spots were observed on his body.

Grice construed non-natural meaning in terms of a speaker's intention to produce an effect on an audience, what he called the speaker's sentence-meaning or occasion-meaning, or what is meant by what is said by the speaker at a particular time in a particular activity rather than "what is conventionally meant" by the word or phrase, so-called sentence meaning, literal meaning, or meaning in a language.[5] In considering occasion-meaning, we examine what I mean when I shout "Dog!" or (to use the dog's name) "Butch!," not what "dog" or "butch" might mean "in the language." Occasion-meaning is primary and irreducible. It is also meaning that is not readily subject to correction, or as it were incorrigible. If when I shout "Dog!" to warn you (or "Butch!" to call my dog) I am challenged on my meaning, it is legitimate for me to ask my interlocutors "Who are *you* to tell me what *I* mean?"[6]

An account of specifically *pictorial* occasion-meaning—that is, of pictoriality used to pictorialize something-or-other in particular—has never really been developed in art history, in part because the distinction of pictoriality and depiction has rarely been explicitly observed.[7] On the face of it, however, such an account would likely be close to some art-historical intuitions about certain peculiarities of picturing. Pictoriality includes not only what the pictorialist effectively depicted—what art historians often call the intended meaning of a picture (or what is better defined as "the depictiveness of configuration"), the object of iconography and iconology.

Equally important, it *also* includes what beholders (including the maker when making the picture) have actually found to be pictorialized, *whether or not it was depictively intended*—a matter to which we must return in evaluating the historical plausibility of "positive" iconography as distinct from its negative hermeneutics (Chapter Seven). Grice recognized this horizon of "occasion-meaning" in natural language. But he excluded it from his preferred definition of the concept, which described the successfully communicated intended meaning of the speaker. Whether we emphasize the maker's or the beholder's awareness of pictoriality, however, we must deal with a one-off, context-specific relay in the successions and recursions of vision and visual culture—a relay to be distinguished, just like Grice's occasion-meaning in speech, from depictive meaning *tout court*.

In turn, and implicitly recognizing the visual primacy of pictoriality in the representational status and communicative functionality of depiction, some art historians have denied that there can be a "language of pictures," the pictorial equivalent of literal meaning or meaning in a language that would regulate pictoriality—regulate it recursively and analeptically—as a program of depiction, an iconography. This entails a certain hermeneutics: depiction must be analyzed in terms of the intentions of pictorialists in replicating specific pictorializations, an inquiry that runs parallel (at least for some distance) with Grice's focus on the occasion-intentions of speakers or utterers. According to this account of the matter, there is no lexicon and no grammar that both fully specifies and wholly constrains what a picture might pictorialize in every instance of the visibility of the configuration and its affordances of pictoriality to beholders, including the picture maker. For this reason we must examine both what the picture-maker intended to pictorialize in the configuration and equally important what it *does* pictorialize to someone in a given moment of seeing the configuration or using it to envision something, whether inside or outside an iconographic succession (Chapters Seven and Eight). As I have already intimated, what the maker intends to pictorialize (to stabilize in a depiction) and what the picture does pictorialize for someone (as depiction for that individual) might be very different pictorialities.

Still, the occasionality of pictoriality—its one-off, context-specific nature for the maker of the picture, for the beholder, or for both—has not always been identified with the historical specificity required by a general theory of visual culture. To be sure, the identification has sometimes been made with some degree of sociological concreteness. In *Painting and Experience in Fifteenth-Century Italy*, for example, Michael Baxandall explicated the pictoriality of painted configurations in terms of canons of visual judgment that supposedly devolved in activities of social life—in,

as it were, the language-games (or the games of seeing) in which pictures were embedded (see Chapters Nine and Ten). Such canons condition the seeing that is brought to pictures. Therefore they help to constitute depiction: people see paintings and other artifacts as depicting what they can see in the configurations (regardless of what they might sometimes see them *as*) as a function of their social activities, interests, and motivations. Baxandall's "primer of the social history of style" specifically addressed the social relations and practices that motivated people in fifteenth-century Italy to see the properties of objects and spatial relations, whether real or depicted, such as absolute size (scaled relative to an observer or another reference point), volume (of a solid body seen under a visual angle as a particular shape), distance (from an implied standpoint or other reference point), and so on.

Baxandall's sociology was plausible. As history of visual culture, however, it was analytically premature (though immensely influential in raising the requisite questions). It tended to assume what needed to be demonstrated. The ability of a fifteenth-century Florentine merchant visually to gauge the size, volume, and weight of a barrel (an acuity that had been honed, Baxandall suggested, in the course of the merchant's activities of trading, banking, and so on) was necessary for his ability to interpret barrel-pictures in certain Florentine paintings. But it could not have been sufficient. The barrel-pictorialization must have already been partly secured in a certain way (secured, namely, as having certain relevant aspects of size, volume, etc., in the depicted object) *before* socially-conditioned visual judgments of apparent volume or weight were relevant or at least *during* the visual successions and recursions in which these judgments transpired.

Some quotient of barrel-pictoriality likely was not satisfactorily resolved visually by taking the configurations, at the level of intended painterly replication, to be painted simulations of actual visible barrels that solicited, confirmed, and sustained the social seeing-as supposedly brought to them in the visual habits of the beholders—as if *pre-iconographic* mercantile recognitions would smoothly transfer into the fully-freighted *iconological* intelligibility of complex figurations. (These terms play a role in the theory of the iconographic succession and will be explored in more detail in Chapter Seven.) Did a Florentine beholder really judge the shield or armor of a painted archangel with respect to the weight, say, of items of *real* armor? (If the shield looked *as* heavy as just that item of real armor, shouldn't supernatural heaviness—or lightness—nonetheless have been seen in it?) Were the perspectivally ambiguous (and sometimes optically unnatural) sizes of certain human bodies in Ghiberti's *Doors of Paradise* at the Florentine Baptistery really tethered

wholly to social activities of visually estimating the *real* size of things? In addition to seeing the shield or the stature of the human figures as the kind of things routinely seen in the world, beholders surely had to see as well the unestimatable *weightiness* of the archangel or the the immeasurable *gigantism* of Jacob in the depictions—construing pictoriality in ways not entirely compatible with Baxandall's supposition that in these contexts pre-iconographic seeing-as simply *equated* depiction (and vice versa).[8] It was partly for this very reason that Baxandall's later work edged away from it. In virtuoso art-historical explanations of ambiguous pictoriality presented in his *Patterns of Intention*, Baxandall edged toward fuller historical interpretations of pictoriality.[9]

Despite *Patterns of Intention*, neither art history nor visual-culture studies (which is often even more attached than art history to discursive and semiotic models of pictorialization) has fully embraced a robust analytics of pictoriality as it emerges, intentionally or not, in the autonomic activity of vision in turn sometimes stimulating iconographic succession. Indeed, insofar as pictoriality succeeds only rarely to the equivalent of linguistic meaning, *depiction always is nothing but a relay of occasion-meaning*—the continuous accession of particular visible pictorialities of a configuration (and their continuous recession) used visually to do something with the marks; namely, to virtualize something.

■ 3

We must take care to notice that a Gricean account of pictoriality cannot be developed without modifying some of Grice's assumptions and procedures. They were tailored to speech and to the construction and reconstruction of the intentions of speakers and their listeners. Pictures are not simply the visual equivalents of proper names or our terms for the natural kinds we recognize (such as "dog" or "archangel"). They must show their objects to have certain visual properties—size, shape, color, and so on—that individuate the depicted object to some extent and in some cases to a very great extent. Still, this does not eliminate the problems of singularity and particularity that bedevil the deployment of names and natural-kind terms. Rather it *compounds* them. If we pursue a Gricean approach to the matter, it will be the *intentions* of the speaker (in our case the intentions of the pictorialist) that "in a nested kind of way" determine what object is referred to by a sequence of sounds (in our case by an array of marks, especially one that displays formality and style) that is afforded to listeners or beholders.[10]

To use David Novitz's formulation, "at least part of the depictor's aim in producing marks and colours is to enable an audience to recognize that they constitute a picture of something or other, and he will assume, quite legitimately, that the audience, in its turn, wants to be able to do so."[11] Specifically, a pictorialist meant something in a picture if (and only if) he made it intending: (1) that the making of the picture produce a certain response in certain beholders; (2) that the beholders recognize this intention; and (3) that this recognition of the maker's intention function as at least part of the beholders' reason for their actual response to the picture.[12] Each of these pieces of the puzzle is analytically distinct—one step or one moment, no doubt involuted and partly recursive, in the intentional analytics (here analyzed as threefold) of the visual succession of pictoriality. Indeed, these stages often must be *empirically* distinct. Usually, for example, making (that is, [1] above) precedes (2) beholding (with the partial exception of the *maker's* on-going seeing of his own picture-making). And often (2) beholding (even the maker's acts of beholding his work of picturing) need not (3) succeed to the maker's (intended) pictoriality even if pictoriality has throughout been guided by (1) the maker's intentional orientation to anticipated beholding (including his own). This is the primary reason (or one way to describe the reason) why it is difficult to give a unified account of picturing as a relation of common, consistent sense-making, of shared culture, that transpires or subsists between the picture maker and immediate beholders of the picture made—that subsists, even for the maker, as an aspect consistently visible to him in the configuration as its intended pictoriality. It is one reason, in other words, why we cannot speak of the meaning of a picture, the iconological horizon of its pictoriality, without reference to the pictorialities it might have throughout its iconographic succession.

As we will see in Chapter Seven, an available iconography, a tradition of deploying visible forms and motifs in a certain way, can sometimes "conventionalize inference" about the intentions of pictorialists and the variable occasion-meanings of their pictures, or pictoriality.[13] A beholder might reasonably suppose, for example, that a picture maker intended him to see a particular bright yellow blob in a painting as the burning sun (compare Van Gogh's *Yellow House at Arles* described by Roger Fry [Chapter Three, Fig. 3.6]) because such blobs in paintings, appropriately configured, colored, and composed in relation to other blobs, have conventionally denoted this solar effect within certain traditions of depiction. (In *other* traditions, such as the ancient Egyptian, a set of linear rays extending from the circle of the sun to the edges of object-shapes—their depicted surfaces—denotes the sun's bright, scorching powers.) But pictur-

ing understood as the picture maker's occasion-meaning, as pictoriality, cannot universally depend on such iconographic conventions with regard to all aspects of the picture *qua* picture, that is, with regard to all of its visible pictoriality. In the case of *Yellow House at Arles*, as we have seen, Fry rightly insisted that the painting did *not* depict what the iconography of Mediterranean climes (clear blue skies, bright hot sun, and so on) had conventionally represented in the visual culture of Van Gogh and his contemporaries, even though the critic did not venture a theory as to what its occasion-pictoriality *did* for Van Gogh.[14]

To sum up, an account of pictorial occasion-meaning, or pictoriality, shifts the analytic burden from iconographic conventions or visual-semiotic codes to *pictorialists' intentions*. These intentions become the art-historical object *par excellence*. Indeed, the picture maker's intentions become the object of investigation not only for present-day art historians who seek to understand how a picture might have meant something to its maker and past beholders. *They must also have been the historical object sought by all past beholders, including the maker himself.* Stated retrospectively or from the point of view of beholders inspecting a picture that has been produced specifically for their seeing (or so they might suppose), the beholders have to find evidence for the maker's intentions in making the picture, that is, for *his* pictoriality or for the pictorialization he produced. This is a *sine qua non*, at least if the picture is to succeed for them to the depiction intended for them regardless of any *other* pictorialities autonomically constituted in their seeing of the visible configuration. Stated prospectively or from the point of view of the maker, a pictorialist must try to get beholders (including himself as a kind of privileged or "test" beholder) to recognize his intention that the beholder have a certain response to the configuration. If both parties are successful in these efforts, if they converge, the pictorialities that emerge in visual and iconographic successions can succeed or accede to (or recede in) an *intended* privileged pictoriality seen to have guided the production of the configuration. This history explains why iconographic successions might sometimes culminate in wholesale visuality despite inherent disjunctions between pictoriality and visuality (see Chapter Eight).

■ 4

Given the autonomic accident of seeing-as and its affordance of pictorialities, the maker's conscious intentions should not be over-estimated in evaluating a depiction. Above all, they should not be assumed to govern the

successions and recursions of pictoriality, even if they shape pictorialities into depiction. When or where is a pictorialization intended, and how?

It has been pointed out that Grice's "reduction or partial reduction" of linguistic meaning to speaker's intentions (to occasion-meaning) places a "heavy load on the theory of intentions."[15] On the face of it, in fact, it seems to be fundamentally circular or vacuous, though perhaps not viciously or fatally so. If a word or phrase has any "determinate meaning" in its utterance, is it not because a speaker's intention involves sentence-meaning, literal meaning, or meaning in a language—the meaning to be received and construed by the speaker's listeners? And if the relevant intention of the speaker's utterance simply is the intention to mean what the utterance means in the language, a meaning understood by the listeners, then have we not simply come full circle? Why appeal to speaker's intentions when all we need to know is the linguistic meaning of the word or phrase, its conventional meaning in a language understood by listeners?[16]

Admittedly Grice was constrained to admit that "a definiens for 'U[tterer] meant that p' which at some point reintroduced the expression 'U meant that p,' or at least introduced the expression 'U meant that q,'" would be "at least prima facie strongly objectionable."[17] If "meaning that p" on a particular occasion is nothing more than the intention to "mean that p" in the language, there is no need for analysis of the putative *occasion-meaning* p—only for analysis of that occasion of meaning-p in the language. Nevertheless Grice stressed that "meaning that p" (on a particular occasion) could not wholly reduce to "meaning that q" (in the language), or merely reproduce or reflect it. Because we can distinguish between an utterance W that here means p and there means q, even if $p = q$ (that is, the things or objects denoted by p and q are identical), the so-called circularity could be *hermeneutically* productive. (Grice's critics have typically taken any analytic circle to be vicious or vacuous; hermeneutic circles do not interest them.) In an activity of interpretation, sometimes described as language processing, the listeners (followed by the present-day historian) seek the evidence that will allow them to determine (however hypothetically or provisionally) whether the sentence in this speaker's use-that-means-p means what q means in the language, or not.

Turning to the domain of depiction, and regardless of the domain of speech acts in such natural languages as English, it is *not* viciously circular or analytically vacuous to say that a pictorialist made a picture-meaning-p intending to mean what p means in some kind of pictorial language. It is not circular or vacuous—only implausible and unrealistic. If there is a heavy load placed on pictorialists' intentions in depiction, its weight

falls differently for picture-makers or beholders (or it must be differently lifted by them) than does the comparable weight placed on intentions in the domain of speech acts in natural language, where the intentions of speakers must be perceived and processed by listeners. (Again, then, the parallel between a speaker's meaning and pictoriality takes us only so far.) Although the picture in its occasion-meaning (p) and its meaning in the pictorial language (q) might be semantically identical, the identity must ride, as we have seen, on a successfully realized moment of (re)securing it in p in the face of *the inherent or natural ambiguity of the marks (p and/or q, r, s, and t) putatively pictorializing something in particular (say, q) that they resemble.* Grice's account of speech acts (which have no inherent natural respects of object-recognizability or iconicity) might well falter in this arena. But we need not pursue the matter. A model of a *pictorialist's* occasion-meaning or pictoriality can survive the accusation of vicious circularity or analytic vacuity precisely because it must take account of the visual history in which seeing objects and pictures (and recursively seeing objects *in* pictures and pictures *as* objects) is embedded: *where in a visual image we can recognize marks to look like objects in the world (objects visually known not to be actually afforded to our vision) we must resecure this resemblance as the particular pictorial aspectivity of the marks—pictoriality.* The depictiveness of the marks, then, arises in our discovery that their visible resemblance to objects has been produced or reproduced as such (presumably intentionally) and, in a further recursion that we cannot assume, that it has been exhibited to us (again presumably intentionally). If we do not grasp these replicatory coordinations, putatively intentional or to be described as intentional acts of seeing and making, we will have failed to grasp an intended pictoriality because the array of marks could resemble any number of other things that can be seen in the configuration. It could even resemble some *one* thing that it could depict but does not insofar as it was not intentionally pictorialized in that respect.

Of course, the crucial evidence that allows a beholder to determine that the picture in the maker's use of it means p (and possibly that the picture in the maker's use-that-means-p means what q means in a pictorial language) cannot simply be the picture itself. If the pictoriality of the marks for the beholder serves as the only evidence for their supposedly determining pictorial intentions and for the supposedly particular (and specifically recognizable) depictive outcome, then it would indeed be quite impossible to say without vicious circularity and vacuity how he could come to discover its meaning.

But here again the natural ambiguity of the marks and their resolution in successions of pictoriality, despite resistance and disjunction, provides

a crucial clue: the marks have visible object-*resemblances* (a phenomenon that happens unintentionally in vision, or happens *to* it) that might or might not warrant our recognition of intended object-*representation* in them. The beholder's evidence for the picture maker's meaning therefore must involve not only what the picture seems to exhibit as the apparent depiction. It must also involve *what the picture exhibits in apparent formality and style* (see Chapters Three and Four). To understand the formality and the style of the artifact, to *see* them, is to see in what respects it replicates attributes displayed (or not) by similar artifacts, and especially to understand the historical—the genetic—chain of replication, how it was *caused* and what can be inferred from that. In turn, the maker's way of replicating marks helps to show the beholder which of the possible pictorial resemblances that might be afforded by the array of marks have been produced to be recognized. Specifically, it helps the beholder to infer that a particular object-resemblance in the marks was maintained in a chain of replications in order *to preserve this very configuration as pictoriality*—a retention that can be interpreted as evidence that the maker intended to depict what that set of marks seems to resemble.

Stated another way, the intentionality of pictoriality—what a particular occasion of depiction intends to picture—emerges in the complex replicatory sequences in which the marks are made, recognized, inspected, revised, reinspected, reproduced, and preserved. (These sequences must possess style; they tend to accrue formality, and even to promote stylisticality.) Replication might involve the making of many discrete sets or arrays of marks—many separate "pictures." But it need only involve the making of *one* set of marks that have been recursively guided in their making by an episode of seeing-as maintained and refined as seeing-in. Indeed, it need only involve the sustained or repeated visual inspection—the *seeing*—of marks as having object-resemblance that should be seen in the marks, or reseen-in the marks, whenever they are visible. The reiteration of this seeing-in cannot prove, of course, that the marks were made *for* it, though if they are artifacts it is quite likely they were (see Chapter Five). But it will be sufficient to pictorialize the marks—for them to accede to pictoriality—regardless of their origin and purpose as marks. As the depiction consolidates in such replication, so too does its intendedness as a *particular* pictorialization. And vice versa: as a particular pictorialization succeeds as the visibility of a configuration (especially in the replication of marks that manifestly refine the initial visual occurrence of object-resemblance), and as nonpictorial and other pictorial possibilities recede, its intentionality has recursively been established. At no point in these successions and recursions must any agent of

replication deliberately intend to see or to make anything in particular, or to produce or to reproduce it. Recursively, however, depiction emerges overall: as the intendedness of particular pictoriality, itself a natural function of vision, subsisting in tension with all the other autonomic ways in which the marks remain visible or can acquire visibility.

Of course, an intention to produce a given pictorial functionality in configuration might be said historically to *precede* the replication of the marks that support and sustain it in virtue of their resemblance to the object envisioned. To this extent, the model of depiction as the replication of the pictorially functional resemblances produced in marks is circular. At certain points we must partly assume the consequent. But when pictorialists and beholders bootstrap themselves into visually understanding the pictoriality of visually ambiguous marks, they can enter this replicatory cycle at any point. These include not only the point to be described in Chapter Seven as the iconographic succession but also the point—the analytic primitive with which I began this chapter—at which the marks seem *only* to have certain features that resemble objects. The discovery of the maker's intention to preserve these features, and in turn the recognition of a pictoriality and its representational objects, follows along.

The question of discerning a picture-maker's intentions in making a picture, then, must be shifted from the spot in which it is commonly asked—the supposed problem of *discerning what the maker's picture means.* It must be refocused on what actually decides that issue, namely, the problem of *discerning what marks the maker effectively intended to preserve* and for what reasons (attending to which aspects of the marks) and purposes (projecting what role these aspects can play). This matter can be addressed by present-day historians as well as by beholders of the marks in the past. Essentially, in fact, it requires all beholders—present or past—to act as historians of the replication of the aspects of marks visible to them in configurations. It can be addressed across a wide range of marks not limited to depictive ones. The aspectivity constituted in this wide arena can be brought to bear on depictive intentionality and used to resolve its internal uncertainty and circularity.[18]

■ 5

Pictorialization or the maker's intention to replicate certain kinds of marks—those having pictoriality—need not be communicable or communicated to anyone else. As linguists have pointed out, in the case of speaker's meaning communication is not the only or the essential func-

tion of language.[19] In the case of depiction, the pictorialist might be the sole intended and the only possible beholder of the picture. Probably this is routinely true for some (perhaps many) aspects of *any* depiction: *only the pictorialist maker sees their pictoriality*, though in most cases this does not matter very much in pictures made with the complex, nested intention (as above) that pictoriality be largely intelligible to other beholders as depiction.

For example, a builder undertaking a new project might draw a building that he has already erected in order to help him remember how it was constructed (see Chapter Nine). Someone else, however, might be able to make nothing out of the builder's scribble, despite the fact that it was fully and functionally pictorial for the builder. Perhaps we should say that the builder intended to communicate with himself. After all, he drew his picture in order to transfer his past success in building to a future project of construction, as if speaking to himself across time. But the builder could draw the building and never again consult the picture for any reason. When he made the drawing it was a picture of the building.

As John Searle has noted, "With pictures the fact that the picture can represent a certain state of affairs is clearly independent of the question whether it is ever used to communicate anything to anybody." Thus, according to Searle, "in order for the picture to be a representation of a state of affairs the speaker [sic] must produce it with the intention that it represent that state of affairs."[20] (Needless to say, however, and as Searle took care to note, the notion of representation—like the Gricean model of intention to communicate—subsists here as the logically primitive term. It is the explanandum of depiction, not the explanation.) Psychologically it is not difficult to grasp why pictoriality understood as an aspect of marks for the pictorialist—a succession in his visual field—cannot be easily transmitted *beyond* the visual experience, visual activities, and visual intentions of the pictorialist himself. It is more difficult to see why depictive functionality conceived as essential visibility (as it were, visually available to *all* beholders) should fail, as it often plainly does— a topic to which I will return at the end of Chapter Seven. Depictions are displayed or exhibited; they are produced for this purpose. But this says nothing yet, one way or another, about whether their pictoriality has been communicated—nothing, then, about history (that is, about pictoriality coming to function depictively), or about culture (about depictions coming to organize vision, stimulating pictoriality). The question of the communication of pictoriality (like parallel questions that arise in other aspective interdeterminations of visual culture) is a question specifically of the *sociology* of visual culture; indeed, it is its primary and es-

sential question. It suffices for a general theory, however, to remark that all the questions of vision and culturality can arise *without* the element of communication.

■ 6

Pictoriality in depiction consists in retaining and relaying the visual resemblance of an array of marks to one possible object (or at least to a determinate set of possible objects) rather than other possible objects (or an indeterminate range of possible objects) that might be visually compatible with the visible configuration. And if we further rule out the notion that participants in a visual culture always depend exclusively on conventions that fix these discernments and discriminations in advance, then "what accounts for the singularity of the singular judgment?"[21] Or, as Gareth Evans has stated the question, "What conditions have to be satisfied for a speaker to have said that p when he utters a sentence which may appropriately be used to say that q and r and s in addition?"[22] In the case of pictures, a two-dimensional configuration can be a correct projection of an indefinitely large set of three-dimensional solids. But it might only be used to depict one of them. What, then, determines that the configuration pictures a cube, say, and not a pyramid? Or to use Dennis Stampe's cunning example, "What determines that it is twin A, and not twin B, that the photograph [of one of two identical twins] represents?"[23]

"In general," Saul Kripke has written, "our reference [in using a word or phrase in a speech act in natural language] depends not just on what we think ourselves, but on other people in the community, the history of how the name reached one, and things like that." He has suggested that "it is by following such a history that one gets to the reference."[24] In the chains of communication that Kripke seems to have had in mind, a proper name or natural-kind term "will denote some item x if there is a causal chain of reference-preserving links leading back from [the utterer's] use on that occasion ultimately to the item x itself being involved in a name-acquiring transaction such as an explicit dubbing or the more gradual process whereby nicknames stick."[25] To use Michael Devitt's terminology, "Our present uses of a name 'borrow their reference' from earlier uses" in a "causal network stretching back from our first uses of the name to designate" an object.[26] Devitt has called such a chain a "d[esignation]-chain." Identifying the d-chain solves the problem of singularity as it applies to all users of a proper name or natural-kind term except the *first* user: "Which object a person designates depends on

which d-chain in fact underlies his utterance and on which object that d-chain is in fact grounded."[27]

Devitt's Kripkean notion of a d-chain runs in parallel for some distance with my model of a chain of replications that precipitates depiction (and enables us to recognize it); namely, a chain of mark-making (or of visually [re]inspecting marks that have already been made) that continuously preserves the object-resembling features of certain marks throughout a visible material history of their application, media, and contexts, especially a history of their visible variation and material transformation in *re*application, *re*mediation, and *re*contextualization. As we have seen, however, depiction differs from natural language in its intentional structure. In a designation-chain in natural language, the essential "reference-preserving link" would seem to be the intention of a later user to use the proper name or natural-kind term with the same reference as the earlier users.[28] Depiction is grounded in a seemingly more primitive event at the autonomic level of the visual processing of visible affordances. At a certain point in the replication of marks (or simply in looking at things) pictoriality simply *happens*. It need not happen as something that the mark maker intended beyond what was intended in the simple making of the marks. And sometimes not even that: the marks might not have been made intentionally *as* marks but created for other reasons. (In certain prehistoric contexts, as we have seen in Chapter Five, marks might have been made on surfaces [e.g., Fig. 5.2] to test the cutting power of a tool or to sharpen its edge.) Still, in due course these marks could support depictive replications. Pictoriality could be constituted in replicating them for certain visible virtuality they might be seen to have. In the case of pictoriality, then, what Kripke has called an "initial baptism" of a proper name or natural-kind term might better be called an initial *advent*. Regardless, it has a pivotal role in the historical, causal, or genetic theory of reference deployed in the notion of d-chains, whether of names and natural-kind terms (designation-chains) or in pictorializations (depiction-chains). It is not so much a question about the "history of the use of a name," which might be secondary or successive in the genesis of linguistic representation, as about the "history of naming the object," which might be primitive.[29]

Like the maker's occasion-meaning in the Gricean model of linguistic meaning, in which intentions bear a heavy load, "baptism" bears a heavy load in the Kripkean approach. If all the later uses of a name are causally linked to earlier uses, then the first use must be causally linked to the object itself in certain ways: by pointing to the object itself, by uttering what will become its name, and perhaps by using a demonstrative pronoun and

common noun ("This dog is [named] 'Butch'"). Similar "naming ceremonies" can be imagined for natural-kind terms.[30] For historical purposes, the notion of an initial baptism or naming ceremony merely suggests a line of thought. A full account would have to survey many permutations and puzzles in the realization of baptisms. The object need not be physically present, for example, for its naming to occur, nor need it even exist. In projecting a plan for a town that might never get built, street names might simply be derived from rules: First Street, Second Street, etc.[31] But for our immediate purposes, the object—whether present or distant, existing or projected, real or imaginary—must figure causally in "the historically correct explanation" of who it was that the speaker intended to name or what it was that he intended to designate.[32]

The situation is different in the case of pictoriality. In depiction, the "reference" of the mark occurs (and it is [re]secured) in seeing the visible mark as an object, followed by disambiguation of this visual experience and the replication of particular thing-resemblances that been have recognized and in which the object can now be seen in the mark (and, of course, in any other marks made to look like the originals). The object figures causally or historically in the depictiveness of the mark because it was *this* object that the maker or viewer of a mark has seen the mark as (regardless of what the marks might really be as objects in their own right), and it was *this* episode of seeing-as that he has disambiguated, replicated, and recognized as intended in the replicas. Nothing more than this will be needed for the pictoriality of marks recursively to emerge in their replication, even if this function cannot be absolutely distinguished from nondepictive marking or from configuration that has no pictoriality.

As a further thesis—a distinct thesis—the causal analysis of pictoriality can be taken, of course, to assert that the mark was seen as something in particular *because* a causal relation obtained between visible properties of the object and visible properties of the mark. According to Dennis Stampe's version of a causal theory of reference that covers depiction as well as linguistic reference:

> The causal relation we have in mind is one that holds between a set of properties $F(f_1 \ldots f_n)$ of the thing (\varnothing) represented, and a set of properties $P (P_1 \ldots P_n)$ of the representation R. The specification of sets F and P will consist of predicates that identify certain constituents, and certain relations among those constituents, of \varnothing and R respectively. The relevant causal relationship between \varnothing's being F and R's being P will be one that normally, if not necessarily, preserves an isomorphism between the structures thus de-

fined. . . . Ordinarily, if Ø's being F causes R to be P, R is Ø *only* because Ø is F, and R wouldn't be P, were it not for the fact that Ø is F. Where this ordinary situation obtains, it will be possible to acquire knowledge of the thing represented from the representation of it. Specifically, it will be possible to tell, from the fact that R is P, that Ø is F (that is, to know *of* Ø that it is F).[33]

For example, my dog has short brown hair and floppy ears that a painting of him depicts him as having (it is a configuration that is a depiction of him) by having within it some brown patches and some floppy-ear-shaped patches *only because* my dog has brown hair and floppy ears. The relation is best phrased in terms of seeing-as. We see the brown and floppy-ear-shaped patches of the configuration as my dog's brown hair and floppy ears at least in part because my dog has brown hair and floppy ears with which the patches are isomorphic in ways that we can see—that spring on us visually. *My dog* figures causally in the account in the sense that if he did not have brown hair and floppy ears, then patches of the picture could not be seen as *his* brown hair and floppy ears and therefore could not be isomorphic with him in these respects.

We cannot simply assume, however, that the *picture* has its brown and floppy-ear-shaped patches because my dog has brown hair and floppy ears. The picture has those patches because someone intentionally painted them there, or at least because the marks were visibly conformed in such a way (for whatever reason, originally intentional or not) as to be recognizable to me (in the pictoriality of the configuration for me) as my dog's brown hair and floppy ears. (The Morellian theory of the *Grundform* should remind us that the ear-shaped patches might have been painted unintentionally, not as a consciously intended pictorialization of *my dog's* ears [see Chapter Four].) And the mark often has its properties quite independent of the object having *its* properties. To use Stampe's technical formulation, no causal relation need obtain between properties $F(f_1 \ldots f_n)$ of Ø and properties $P(P_1 \ldots P_n)$ of R, where R is understood as the configuration *simpliciter*. We should not build into it just those properties that make it the depiction that we are trying to explain.

The possible causal independence of $P(P_1 \ldots P_n)$ from $F(f_1 \ldots f_n)$ tends to be forgotten by many causal theorists obsessed specifically with depictive photographs and so-called photographic indexicality. In photographs, of course, the configuration has brown-colored patches and floppy-ear-shaped patches because of the light reflected at various wavelengths from my dog's real brown hair and floppy ears—causal relations that were wholly contingent on making the visual display by this means, namely, photo-

graphically. But the same causal relations could obtain between object and display (the dog's features photographed by the camera and printed in the photographic image) without the display being *seen as* that object (in this case, my dog) or indeed as anything whatsoever. In the generation of depiction, the properties of the object might sometimes figure causally in the conformation of the mark. But that causal tightness is really as nothing compared to the requirement that the properties of the object *must* always figure causally in seeing the mark as said object. To grasp the depiction of it, the beholder must know that it has been grounded in *this* particular moment of seeing-as—this seeming vision of an object in the mark—rather than other d-chains (some of them perhaps equally obvious) that might equally well account for the visible morphology of the configuration.

Likely enough, as I have already insisted, the beholder can only develop a highly "conditional hypothesis" about the episode of seeing-as that grounds the picture, that is, about its primal pictoriality.[34] Indeed, his only evidence for the plausibility of the hypothesis is its power to account circumstantially (and with provisional functional efficacy) for the whole range of morphologies that could be produced in similar activities of replication, or that could be coherently and consistently coordinated with them. It is the power of this assumption that enables him to go on provisionally treating certain object-resemblances of marks as having been intended for such visual recognition as pictorial aspects.

■ 7

If the theory of pictoriality and its successions in what I have called the intentionalization of pictorialization and depiction is roughly correct, it has many direct implications for the history of art and especially of visual culture: in the aspective successions, much of visual culture must be constituted in histories of pictoriality (interdetermined by formality and style), and especially in the recursive effects of depiction. In the remaining sections of this chapter, I will analytically model some of these implications. For economy, I will adopt a simple notation: D is a picture or depiction, a configuration constituted, that is, as having a quotient of pictoriality in a particular depiction-chain; Dx is a picture of X, or the pictoriality of X in D (that is, the matrix of marks that surrounds and sustains it), Dy is a picture of Y, or the pictoriality of Y in D (that is, the matrix of marks that surrounds and sustains it), and so on; and X is an object (something pictorialized in D by x), Y is an object, and so on.

Let us consider the puzzling hypothetical case of someone who makes a picture Dy that is visually (morphologically) indiscernible from our own picture of X, Dx. This configuration cannot be a picture of X unless it is either part of the relevant chain of replications of the canonical form (Dx) or independently grounded in X (though here it might or might not be true that $Dy = Dx$).

Needless to say, the evidence that either one of these conditions actually holds might be unavailable. A beholder might well take the picture, Dy, that is indiscernible from our picture of X, Dx, to depict X (this would be a natural interpretation) even though actually it depicts Y (that is, even though it is actually Dy). In some ways he would neither be visually deceived nor cognitively misguided. A display that looks like Dx can surely be used to depict X, just as it can be used not only to replicate Dx but also to depict it. But there is a good chance that this beholder would be socially mistaken, that his use of the configuration would be incorrect within his cultural tradition, which uses Dx to depict X, not Dy. There might be no practical situation in which his mis-envisioning of Dy as Dx would be exposed to him, or in which it would do him damage in representing and communicating his intentions. Nevertheless we can readily imagine certain scenarios in which his lack of information about the d-chains particular to X/Dx and to Y/Dy could lead him into gravely defective engagement in social affairs.

For example, suppose Dx depicts Brillo-brand scouring pads because it is a carton containing such pads. The promise of its depiction will be redeemed by the actual coexistence of the depicted objects. But what about Dy, which depicts such a carton without *being* such a carton; that is, without containing X, the scrubbing pads, depicted in Dy? If Dx and Dy are indiscernible (for an undiscerning observer), then using Dy as an actual token of the type of pictorializing carton sold in the form of Dx could be a criminal offense. (In turn, the defendant who sold Dy at a flea-market as Dx might plead innocence or legal irresponsibility on the grounds that for him Dy and Dx were indiscernible, and he did not *intend* to commit the crime.) To take a parallel example, consider two pictures of horses, Da and Db, that look identical. Observers know, however, that the horse A is an animal god and the horse B is a mere avatar, and, more important, they know that the maker of Db intended to pass it off as a substitute for Da. There could be situations in which using Db to show A would be a gross affront—if, say, the pictures were to be used in certain religious traditions to relay the vital potency of particular animal divinities to the human agents who collect and display representations of them.[35]

Needless to say, we have to stipulate that Dy is not a picture of X but a picture, a pictorial replica, of Dx; the d-chain of Dx is grounded in X and the d-chain of Dy is grounded in X, if it is grounded in X at all, only by way of Dx. This stipulation is reasonable because it is hard to see how the maker of Dy would have made it to be very alike to—perhaps visually indiscernible from—Dx, a carton depicting Brillo pads (which also *contains* Brillo pads), without in some way pictorially representing Dx. However, the maker of Dx, most likely a designer or illustrator for the company that actually makes Brillo pads, depicted X in a way original to him. And he might well reject the very notion that his Dx representing X might be properly replicated in Dy—a reaction likely shared by the actual buyers of X as depicted by and coexistent with Dx. The maker of Dx might sue the maker of Dy not as a counterfeiter of commodities (though the Brillo manufacturer or a Brillo-buyer might do so) but as a plagiarist or an infringer of pictorial copyright.

The historical case to which this thought experiment partly alludes concerned Andy Warhol's *Brillo Boxes*, silkscreened wooden versions of a cardboard carton of Brillo-pad boxes. (Several versions or iterations were first exhibited at the Stable Gallery in New York in 1964.) Warhol played with the conceit that he could have made Dy grounded in Dx in such a way that it happened to look like Dx grounded in X—and this because the mode or style of the making adopted in Dy with reference to Dx (i.e., the mode of advertising graphics) permitted or even encouraged what might otherwise be a coincidental replication as the very means of making *both* commodities *and* pictures. If Warhol had made a traditional fine-art sculptural representation, Dz, of Dx (or of X)—a representation, say, in cast bronze—it probably would not have *looked* much like Dx, even though Dz, like Warhol's Dy, would be partly grounded in Dx. Of course, Dy was partly grounded fictively in X and was possibly indiscernible from the Dx that was *actually* grounded in X. More exactly, the overlaps or recursions of Dy and Dx in relation to X (as well as interacting notional horizons such as Dz) questioned or undercut then-current notions of what it was to be "fictively" as opposed to "actually" grounded in X, considering not only that X contained real Brillo pads but also that it *pictured* them. For in the example as I have constructed it, X itself is somewhat indefinite or undecidable: X is *both* the carton that might contain Brillo pads (though in no representation does the carton actually open up for our inspection so as to decide the point) *and* the picturing of the pads on the carton or *as* the carton. Therefore the grounding of Dx, Dy, and Dz in relation to X cannot always be perspicuously sorted

in every way: Dx might better be described as grounded in Dx than in X, for X *is* Dx, at least in part or in some respects.[36]

In this regard, the visible *difference* between a Warhol *Brillo Box* and Brillo-box cartons might be interpreted in terms of the fact (a fact accessible to beholders in their awareness of the relevant d-chains) that Warhol's work was not a commodity. Rather it was a representation of a commodity, albeit a representation that seemed to be ambiguous about its grounding in Dx (Brillo pads as merely depicted on Brillo-box cartons) or X (real Brillo pads in cartons). To some extent, then, and to pursue the recursion, in a sense *Brillo Box* by Warhol was an *image* of a commodity (maybe in that very respect a viable instance of a commodity as well) in virtue of showing that the d-chain of such an object (a real box of Brillo pads) can effectively be grounded in representations. We have to see Dy as being a token of Dx (indeed derived as an actual replication of it) at the same time as we know Dx to be grounded in X in ways no more actual than Dy is grounded in X. Indeed, we can almost say that Dx is only known to be grounded in X because Dy is known to be grounded in Dx: Warhol's Dy definitively confirms that Dx is simply a *representation* of X, not its simple material coexistent and container as one might think. *Without* Dy one might not fully grasp that Dx might be no more grounded in X than Dy. Thus Dy does not so much *duplicate* the commodity X/Dx as expose its imagism.

Probably this was only one strand of the involutions of the d-chain(s) in *Brillo Box*. Another strand explored the conceit that Dy, despite certain vivid visual appearances, *does not* depict Dx or in any way refer literally to the material containers and pictorial images of X/Dx. In *Brillo Box*, X/Dx is really Y imaged by Dy—for example, whatever objective designations Warhol might have intended in (re)presenting the phrases (found on Dx) "24 Giant Size Packages" used to bring things to "a shine," a contemporary gay term for fellatio as well as American slang for drunken happiness (as in "he's got a real shine on"), an ephemeral crush in love (as in "he's taken a shine to him"), and the results of a beating ("he really gave me a shine"). In this dimension *Brillo Box* could be partly a self-portrait. It figured Warhol's sexuality (Y), not Brillo boxes (X). Or rather, it depicted Brillo-pad cartons in presenting a metaphor for—a relay of—Warhol's sexuality (call it XY). And perhaps vice versa at the same time: perhaps it used the reference to sexuality, or the sexual slang, that might be seen in Dx as a metaphor for our relation to the commodity, X, *as* aestheticized or even eroticized (call it YX). Overall Dy seems to be grounded in these (and perhaps other) emergent objects—depictively constructed objects, or objects constituted specifically in the pictorial recursions.

As the previous section might suggest, in a given visual-cultural tradition several different pictures of X can be made at different times and for distinct reasons. The pictures could be morphologically indiscernible—visually identical, at least on first glance, in the sense considered in the previous section and in Chapter Two. But likely they will be visibly different, even if the significance of the difference remains unclear to some beholders. Each X-pictorialization inaugurates its own d-chain. But in practice a beholder might not be able to determine whether he should be dealing with one d-chain grounded in X or with several d-chains. In this case, the different properties and aspects of X (or distinctions about it) that are marked in the different pictures might not be understood. Perhaps the beholder manages only to see pictures of a generic animal (one d-chain) where instead its gender (another d-chain) or age (a third d-chain) have been pictorialized in replication, and should be seen; this beholder sees one picture of X—the same X-picture in each painting—rather than two or three.

This might seem to be a trivial consideration. But because replication in the service of a single intended pictorial function (a d-chain of Dxs depicting X, a d-chain of Dys depicting Y, etc.) generates morphological variants, and because beholders need both the presence and the pressure of morphological variants (actual or possible) in order to identify the pictorial intention, there will always be areas of essential visual confusion between different depictions potentially vested in the *same* configuration taken to pictorialize one particular entity. Where X can be depicted by Dx and Dy, sometimes the picture in front of us might be *either* Dx *or* Dy though it visibly picks out different (and perhaps equally visible) aspects of X. In the case of the different horse-pictures imagined in the previous section, for example, if the animal can be depicted by Dx, Dy, and Dz, Dx might be Dy or Dz, Dy might be Dx or Dz, and Dz might be Dx or Dy even though Dx depicts the generic animal, Dy depicts the gendered animal, and Dz depicts the animal at a particular age. These differences and their overlaps and recursions might not effectively matter in most cases. Functionally the depictions could signify as intended, that is, as Dx, Dy, and Dz, even if the d-chains have been conflated, confused, or cross-wired. But as the previous section made clear, there are scenarios (investigated by the anthropology of art and visual culture) in which these differences matter very much—indeed, in which the differences are the whole field of pictoriality.

This domain of overlap and (in)discernibility and (in)discrimination is the very condition of pictorialization. In order to identify the functional

intention in Dx as a picture of X, Dx could be Dy, a *different* picture of X. This possibility is not simply present *outside* the chain of replications. It is threaded through its requisite history of visible variation. If Dx were taken to be a picture of X but no possibility that it might be Dy—a *different* picture of X—can be encountered, at least notionally in a projection of the material history of the replicatory sequence, then Dx itself could relay a fortuitous resemblance to X—not its pictorialization in a configuration that intentionally preserves particular X-resembling features that can be distinguished from the features that would be picked out in Dy.

Compared to different pictures Dx and Dy grounded in the same object X, different pictures grounded in *different* objects X and Y have greater leeway to escape this essential ambiguity (as well as the interpretive uncertainty or cross-wiring to which it gives rise) because the objects themselves are naturally distinguished. Different pictures (d-chains) grounded in the same object cannot trade so readily on the *object's* distinctiveness. For it is particular distinctions of the putative pictorial object, marked specifically in a picture, that inaugurate a d-chain in the first place—a chain of replications observing distinctions in the object (that is, different aspects of it) that can be occluded by the object's own natural distinctiveness. Of course, the distinctions that mark an x-picture of X rather than a y-picture of X might well be distinctions that *also* differentiate X from Y. But likely there are some properties of X marked in Dx that are not salient in determining that Dx depicts X, not Y. Conversely, that Dy might not include these properties (it is a different d-chain) does not entail that Dy depicts Y. It depicts X differently. (Our notation can capture this by denominating Dx-1, Dx-2, etc.)

To be sure, a strict pictorial nominalism must say that in situations of this kind Dx and Dy (i.e., Dx-1 and Dx-2) depict two different objects—indeed, that they constitute, construct, or project them. This nominalism has obvious advantages. It calibrates the specificity or individuality of a d-chain to the singularity of the object it picks out.[37] But this rigorous approach, though sometimes needed, flies against the wind. In real life, people seem to be prepared to admit that two different-looking pictures, readily grasped as devolved in discriminable d-chains, depict the same intended object—though they are intended to do so differently. (This basic fact of the phenomenology of depiction suggests why an account of pictoriality is needed in the first place.)

Moreover, in real life people distinguish between the chain of replications by which they receive a depiction (chiefly in their own visual inspection of a pictorial configuration, involving its pictoriality for them) and the advent of the pictoriality inaugurating the picture (chiefly in the maker's

pictoriality and his replication of it in the configuration). The strict nominalist approach would override this distinction by yoking each d-chain to a baptism of a particular object (i.e., an object different from the ones that ground all other d-chains). This might be fair enough in the case of designation in natural language, especially with respect to proper names (i.e., the name of *this* object, and no others). It might be appropriate as well when handled as a teleology: a baptism inaugurates a tradition of naming or otherwise representing the particular object baptized. But d-chains in real life must be handled retrodictively or anachronistically; that is, as *reconstructed* histories of the founding intentions replicated throughout continuing uses. Here it is possible, for reasons already reviewed, to find that several d-chains converge historically on the baptism of an object taken to be self-identical across the ramified array of its depictions. Indeed, one of the deep functions of depiction is simply *to open a representational territory for the virtual differentiation and particularization of an object*, including the possibility of transforming and recreating it. Here recognized objective identity must be held noetically constant precisely in order to project and inspect the differently recognizable visible aspects, horizons, or potentials of its existence. We have to know that X is represented in an x-picture (x-1-picture) in order to see just how the x-picture shows aspects of X not realized in its y-picture (x-2-picture). This is not the same as saying that X, when pictured in Dx-2/Dy, is a different thing.[38]

In turn, unlike naming in natural language, depiction can be paradoxically *de*individuating in virtue of its highly particularizing function. We can see this readily in many pictures—indeed, in practically any picture that is not simply a visual illusion of distinct objects, a trompe l'oeil. At the same time as they differentiate and particularize aspects of each thing depicted, they show the commonality of many *different* things pictorialized in the configuration. (Of course, this is also a function of configurative formality and artifactual style—aspective horizons used, as we have seen, partly to pinpoint pictoriality.) For there is no contradiction between discovering that one d-chain depicting X, Dx, should be sharply distinguished from another d-chain depicting X, Dx-2/Dy, on the one hand, and, on the other hand, that Dx and Dz, depicting Z, and hence X and Z, might be virtually indistinguishable. Consider, for example, a classically painted Chinese landscape (Fig. 2.5) in which clouds, treetops, and river blend or shade together, or a Western pictorial experiment (Fig. 2.6) in which similar effects were attained. We do not say that one bit of the landscape is Dx depicting the clouds, X, another bit is Dy depicting the trees, Y, and yet another bit is Dz depicting the river, Z. Rather, the whole is Dxyz depicting XYZ.

An overly strict pictorial nominalism cannot easily handle this result because there is no name or objective correlate for the thing (call it XYZ) picked out in the commonality of X, Y, and Z as imaged in the similarity of x, y, and z in D (e.g., an entire landscape). If there is a description of XYZ, it is only the picture itself: in virtue of its formality and style, the picture constitutes a unified virtuality that synthesizes X, Y, and Z (in x, y, and z in D or better in Dxyz) as aspects of a certain state of affairs, namely XYZ—a state of affairs perhaps only visible and visual as virtual and pictorial. In real life, however, people do not always take pictorially constituted virtuality to be the objective correlate of depiction. In virtue in part of the formality and style of the picture, they simply take it to suggest virtual visual relations between objects that are understood to be different. After all, x, y, and z in D cannot be *entirely* identical else they could not successfully depict X, Y, and Z in Dxyz, regardless of the common matrix (the virtuality XYZ) to which X, Y, and Z are proposed by the picture to belong.

To go any further than this, it seems to me, would be to find something like phlogiston in the virtual world constructed by depiction: the object of the picture would not be the world of objects that it depicts, X, Y, and Z, but the meta-reality of their pictorial-virtual relations, or A, because x, y, and z in Da share many visible features (as it were the pictorial phlogiston). This model and its nominalistic outcome (namely, the constitution of Da as pictorialization of the A in which supposedly X/Dx, Y/Dy, and Z/Dz participate) can be deployed, of course, in a practice or ideology of picture making. Sometimes this model can be taken to considerable lengths in pictorial practices (we might call them highly formalized or stylized, or alternately highly expressionistic) in which pictorialized objects have been morphologically interrelated or interthreaded in a unified imagistic field. But the morphological interthreading of depicted objects, and the seeing of their resulting resemblance as an intended feature of the pictorialization, is not an inherent condition of pictorial phenomenology.

More exactly, *pictorial nominalism* or the constitution of a picture of aspects visually pertaining to all the depicted objects subsists in dynamic tension with *pictorial deindividuation* or the constitution of depicted objects as recognizably differentiated and interrelated. Typically beholders want to recognize what X, Y, and Z might be as they are depicted in the picture. Only then can they understand what the picture claims about X *and* Y *and* Z, perhaps in turn inferring the existence of XYZ as depicted in Dxyz. They must start with the ambiguity of each d-chain, and pursue it in the aspective successions.

Despite this phenomenological fact, some cultural traditions of depiction have worked to *prevent* the emergence of different pictures

(d-chains) of the same object or world of objects. In order to consolidate the identity of a world and to control people's understanding of it, only *one* picture (or a narrow set of pictures) can be tolerated, however many replications must be permitted (materially there could be very many). Needless to say, however, this "one picture" need not consist in the invariant replication of identical-*looking* pictures. As I have already noted, variation in the replication of any pictorialization is required for its very pictoriality to be identified as such. In ancient Egypt, what I have called the "canonical tradition" of depiction permitted, even encouraged, considerable stylistic variation in the replication of a single comprehensive pictorialization of the world—a canonical d-chain (see Fig. 7.2[b]). This variation did not contradict canonicity. Noetically it was the very condition of the canon, the proof that a particular pictoriality had been intentionally stabilized.[39]

■ **9**

A pictorialist can use pictures of X (d-chains grounded in X) when he generates a picture of Y. And this picture, Dy, can be similar in some respects to the X-pictures as a function of the replicatory context within which it was constituted. Indeed, this might be the reason *why* the Y-picture Dy is similar to the X-pictures. When realized in a cultural tradition of depiction, this situation is the obverse of the one described in the previous section. Pictures that look alike can nonetheless tend toward the discrimination of different objects because they are differently pictorialized, and distinguishably so. But the very fact of visible morphological similarity recalls the foundational possibility that all the d-chains (including the newly proposed picture of Y) really originated in X. (And in fact Dy *did* originate in Dxs, that is, in pictures of X). Therefore the similarity to Dxs found in Dy, and perhaps of Y to X, becomes a double-edged sword. Perhaps the picture of Y finds something new (possibly Y itself) in the pictorial virtuality that it has constituted. Here the very contiguity with the d-chains grounded in X can confirm the visible *specificity* of the novelty depicted in Dy. In turn this promotes the possibility that the novelty, once recognized in the pictorial virtuality Dy, can perform a *critical* function in the visual-cultural field. Different and distinct from X/Dx, it can be seen as revising, resisting, or refuting it.

Perhaps, however, the pictures of X that were used to generate Dy continue to govern it. Perhaps the distinction of Dy from Dx (and the possible critique of X that can be generated by virtualizing Y in Dy as

specifically opposed to Dx) has merely been mechanical. Perhaps it simply involves the reflexive ascription of differentiated or individuated aspectivity (albeit in a new d-chain, Dx-1) to the *required* variation of Dx. On this analysis, and paradoxically enough, the critical power of pictures (relative to the world of visual images from which they spring and to which they must continually relate in pictoriality) could be vested as much in the pictorial discrimination of X into different d-chains as in the constitution of Y in the definitive revision of *one* d-chain grounded in X.

These possibilities have different horizons and recursions in distinguishable historical situations of visual culture. To revert to the example cited at the end of the previous section, it is possible that the "one pictorialization" of the world promulgated in canonical Egyptian picture making (one d-chain grounded in X; a uniform X projected in Dx-1, Dx-2...) was actually differentiated in Egyptian art history, in the stylistic variations within Egyptian art, into *several* culturally functional pictures of the world; that is, into two or more d-chains grounded in X. Did this development bespeak modes of reflection that were less critical, less self-recognizing or self-reflexive, than modernist Western attempts to *replace* X (pictured in one or many d-chains) with Y, especially if we grant that Dy had to replicate Dxs in some respects in order to secure a pictoriality that otherwise might have failed? G.W.F. Hegel and many subsequent commentators have thought so; for these writers, ancient Egyptian art lacked the recursions of self-consciousness and the cultural potential of criticality achieved in the later arts of Greece and in the modern European world. But this thesis has little theoretical plausibility. It seems to be quite possible to find a modernism, an avant-garde, in ancient Egyptian pictorializations that rivals the modernisms of the modern Western world, at least insofar as the morphological variation and the cultural temporality of d-chain(s) grounded in their object(s) is the guide.[40]

Modernization and even critique or criticality have always threaded through the history of depiction constituted in the recognition and replication of original pictorialities resecured and recombined in the aspective successions. In theoretical terms, in fact, *a depiction simply is the modernization and critique of the visible object-resemblances from which it began in light of the visual recursions and configurative ambiguities that it constitutes and that must be resolved despite (and to some extent because of) persistent disjunctions and resistances.* For this reason we can be skeptical of the real purchase—the theoretical plausibility—of art histories in which a *particular* practice of depiction lays special claim to modernism or criticality, let alone to modernist criticality. All practices of depiction have this capacity, and all carry it out to some extent. By the same token,

but conversely, merely looking the part of morphological variation in picturing—looking like modern critique—is not the same thing as changing imagistic virtuality; that is, what is seen in the world as something that can be pictorialized in some way.

A picture Dx is a picture of X just to the extent that throughout its replication a particular object-resemblance (namely, the resemblance retained to pick out X in Dx for a beholder, or pictoriality) is judged to be constant. But replication always introduces morphological variation. At some point, then, the latest marks in the series of marks made to resemble X (and in turn to depict it) might not be judged to resemble X. Perhaps they will be judged to resemble nothing at all. In this case the X-pictoriality of the d-chain will cease to exist, even if the configurative morphology might continue to be produced in new versions—versions now made for nondepictive purposes and without pictorial intentionality.

Alternately, the marks in the sequence of replications of X-pictoriality can be judged at some point to resemble another object, Y. But *that* judgment (the Y-pictoriality) might not be replicated as such, as would be required for the newly-emergent resemblance to become depictive (i.e., to constitute a picture of Y, Dy). Finally, it is possible that the latest variant in Dx (or an earlier variant that has been reinspected if not wholly resecured) might inaugurate a new chain of replications depicting Y; that is, inaugurate a picture Dy. The first chain of replications for the picture of X causally underlies the second chain for the picture of Y; the latter (Dy) could not have been made in the way it was made had not the former (Dx) been made in the way *it* was made. But the depiction-causing connection between the two chains lacks the essential "reference-preserving link" of a d-chain (the advent, retention, and relay of the particular pictoriality in question) insofar as one mark in the sequence (suppose that it is the latest variant of the first chain and the earliest variant of the second chain) is not judged to resemble X (instead it is judged to resemble Y). In this case, the picture of X will cease to exist even as the picture of Y emerges, and indeed because of this emergence.[41]

The sequence and succession of these recursions, reversions, terminations, recombinations, and reemergences need not be modeled in the simple structures I have described so far. They need not be modeled in the form, for example, of a d-chain

$$X \rightarrow Dx\text{-}1 \rightarrow Dx\text{-}n \rightarrow Dx,$$

or even of a more complex d-chain

$$X \rightarrow Dx\text{-}1 \rightarrow Dx\text{-}n \rightarrow Dy\text{-}1 (\leftarrow Y) \rightarrow Dy\text{-}n.$$

In theory the replication of Dx can temporarily support the emergence of Dy, in "a nested kind of way," *anywhere in the sequence or succession of its replications*. Pictoriality in the aspective and iconographic successions, as we will see in more detail in Chapter Seven, not only shifts and slides. It also comes and goes. Even in the moment of baptism or advent, the possible emergence of a pictoriality Dy, as noted, is not only a logical or notional horizon of the pictorialization of X. It is one of the material and phenomenological conditions of its consolidation, at least in Dx-2 and its successors in the d-chain of Dxs grounded in X. In this sense, and at least notionally, Dx *partly comes to an end in the very moment of its constitution*. Materially and phenomenologically, pictoriality terminates and reemerges many times and in many places in the history of its replication, whether that history occupies a duration of minutes, years, or centuries.

Of course, if X (let alone a complex or nested pictorial virtuality like XYZ) is a strictly pictorial denomination, a pictorial virtuality that lacks a real objective correlate, then X might come to an end too. Still, and even if the *picture* of X has subsided, receded, or disappeared in the ordinary history of replication, it remains possible that the *image* of X might persist. (As in other contexts, rigorous distinction of image and picture allows us to observe fundamental features of both retinal and depictive phenomenology.) The virtual X constituted in Dx does not require the continuous visibility of the mere material tokens of its picture Dx in order for it to be retained and transmitted *as* image. (It might subsist wholly as a "memory-picture" or "mental image," though this requires careful description [see Chapter Eight]. Certainly it can subsist as the visual image—and *its* mnemic replication—that a latter-day beholder might be able to obtain of past *pictures* of X, i.e., Dx-1, Dx-2, etc., even if X has become defunct. Probably the material persistence of Dx can recursively permit a beholder to suppose that the picture must be grounded in a real X, however defunct, especially if Dx has pictorially virtualized its putative object X in an optically naturalistic way.) *Only the total disappearance of the imagistic replication of pictoriality (even if only in the visual memory, mind's eye, or notional vision of beholders) will definitively erase the emergent virtual possibility of the depicted object.* No amount of mere iconoclasm will suffice. For this very reason, material iconoclasms (the mere physical destruction of the configurations that permit and replicate pictoriality) have often done little in world art history to eradicate the continuously available existential possibility of objects pictorially virtualized in human image making. Indeed, material iconoclasms of pictures (as distinct from the physical extermination of the human agents of pic-

toriality) may well have *entrenched* this imagism that is inaccessible to them at the advent of pictoriality.

The imagistic replication of pictorial virtualities, such as our memory of pictures (Dx or Dy as the case might be), must be vulnerable, of course, to morphological decay. It seems to be susceptible, in fact, to a kind of *natural* iconoclasm, a natural biopsychological arc of image-recession. (It has often been noticed that without pictures of past or distant objects, however well known to us, we tend to forget their specifically visual configuration.) But we should not despair of losing the virtual objects constituted in pictures whose pictoriality has receded from us in the aspective successions, or has entirely disappeared.

Human vision is naturally capable of constituting pictoriality in marks. Indeed, as I have already put it, pictoriality simply *happens*—it dawns. And because the resulting virtual objects (*qua* visual images) are governed by a few simple laws of geometrical optics, or at least they were so governed when they were seen in pictures, imagistic reemergences of pictorial virtualities that were constituted in marks made long ago and by faraway peoples must be mundane facts of human vision. Just like the ancient Egyptians, in imaging we will be disposed reflexively, for example, to restore apparent visual volume to a flat, frontal picture of an object. Thereby we will tend to virtualize it as the object it intentionally was in the Egyptian depiction of it, that is, a particular polyhedric solid in the world, and *not* other possible solids—just as Egyptians did. More exactly, we will reflexively tend to resolve the ambiguity of the depiction in just the same way that the pictorialists did. To be sure, they resolved the ambiguity of Dx as a picture of X, an object perhaps now wholly unavailable or entirely unknown to us, whereas we resolve the ambiguity of *our image* of Dx. But the two d-chains overlap in well-defined morphological respects. In theory, in fact, they permit a continuous replication from the visual world of the ancient Egyptians (where X was visible or real, and pictorialized in the Egyptian way) to our own world of images (where we can see X, visible to us in "Egyptian" pictoriality). I will turn to this circuit or recursion in Chapter Eight. It suggests the specifically *methodological* circle of iconology and visual-culture studies.

■ 10

In none of this do we really confront a question of "what pictures want."[42] Depictions are arrays of marks—clumps of matter. They have no *self-directed* intentionality. Even at the level of their pictoriality, as noted in

this chapter, they can look like things—look *just* like *many* things—that they do not depict, and therefore presumably do not "want." Instead we confront counterthrusting questions of what *pictorialists* want, what *beholders* want, and how these two sets of intention—these intentional series that seem to have threefold or even more complex structures—might intersect, whether or not in an intendedly communicative context.

To be sure, the metaphor of the intentions of depictions (or the "power of images" when images have been miscategorized as pictures) is attractive. Sometimes it can serve, in fact, as convenient shorthand for full analysis of the circuitry of intentions in replication, inspection, exhibition, and communication, in "meaning"—a circuitry in which many agents with distinct intentional directions might participate. Sometimes, however, the metaphor is an obfuscation: aestheticist rhetoric. It seeks to reify the capacity for depiction (or art) to enchant the observer and to re-enchant the world.[43]

According to the general theory of visual culture that I propose, however, the *world itself* enchants the observer, however ephemerally or modestly. It provokes pictoriality and pictorialization *in* him, whether or not it is regulated in turn by an iconographic succession (Chapter Seven). Far from being the cause of his uncertainty, mystery, and excitement, then, depiction is the observer's autogenous *response* to sensuous assaults of pleasure and pain in visible things and in his visual world, including the making of marks. Some of this experience (and the resulting depictive configurations if the successions of pictoriality proceed that far) springs from or might evoke ecstasy and despair—involving our most consequential fears and fantasies. Presumably this is one reason why art historians have been tempted to reify and fetishize pictoriality and pictorialization and to write of them, when relayed into and recursively consolidated as depictions, as if they make autonomous psychic demands on the visual systems that created them—demands, that is, as an importuning picture (supposedly it *wants* something from us) or as an overwhelming image (supposedly it *does* something to us) addressing the subject from without.

But many—most—of the visual events and aspective successions in question do not warrant hyperbole. Pictorialization is a routinely intentional adaptation of the human visual system. Among the relations organized in the visual field, human agents sometimes seek to see—that is, to direct their visual attention to, or intentionally to inspect—the aspectivity of things when natural isomorphisms, routine ambiguities, and ephemeral virtualities spring upon them, as they do dozens of times every day. This visual activity can sometimes be directed by a previous cultivation of vision in the iconographic succession (Chapter Seven) or

even more powerfully in the organized analogies of a social group in its practices and traditions (Chapter Nine): in successions of visual culture. But this is self-evident. It is a mere truism that I cannot see a camel in the cloud (a camel-like cloud) if I have never seen a camel, real or depicted. (In Chapter Two I called this the "depictive disjunction" that enmeshes the very possibility of depiction, whatever its recursions and successions.) And it is obvious that I might not spontaneously replicate the visual occasion of having seen a camel in a cloud (a cloud-camel) if there is nothing in my form of life that warrants the calibration or devolves from it. A general theory of visual culture should insist, instead, that accidental resemblance, replicable pictoriality, and functional pictorialization can be the bread-and-butter of a daily visual life, of vision in the world, *without* succeeding to depictive consolidations—to pictures in the sense designated in art history and visual-culture studies, and there invested with florid intentions.

Given all this, what pictures want, if they want anything at all, must be analyzed in terms of pictoriality and its consolidation (or not) in successions of formality, style, and iconography (Chapters Three, Four, and Seven). What pictorialists want, if anything, is successfully to relay pictoriality into a depiction, into visible configurations offered for seeing-in that reproduces the original intentional order of the maker's vision—now seemingly resituated in the picture itself as what it depicts.

Chapter 7

The Iconographic Succession

■ I

According to Arthur Danto, the perception of pictures has a natural history. Certain experiments, he tells us, show that pigeons can be "easily trained to identify and classify pictures by their content." In the case of the pigeons and in similar nonhuman cases, he concludes, "whatever in evolution accounts for the range of their perceptions accounts for their hitherto unrealized pictorial competence."[1] Because evolution is an historical process, the pigeons' supposed perception of pictures, and perhaps their vision, must be historical—perhaps historical in the sense intended by Heinrich Wölfflin that was mentioned at the outset of this book. It enters into the pigeons' form of life when (and only when) they have been trained to identify and classify pictorial shapes. Moreover, the training would seem to extend the pigeons' repertory of behaviors by consolidating a "hitherto unrealized competence" in reflexes of shape-recognition. In turn, then, we might be tempted to say that depiction has organized the pigeons' perception historically. We might associate *this* claim with visual-cultural studies. Although pigeon vision has an evolutionary basis, its empirical realization depends on the introduction of pictures. In the natural history at issue in this case, in other words, the effects of a particular culture of seeing, a visuality, might be felt.

Danto himself did not want to draw the last conclusion. According to him, the pictorial perception of the pigeons, a competence realized once they have been trained to recognize pictorial shapes, in no way alters their natural shape-recognizing abilities. As described, however, the experiments do not decisively confirm this assertion. They do not compare the pigeons' range of perceptual behaviors and perceptual competences *before* the training to their perceptions *after* the training, except by noting that an unrealized competence has apparently now become an actual behavior in a history of cultivation. Without the introduction of pictures, this behavior would not exist.

Of course, the relevance of these experiments to the question of depictively organized vision rests on assuming that the pigeons really do perceive and classify objects in *pictures*. But descriptions of the experiments suggest that they may reveal merely the ability of the pigeons to "identify and classify" shapes that they have been adapted to recognize, such as (the shapes of) a nutritious morsel or a dangerous predator. Apparently the pigeons can respond suitably to what the picture (for us) resembles, though what triggers their response might simply be a shape. In turn, supposedly this resemblance can be preserved for them through a range of variations, though not an unlimited one. They will continue to recognize and respond to the shape or type of shape despite what we might call formal and stylistic differences in its various presentations or representations. In human cultures, the preservation of object-resemblance throughout a series of variations in its configuration can serve as an observer's prime evidence for the presence of depiction in some of the configurations. We can see (though the seeing inevitably remains as much a perceptual inference as an empirical confirmation) that object-resemblance has been used in replication—that the resemblance has been preserved throughout variations in its configuration *because of the resemblance and in order to display it*, a likeness intended to be seen in the several presentations regardless of the variation. It is a short step from this discovery to the constitution of pictoriality and perhaps to the succession of depiction (see Chapter Six). Or at least it is a considerably *shorter* step to pictoriality from this discovery than from the mere recognition of shapes by pigeons.

In the experiments cited by Danto, the animals did not actually make the supposedly pictorial replications: they did not manufacture the varying configurations, and they did not compare their preservation (or loss or reordering) of object-resemblance throughout the series of variations. Therefore the experimenters did not directly observe (and it is hard to know how one could observe) *the animals'* preservation of object-

resemblance in the replication and variation of configurative morphology. In the experiments, then, the pictoriality of pictures, which must resemble what they depict, seems to be bracketed out. The animals have simply been investigated (or manipulated) for their shape-recognizing ability. Needless to say, they tend to be successful when the experiment presents the stimuli to them in such a way that the morphology of each stimulus closely resembles the real (extrapictorial) object that each *picture's* salient shapes would resemble.

For example, Danto has described an experiment conducted in total darkness in which sheep were "suspended in hammocks with their heads immobilized so that . . . visual stimuli" presented by the experimenters, such as slides of the faces of monkeys and of human beings, "fell on the area centralis of each [animal's] eye when the sheep was looking forward." Under these conditions, Danto insisted, the sheep seemed to "recognize" the various faces.[2] The experimental set-up certainly creates a shape that the animal evidently cannot distinguish from the real object; as an ethologist might say, the shape mimics the object. (Indeed, the shape might even *be* an organism evolved to effect such mimicry; a predator will perceive it as the shape, the thing, that this creature mimics.) But the set-up also removes one of the basic characteristics of depiction from the experimental situation: it suppresses the fact that pictures typically do *not* simply mimic objects, and are usually not indistinguishable from them. The sheep might well respond to a photograph of a human face when they are entirely immobilized and the photograph is projected precisely on the "area centralis" of one of their eyes. In this situation the photographed face, a picture, is indiscernible from an actual face, wholly substitutable for it. But would the sheep also recognize highly expressionistic paintings of human faces (by Oskar Kokoschka, say) while ambling about in an art gallery?

Crucial as it might be, the question whether pigeons, sheep, or other nonhuman creatures can do more than "exhibit recognition dispositions upon presentation of pictures" diverts us from the dispute between Danto and historians of visuality.[3] For the sake of argument, we might accept Danto's claim that natural "recognition dispositions" can provide for the visual perception of pictures by animals when the creatures are presented with particular kinds of depiction in certain controlled situations. But if the pigeons or sheep can see (what is depicted in) these pictures, this competence must have an evolutionary history—a history that Danto wanted to deny for human beings. (According to Danto, the evolution of the human eye has ceased in the past few thousand and certainly in the past few hundred years. I commented on this implausible claim in

Chapter Two.) Or their competence must be constituted in some culture that they have created, but that Danto has denied for them. Given the animals' form of life, such a culture would have to be introduced to them artificially (for example, by immobilizing them and projecting pictures into their eyes in a certain way). But it is natural to the human form of life to have systems of representation like spoken languages and depictive styles.

In our form of life, then, it is a natural-historical fact that pictures can be present for us *as* pictures, as configurations having pictorial aspects that always involve object-resemblance and sometimes a full-blown mimicry in the ethological sense or what an art historian might call "trompe l'oeil." (Still, pictures are not always present for us, even when they are displayed to us; nor are they always *fully* present for us, even though we might see something of what they show. Pictures have aspects that must come to dawn on us.) In turn, it is possible that this natural history derived in human evolution from the dissemination of depictive culture, and perhaps of its historically different styles. In a long-term development occupying many millennia, in other words, depiction might introduce new historical contexts for the evolution of human visual perception—a proposal considered already in Chapters One and Two as a founding hypothesis in visual-culture studies. But obviously this is the very question at issue between Danto and historians of visuality. We are back where we started with little or no help from the pigeons and the sheep.

In human evolution or human forms of life, the difference made *by* pictures *for* human visual perception—for any beholder's perceptual abilities and activities—might be difficult to identify historically. The historian's difficulty, however, can best be described as the inverse of the problem that confronted the ethologists and animal psychologists in the experiments cited by Danto. The advent of depiction in someone's form of life might make *absolutely no difference* to his perceptual activities and abilities for the simple reason that pictures can, in some perceptual situations, be indiscernible from the real objects that they resemble. In such cases, they will evoke the same responses as those evoked by configurations that are not pictures, including the pictured objects themselves or such functional substitutes as successful natural or artificial mimics of the depicted objects. Here it would be as if the pictures, as distinct from their depicted objects, did not exist perceptually for their beholders. Like the sheep in the experiments cited by Danto, beholders would recognize the shapes presented without seeing them *in* a configuration or *as* an object, a recognition without pictoriality. Indistinguishable from real objects, such configurations could have no effect on visual perception be-

yond the effects exerted by the recognition of the depicted objects. Yet highly naturalistic pictures have been said to constitute a revolution in human knowing, and traditions of making pictorial illusions (trompes l'oeil) would certainly seem to constitute a visual culture, if anything at all does. We will return to this puzzle. But for the moment, suffice it to note that the presence of pictures in the human form of life can be as difficult to detect and to measure as the *absence* of pictures in the forms of life of nonhuman creatures.

Needless to say, the theory of evolution does not encourage us to draw rigid distinctions between nonhuman behavioral situations and human cultural ones. With or without pictures, nonhuman and human forms of life subsist in an historical continuum. It would not be surprising to discover that in this continuum the advent of depiction constitutes a threshold between nonhuman or prehuman and human forms of life. For reasons enumerated already, however, it might be difficult to locate these archaic milestones. And whatever its prehistory, pictoriality comes and goes in *present-day* human life just as it can be introduced into *non-human* forms of life or removed from them. Even if pictoriality exists naturally as a behavioral competence, it must be introduced historically as a perceptual culture.

According to Danto, the direction of causation in the history of depiction (and hence of explanation) runs from perception to cognition—from the recognition of shapes to the interpretation of motifs. By contrast, E. H. Gombrich has proposed that a "minimum image," a kind of mental image that he calls the pictorial "schema," opens the lock of a picture, enabling its recognition. In his view, the direction of causation in the history of depiction (and hence of explanation) runs from cognition to perception, or at least from the behavioral purposiveness and perceptual readiness of the organism (a protocognitive "mental set") to proprioception and action—that is, from motif-making (albeit an internal or mental imagism) to shape-recognition in the external world. The schema has the properties of a natural structure in perceptual cognition. Gombrich cites the case, for example, of a herring gull that will take a wooden egg as her own egg. But it is also a *social* parameter of depiction, what Gombrich sometimes calls a "stereotype," a disposition or predisposition of beholders founded in their social purposes and interests. Here Gombrich liked to cite the example of man-made caricatures, which replace or suppress full and realistic representations of objects with socially functional (and often ideologically charged) pictorial substitutes. If Danto would recall cultural history to its natural basis in visual perception, then, Gombrich would recall it to its natural basis in stylized making. But Gombrich's ac-

count of making does not fully explain the perceptual-cognitive history of the underlying recognitions: they simply constitute a succession that supposedly proceeds, Gombrich claims, from substitute objects to object schemas.[4] In parallel, Danto's account of perceptual invariance does not fully explain the functional-stylistic history of the underlying recognitions: they simply constitute a succession, Danto claims, that proceeds from worldly objects to object pictures.

In symmetrically opposite ways, then, both Danto and Gombrich partly failed to explain depiction and the history of vision, including the successions and recursions of pictoriality—whether radical or intentionalized—considered in the previous chapter. In particular, both writers partly overlooked a history of depiction *in* vision, a history that has in fact been traced in detail in the inquiries of so-called iconology. It can be generalized in the theory of what I will call the *iconographic succession*.

■ 2

The iconographic succession leads from our recognition of expressive forms, or formality, in the sense identified by formalism (what Erwin Panofsky called the pre-iconographical meaning of a configuration) to our recognition of pictorial motifs (what Panofsky called iconographical meaning) and onward to our recognition of pictorial symbols (what Panofsky called "ultimate cultural meaning" or iconological content). In principle an observer builds up a depiction, then, as an "accretion of recognitions," to use phrases that I adopt from Michael Podro; that is, as an open-ended and ramifying "continuity within realization."[5]

In the iconographic succession, the other aspects of configuration help in certain respects to ground pictoriality. In particular, as we have seen in previous chapters, a history of style—a stylistic succession—interacts with the iconographic succession. Among other things, this interaction suggests to us that the configuration can be taken to be a picture in the first place: its object-resembling properties have been replicated in identifiable ways *in order for* this particular likeness to objects to be visible to appropriately informed beholders. Without the fundamental, if complex, recognition of pictoriality achieved in the iconographic succession (as we will see, the recognition is internally sedimented and recursive), the configuration might function simply as a nonpictorial substitute for an actual (and equally nonpictorial) *example* of the object that it would otherwise depict (indeed, it might function *as* that object, without the intervening relation of possible substitution).

Of course, our primal determination that a configuration is a picture—our primary recognition of its pictorial aspectivity or pictoriality—does not by itself tell us what it is a picture *of*. Our knowledge that a display depicts, for example, Winston Churchill glowering through the smoke of his ever-present cigar (Fig. 7.1) might not be sufficient to inform us that it is a pictorial symbol (a once-very-familiar cultural convention) of the indomitability of the sailors and soldiers of the British armed forces (in Walter Sickert's portrait of 1927, the artist presumably had in

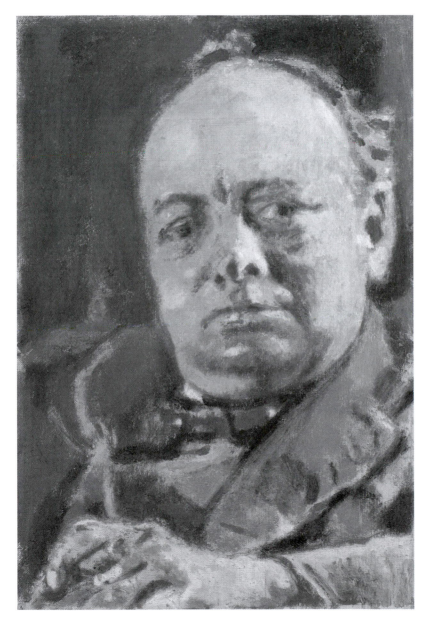

Figure 7.1. Walter Sickert (1860–1942), *Portrait of Churchill*, 1927. National Portrait Gallery, London. © 2010 Artists Rights Society (ARS), New York/DACS, London.

mind Churchill's service as First Lord of the Admiralty and Secretary of State for War during the First World War, though he was serving as Chancellor of the Exchequer at the time) or of the steadfastness of the British people during the Blitz (pictures of Churchill in this characteristic pose continued to be produced throughout his life and beyond), and not, say, a symbol of famous cigar-smokers (though it could be that too) or perhaps even a symbol of notorious strike-breakers or bull-headed politicians. (In 1926, Churchill opposed the miners in the General Strike; Sickert was personally and ideologically close to Churchill's powerful opponent Lord Beaverbrook, who strenuously objected to the Chancellor's economic policies.) The configuration can contain several kinds or orders of likeness despite the fact that only some of these constitute a pictorially functional motif. Some of these likenesses are remote from pictoriality. For example, in terms of pure style (explored in Chapter Four) the picture might look like other pictures, such as pictures by the same painter. But other likenesses seem to be meshed with pictoriality in lesser and greater degrees. The man in the picture might look like Winston Churchill formally to us—he might have the sensuous configuration of Churchill—without depicting him (recall the ambiguities of portrait identification in Raphael's *Bindo Altoviti*, discussed in Chapter Four), or without *only* depicting the particular man Churchill. Rather, this Churchill might depict "the British people." And a man in a similar picture might hold his cigar like Churchill, acting in the style of Churchill without looking like Churchill: he would instead depict "the British people in their Churchillian style."

In virtue of these and many other possibilities of interaction and disjunction between formality, style, and pictoriality, depictions tend to be incorrigibly open-ended *despite* their apparent specific likenesses to objects, to other pictures, and to the formality, style, and pictoriality of things in the world. Pictures are inherently decomposable and recomposable in recognition. And they are continually constituted and reconstituted in aspect-seeing. In this regard, the iconographic succession loops from primitive pre-iconographic recognitions to ultimate iconological understandings and back again. It can be defined as a history in which the many ambiguities of pictoriality as it is interleaved with configuration, and especially with the possible and available likenesses of configuration, have been resolved in a particular way, namely, to stick with our example, as a picture in which Churchill personifies the British people. He has their look; they have his style: it is a picture of them in him, of him as them.

Ambiguities of pictoriality occur and persist at every stage of the iconographic succession and in all its recursions. At the beginning of the

succession, we must decide the question whether the configuration before our eyes is any kind of picture at all. It is conceivable that we have noticed a resemblance to objects in a configuration that depicts nothing at all. (This "depictive disjunction" has already been discussed in Chapter Two.) We must discern, then, that the configuration has pictoriality, that a resemblance to Churchill functions pictorially even if the visible likeness to Churchill—the visible likeness of Churchill in the configuration—does not exhaust the pictorial ramification of the image. At the end of the succession, we must know what it means; namely, that it is an image of the British people (having a particular historically-located culturality in the sense to be discussed in Chapters Nine and Ten) personified in the recognizable likeness of Churchill. To resolve the former question is not, of course, to resolve the latter, or at least to resolve it fully. Still, to know what the picture means is surely to know that it *is* a picture; and to know that Churchill's likeness ramifies in the symbolism of the image must be to suspect that the resemblance to Churchill in the configuration is pictorial. The iconographic succession, then, involves regresses and recursions. And each recognition does not depend entirely on specifically pictorial knowledge. As noted, it involves formal, stylistic, and, as we will see in this and later chapters, cultural understanding of the artifact that help us recognize what pictoriality subsists at every stage of the succession.

As this might suggest, a robust theory of the iconographic succession must be able to address unstable or incomplete relays of the recognitions traversed, or what I will call the *transreflexive relay of recognitions*. Indeed, uncertainties and perturbations of recognition in the iconographic succession lie at the heart of the anthropology of visuality. (As we will see in Chapter Eight, this intrinsic fundamental fact of visual culture is not always fully respected by a culturological tendency to reify the smooth completion of the iconographic succession as a successful transpersonal transmission of pictorial symbolism.) We identify pictorial motifs and symbols not despite the possibility of the nonrecognition or invisibility of pertinent aspects of the configuration but *because of* the possibility of nonrecognition. At every stage of the iconographic succession, pictoriality leaps through its ambiguities and disjunctions—ambiguities and disjunctions that persist in the configuration and create a particular texture in the iconographic succession as we experience it in seeing the picture. In this respect, the positive archaeology of the iconographic succession that has typically been practiced in iconology following Panofsky (and sometimes reified in visual-culture studies) must be complemented, point for point, by a negative analysis of the possibility of disruption in

the succession, even its necessity. At the same time as a positive iconology identifies the emergence of image, motif, and symbol, a complementary criticism must track the instability and incompletion, even the reversibility and collapse, of any and all pictoriality in the configuration. Only a conjoint analysis of this kind can provide a deeply historical hermeneutics of pictoriality in visual culture, and, as we will see, outside it as well.

■ 3

Iconologists typically assume the primitive recognizability of the depicted objects or "factual subject matter" of a picture, what Panofsky called the "primary expressional meaning" of pictorial configuration. To use one of Panofsky's examples, we might recognize a picture of thirteen men seated at a table as showing (in Panofsky's phrase, as being a "primary expression" of) thirteen men seated at a table.[6] Within this primary purview Panofsky explicitly included our recognition of the attitudes or expressions of the depicted objects and figures. In the very moment of recognizing them, we might recognize the thirteen men seated at a table to be serene, anxious, or hostile. Only "secondarily," in our recognition of their "conventional meaning" (*I & I*, 6), do we recognize these thirteen serene or anxious men seated at a table to be Christ and the twelve disciples at the Last Supper.

Panofsky believed that certain primary expressional meanings must be transhistorically recognizable. On this account he could explain how secondary conventional meanings, which are always culturally specific, ride on the survival and revival of motifs inherited by image makers from long-past ages and faraway places. Panofsky's friend and colleague Aby Warburg had called this process *Nachleben*, the afterlife of the primary expressiveness of configuration. In Panofsky's hands, *Nachleben* became *iconography*. For example, a certain depicted male figure, youthful and beardless and often accompanied by attributes such as a lamb, could be recognized as a Calf Bearer (*Moschophoros*) or "good shepherd" in Greco-Roman antiquity and as Christ ("the Good Shepherd") in the Christianized world. (In the earliest Christian pictures, Christ did not have a beard.) If the iconographical dimension of Panofsky's iconology is correct, the primary recognizability of the motif must have been transmitted between different cultural sites, each of which recognized its own forms of likeness in using the image despite the constancy and continuity of the configuration. There were sites, contemporary or not, that recognized Apollo (or other caring and healing gods) and others that recognized Christ when they reproduced the motif. Indeed, the primary recogni-

tions vested in the primitively expressive form of the good shepherd *must* have been transmitted between cultures, moving from one network of recognized likenesses to another, if Christ replicated Apollo or similar gods (as Panofsky's brand of art history claimed to discover by way of its wide-ranging antiquarian inquiries). How could two similar images of a good shepherd, apparently having cognate symbolism and often constructed in stylistically similar ways (namely, in a classical or classicizing fashion), have otherwise arisen in disjunct historical situations? (To be sure, part of the point of iconographical investigation might be to show that the two situations, though historically disjunct, were not culturally discrete.) In the end, the most narrowly focused consideration of site-specific conventional symbolism cannot avoid raising the deepest questions suggested by Warburg's concept of a universal mnemology.

Panofsky asserted that the study of the primary expressional meaning of motifs must be a pre-iconographical investigation (*I & I*, 9). In one sense, then, he excluded it from his iconology, leaving it to the inquiries of ethology, psychology, and sociology—to speculative anthropology broadly speaking. Nevertheless, in a deeper sense Panofsky's iconology made a crucial contribution to anthropology. In effect it developed an anthropology of vision. Its object might be called visuality: *picture-seeing*, the particular and proximate object of iconology, in the final analysis constitutes the inherent pictoriality of *world-seeing*, the general and ultimate object of iconology.

Much of this anthropology, especially the closing of the methodological circle of iconology in the discovery of visuality, remained implicit in the way Panofsky himself framed his program. To be specific, according to Panofsky an investigation into the secondary conventional meaning of a motif requires iconographical and iconological study, usually based on extra-pictorial documents. And this manner of study inevitably consumes the lion's share of our attention as historians. The inquiry must be conducted as a cultural history of pictures; it considers both their traditional types (iconography) and their culturally specific thematization and symptomaticity (iconology). Here, however, Panofsky's distinction of the pre-iconographical and the iconographical levels of analysis obscured the fact that we must conduct *an iconography, even an iconology, of an object's primary expressiveness*—namely, an iconography, even an iconology, of *the historical recognition of its having been depicted in the first place*. But how can this iconography or iconology proceed without vacuity and tautology—without falling into vicious circularity—if the iconographic and iconological dimensions of a configuration are devolved from its *pre-iconographical recognizability*?

In his presentation of iconographic method in "Iconography and Iconology," Panofsky located form "in Wölfflin's sense" (*I & I*, 6) at the pre-iconographic level. In Chapter Eight I will return to the difference between Wölfflin's and Panofsky's approaches to formality and pictoriality. Here it suffices to say that where Wölfflin regarded form as primary, Panofsky, despite his terminology, regarded it merely as *primitive* in our recognition of pictoriality. Form in Wölfflin's sense is the level, as Panofsky put it, simply of "'what we see'" (*I & I*, 7).

Panofsky's careful quotation marks in the last-noted phrase were intended to recall that according to his theory what we see must be a visual world that has ultimately been constituted and organized in pictoriality—a visuality. What we see (*without* the quotation marks) is, of course, simply a "change of details within a configuration . . . in [our] world of vision" (*I & I*, 3). Our primary recognitions provide automatic identifications of objects and events, a "factual meaning" based in "practical experience," that is often coupled with awareness of the "psychological nuances" devolving from our empathy with objects and events, especially the actions of other people (*I & I*, 3). Factual and psychological visual intuitions jointly compose the expressional meaning of perceived states of affairs. Not all such realizations need be conscious and intentional, but they are always sensible: they are constituted in visual perception alone. As Wölfflin had said, they must be immediate.

Our recognition of the expressional meaning of objects and events in pictures must be included in what we see, because pictures, like other objects and events, are furnishings of the world that are fully open to our vision. Indeed, they are replicated specifically *for* our vision. But when Panofsky asserted that what we see in pictures can be grasped in a "*fraction* of a second and *almost* automatically" (*I & I*, 11; my emphasis), he noticed that seeing pictures seems to include a not-quite-immediate recursion or reflexion that occupies psychological duration and requires psychological work, at least until the configurative conventions of pictoriality have been fully learned. This duration, this work, is not to be found in extra-pictorial seeing. In the case of seeing pictures, in fact, pre-iconographical visual perception (Wölfflin's formal apperception) consists in "identifying pure forms . . . as *representations* of objects, events, [and] expressions" (*I & I*, 5; my emphasis).

In Panofsky's vocabulary, "forms thus recognized" are called motifs. In part, Panofsky used the term "representation" (*Darstellung* [*PB*, 95]) to refer to the original schematic constitution of visual intuition: objects and events in perception are representations or what Ernst Cassirer, Panofsky's mentor, called "representative meanings" created by the essential

Darstellungsfunktion of human cognition.[7] But Panofsky introduced *Darstellung* specifically in his effort to "transfer the results" of a psychological analysis of extra-pictorial situations in everyday life "to a work of art" (*I & I*, 5); that is, when he moved (as the art historian must move) from seeing the world to seeing pictures—from vision (and perhaps visuality) to pictoriality.

As representations, motifs in Panofsky's sense lie in a strange position midway between the pre-iconographical and the iconographical level of analysis. Extra-pictorial mundane seeing is not, we might suppose, a seeing of the world *as* a world of motifs. Rather it is simply seeing the world *simpliciter*, even if that seeing, insofar as it is a visuality, must be driven recursively by pictoriality (at least insofar as we see the motifs in the world). To use Panofsky's initial example, we might see a man tipping his hat to us in the street (*I & I*, 3). This event has an ultimate iconological meaning: the symptomatic cultural significance of the man's gesture. It does not, however, require a discrete moment of pre-iconographic picture-seeing, of "identifying pure form as a representation of" In the street we see the actual man really tipping his hat to us, not a representation of the man tipping his hat to us. (To use the philosophical terminology developed by Cassirer, the representation is the substance of the seeing, not its object.) It is only in confronting a *picture* of the man tipping his hat that we can see the representation of the man tipping his hat (at least insofar as we recognize the pictoriality of the picture in the face of its possible depictive disjunction), and recognize its motif. And to recognize pictorial motifs, if we do so at all, is to edge into iconographical and iconological understanding (*I & I*, 6-7).

The recursion, the "fraction of a second" it takes us to see the *picture* of the man tipping his hat, marks the passage through which the method of iconology needs to move in its theory of an ultimate visuality. (The quoted phrase need not refer to a literal duration that could be measured by psychophysiology; it refers to the fact that the recognition is not automatic, however we might understand the history of the reflex or reflexes in question.) But it is also the moment of possible disjunction, resistance, or blockage. It might be far more difficult for us to recognize a pictorial motif, the primary expressional meaning of objects in depicted worlds, than to see the same objects and events in our *non*pictorial world. By the same token, it might be more difficult to recognize objects and events in our nonpictorial world than to see them in *pictorial* worlds. This possibility might well warrant and justify the making of many pictures in the first place. But this recursion proves the point: not all recognitions are equally easy.

Most important, the recognition that gives us the picture (the primary expressional meaning of this particular object or event) and the recognition that gives us its motifs (the primary expressional meaning of the objects or events *depicted by* this particular object-event) are not the same. Pre-iconographical picture-seeing involves a recognition of representationality. But because this representationality occurs pre-iconographically, it *precedes* the traditional symbolic determinations it seems to require. As the pure form of depiction, it seems to subsist (so Wölfflin thought) as a configurative formality unrecognized by us *as* traditional motif or cultural symbol. In Chapter Eight I will turn in more detail to the deep dispute between Wölfflinian formalism (despite its stress on the historicity of vision) and the Panofskyan iconology that devolved in part as a response to Wölfflin's fundamental observation.

It should not be inferred that the pure form of depiction—the recognition of representationality preceding the understanding of symbolism—lacks meaning. If it resists being interpreted, if it keeps its secrets (as Wölfflin once put it), nonetheless it manifests a primary expressional meaning, namely, the factual identity and the psychological nuance of objects and events as they can be grasped in pictures. Nor does it entail that this significance escapes traditional or cultural determination, that it is entirely outside visuality—though it is quite possible that it sometimes is. It implies only that the recognizability of pictorial form must be constituted in a moment, a recursion in the iconographic succession, that is quite distinct from the constitution of anything that might be represented *by* pictorial form. In theory, iconology wants to say that these identifications and realizations are one and the same: one and the same visuality provides the ground for both recognitions as an integrated and unified (if not-quite-immediate) perceptual and cognitive succession. But this determining ultimate visuality must somehow have been coaxed into being through the very synthesis of recognitions that would make it possible in the first place. In all of this, as Panofsky observed in retrospective ruminations on his method, "there is . . . some danger that iconology will behave, not like ethnology as opposed to ethnography, but like astrology as opposed to astrography."[8]

Needless to say, if the man of flesh and blood tipping his hat and the depicted man tipping his hat were visually indiscernible we might confuse the two kinds of pre-iconographical recognition. (For the sake of maximum exactitude, we should say that the former situation involves *pre*-pre-iconographical and the latter involves pre-iconographical recognition. Though cumbersome, this distinction takes account of the supposed original passage of pictoriality into visuality—the pictorialized vision that is

ultimately returned recursively to the pre-pre-iconographical seeing itself.) But a man in the street and a man in a picture are rarely if ever identical in this way. We can see the difference right away. In fact, Panofsky emphasized that historical practices of depictive stylization (the object of Wölfflin's *Gestaltungsgeschichte* or "history of formalization") prevent us from indiscriminately applying our practical experience of seeing the world, our ordinary recognitional abilities, in our seeing of pictures (*I & I*, 9). This fact leaps into view for us, literally enters into our seeing, when the pictures in question are unfamiliar to us in their formality if not in their objects as well. Nonetheless, Panofsky almost conflated the two applications of practical experience in visual perception. Certainly the transfer between them requires the primary recognition of *the formal integrity of a picture as such*, the point Panofsky partially obfuscated.

Panofsky assumed a complete, unperturbed transfer from the pre-iconographical recognitions that support the picture to the iconographical recognitions that the picture supports. In the succession from pre-iconographical to iconographic recognitions, it initially seems that the seeing of pictures must have become almost identical with extra-pictorial seeing: our abilities in world-*recognition* enable us to recognize pictures. Vision enables pictoriality. In the end, however, it becomes clear that extra-pictorial seeing must, in Panofsky's view, have been entirely identical with a seeing of pictures, that our abilities in world-*representation* enable us to recognize the primary expressional form of pictures. Visuality enables pictoriality. But the pictoriality enabled by world-recognition itself enables this recognition of world-representation. In other words, we have moved in a great loop from vision to pictures to the pictoriality of vision to the visuality of pictures . . . and presumably round and round again. Throughout this loop, at least in Panofsky's treatment in *I & I*, all moments of nonidentity, any disjunction between seeing the world and seeing pictures of the world, must be converted into identity.[9] And this translation requires us to forego a fully critical *Gestaltungsgeschichte*, what might properly be called a skeptical formalism—a history of configurative organization that might explain how the integrity (or nonintegrity) of a picture does (or does not) entirely cohere with the integrity (or nonintegrity) of the world it putatively depicts. This is a question neither of visuality nor of pictoriality alone. Thus it is a task neither for the anthropology of visual culture nor for pictorial formalism on their own. It calls for their mutual critical negation; that is, it requires the critical method of confronting each and every visuality with its reciprocally requisite pictoriality and vice versa. I will return to this matter later in this chapter and in more detail in Chapter Eight.

We grasp the primary expressional meaning in a picture partly because we understand its depictive *style*. For this reason Panofsky took the theory and history of styles to be the very foundation of iconography and iconology in his sense (*I & I*, 11). Pre-iconographical picture-seeing is separated from pre-iconographical world-seeing by the fact of style: the world looks natural, or objective, while pictures often look constructed, or subjective. Naturally, of course, it is a different matter when the full loop of visuality has been traversed and recognitions of cultural imagery or image-symbols constitute vision as such. Then we may say, returning to the issue raised at the beginning of Chapter One, that seeing itself has a style. Panofsky was entirely right about the general principle: style is an unavoidable feature of visual culture as well as one way *in* to visual culture. (In my terms, style—the "look" of things and especially the look of pictures—includes *both* configurative formality *and* the recursion of stylisticality in the stylistic succession [Chapter Four] *as well as* the recognition of culturality to be explored in Chapters Nine and Ten. Needless to say, such complex aspective interdetermination cannot be taken for granted.) But Panofsky did not fully make good on the implications of the principle. The reflexive recognizability of the world affords its primary expressional meaning for the inhabitants of any form of life within in it. In looking at a picture, those inhabitants must recognize what objects, attitudes, and expressions that are reflexively recognizable in their form of life have actually been *depicted* within the picture as well. This requires a primary recognition of the picture as such, of the very fact of pictorial configuration and its attendant stylization. Oddly enough, when Panofsky distinguished iconographical and iconological significance from pre-iconographical expressiveness, he waved away this phenomenon of "style," the recognitional challenge posed by the pictorial configuration, at the very point at which it should have taken center stage.

In the framework of Panofsky's statement of iconographic method and his own account of the iconographic succession, the distinction between world-recognition and world-representation, or world-seeing and picture-seeing, might seem to be indefinite and impalpable. In one sense, the very notion of the iconographical succession as a great loop of visuality and pictoriality suggests that in practice the reciprocally and recursively constituted recognitions must be nested within one another—always co-present.

But in another sense, the distinction between recognizing what is going on in the world and what is going on in a picture must be vast and dramatic, however the one case inflects the other. Despite the fact that a *depicted* world is in the world, and that we navigate in relation to it as an

object in the world, we cannot navigate *within* it. If a picture has a smell or a sound it cannot (or cannot usually) be the smell or sound of the depicted objects. We cannot reach inside the picture (at least insofar as we are dealing with a two-dimensional depiction) or walk about it or feel and taste its depicted substances. Its seeming solicitation of such actions, however they might be figured in the pictorial world, can never be realized in the world of our actual locomotive exploration. Indeed, our exploration tells us, again and again, that the world depicted for our vision has little or no material correlation to the world that is routinely available to our navigation. Even if the picture proffers an immersive virtual space of some kind (for example, in a holograph), it resists navigationally reflexive discovery of solid material objects.

Of course, we can literally build the world we inhabit in such a way that it is *like* a picture—a visual culture that exists in solid, spatially extended reality. Here the constituting pictoriality would be entirely converted into visuality, as the iconological outcome of the iconographic succession requires and as visual-cultural studies tends to assume. And we could navigate quite naturally in this visual culture without recognizing it to be a picture—that is, without seeing it *as* a picture. But this world, this visually cultured world, could not be built without the original recognitions of pictoriality that allow us to realize its configuration in the way we live in it.

■ 4

Although the motif depends on pre-iconographic recognitions, the iconologist focuses on its secondary conventional meaning, what its primary recognizability "stands for" for a particular group of beholders.

Despite the achievements of iconology, the relays and recursions of the succession from primary expressional meaning to secondary conventional meaning have not been well understood—that is, the succession from pictorial motif to what Panofsky called the "image." The latter is better designated, however, as the "pictorial symbol," a term Panofsky also used for this phase of the iconographic succession. An *image* is projected on the retina of the eye, as in the case of the immobilized sheep mentioned at the beginning of this chapter, or more exactly an image is established in the optical cortex. Subject to the geometry of the visual angle, it encompasses the entire visual field or field of view, including any pictures in it. We do not see images, then; we see *with* images. ("Images are not pictures. I do not tell what object I am imagining by the resem-

blance between it and the picture."[10]) Of course, when a visuality has been constituted, the image or "what we see" is a world-*picture*, organized in or as cultural symbols; that is, images in Panofsky's sense of the term. But insofar as we should not assume its presence—human vision must succeed to visuality—it is best to reserve the term *image* for the optical image, whether inside or outside visuality (or outside *and* inside it).

From the iconologist's point of view, somehow we must see the motif of thirteen men seated at a table in its primary expressiveness, even though this must be mediated in the specifically pictorial relay discussed already. But, again according to the iconologist, we see the Last Supper specifically (that is, we recognize the picture to be a "Last Supper") in terms of more restrictive and contingent conventions. These are not the same conventions of depiction that mediate in pre-iconographical recognition, for that recognition requires only that we see a picture of thirteen men seated at a table. To some extent the secondary conventions of pictoriality, then, supervene in the relay between primary expressiveness and symbolic significance—not in the relay between extra-pictorial object-recognition and recognition of pictoriality. Nonetheless, the primary expressional recognition seems to be necessary for the secondary conventional recognition, though evidently not sufficient. How could one recognize the Last Supper when presented with a picture of thirteen men seated a table *without* also recognizing the pictorial motif of thirteen men seated at a table? The motif and the symbol must be continuous. And there's the rub.

We can pursue iconography without iconology. It would be a historical inquiry into the transhistorical and transcultural transmission of pictorial motifs. Indeed, Warburg demanded this—an iconography, as he put it, "without border guards."[11] (He continued to elaborate the notion, with great conviction and little success, in his universal mnemology.) We cannot, however, pursue iconology without iconography, even though iconology typically wants to leave iconography entirely behind. As we have seen, an iconography of depicted primary expressional meaning, supposedly pre-iconographical, is actually required to determine that there is a configured motif that could have any symbolic value (be an "image") in the first place.

It is evident, then, that the several recognitions that organize the iconographic succession are not unitary. They do not comprise a single reflexive recognition that simply succeeds (in which case the picture becomes fully present for a beholder as a wholly intelligible cultural symbol) or simply fails (in which case a beholder apprehends no pictoriality at all). Rather, the psychological order of the full iconographic succes-

sion should be described, as I have already suggested, as a transreflexive relay of recognitions. When the transreflexive relay is terminated, interrupted, or diverted, a picture cannot become fully present for the beholder even though aspects of its pictoriality might be seen. We can see a picture of thirteen men at a table and *not* see the Last Supper; the reflex that recognizes pictoriality in the motif has not succeeded to the reflex that recognizes the symbolic status of the motif. The picture, then, is only partly present. Its pictoriality subsists only at the transflexive stage of recognizing a particular motif. To be sure, if we say that the picture is only partly present, we are assuming the necessity of its full succession to culturally symptomatic symbolism; and as we will see, this cannot be taken for granted. No doubt the study of visual culture in the fullest and strictest theoretical sense requires this succession, creating an implied standard for the very presence of pictures. But if we do not assume the succession, then there is no standard for saying whether a picture is fully present for a beholder; and visual-cultural studies becomes an empirical or historical inquiry into *what* pictoriality and thus *which* picture, if any, might be present.

Needless to say, successful transreflexive relay seems to us to be immediate, incorrigible, and irreducible. Like any reflex, it usually seems *phenomenally* to be unitary insofar as the relay coheres without sensible loss, without remainder, and without disruption. For this reason a pure phenomenology of picture-seeing is unlikely fully to identify the deepest historical relays of visual culture, and therefore the deepest hermeneutic questions of visual-culture studies—for these relays are partly occluded phenomenally even if they can be reconstructed retrodictively or in an archaeology of our vision. When we fail to see the Last Supper because we do not know the religious symbol, we do not inherently *see* that we are failing to see something in the motif of thirteen men at a table. We might, however, become aware of evidence (especially in the way in which the picture is being used by other people) suggesting that there are certain aspects of the picture as yet unseen by us or that, if we are seeing them, might be endowed with significance that we do not yet recognize. In Chapter Nine I will consider this matter in terms of learning to play the appropriate "language-game" of the picture.

When the transreflexive relay encounters resistance, pictoriality in the configuration will be experienced as perceptual and cognitive work, a palpable *difficulty* in picture-seeing that occupies psychological duration and demands our attention and inspection. Lack of motivation or evidence for seeing certain aspects is not resistance; resistance is an *internal* aspective conundrum in the iconographic succession, typically a picto-

rial ambiguity, a stylistic unfamiliarity, or a configurative obscurity. Faced with difficulty, the agent of the relay (he or she might be called a *viewer* if this term did not tend to assume the ideal completion of a transreflexive relay in the recognition of a cultural symbol) likely will try to reduce or alternately to consolidate some of the recognitions that have already been attained in the succession. The transreflexive relay will tend toward reflexion. But the self-reflexive collation of recognitions, though it involves what we might literally experience psychologically as the flexing of our consciousness, does not in itself guarantee that the picture will be fully recognized. It only means that pictoriality will be pursued in ways that will not be sensed or seen to be needed when the relay is fully reflexive, whatever its actual succession.

In its explicit theoretical program, the cultural history recommended by Panofsky and its reproduction in visual-culture studies usually offers itself as an archaeology of successful transreflexive relays of picture-recognition from one end of its history to the other, that is, from the recognition of the material fact of the picture and its configuration of expressive forms to the recognition of the symbol (Panofsky's "image") and its cultural symptomaticity. In notorious studies of Early Netherlandish painting, Panofsky did acknowledge resistances in the iconographic succession: he posited a "hidden symbolism" in certain pictures. Nonetheless Panofskyan art historians have generally tended to pursue this phenomenon as a positive question of the eventual intelligibility of these symbols (if only to latter-day iconologists) rather than as a negative question of their inherent unrecognizability or at least their *empirical* unrecognizability to original beholders. More important, hidden symbols constitute only one species, probably the least interesting, of resistance in the transreflexive relay of pictoriality. Specifically, a hidden symbol must be a "late" resistance; it occurs in the succession from a motif to a pictorial symbol (or Panofsky's "image"). For this reason, we tend to be surprised by proposed iconological decipherments of hidden pictorial symbols, and sometimes unconvinced. We had felt confident that the transreflexive relays had already terminated in seeing the picture *without* this recognition—the seemingly further or later recognition—of a hidden or at least a latent pictoriality.

It is a peculiarity of the iconographic succession that we regularly see the pictoriality that is present for us—that *we* have visually constituted—as all the pictoriality there is to see. Our awareness of a perceptual or cognitive difficulty in apprehending pictoriality must in itself emerge as a sensible stage of the iconographic succession, even as an aspect of the configuration. By definition, then, "hidden" symbols do not display their puzzling pictorial status to us. Instead they seem to subsist on the

far side of a gap in the transreflexive relay—a gap readily identified with the putative termination of the relay, and often confused with it. Stated another way, hidden symbols seem to *continue* depiction in a way or to an end that the achieved pictoriality of the configuration does not seem to us inherently to need. They provide one of our best kinds of evidence that the linked reflexes in the transflexive relay of recognitions must be detachable one from the next and, conversely, that they must be forged across several distinct thresholds, whether this process occurs reflexively throughout the relay or in self-reflexive sensations of resistance.

▪ 5

In a powerful thought experiment, Danto has proposed that we "imagine a pair of indiscernible pictures from different notational systems which mean quite different things, between which the eye of course cannot discriminate."[12]

It is not entirely clear what Danto means by "different notational systems." All pictures might be thought to belong to the same notational system of depiction, if depiction should indeed be described as a notational system of *any* kind. Probably Danto means to refer to the use of pictures in, for example, a written script on the one hand and a drawn likeness on the other hand. Even this has its problems, however. In ancient Egypt the very same pictorial configuration could be used as a picture of a man functioning as a hieroglyph (even as a textual "determinative" indicating that a text is about a man) and as a likeness of a man in, for example, a commemorative representation (compare Figs. 7.2[a] and [b]). The discrimination of hieroglyph and portrayal, or conversely their entanglement in the rebuses constructed in Egyptian pictoriality, has long challenged Egyptology.[13] The configurations look alike in both uses, so which use should we follow? An educated observer usually can discern contextually, of course, whether the configuration belongs to script or a portrayal. In turn, however, when this distinction can be made it is by no means certain that the two configurations would in fact look *identical*, as Danto's thought experiment must have it. When we know that the pictorial configuration is being used as a hieroglyph, we might ignore its scale (readable hieroglyphs could be written at any scale, and sometimes hieroglyphs were much larger than the pictures they accompanied); when we know that it is being used as a portrayal, its scale might become significant (in canonical Egyptian art human beings were differentiated as to their status by distinctions in the actual scale at which they

were depicted). Real-world cases that satisfy Danto's conditions might be limited to rare and subtle conceptual experiments.

In any event, in Panofsky's terms, the scenario identified in Danto's thought experiment seems to be a case of constancy in motif-recognition—the two pictures look just alike in constituting visual images of the same recognizable depicted object—despite variable symbolic values. Still, the thought experiment must presume a transreflexive relay. Supposedly we see the particular symbolic value of each of the indiscernible pictures *despite* their indiscriminability as pictorial motifs. Danto's point, then, is simply that the transreflexive relay of recognitions must be entirely one-way. Consistent with Panofsky's original specification that symbols emerge in the latest or in the highest stage of an iconographic

Figure 7.2.

(a) The hieroglyphic writing of Egyptian *hwt-sr*, "castle of the noble," Tomb of Mery[amun] (Chief Royal Herald and Steward of the Palace) at Thebes, Mid-Eighteenth Dynasty, c. 1400 BC. (b) The deceased receiving accounts and offerings, Tomb of Prince Merib at Giza, Fourth Dynasty (c. 2530 BC; removed in 1842). After Nina M. Davies, *Picture Writing in Ancient Egypt* (Oxford 1958) pl. 7, no. 5 (a). From Richard Lepsius, *Denkmaeler aus Aegypten und Aethiopien* (Berlin 1849–56) vol. 2, pls. 19–20 (b).

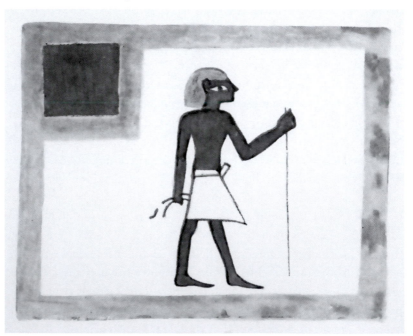

(a)

succession, in Danto's thought experiment our recognition of the two pictorial symbols (what Danto calls our cognitive representation) does not recursively affect our seeing of the shared motif. To use Danto's terms, already discussed in Chapter Two, the functions of visual perception are impermeable to cognitive representations that as it were re-view visual-perceptual recognitions in the succession. Indeed, Danto wanted to take Panofsky's "iconographic disjunction" between motif and symbol to mark a categorical interface between perception and cognition. Panofsky's preferred iconology becomes Danto's philosophical psychology.

Danto's thought experiment identifies a phenomenon that any theory of the iconographic succession must address; namely, the constancy of motifs in contexts of symbolic variation. Indeed, Panofsky put icono-

(b)

graphic continuity and iconological disjunction in just this sense at the center of several art-historical investigations. In Panofskyan iconology, in fact, the world history of art can practically be *defined* as a record of the constancy of motifs in their transmission through disparate historical contexts of symbolic re-specification, often tendentiously said to be *cultural* contexts. Iconology tracks the replicatory vicissitudes of "symbolic form," including the likelihood that when symbolic form survives into new historical worlds, its significance, even if intelligible to the later beholders, takes on aspects of anachronism and of spatial and social dislocatedness that were lacking in the original contexts of its use.

Nevertheless, the categorical distinction between perception (when defined as *recognizing objects*) and cognition (when defined as *understanding symbols*) does not always map onto the transreflexive relays of pictoriality in the iconographic succession in the simple and straightforward way projected in Danto's thought experiment. Danto must assume that in seeing a picture we have sustained mundane perceptual reflexes of object-recognition without disjunction until the pictorial motif has been recognized. As already noted in Chapter Two and reiterated in this chapter, however, a primal recognition of pictoriality (which intervenes between mere object-recognition and *depicted*-object-recognition) must launch the iconographic succession. This recognition of pictoriality must be sustained and enriched throughout the succession insofar as the recognitions in the succession, recognitions supposedly taking us from motif to symbol, have been sustained as a seeing of *pictures* rather than a seeing of the indiscernibles into which pictures can always subside (as noted in Chapter Two, the indiscernibles do not have to be pictures, but they could be *substitutes* for objects they resemble, or even real examples of them).

In fact, the transreflexive relays of the iconographic succession cannot be wholly identified at any point with the reflexes of object-recognition in mundane visual perception, barring the extreme case of trompe l'oeil pictorialities. If there is a categorical distinction, then, between perception as object-recognition and cognition as symbol-recognition, aspects of pictoriality must be required, sustained, relayed, and transmuted in *both* registers. Seeing that the object is depicted must be integrated with seeing what the depicted object is. This interaction warrants the suspicion that in pictoriality so-called cognitive representation must be thoroughly bound up with visual perception. Cognition does not quite precede perception in this context of seeing. But equally cognition does not seem simply to *succeed* perception. If there is a disjunction between pictorial motif and pictorial symbol, there must also be an "interface" between them, as Danto has said—even an interchange.

We can approach this matter in another way. In Danto's thought experiment, the specification of perceptual indiscernibility between two "pictures from different notational systems which mean quite different things" requires not only the positive hermeneutics that it explicitly assumes (the two pictures "mean quite different things" to an observer . . .). It also requires the negative hermeneutics that has been built into the thought experiment (. . . nonetheless the two pictures are indiscriminable). Of course, the thought experiment puts—it is intended to put—the positive and the negative hermeneutics into seeming conflict. Isn't it odd, Danto wants us to ask, that the pictures *look* exactly the same even though they *mean* quite different things? But cases of this kind are ordinary in iconology; motifs often remain constant while symbolic specifications can be varied. (Indeed, the very notion of the symbol seems to be partly predicated on the constancy of motifs, and the empirical *history* of symbols—at least so far as it has been tracked by iconology—simultaneously exposes the transhistorical genealogy of motifs reworked symbolically in transmission.) The seeming conflict identified by Danto, then, simply manifests the material relay, the recursion, and the resistance of the iconographic succession as such.

As stated, Danto's thought experiment makes it difficult to unravel the interface in question, and obviously it tries to buttress his claim that any interchange at the interface must be limited to a one-way permeability of cognition to perception. The thought experiment would treat a beholder who failed to discriminate the "meaning" of the pictures like a pigeon that only recognizes shapes—not a human being who recognizes pictures. Moreover, the beholder has been given absolutely no evidence to turn to in resolving the episode of indiscernibility narrated in the thought experiment. Supposedly the beholder has room to determine whether the shape recognized in one picture has the same symbolic value as the shape recognized in the other, a case of iconographic disjunction in Panofsky's sense, and as the thought experiment specifies. But he has no room to determine *whether the shape that is a motif in one picture is indeed the shape that is the motif in the other picture.* We could call this the issue of *recognitional* disjunction. If iconographic disjunction intervenes between the iconographic and iconological stages of the succession, recognitional disjunction intervenes between the pre-iconographical and iconographical stages.

In Panofsky's preferred iconology, recognitional disjunction would precede iconographic disjunction and must be resolved *before* iconographic succession. Danto reproduced this *mise-en-scène* in his thought experiment: the perceptually indiscernible pictures appear to depict the same ob-

ject that they both resemble. There is no recognitional disjunction in this succession as Danto has described it; it has been resolved or circumvented in a transreflexive relay that leaps right over or right through it. Indeed, in the thought experiment as stated, the iconographic disjunction can only be dramatized by *denying* the presence of recognitional disjunction: in the thought experiment, the depicted objects are recognized to be the same in the motifs seen as indiscernible. But in the succession the perceptually indiscernible pictures might not depict the same object they both resemble: they might depict *different* objects. In another formulation of the thought experiment, then, the beholder could be said to be confronted with "two indiscernible pictures from different notational systems that depict quite different things, between which the eye cannot discriminate." This thought experiment would dramatize the possibility of recognitional disjunction in the iconographic succession. And it suggests that its resolution requires symbols. Although the two pictures look just alike, we can recognize that they depict different objects because we see what each picture represents.

In most real cases of pictoriality, both kinds of disjunction—what I have been calling recognitional disjunction and iconographic disjunction—must co-exist. Both disjunctions must be resolved in the succession from object-recognition to motif-recognition to symbol-recognition—a succession assumed in Danto's thought experiment to have already transpired. The thought experiment simply stipulates that *in this case* the total absence of recognitional disjunction has cleared the way for a dramatic iconographic disjunction. But in most real cases the resolution of each disjunction helps resolve the persistence of the other: a recursion in pictoriality reduces the resistance of pictoriality. Cognition reaches or reaches back into perception (iconographic resolution reduces recognitional disjunction) in the same way as perception reaches or reaches back into cognition (recognitional resolution reduces iconographic disjunction).

Imagine, for example, an all-black picture of the face of a cube that seems to be indiscernible from an all-black picture of the bottom of a pyramid. Both pictures are simply all-black squares; they seem to look identical. But they depict different objects. This could be true even when they might be used in an experiment (with stipulated conditions different from Danto's) to mean exactly the same thing, say, a presentiment of death. (We will stipulate that in this visual culture a black square in itself does not mean Death; only cubes and pyramids do.) Because both of the pictures mean Death, a beholder might be indifferent to the fact that one picture should be recognized as a cube and the other picture should be recognized as a pyramid. When acquiring a grave marker to be

ornamented with one or the other picture, and asked which picture he prefers, the patron might well say, "it doesn't matter—they both mean exactly the same thing."

But the iconographic equivalence of the pictorial motifs might become puzzling, and the difference in the depicted objects might become salient, if the beholder asks *what* means Death in the case of either picture. The answer cannot quite be that the black square means Death. It has to be the cube recognized (or not recognized) in one picture and the pyramid recognized (or not recognized) in the other picture. In this instance the availability or imposition of the symbolic meaning to some degree promotes (or at least leaves unresolved) a recognitional disjunction. Nonetheless the disjunction in recognizing motifs could itself resist the succession to their shared symbolic meaning. Uncertainty about what means Death in the pictures (it's not the black square) must surely raise the question *how* Death should be recognized (if it isn't the black square) and thus whether either picture really *does* mean Death (if only a black square can be recognized). Despite the recognizability of their meaning, then, these two pictures, when paired, might succeed to it incompletely: we cannot be quite sure which picture, if either, presents what motif of Death. This might not matter very much when *both* symbolize Death *and* look the same. But if both symbolize the same thing in depicting different objects, can we be entirely sure that the pictures really do look exactly the same? We will probably want to look more closely. In turn this inspection might eventually discern differences between the two pictures that were taken at the beginning of our looking to be indiscernible. And the discovery of these differences might only increase our uncertainty, in this case about what depicts Death and perhaps whether Death is depicted at all.

A specifically *iconographic* transreflexive relay from recognizable motif to intelligible symbol poses, and provisionally answers, a basic "This is That?" question. In the succession imagined in our thought experiment, Is a cube Death?—Is a pyramid Life? (Remember that in Danto's scenario the two indiscernible pictures symbolically mean "quite different things"—say, the presentiment of Death in the cube-picture and the affirmation of Life in the pyramid-picture.) Transreflexive *recognitional* relays and possible disjunctions, however, pose and must somehow answer questions that arise all around the transreflexive iconographic relay as such—before the relay, in the relay, and after the relay. They interact with it continuously, sometimes depending on and sometimes determining how the "This is That?" question might or might not be successfully re-

solved. In our thought experiment, these recognitional pressures include several questions that depend for their answers on the point at which and the direction from which a beholder enters the succession equipped to make the appropriate discernments:

- "Which is What?" question (Is one black square a cube, is the other black square a pyramid?—thus one is Life, the other is Death);
- "This is What?" question (Is the black square a cube or a pyramid?—thus Death or Life);
- "Which is That?" question (Is the black square Death or Life?—thus a cube or a pyramid);
- "What is This?" question (Is Death one black square, is Life the other black square?—thus one is a cube, the other is a pyramid);
- and a "That is Which?" question (Is a cube one black square?—thus Death, is a pyramid the other black square?—thus Life).

In our thought experiment, it cannot (only) be a symbolic convention that enables the beholder to recognize that one black square is a cube symbolizing Death and the other black square is a pyramid symbolizing Life, even though Death and Life seem to look exactly alike. There must (also) be a recognition that one black square is a cube and the other black square is a pyramid, even though cube and pyramid seem to look exactly alike. This is not a symbolic convention because the cube and the pyramid, outside of being recognized as Death or Life, do not symbolize anything: they are simply what a particular black square must be recognized to be in order to be recognized as either Death or Life. In the iconographic succession, the transreflexive relay of recognizing the black square to be recognizable as the cube that symbolizes Death or as the pyramid that symbolizes Life might proceed without uncertainty, interruption, incompleteness, or excess—as the unitary transreflexion toward the symbol assumed in Panofsky's preferred iconology to be the epistemological ideal of human seeing. But it might not do so if the required recognitions cannot be secured relative to the points at which, or the directions from which, the beholder has entered the succession.

In addressing these questions analytically, a "formalist" attention to configuration (Chapter Three) and the critical hermeneutics of its iconographic succession can—and probably must—go hand in hand. Still, they risk becoming mutually self-fulfilling, and thus historically vacuous. Formalist attention to the phenomenal aspects of configuration can readily excavate disjunctions in pictoriality that might be routinely circumvented

were we not to conduct this kind of scrutiny. In the case of our thought experiment, for example, we might ordinarily be *indifferent* to differences in the objects used to symbolize Death. When we begin to look closely at the depicted differences—it is likely that some slight material differences will always be seen—the symbolic termination of the succession seems to become more uncertain. But would this uncertainty really be apposite? Critical interpretation attends to the putative difficulty of the picture; that is, to our uncertainty. But it might mistake the real vitality and intelligibility of pictoriality. It finds disjunction or disruption as a function of inevitable formal complexity where no disjunction or disruption really pertained in the requisite recognitional operations of pictoriality. For this reason, formalist criticism and criticism of the iconographic succession should always be framed methodologically as systematic *challenges* to one another's observations and results—not as mutual confirmations. They enable us to enter the matrix of aspective interdeterminations from different angles and from each angle to put pressure on what is seen from the others, and possibly to resolve them.

Even when it proffers the possibility of consolidated representation, a picture (presuming it has been recognized as a picture in the face of possible depictive disjunction) tends to resist its own recognitional and iconographic terminations. It tends to escape our understanding of immanent pictorial symbols, especially "hidden" ones, before they can (re) constitute vision—that is, before they can be deployed *as* vision. We cannot see the world as Paul Cézanne did (or more exactly, we cannot see it to be like a still life or landscape painting by Cézanne) unless we see exactly what Cézanne's painting means. Even then, we will not see the world to *look* just like a Cézanne painting, though for reasons explored in Chapter Nine we can say of a plate of fruit or a mountain across the valley that "it's *like a* Cézanne." For this reason visuality can only be the *prospect* of an intelligible pictoriality that is always ahead of or behind or around the pictures that relay it. One can look at pictures from this prospect and understand what they mean. But one needs to recognize what the pictures mean in order to adopt the prospect. The transreflexive relays of the succession, then, must be closed and continuous in a complete cycle.

When realized, this state of affairs can correctly be described as a visual culture. It is, however, an unstable collation. It depends on the recognitional and iconographic vicissitudes of pictoriality in the iconographic succession—or not—to symbolic intelligibility. Many historically important pictures *did not belong to a visual culture in this full theoretical sense*. In fact, they are historically important for this very reason.

Édouard Manet's *Olympia* (Fig. 7.3) was substantially finished in 1863. During its exhibition in Paris in the Salon of 1865, critics greeted it with hostility. According to T. J. Clark in his "preliminaries to a possible treatment" of the critical controversy, published in 1980, the critics did not simply condemn *Olympia* for being an incompetent rendition of a motif and symbol that was already well known to them.[14] They dismissed and sometimes vilified the painting because in it Manet had offered them little or no grounds for determining what or which motif and symbol the painting presented to them in the first place. *Olympia*, then, was not a bad painting, or it was not *simply* a bad painting. More important, and even if it could be recognized as a finished work displaying the skills and virtuosity of the painter, *Olympia* "failed to signify" (*MO*, 8).

Before the publication of Clark's essay on *Olympia*, modernist historians of Manet's reception in 1865 tended to suppose that the painter's critics failed to understand the positive significance of *Olympia*. Blinded by prejudice and convention, the critics, according to this account of the matter, did not yet recognize Manet's formal, stylistic, and iconographic originality.[15] At the same time, however, modernist historians did not specify exactly what significance Manet's critics might have grasped in *Olympia* had they had the wit to see it. According to George Heard Hamilton, the art historian before Clark who had devoted the most systematic attention to Manet's critics,

> Olympia is a puny model, stretched out on a sheet, and the Negro woman and the cat are there. That is all. There is no need to explain them; it is impossible to explain them, except as elements which occur in the work primarily for pictorial necessity, a necessity which is inextricably part of the painter's vision. . . . Olympia explains and corrects nothing.[16]

If Hamilton is right, the significance the critics failed to grasp in *Olympia*, paradoxically enough, was the fact that *Olympia* does not signify anything. Needless to say, however, it is not obvious how this differs from what the critics themselves said. Hamilton meant to say that in not representing much of anything the painting showed a great deal: in the very negligibility of its motif and symbol, it highlighted what Hamilton calls its "pictorial necessity."

In Hamilton's vocabulary this phrase does not really denote the depictive aspects of the painting, its pictoriality. Rather, "pictorial necessity" describes formal and stylistic aspects of the painting that are "inex-

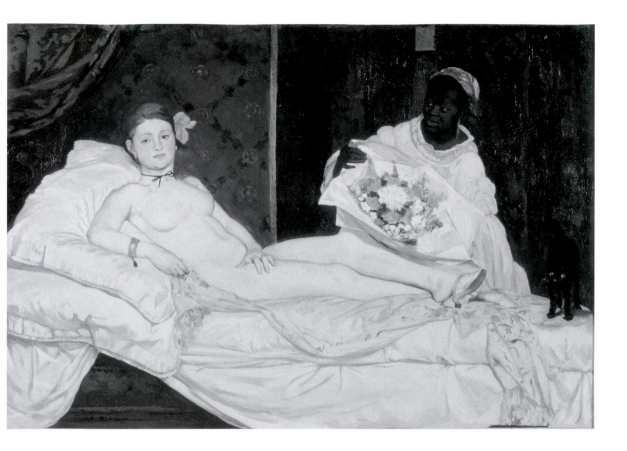

tricably part of the painter's vision." Because pictoriality in the painting supposedly was inconsequential, simply "there," these pictorial necessities—painterly necessities of configuration outside and around pictoriality—became dominant, as if they were not simply aspects but rather the very essence of the painting. (Hamilton's emphasis on the primacy of formality as the *raison d'être* of the painting, what he once described as the primacy of the "artist's interest in the formal resolution of the motif," defines him as a high formalist in the sense explored in Chapter Three; as Hamilton put it, "an artist's power can be said to depend upon his ability to discover the right form for his own work."[17]) Manet's critics supposedly failed to grasp this signification, the emergence of form (and to a much lesser extent of style) in a recession of depiction. It is awkward for Hamilton's approach that the critic Gonzague Privat, among others, explicitly attended to Manet's seeming devotion to "still life" detail, to his "flat" tones and color-fields, and to his silhouette outline and awkward posing of figures—the very qualities of Manet's formal and stylistic originality that modernist art historians of avant-garde art, including Hamilton, have approved. Privat fully recognized these aspects of Manet's

Figure 7.3.
Édouard Manet
(1832–1883), *Olympia*,
1863. Musée d'Orsay
Paris. Photo courtesy
Réunion des Musées
Nationaux / Art
Resource, NY.

painting. But he found little value, as it were no sense, in the recession of depiction that they required.[18]

Privat aside, critics who were unsympathetic to *Olympia* in the Salon of 1865 had previously been hostile neither to Manet nor to unconventional paintings by other painters. For this and related reasons, Clark suggested that a historical explanation of the painting's failure to find contemporary approval must be transferred from the critics to the painting itself, at least in part: the inability of intelligent, experienced, and even sympathetic viewers to grasp the significance of *Olympia* represented a "real recalcitrance in the object of study" (*MO,* 22). In turn, Clark urged, the bewilderment registered in the critical response to *Olympia* might illuminate Manet's concerns, even if these concerns were themselves uncertain and contradictory.

The logic of Clark's striking argument was refined, even exotic. In methodological terms it can best be read as a negative hermeneutics of the iconographic succession, of the disjunctions and disruptions of pictoriality, that has been undertaken in order to identify the disturbed interactions of pictoriality with the emergence and ramification of formality and stylisticality. Insofar as Manet allowed these disjunctions and disturbances to emerge, proliferate, and persist in the painting, the upshot (*pace* Hamilton) could not have been a *reduction* of pictoriality in the painting. Instead, they consolidated and relayed the *resistance* of pictoriality to full legibility in symbolic intelligibility, to visuality. It was not that the painting lacked iconography. There was too much iconography.

Clark focused on what he called the pictorial "productivity" of *Olympia,* on the way in which it might be taken to have generated a set of "possible meanings" (MO, 22–23). In 1865, Salon critics produced several interpretations of the painting. But few of them succeeded in recognizing its most elementary relays of pictoriality. For example, they failed to recognize the depicted occupation and social status of Olympia, the principal figure, even if the real-world identity of Manet's model for *Olympia,* Victorine Meurent, might have been known to some of them. (Knowing the identity of Victorine, already painted by Manet in a portrait of 1862, would not have helped all that much, for Olympia in *Olympia* was not necessarily a *portrait* of Victorine, though based on Victorine as a model. And even if it was a portrait, Victorine-as-Olympia was quite different from the real-life Victorine.) As we have seen, there is always a possibility that depicted objects might be disjunctive in recognitional and iconographical specifications. But Clark wanted to show that the painting can be held to account for the pictorial interpretations, or rather the pictorial nonrecognitions, that it generated. In approaching the matter this way,

Clark asked a basic question: on what grounds can we say that *Olympia* "failed to signify" if its recalcitrance in the year that it was painted, 1863, produced a commensurate uncertainty and confusion in 1865, as if pictorial resistance was seen by its viewers *as* the painting's disturbed pictoriality? Clark shifted Hamilton's positive specification of Manet's negative significance itself into the negative. Is it not possible, he asked, that the negative significance of the painting's "indifference" to depiction lacked meaning altogether, that it was a kind of *un*significance?

Clark raised a potent question. If he answered it (its force might be mostly rhetorical), he did so by pointing to the delay of iconographic intelligibility in the painting, just as Hamilton had done. According to Hamilton, Manet's depiction amounted to little that was (and is) worth trying to understand iconographically and iconologically because Manet, he thought, wanted to render his forms visible as formality in the narrowest high-formalistic sense, that is, as visible aspects of configuration somehow *distinct* from pictoriality. In Clark's interpretation, by contrast, when the pictoriality of the painting failed to secure iconographic and iconological intelligibility, its formality became unstable as well, and vice versa. For Clark, it seems, there can be no such thing as the purely formal aspect of the painting. More exactly, there can be no such thing as the "pictorial necessity" of formality incoherently assumed by Hamilton. All of the configurative aspects of painting interact; they are interdetermined.

In turn, then, Clark could not claim that Manet's *Olympia* "failed to signify" simply because the critics did not recognize its depicted object (Hamilton had already acknowledged that they did not). Nor did it "fail to signify" simply because the critics could not detect all of Manet's pictorial and painterly models even though these disjunctions of recognition provided evidence for Clark's larger point. (Art historians before Clark had already shown that Manet's sources were disparate and sometimes arcane.[19]) Rather, Clark tried to prove something different. When Manet's principal motif in *Olympia*, the lower-class prostitute who is Olympia (and *not* Victorine), failed to be recognized by critics, this unsignificance (as I have provisionally called it) could not be recuperated or recalibrated and in turn relayed as the painting's "pictorial necessity" in formal or stylistic terms; that is, as a recognizable formality and style or stylisticality. The failure of pictoriality was also—and intrinsically—a failure of formality and of style or stylisticality. *Olympia* failed *all around*. The critics could not recognize who Olympia was, or better *what* she is (a crucial aspect of the pictoriality), nor could they actually *see* her in the painting (her form) or tell how she was painted (her style). In every sense, we can say, they could not see what she looked like.

When stated this way, the immense hurdle for Clark's approach comes into clear view. To say that a configuration subsisted in wholesale aspective *noninterdetermination*, an all-around failure to signify, comes close to saying that the painting had no history. For the interdetermination of the formal, stylistic, and pictorial aspects of the painting simply *is* its history—its generation in a form of life, and its representation of and its contribution to it. (Of course, historically the painting had a social context in an everyday sense—an author, a date, a history of exhibition. But social context is not historical determination.) In modernist aesthetics and art history, the absence of interdetermination need not be troubling. According to Hamilton, for example, Manet's *Olympia* integrated itself as a new kind of aspective interdetermination. When Manet visibly detached formality from pictoriality, downgrading the customary privilege of pictorial motifs and symbols, shunting aside the expected display of stylisticality, and discovering the configurative independence of formality, the painting as it were launched a new art and requires a new art history: it *made* art history. Needless to say, Hamilton's art-historical formalism was supposed to be congruent with the invention of formalism by the modern artistic avant-gardes. But Clark's history of art aimed to correct modernist formalism and its tendency to convert every resistance, disjunction, or negation in the interactions of form, style, and depiction into a progressive *Aufhebung*.[20] According to Clark, we might wonder what kind of progress resides in the wholesale noninterdetermination of a failed painting, deeply disturbed in the relays of recognition that were required to constitute and to understand it. Can a representation of a form of life and its relays of intelligibility, let alone a transformation, really be achieved in these conditions?

At this point we must turn to the iconographic succession instated in the painting. For the critics of 1865, Clark argued, Manet's "transgression" in *Olympia* lay in his attempt to make a painting in which the "terms nude and *fille publique* [public woman or street whore] could be mapped on to each other, and shown to belong together" in the image (*MO, 24*)—as they did in the social and sexual life of many of Manet's implied male viewers. Needless to say, high-status courtesans, especially in exotic settings, had been painted many times before in the tradition. (Indeed, they had been painted using models who were known to many contemporary beholders, and known—or at least believed—not to be prostitutes.) And Parisian street prostitutes had already turned up in popular prints and smutty photographs. But Manet painted the street whore at the scale, and with aspects of the formality, accorded to the nude in a grand historical or exoticizing tableau. This configuration made

it difficult, however, to see Olympia *as* a whore, for under what conditions of propriety in painting—let alone real social conditions of sexual commerce in the street—would one exalt a common prostitute?

At the same time, Manet avoided formal, stylistic, and pictorial conventions (everything from spacious setting and *sfumato* to the customary symbolism of jewels and pets) that would have definitively suggested the grace, decorum, refinement, and pliancy of the courtesan. Notably, "the hand of Olympia . . . disobeys, crucially, the conventions of the nude" and "comes to stand for the way Olympia's whole body is disobedient" (*MO*, 25). According to Clark, "the picture, it is clear to us now, certainly attempts—blatantly, even ponderously—to instate within itself a relationship to established, previous forms of representation." Indeed, in 1856 Manet had made an oil-sketch rough copy of Titian's *Venus of Urbino*. But "for almost everyone [at the time], the reference back to tradition in *Olympia* was invisible" (*MO,*9). Only two critics recognized that Titian's painting must have served as a model for Manet, if only to motivate his "aping" and "mocking" of the earlier image, to use the words of the critic "Pierrot."

To be sure, as Clark pointed out, Gustave Courbet's female nudes had already "invented a set of refutations" for one of the "primary operations" of Titian's nude; namely, its effort to situate the implied male beholder "in a position of imaginary knowledge" of the body of his purchase (*MO*, 14, 16). Manet's *Olympia* did not fail to replicate Titian, however, only in order to replicate Courbet's refutation. Rather, as Clark put it, Manet's *Olympia* "contrives . . . stalemate, a kind of baulked invitation" of any and all recognitions of likeness with Titian's *and* Courbet's and practically any other depictions of aspects of the nude *and* the whore, including popular prints and photographs. For this reason a ramifying and unresolved recognitional disjunction (is Olympia a whore, a courtesan, both, neither?) precipitated from an iconographic disjunction (why doesn't she look like Titian's Venus or Courbet's women?). As Clark put it, *Olympia* "refute[d its] prototypes too effectively" (*MO*, 17, 27).

In Clark's view, in sum, *Olympia* did not subtract conventional pictoriality and stylisticality from formality, as Hamilton had claimed. Instead *Olympia* refused to grant to pictoriality the available formality and stylisticality. The painting as a whole consequently fell into ambiguity and unintelligibility; its recursions, an iconographic disjunctiveness that fed back into earlier stages of the succession and created recognitional disjunctions, were not resolved. In the end it failed to signify because it failed to formalize and to stylize, or more exactly to formalize and to stylize in recognizable ways that were well reconciled across the pictorial field. Pic-

toriality could not succeed all the way to intelligible symbolism because it was insufficiently interdetermined by formal and stylistic aspects that could so relay it. The seeming independent emergence of these aspects—such as the essential formality of avant-garde art lauded by Hamilton's modernist criticism—was simply the detritus of this disturbance.

■ 7

If Olympia was neither courtesan nor *fille publique*, though partaking of both, who was she, and what was *Olympia*? As Peter Wollen urged in a response to Clark's interpretation of the painting, Olympia's social class was not easily recognized.[21] According to Wollen, she did not "unambiguously" have a visible class: she was neither wholly "owned" nor wholly "owner" in relation either to her belongings, her quarters, and her maid or to her implied male visitor, customer, or buyer. Clark had certainly insisted on this too. According to him, the "signs of social identity" in Olympia were "as unstable as all the rest" (*MO,* 39). In Clark's view, as already noted, this instability contributed to the inability of Manet's viewers to gather coherent significance from the painting. In Wollen's view, however, instability in the social context assumed and addressed by the painting, especially regarding class affiliation, should simply be taken for granted in Manet's and in the critics' visual and cultural world of the early 1860s. As we might put it, visual uncertainty about the signs of social class was a feature of mundane world-recognition at the time. It was not, or not only, a recognitional and iconographic disjunction constituted in pictoriality.

According to Wollen, Olympia's real social identity could not have been recognized and realized in definitive pictorial ways until contemporary class conflict had been resolved in favor of the "meanings of the dominated," Clark's term for the intended intelligibility that he took to be "struggling for room" in Manet's painting. (Presumably the "meanings of the dominated" would include a real-world Olympia's way of picturing her own identity as a certain kind of whore, perhaps a new kind of whore, furnished with private quarters and a maid—even if she rented both of them for the sexual transaction implied in the painting.) In Wollen's view, "the elements of such a new structure already exist[ed] [in 1865], 'the meanings of the dominated' produced in class struggle, but they [were] not yet settled, complete, and consistent." If we accept Clark's account of these circumstances, then, it is no wonder that Manet could not depict these meanings: probably he could not actually *see* them. But in Wol-

len's view, we should allow the possibility that Manet might have seen the instability of Olympia's social identity perfectly well, and might have depicted it successfully in terms of *pictorial* ambiguity and uncertainty.

As I have set it out, the difference between the two historians is profound. In Clark's account of *Olympia*, Manet *painted in* contradiction, or better, *painted as* contradiction. The painter inhabited a form of life in which Olympia's (and probably his own) unstable, contradictory class identity—his unfixed or fluctuating class consciousness—determined, or rather *un*determined, many relays of recognition in the world and the work. By contrast, in Wollen's view Manet might be said to have *painted contradiction*, namely the contemporary contradictions incarnated in the bifurcated, complex class of Olympia as part-owner and part-owned, as renter and rented. Although we might acknowledge that contradiction of this kind can be grasped as such (for example, by a Marxist historical theory of the economic infrastructures and cultural superstructures of late nineteenth-century France), we have not really established one way or the other whether Manet "failed to signify" its recognition.[22] In other words, Wollen's critique of Clark returns us willy-nilly to the modernist state of the question, rewritten in Marxist terms—to the notion that *Olympia* might have stepped ahead of history, and indeed might have contributed to the visual reconfiguration of history precisely by picturing it, a veritable revolution. Wollen's Manet created a visuality. By contrast, Clark's Manet had no such clairvoyance. The artist could not depict what he could not recognize. By the same token, his critics could not recognize what he could not depict. This Manet was wholly constrained by vision.

Clark's account of realist and avant-garde painting in nineteenth-century France (and more broadly his historical instinct that any putative aesthetic supersession of real social life must be unstable and perhaps factitious) has been influential. The retractive or recessive realism of *Olympia* identified in his account of the painting would seem to suit the evidence, unlike the projective and progressive realism claimed for it by modernists like Hamilton or even by Marxists like Wollen. At the time (that is, in 1863 and 1865), bourgeois painters and critics could not readily recognize what was going on in the swiftly changing society in which they lived, could not see, for example, the ramifications of the dramatic "Hausmannization" of Paris and the demographic and social upheaval that accompanied it. Therefore they could not easily depict or describe it. (In particular, as Clark saw it, capital and its mechanisms of producing, owning, and renting such commodities as living quarters, household services, bodies, and pleasures were being reorganized in unprecedented ways.) In turn, contemporary artistic representations of this process

cannot usually be said, without critical inflation, to have offered radical sociopolitical or economic-historical (that is, Marxist) insight into their own conditions within it, instating aspect-seeing that would have disentangled them from mundane bourgeois awareness. In Clark's view, in brief, it must be quite as difficult and quite as implausible to make the historical case for Wollen's Marxist-modernist Manet—for Manet's formalism understood as a kind of Leninism—as to make the case for Hamilton's modernist Manet *simpliciter*.

But there remains at least a *theoretical* possibility that the iconographic succession in Manet's *Olympia* issued in a pictorial symbol of objective contradiction, a kind of obverse of the hidden symbolism identified by Panofsky. To buttress his historical interpretation, Wollen suggested that the painting exemplified the kind of "nonstandard logic" presumed in such representations as the "round square" considered in 1904 by the philosopher Alexius Meinong. The *term* "round square" is intelligible. But it would appear to designate a strange *object*. To use Meinong's vocabulary, this object (that is, the target of a mental act) lacks "content": it cannot exist.[23] On Wollen's hypothesis, in the round-squareness of *Olympia* Manet depicted the class contradictoriness of Olympia. But equally Clark could be correct. In the early 1860s there was no real socioeconomic resolution of the "unstable signs of class," in this case, of a social agent holding the peculiar concrete position of owner-and-owned. How, then, could such a being be recognized in the world as an object for depiction? Could Manet actually *see* prostitutes as owned owners?

We must remember that both Clark and Wollen approached this question as Marxists, committed to the notion that people in capitalist economies do not own the means of production, including their own bodies, in the objective sense. To think so (as Manet arguably might have done in painting *Olympia*) would be to misrepresent the supposedly objective condition that *no one* in capitalism really owns his labor and its products. In theory, then, a working-class prostitute figured as Capital *and* Labor was a round square. For the sake of argument, she was *imaginable* for Wollen's Manet but *impossible* for Clark's Manet. (In a different model of political economy and its history, the point of this interpretive controversy might be lost. But to pursue the theoretical issue we must grant the doctrinal framework.) In Wollen's account Manet is not only a Marxist *avant la lettre*. He also turns out to be a Meinongian *avant la lettre*. Conversely, it was Clark's claim that Manet was *neither* a Marxist *nor* a Meinongian. Indeed, Manet was not even a modernist. He was a modern artist engaged in the difficult work of the "painting of modern life."

The round-squareness that Wollen proposed to grant to *Olympia* might wholly subsist *within* the iconographic succession. Indeed, Wollen would have to insist that in *Olympia* Manet successfully imagined a kind of social being that beholders had not recognized before, but that they might be able to see once Manet had depicted it. In the terms developed here, this would certainly be a case of pictoriality (specifically of pictorial symbolism) issuing in visuality (specifically in object-recognition). But in the context of the iconographic succession, the question is not simply about the referential value of terms—of the extension of formulae or phrases like "round square" or "the square root of 2" (another Meinongian object without content). It is also about the *imaging of objects*. In the context of pictoriality and visuality, it is hard to see how round-squareness can be depicted (though it can be *designated* in the peculiar logics investigated by Meinong) insofar as mundane object-recognition persists in the iconographic succession and supposedly issues from it. If one cannot see round squares in the world, is it possible to see round squares in pictures? To be sure, we see immortal creatures and resurrected bodies in pictures. But we could also see immortal creatures and resurrected bodies in the world, precisely because they can be seen in pictures, while we will never see round squares in the world *or* in pictures precisely because we cannot see them in either of these contexts in such a way as to transfer them to the other context. (Of course, we can draw something that looks *like* a round square, but it would have to be perceptually ambiguous between a round square and something else—and therefore could not serve as a unique designation for the specific extension "round square" in Meinong's sense, the strange contentless object. And we could deploy any visible configuration whatsoever as a symbol of round squareness, but it would not be pictorial: it could not saliently resemble the object it denotes.) There will never be a visuality including round-squareness because there cannot be such a pictoriality. And there will be no pictoriality because there cannot be any kind of vision that will ever be able to see round squares. Or if there is a vision of this kind, no human agent included in the entire purview of this debate—the artist Manet, his model, his contemporary critics, and present-day historians—will ever *see* just what it is like to live in the world in that way.

Both Clark's Manet and Wollen's Manet could have painted *Olympia* in exactly the way that Clark argued the painter did paint it, namely as an unstable sign of uncertain times. The main difference between them lies in the fact that Clark's *Olympia* failed to signify because it was contradictory, while Wollen's *Olympia* attained communicative coherence because it painted contradiction. Wollen described his conception of history as

"open" in what he took to be a direct contrast with Clark's assumption, he thought, of a "closed" history. But what seems to distinguish an "open" from a "closed" historical situation—or the avant-garde of history from the rest of us in history—is the ability of participants to represent its real contradictions as an aspect of it and thereby to re-see or review if not to reconfigure it materially.

We remain, then, with the question of recognition, whether recognition of objects or recognition of representations or, more likely, recognition of objects in representation and recognition of representation in objects. While Clark attended to the recalcitrant and perturbed pictoriality of Manet's *Olympia*, Wollen asserted its radical and clairvoyant visuality. Both historians cited much the same evidence and both described the same features of the painting. But they must have entered the loop or cycle of the iconographic succession at very different points or from very different directions.

■ 8

In a two-pronged response to Clark's original essay on Manet's *Olympia* and Wollen's criticisms of Clark's arguments, the Art-Language group approved Clark's effort to interpret "Manet's *Olympia* in 1865" (that is, in its critical reception among beholders who saw it at the Salon of 1865) without automatically canonizing the painting as one of the projects of the putatively radical avant-gardes of artistic modernism.[24] But Art-Language remained dissatisfied with Clark's approach. Clark's "preliminaries to a possible treatment of Olympia in 1865" derived, as Art-Language put it, "from a normal and institutionalizing concern to secure conditions of interpretation without doing adequate historical materialist . . . work into conditions of production." And from a conceptual point of view, they wrote,

> . . . both [Clark and Wollen] seem confused as to the distinctions between those ontological features of a work of art which may determine what it *can* express and mean and signify historically (and which may or may not signify to someone or anyone), and those user-dependent categories which are relevant to talk of what the meaning of that work has been or is or could be *for* someone (and which bear on the matter of interests, dispositions, and knowledge on the part of spectators). They fail adequately to

distinguish, that is to say, between a) the work of art as a piece of production, and b) those interests and experiences in spectators for which the work of art may or may not have been a necessary causal mechanism.[25]

Moreover, the inconsistencies in the painting identified by Clark (at least in the reception of the painting by critics in 1865) might have been coherent from *someone's* vantage point (possibly in its material production in 1863), although not, as Art-Language argued against Wollen, from the vantage point of the modernist avant-garde. Whereas Wollen suggested that in painting *Olympia* in 1863 Manet had painted a "round square," Art-Language suggested that the reactions of the critics in 1865 might be considered to be "an occurrence of the phrase 'round square' in someone's discourse."[26] (Here Art-Language deployed Meinong's distinction between object and content more accurately than Wollen: "round square" is a term that can be deployed in discourse to refer to this impossible object—an object, from the point of view of the present discussion, that cannot possibly be depicted.) In this regard, Art-Language noted, *Olympia* might have been a "referring (or referential) symbol or thing that fails to refer" *for* these observers in 1865. Of course, in itself this says nothing about the painting's significance for Manet in 1863.

Wollen would admit the point. Indeed, in a sense this *was* his point, shared with Hamilton's modernist assessment of the art history in question. According to Wollen, as already noted, "round square" (if that is what Manet painted) can be a kind of coherent signification (it can be a Meinongian object). Moreover, when the critics designated Manet's painting to be a round square (their metaphors for the peculiar indecipherability of the painting sometimes had Meinongian overtones even if they did not use his terms), they made the coherent statement that they did not approve of it because it did not mean anything concrete or, more exactly, did not show whatever in the world it was supposed to be about, to model. But in another sense, Clark might admit the very same point. As Art-Language wrote, "Clark can reasonably be taken as saying that Manet's *Olympia* was . . . like a messed-up attempt at reference or some such non-exotic failure,"[27] unlike the *exotic success* that Wollen's modernism presumably would take it to be.

Setting aside Wollen's modernist interpretation, Art-Language proposed to engage Clark's materialist interpretation in these terms. If Manet's "attempt at reference" in painting *Olympia* was not exotic, how and why did he mess up? In part, Art-Language would underscore the ordi-

nariness of Manet's painting: "In fact, *Olympia* doesn't really need to be seen as any more or less inconsistent than most other bits of modern art at the time."[28] Manet's mess-up, Art-Language would have it, must have been a standard-issue bourgeois misrepresentation of the real forces and relations of production. If this was a failure to signify, it was not, as it were, a significant failure.

Whereas Wollen tried to rewrite Clark's account of *Olympia* as a modernist interpretation of Manet's *transcendence of* his class consciousness, Art-Language would have to reduce Clark's account to the "historical materialist" interpretation of Manet's *determination in* his class consciousness. Art-Language, then, would wholly identify visuality and pictoriality in the "ordinary [artistic] language" that they must attribute to Manet. Without an underlying transformation in consciousness, the iconographic succession cannot introduce new recognitions *of* objective reality *into* objective reality. It must recycle the same misrecognition through its representational reversions.

Fair enough: Art-Language tried to push Clark's interpretation of *Olympia* even further away from the modernist thesis toward the Marxist antithesis. But Art-Language must be hoist on their own petard. If Manet's *Olympia* produced standard-issue bourgeois misrepresentation, Manet's critics could have readily accepted it: his misrepresentation would have been entirely *their* misrepresentation as well, a bourgeois ideology shared by Manet and his critics. As Hamilton and Clark alike had shown, however, this was simply not what happened. For the Salon critics in 1865, Manet's *Olympia* of 1863 was some kind of pictorial misrepresentation *of* a misrepresentation persisting in the consciousness of both Manet and his critics. In the end, then, Art-Language found themselves affirming what Clark himself had proposed: "Manet's *Olympia* is at one and the same time a volatile and a somehow incompetent semantic usage." In brief, it was an *incompetent misrepresentation*.

Thus we have been returned willy-nilly, yet again, to the vicissitudes of the iconographic succession. *Ideological misrepresentation* in the Marxist sense might characterize the entire history of bourgeois consciousness from one end to the other—from object-recognition to representational symbolism and back again, and including all social agents involved in its continuing replication. But for that very reason this model of consciousness must be entirely uninformative about the historical point at issue; that is, about the *difference* between Manet and his critics in their replications of the bourgeois misrepresentations shared among them. More to the immediate point, *pictorial incompetence* should be described spe-

cifically as a slippage in the relays and, most important, the resistances of the iconographic succession as it moves these recognitions and representations (all of them to be classified as *mis*representations according to the Olympian vantage point adopted in the Marxist socioeconomic history of culture) into depictive visibility. In its failure to signify, Manet's *Olympia* did not forward misrepresentation adequately: visuality was not wholly converted into pictoriality, and vice versa, even though (perhaps precisely because) a slew of ordinary bourgeois misrepresentations cycled continuously through all registers.

Whether this failure, this pictorial inadequacy, should be counted as a legitimate and productive form of resistance to bourgeois misrepresentation is another matter. But one might suspect that in certain circumstances an alignment (even an alliance) could be constituted between resistance in the iconographic succession of pictoriality on the one hand and resistance to misrepresentations of the world in established visuality on the other hand. (Clark proposed versions of a thesis something like this in writing published after "Preliminaries to a Possible Treatment of *Olympia* in 1865.") Perhaps it is possible, for example, to make misrepresentations that have been recursively entrenched in visuality become visible *as* misrepresentations by reviewing them pictorially, and possibly reconfiguring them. This would appear to be a dispute not only between modernism and Marxism: between Hamilton on the one side and Clark, Wollen, and Art-Language on the other side. It must also be a dispute between a positive and a negative aesthetics *within* Marxism: between Wollen and Art-Language on the one side and Clark on the other.

Disputes of this kind are not the immediate subject matter of this book. They take place in a domain or at a level of analysis, broadly sociological, that already assumes the distinctions I have made in this chapter, and, in particular, they already trade on an implied notion of iconographic succession. But the general theory of visual culture as I have sketched it provides a frame in which to read and maybe to adjudicate them. It is only by knowing where pictoriality originates, subsists, and ramifies in the iconographic succession, and in all its relays and recursions from world-seeing to picture-beholding and back again, that it would be possible deliberately to *change* its most entrenched reversion in the visuality that we bring to the pictures in the first place. All other developments in pictoriality involve reflexive recurrence.

Chapter 8

Visuality and Pictoriality

■ I

As I have already suggested in previous chapters, "visuality" is the symbolic form of visual perception, or, as I will argue in more detail in Chapters Nine and Ten, the culturality of vision. To use Susanne K. Langer's formula, though she did not use the term "visuality," it is the "constitutive character of symbolic renderings in the making of 'experience,'" in this case, our experiences of seeing, of imaging, and of picturing.[1] Indeed, visuality has simply become another word for the experiential correlates—the visual basis and the visual effects—of the imaging habit of thought described in Erwin Panofsky's neo-Kantian iconology. Pursuing Kant's contention that human understanding is in "need of images" (*ein der Bilder bedürftiger Verstand*), Panofsky proposed that mundane visual experience (as noted in Chapter Seven Panofsky cautiously called it "'what we see'"), including our seeing of social affairs and the psychological states of other people, must be grounded in successively assimilated strata of meaning that are ultimately rooted in "symbolical values" organized in the traditions of a historical culture. When we speak of visuality, rather than simply vision or visual perception, we address the difference introduced into human seeing by traditional cultural meaning consolidated and reconfigured in images.

These images do their work whether or not they actually have been produced and replicated as pictorial artifacts, or will be so produced and

replicated. Traditional cultural pictures can *become* visual images—how people see things. And once pictoriality has become visuality in this way, a "way of seeing" the world as having a form, style, and representationality, no picture making is needed to replicate it; when the world *is* a picture, to see it is to see what depiction has configured. Indeed all *further* picture making in this world will tend to *resist* visuality—to resist it in virtue of its very pictoriality, that is, of the irreducibility of depiction to an immediate seeing.

In turn, then, the goal of a pictoriality in aiming to constitute a visuality (if it does aim to do so, or ends up doing so) is to do away with any visual need for itself *as* depiction distinct from visual imaging. Thereby it converts itself into pure seeing. And presumably the goal of a pictoriality in aiming to escape a visuality (if it does aim to do so, or ends up doing so) is to assert the difference between its depicted world and the visible world in a way that the predicated visuality cannot wholly assimilate. Thereby it forces pure seeing into impure mediations—especially iconographic succession—or, perhaps, toward the pure seeing of its own previously invisible ground. To be sure, these aims—these cultures of the reciprocal interaction of visuality and pictoriality—will generate different visual cultures, even if the artifacts in question look just alike. Many pictures in the Western tradition, especially certain pictures made in the later Middle Ages, have been intended to do away with themselves as present *as* pictures. At least notionally their pictoriality is reduced to a primally intended or primally desired visuality: pictoriality produced visuality. But other pictures, especially pictures made in certain avant-garde traditions in modernist art, have aimed to assert their presence *for* vision. At least notionally their visuality constructed a primally intended or primally desired configuration apprehended *as* configuration: visuality produced pictoriality. (All this despite the fact that the Western tradition since the scholastics, if not before, has maintained a fairly continuous underlying theory of images as a complex mediation of world, sight, sign, thought, and interpretation.)

These historical vicissitudes and permutations of visuality and pictoriality have consumed the attention of many art historians for many decades. Because historical successions have generated and supported historical cultures as different from one another (or so it has seemed to generations of art historians) as the later medieval modes and the modernist modes of the visual presencing of pictures (pictoriality) coupled to the pictorial management of vision (visuality), art history has been provided with an inexhaustible object of study. (Admittedly academic art history has done itself a grave disservice when it has delimited itself

aesthetistically to the field of artifacts made to be unusually visible, what is called "art," as opposed to the field of things seen in the world as aesthetically pictorialized. But the principal exponents of a theoretical art history, from Wölfflin and Riegl to Gombrich and Summers, have never made this self-crippling mistake.) And fair enough. As I have suggested all along, the vicissitudes and permutations of visuality and pictoriality constitute the raw material—the empirical texture—of the endlessly ramified history of visual culture *as* art history. But for this very reason the raw material or empirical history of the vicissitudes of art as visual culture does not solve any deep theoretical questions. To date, it has only served in art history to raise and to refine an *unsolved* theoretical question.

In visuality, one does not see the world. One sees an *image* of the world. Paradoxically, however, this image can only be experienced visually *as* seeing the world, that is, as an *extra-pictorial* world-recognition. It cannot be recognized simply as the picture it is. If it were, visuality would not be *world*-recognition; it would not be an intelligibility carried into the recognition of pictures as objects in the world. It would simply be a recognition of a particular *depicted* world—of pictoriality. And therein lies the difficulty. As world-seeing, visuality constitutes a picture of the world. But if the specific depictiveness of this image is to be recognized in the first place, it requires the pictorially mediated seeing that it supposedly produces. And this picture-seeing, this recognition of a world being depicted, cannot be entirely subsumed by the visuality, the world-seeing, that it ultimately relays.

We need not be confronted with a vicious circle here. In fact, we have encountered a fundamental feature of the historical character of visuality: visuality *both* projects *and* presumes a picture of the world as a way of seeing, or world-recognition, including its way of seeing pictures in the world. This projection has a peculiar history that we need to track. And here we must notice a *methodological* circle. Visuality is not a pure seeing. It must be mediated in activities of image-making, even in activities of picture making, that cannot be entirely reduced to the visuality they constitute. As we have seen in Chapter Seven, there is a difference—even a disjunction—between seeing the world and seeing things in pictures, even if seeing things in pictures enables one to see (more of) the world and seeing the world enables one to see (part of) the picture. In this sense visuality, and its active correlation or realization in viewing, is not an historical object. Rather, it is one analytic pole of historical *method* when it addresses its actual historical object, namely, human vision both projecting and presuming pictures.

Visual-culture studies, however, often reifies a pure visuality. Indeed, visuality often seems to be taken to be an historical object—namely, "visual culture" as such.[2] But this approach reduces pictoriality to visuality and in

turn identifies visuality with vision. It violates the underlying theory of an original and continuing—an interminable—phenomenal succession to culturality, a succession putatively identical in the end (in the closed loop of the iconographic succession) to an original noumenal succession to visual apperception. When visual-culture studies takes visuality to be the very ground of the history of image making rather than one moment of it, we have no coherent way to relate the effects of the image itself—its supposed ordering *of* vision—to the causes of its pictorial vehicle *in* vision. We have no coherent way to relate them, that is, beyond identifying them wholly with one another. Such a reified pure visuality is just another question-begging dogma of a visual *Weltanschauung* or "period eye."

Visuality and what I have called pictoriality, though always interconverting, are at no point identical. Indeed, at every point in their succession they must be disjunct. A picture cannot entirely express the essential "symbolical values" of a visuality, just as a visuality cannot entirely conceive the essential "formal values" of a picture. This founding disjunction creates disruptions that provoke perceptual exploration, visual imagination, and pictorial configuration. And these disruptions are the very mechanisms of the cycle of form to symbol, of image to "discourse," of the sensible to the intelligible, and round and round again. (They can occur at the level of reflexive recurrence or at the level of deliberated intervention or at both levels or in between them.) For this reason, the notions that visuality determines pictoriality or that pictoriality determines visuality are senseless. Both notions can be found in visual-culture studies, or in debates about it. Visual-culturalists tend to identify with the first notion: it helps them to reduce the aestheticism of art history to an account of generic social modes of looking, or at least of the imagistic stereotypes of society. Art historians who think they oppose visual-culturalism tend to identify with the second: it helps them to identify what is unique about art and to describe the unusual and innovative pictorialisms in the domain of things made to be seen.

But both notions are reductive simplifications—unrealistic models of the real history of visual culture or the culturality of vision. And we need not—we should not—choose between them. Most important for my purposes, these two notions of the direction of causality each have both an analytic and a methodological usefulness to a general theory of visual culture. Visuality and pictoriality are reciprocally and recursively interdetermined and interacting aspects of world-recognition. While they cannot be reduced to each other, they cannot subsist without each other: they require each other. The endless permutation of this interdetermination and interaction, including its disjunctions, resistances, and failures, is the object of our historical analysis.

It will be helpful to consider all this in a concrete instance, a paradigmatic case in the development of iconology. As we have seen in Chapter Seven, the art-historical method developed by Panofsky in the 1920s and 1930s distinguished the pre-iconographical, the iconographical, and the iconological levels of analysis. For the moment they can be regarded as requiring the historian to identify forms, motifs, and cultural meaning respectively.

Panofsky's most succinct statements of his method can be found in two well-known essays. The first, written in German ("Zum Problem der Beschreibung und Inhaltsdeutung von Werken der bildenden Kunst" [*PB*]), was published in 1932 in the journal *Logos*. The second, written in English ("Iconography and Iconology" [*I & I*]), was published in 1939 as the first part of the "Introductory" section in *Studies in Iconology*. Panofsky republished it with a two-paragraph addition in 1955 in *Meaning in the Visual Arts* under the rubric "Iconography and Iconology," the title I will use here.[3] I will return to differences between Panofsky's claims in 1932, 1939, and 1955. At this point we should notice a third text that has been overlooked in subsequent discussions of Panofsky's program. In 1951, Panofsky published "Meaning in the Visual Arts," a brief essay presaging the title he gave to the collection published in 1955; it appeared in the *Magazine of Art*, a periodical intended for American readers, especially artists, and it introduced Panofsky's iconology to the nonacademic American artworld.[4] To some extent "Meaning in the Visual Arts" repeated and to some extent it summarized "Iconography and Iconology." In the final paragraphs, however, Panofsky turned to an issue that he had not directly addressed either in the German essay of 1932 or in the English essay of 1939/1955, even though the matter had occupied him ever since his doctoral research in 1911–14, most notably in one of the most important books he wrote *between* 1939 and 1951, namely, *The Life and Art of Albrecht Dürer*, first published in 1943.[5]

In "Meaning in the Visual Arts," Panofsky tried "to illustrate what may be called the gradual revelation of content" in a work of pictorial art (*MVA*, 48). He addressed a familiar print by Dürer—the large engraving or *Meisterstich* (it measures 24.6 x 19 cm) usually known as *Ritter, Tod, und Teufel* (*Knight, Death, and the Devil*), bearing Dürer's monogram and the date 1513 (Fig. 8.1).[6] Above all, Panofsky hoped to discover "the *indissoluble unity* of forms, motives and narrative subject matter" (*MVA*, 48; my emphasis). His analysis could serve, he believed, as an example and as a proof of his preferred method, already considered

Figure 8.1. Albrecht Dürer (1471–1528), *Knight, Death, and the Devil*, 1513. Museum of Fine Arts, Boston. Photo courtesy Museum of Fine Arts, Boston.

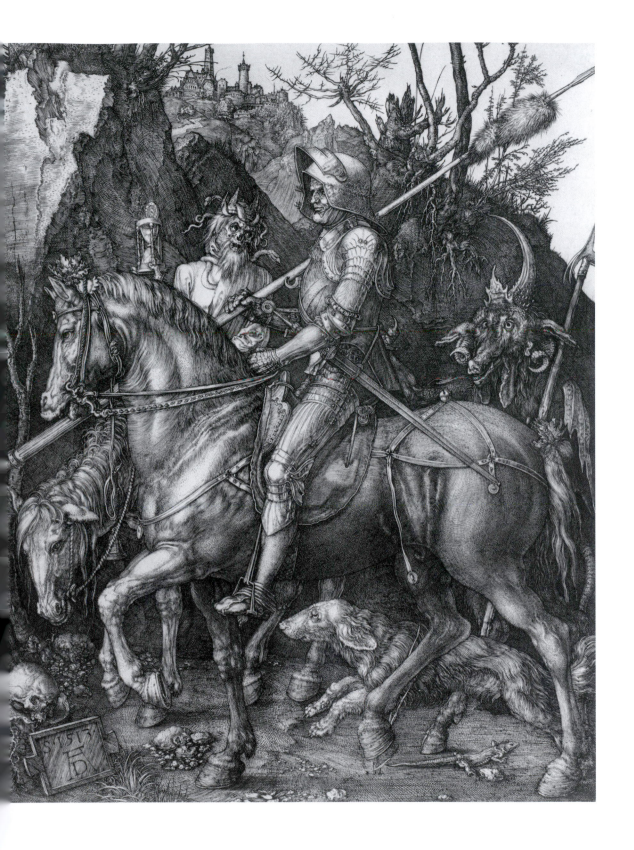

in Chapter Seven, of tracking a continuous smooth succession from the pre-iconographical (or formal) to the iconographical (traditional) to the iconological (cultural and symptomatic) levels of pictorial significance.

That forms, motifs, and contents *should* constitute an indissoluble unity cannot be taken for granted in iconographic terms. As Panofsky noted straight off, the magnificent trotting horse and the stern, sanguine rider in Dürer's picture "come from two different sources" in the artist's production (*MVA*, 48). Dürer based the principal rider, an armed knight, on a life study of an armed and mounted groom that he had painted in watercolor in 1498 (Fig. 8.2); the man depicted was said to be Philipp Link, groom to the family of one of the artist's patrons. As the artist's inscription tells us, this study was intended to illustrate "the armor [used] in Germany at the time." By contrast, the rider's horse precipitated from

Figure 8.2.
Albrecht Dürer
(1471–1528), *The Rider*,
1498. Albertina, Vienna.
Photo courtesy
Albertina, Vienna.

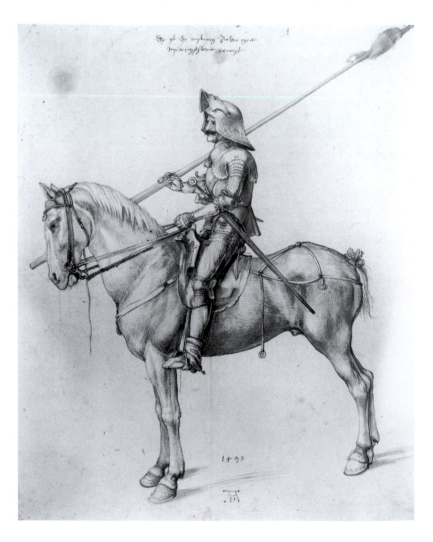

Dürer's "theoretical studies" of equine proportions, especially a sheet of studies now in Nuremberg (Fig. 8.3). These drawings had been thought to derive from "one or more drawings by Leonardo da Vinci" (presumably known to Dürer) in which the "exquisite rhythm" of equine movement had been captured by the Italian artist (*MVA*, 48).[7]

But despite the disparate pictorial materials that found their way into the image created in the print of 1513, Dürer achieved an indissoluble unity of forms and motifs, according to Panofsky, because he was able to "display this perfect posture of a horseman for its own sake" (*MVA*, 48), creating a complete pictorial image and a self-suffcient work of art. In this unification, as Panofsky and his collaborators later wrote, the artist created one of his "great symbolical forms."[8] That term derived in part from Ernst Cassirer's philosophy of symbolic forms; that is, his anthropology of the different modes of representation within which human beings make sense of (and see) their worlds. But it should also be taken quite literally to denote a highly particular and characteristically Panofskyan result of the iconographic succession that I have described in Chapter Seven, namely, the meaningful synthesis of form (apprehended at the pre-iconographical level) and symbol (comprehended in the specifically *iconological* moment of the succession).

Figure 8.3.
Albrecht Dürer (1471–1528), study of a horse, detail of MS. Nuremberg, fol. 162r. From Erwin Panofsky, *Dürers Kunsttheorie* (Berlin 1915) pl. 21.

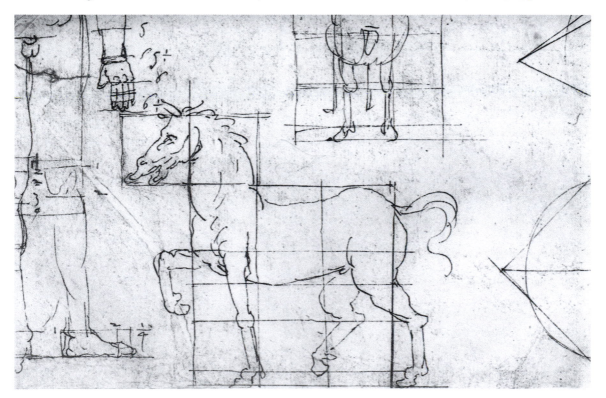

Indeed, the invention of a "great symbolical form" could be taken to be essentially equivalent to the creation of a visual culture. The social purview of that culture—the community of beholders who saw the world in terms of that pictoriality—remains to be specified historically. But the picture that achieved this totality would be the very opposite of Manet's *Olympia* (Fig. 7.3) considered at the end of Chapter Seven, in which visual culture partly *failed* to crystallize. Panofsky certainly took Dürer's engraving—wanted to take the engraving—in just this way, and he thought he knew in what its culture consisted. As we will see, in fact, he likely wanted to rescue the picture, and by implication the German tradition it exemplified, from an *incorrect* attribution of culturality.

Whence, however, the "gradual revelation of content," not only of the manifest "narrative subject-matter" but also of the overall symbolic charge of the picture, the iconologist's "intrinsic meaning or content" (*I & I*, 7-8)? Panofsky aimed to describe an unbroken continuity *from* formal and strictly iconographic *to* iconological identifications of the significance of the print. Thus he was compelled to suppose that Dürer was in fact "not satisfied" with the picture of a horseman's posture displayed "for its own sake" (*MVA*, 48). As Panofsky put it, in the engraving of 1513 Dürer "added" other elements: the figures of Death and the Devil on their horses, the Knight's running hound, and the landscape setting. In this way he "invested [the image of the horseman] with an intelligible idea, and even transformed it into an allegory" (*MVA*, 48). Specifically, in its intrinsic meaning (the ultimate object of iconology) the printed allegory depicts "the Christian Knight [who] finds himself in the dense, pathless wilderness of the World, haunted by reptiles and the remains of those who died on the road, . . . waylaid by Death, who threateningly holds up his hourglass, and by the Devil who sneaks up from behind" (*MVA*, 48). These elements may have been added. But they also translated the self-sufficient pictorial display of the horse and rider into the "intelligible idea" of a Christian Knight on his dread journey. In turn this idea subsisted in indissoluble unity with the form and motif of the horse and rider: there was no reason for Dürer to depict the horse and rider *except* in order to depict the passage of the Christian Knight. In sum, in Dürer's print pictoriality, including the formal and iconographic constitution of the picture over time, smoothly transferred into visuality, the cultural meaning of the image—even as that visuality determined pictoriality. But the peculiar temporality of this historical process, and in particular the anachronism embedded in Panofsky's reconstruction of it, belies Panofsky's confidence.

As Panofsky knew very well, the purported unity of the sensible form and the intelligible idea of Dürer's print had been questioned by

"the greatest advocate of purely formal analysis," namely, Heinrich Wölf-flin (*MVA*, 48–49). Panofsky's doctoral thesis on Dürer's art theory (Freiburg 1914) began its life in an essay awarded a prize, on Wölfflin's recommendation, by the University of Berlin in 1911. Six years earlier, in 1905, Wölfflin had published the first edition of *Die Kunst Albrecht Dür-ers*; its sixth edition, revised by Wölfflin's student Kurt Gerstenberg, was published in 1943, the same year in which Panofsky published *The Life and Art of Albrecht Dürer*.[9]

In his treatment of *Knight, Death, and the Devil*, Wölfflin had insisted that Dürer was "originally"—and as it were *throughout the entire process of making the image*—"merely concerned with the simple subject of a horse and rider" (*KAD*, 242). Earlier commentators had observed the painterly (*malerisch*) qualities of the print, its painterly formality, and associated them with Dürer's "translation of the symbolic into the naturalistic."[10] By contrast, Wölfflin explicitly highlighted the "completely unpainterly" aspect of the knight's horse: Dürer had systematically presented the beast "in pure side view, and there has been no playing down of the intention to reveal the actual shape in its utmost distinctness" (*KAD*, 241). As Wölfflin saw it, the engraving virtually transcribed Dürer's theoretical studies of equine proportions, even though, as Wölfflin suggested, "it is surprising to see another constructed figure [of this kind] in a picture" (*KAD*, 242).

In what sense is the construction of the horse surprising? Dürer must have concluded, Wölfflin acknowledged (like Panofsky after him), that the theoretical constructions as such (as well as a transcriptive picture that could have relayed them in the "simple subject of a horse and rider") could not "fill an engraving." Such merely didactic and documentary im-ages would be "too insignificant" to set forth in a medium that had such high status and required arduous and expert labor (*KAD*, 242). But if Panofsky would contend that Dürer had been unsatisfied with the horse and rider displayed on their own, Wölfflin implied that Dürer would have been satisfied. Indeed, the artist, as Wölfflin saw it, did his best to *preserve* the strictly formal and iconographic unity of the initial pictorial image (originally constituted in the theoretical constructions and related works) in the elevated context of the engraving. In particular, Wölfflin claimed that the watercolor of the rider that had been produced in 1498 "still satisfied Dürer fifteen years later," even if the horse was "drawn afresh with a different structure and movement" inspired by (and perhaps allud-ing to) Italian works that Dürer had seen in the meanwhile (*KAD*, 242).

According to Wölfflin, this replication, the irreducible formal and pictorial order of Dürer's image in the print, subsisted in tension with

the "intelligible idea" imported in its wake, even in clear contrast with it. Most striking, the artist's additions were an obvious failure—evidence, for Wölfflin, that the persisting primary pictorial determination continued to overwhelm a secondary symbolic reformatting. To be sure, Dürer gave a "new sense" to the horse and rider by "bringing in Death and the Devil" (*KAD*, 242). But Wölfflin insisted that this change was "not to the advantage of the picture." As he put it (and in "Meaning in the Visual Arts" Panofsky quoted this remark [*MVA*, 49]) "it cannot be denied for a moment that the accompanying figures [of Death and the Devil] are merely tacked on and that the whole scene represents a compromise" (*KAD*, 242). The subsidiary figures interfered with the horse at the noetic center of the image. Perhaps we can gradually identify what Death and the Devil might be doing; we can reconstruct a possible narrative. But in seeing the horse, as Wölfflin asserted, "the eye immediately feels the order on which the principal outlines and their rhythm are based, even though the mind is incapable of penetrating the secret" (*KAD*, 244–45). At the Wölfflinian origin of the picture, then, there was no intelligible idea even if and indeed precisely *because* the formal unity of an original image (and its occlusion in a secondary symbolism) remains palpable.

This is not to say that Wölfflin saw no significance in Dürer's horse and its rider, let alone that he supposed the print "failed to signify" in the sense explored at the end of Chapter Seven. The very presence of a secret implies a deep significance, perhaps a surprising and profound one. It is only to say that for Wölfflin this significance cannot be limited to the cultural-traditional significance of the Christian Knight later identified by Panofsky as the "gradual revelation" of the secret, that is, as the "intrinsic content" that expresses a "cultural philosophy condensed by a single personality and determining even the form of a work of art" (*I & I*, 8). In Wölfflin's treatment of the print, the secret of the image simply *is* its primary formal unity persisting in a symbolic reconstruction—and overwhelming it. This inner image harbors a significance that must be radically outside an intelligibility that is wholly cultural, noetically prior to it, in part because it was Dürer's own expression—*his* image rendered in or as a picture. And in part it must be outside an intelligibility that is merely cultural because its unity can be grasped immediately *by us*, observers belonging to a much later and a very different cultural universe, who nonetheless visually understand the aesthetic history of Dürer's print. We immediately grasp its "principal outlines and their rhythm" and the primordial and persisting meaning they betoken: an artist's visual imagination in direct engagement with its configurative means.

Wölfflin's approach to Dürer's engraving formed part of the intellectual context in which Panofsky devised the methods he described in 1932. As late as 1951, in fact, Panofsky chose to reengage Wölfflin's views. Surely he recognized the fundamental threat that they posed to his own procedures.

As already noted, Panofsky's dissertation researches had focused on Dürer's didactic art theory.[11] According to Wölfflin, evidence for Dürer's theory of art must be found in the artist's pictures. By contrast, Panofsky tried to find it in Dürer's writing. Throughout his career, in fact, Panofsky tried to discover the significance of the formality of pictures in contemporary discourse, and thereby in part to prove the succession from formality to motif and symbol, that is, to the iconological level of pictoriality. (Clearly a picture has attained specifically *symbolic* pictoriality when the symbol can be translated into a nonpictorial mode or derived from it.) In this respect the resolution to the secrets of visual culture could be found, in Panofsky's art history, by systematically converting visual culture into discursive culture. In Panofsky's judgment, then, Dürer's characteristic interests in formality and stylisticality could be discerned in the artist's sophisticated technical investigations of natural and human beauty. These inquiries, including a written treatise, had concentrated on the *proportions* of beauty.[12]

Panofsky's judgment was not shared, however, by all art historians who had studied Dürer's written theoretical reflections and complementary pictorial constructions. In 1924, Hans Kauffmann tried to show that Dürer's art theory had devolved from primary notions about *rhythmic* formality. In fact, Kauffmann took rhythm in configuration to be the central analytic concern of the "founders of *Kunstwissenschaft*," including Wölfflin; proportion and other systematic pictorialized constructions like linear perspective are merely epiphenomena of visual rhythm. Endorsing this focus, Kauffmann criticized Panofsky's account of Dürer's supposedly "rational" aesthetics; that is, the artist's reconstruction of formality in discursive terms and what amounted to the pictorial exemplification of these terms in such works as the theoretical drawings and even the *Meisterstich* of 1513. Instead Kauffmann stressed the incomplete formal expression of the latter: he seems to have endorsed Wölfflin's negative judgment on the formal coherence of the engraving.[13]

Two years later, in 1926, Panofsky published a long and erudite critique of Kauffmann's contention that Dürer's cryptic art-theoretical remarks and practices (including the studies that had crystallized in the

engraving of 1513) might be traced to a personal Dürerian philosophy of "rhythmische Kunst."[14] This important and revealing article was never reprinted or translated, perhaps because it lay too close (here I speculate) to the professional and even the political origins of Panofsky's art history in its German-speaking context. In order to explicate Dürer's interests in the formality of rhythm, Panofsky, like Wölfflin before him, invoked late-nineteenth-century German physiological aesthetics and its analysis of an intrinsic—a biopsychological—rhythmicity in visual and acoustic phenomena.[15] Wölfflin had implied that our visual sensation of rhythm derives at least in part from the constitution of rhythm in pictorial formality. Indeed, this was the whole point, Wölfflin had suggested, of Dürer's configurations conceived as quasi-scientific or didactic interventions in the routines of sight and sensation: Dürer hoped as much to *shape* beauty as to simulate it. But in Panofsky's opinion, biopsychological or phenomenal rhythm and its succession into pictorial formality can simply be taken for granted. For this very reason, configurations of visual or acoustic rhythm in the arts (such as Dürer's theoretical models of beautifully proportioned configurations) must be considered in *symbolic* terms. They relay images of order, beauty, or fitness. In other words, though Panofsky acknowledged habits of formal apperception, what he emphasized was their cultural significance: if Dürer embodied a human rhythmic awareness, he could only *express* it in traditional motifs governed by a culturally specific idea.

Methodologically then, Panofsky tried to ensure that formalities were located in the iconographic succession, and remained located, in a *pre*-iconographic domain—an essentially biological and psychophysiological domain. Only iconographic and iconological transcriptions and transformations in art theory and picture making could make them culturally visible or give them "meaning," to use the term Panofsky preferred to apply in English. Stated another way, Panofsky rejected the primordial recursive possibility explored by Wölfflin and Kauffmann; namely, that the rhythms we see might be shaped by the rhythms we configure in pictorial formality. He favored a different, later recursion: the rhythms we configure in pictorial formality, and which we see in pictures, are shaped in symbolic, even discursive terms.

Panofsky's approach to rhythm in Dürer's art was a major step toward his emerging iconology. But it did not directly engage Wölfflin's understanding of Dürer's engraving, and it did not tell against it. Wölfflin had not denied the allegory that Dürer might have attached to his horse and rider. Nor had he disputed the role of Dürer's proportional theories in

determining the construction of the horse. Instead, Wölfflin pointed to the palpable disunion between the apperceptive significance of the image ("the order on which the principal outlines and their rhythm are based") and its symbolic legibility. In this he implicitly recognized the very distinction between an embodied meaning and an expressive meaning that Panofsky himself deployed in his critique of Kauffmann. To dramatize this conclusion, in the fifth edition of *Die Kunst Albrecht Dürers*, published in 1926, Wölfflin included an illustration of Dürer's engraving with everything but Dürer's primary pictorial form and significant image—the horse and rider—completely blacked out (*KAD*, 244) (Fig. 8.4). It is hard not to suspect that he made this striking gesture partly in light of the recent fundamental dispute between Kauffmann and Panofsky.

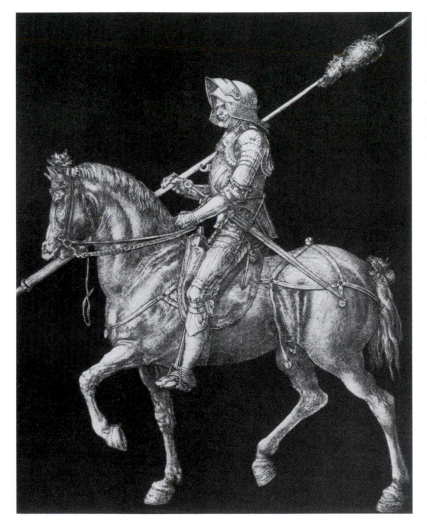

Figure 8.4. Heinrich Wölfflin (1864–1945), illustration of *Knight, Death, and the Devil*. From *Die Kunst Albrecht Dürers*, 5th and 6th editions only (Munich 1926, 1943) 244.

According to Wölfflin, who added a brief new footnote to his original text, the illustration enables us to see how Dürer "secured the entire rhythmic action" of the horse (*KAD*, 245, n. 1).[16] Wölfflin did not actually mention that his illustration includes the figure of the *rider* seated on the horse; in Wölfflin's eyes the two figures evidently made up an indissoluble unity despite having different formal and iconographic derivations. But Panofsky himself had already suggested that Dürer's proportional constructions in the engraving systematically interrelated the figure of the horse and the figure of the rider, and therefore that the two figures constituted a formal unity.[17] Rather, and in keeping with his original criticism of the engraving, Wölfflin's illustration suggested why that unity could not be fully extended to the rest of the image. Because the rider "fills the whole breadth" of the picture plane, Death and the Devil must be squeezed behind him. In particular, the "mere size" of Death makes him appear "insignificant." Dürer managed to mitigate this incongruity by making Death's white shirt stand out strongly against the mane of the horse in front of him and the dark cliff behind him (the effect is most dramatic in earlier impressions of the print); Death looks bigger than he is. "The disastrous muddle of the legs," however, "was irreparable; nothing could undo the impression of incoherence" (*KAD*, 247). Moreover, Death would seem to be improperly mounted on his puny and grossly hunchbacked steed. For his part, the Devil seems to have monstrously long legs upholding his shrivelled trunk. Still, Wölfflin conceded a configurative logic to this mess. "Just because the subsidiary figures seem so dismembered, the main figure gains its flat, structurally clear and concise appearance, which goes well with the print's meaning" (*KAD*, 247); namely, the Knight's implacable resolve and imperturbable faith in the face of mortality and temptation. But for Wölfflin this meaning was built around an original unity to which it remained a symbolic complement—a formal accessory.

■ 4

In 1943, Panofsky published his *Life and Art of Albrecht Dürer*. It criticized Wölfflin's interpretation without mentioning him by name. And in 1951, Panofsky reproduced Wölfflin's illustration in "Meaning in the Visual Arts" in order to restate his condemnation of Wölfflin's interpretation. According to Panofsky, Wölfflin's illustration of Dürer's print with everything but the horse and rider blacked out "defeats its own purpose"

(*LAAD*, 153). It really showed, against Wölfflin, that "the 'many odds and ends' [in the engraving] are indispensable" (*LAAD*, 153):

> In my opinion, this attempt to teach a great master his business defeats its own ends. The blacked-out composition appears less meaningful, not only from the point of view of subject matter but also from that of form. With the background eliminated, the group simply *looks* wrong. It looks like an equestrian monument deprived of its pedestal and taken out of its architectural context: overmodeled, yet unstable, expressionlessly moving no one knows whence, no one knows whither (*MVA*, 49).

Nevertheless, Panofsky recognized that his objection, avowedly formalistic and even Wölfflinian, cannot dispose of Wölfflin's illustration. According to Wölfflin, it was the very *contrast* between a primal image of a mysterious horse and rider ("moving no one knows whence, no one knows whither") and the secondary symbolic significance (Dürer's elaboration of narrative and allegory) that constituted the noetic history of the engraving.

Panofsky realized, then, that he needed to preserve the tension identified by Wölfflin even as he needed to convert its chief index, the formal disunity and aesthetic disorder of the print, into an indissoluble unity that took in all the forms and motifs and their cultural meanings. As he went on to say in 1943,

> It is quite true that Dürer was anxious to find a subject matter which would permit him to demonstrate the final results of his studies in the anatomy, movements, and proportions of the horse. But he would not have been a great artist had he conceived of this problem in terms of detachable accessories. Once he had discovered his theme in the idea of the Christian Knight, the visual image of the perfect horseman merged with the mental image of the perfect *miles Christianus* [Christian soldier] into an artistic concept, that is to say, an integral unity. The iconography of the Christian Knight took shape according to the formal pattern of a carefully balanced equestrian group while, conversely, this formal pattern assumed, as such, an expressive or even symbolic significance (*LAAD*, 153–54).

We could hardly find a more succinct application of iconological method—or a better demonstration of its methodological circularity—in the entire literature of visual-cultural studies. It needs careful unpack-

ing. In order to unify "visual" and "mental" images as an intelligible artistic concept, Dürer, according to Panofsky, had to have "discovered his theme in the idea of the Christian Knight." In itself, however, the idea of the Christian Knight could only foreshadow the "intelligible idea" of the final image relayed in the engraving. The idea cannot be *identical* with that image because the print narrated the Christian Knight's activity in a particular setting. It pictorialized a particular allegory. But putting first things first, at least in Panofsky's model of this iconographic succession, we need to ask where Dürer got the idea of the Christian Knight.

In 1521, in the diary of his journey to the Netherlands, the artist responded to rumors that Martin Luther had been assassinated by appealing to Erasmus: "Ride forth, you Knight of Christ!" (*du Ritter Christi*).[18] Panofsky wanted to associate this exclamation of 1521 with the artist's print of 1513, even though in the same diary, as Panofsky noted, Dürer himself referred to the engraving not as *der Ritter* (the Knight) but as *der Reuter* (the Rider).[19] According to Panofsky, "No doubt the phrase '*du Ritter Christi*' alludes to Erasmus's youthful treatise *Enchiridion militis Christiani* ('Handbook of the Christian Soldier')" (*LAAD*, 151). Panofsky recalled that Erasmus's *Enchiridion* was first published in 1504, implying that the book influenced Dürer's outlook in 1513.[20] In particular, Erasmus's imagery, according to Panofsky's logic, must have colored the artist's identification of his own earlier armored man on horseback with an Erasmian Christian Soldier when the watercolor of 1498 came to be "adapted to the new purpose" in 1513 (*LAAD*, 152).

But Panofsky neglected to mention a fact that he must have known. Erasmus's *Enchiridion* was not translated into *German* until 1520 and 1521, well after the engraving had been made.[21] Panofsky suggested instead that the supposed fact that Dürer "promoted the Erasmian 'soldier' (*miles*, not *eques*) to a 'knight' riding forth on horseback shows that his mind involuntarily associated him with the hero of his own engraving" (*LAAD*, 151–52). As the chronology of the iconography suggests, however, Dürer need not have effected any such promotion. His awareness of the Erasmian applications of the Christian Soldier, and hence any link he made to his own Rider (*Reuter*) as a Christian Knight (*Ritter*), could well have *post*dated his pictorial visualization of his knightly rider. If these involuntary associations were made at all, they were quite as likely to have been made *after* the engraving (and in response to it) rather than before it as its founding idea.

In other words, Panofsky conjured the crucial linking of an Armed Rider and a Christian Knight out of nowhere. A link made only in the print itself, Dürer might have partly ratified it in his own later thinking

and writing, but it cannot be discovered in a preceding iconography. In the engraving, then, Dürer's association *had* to be involuntary. Of course, this involuntary slip from *Reuter* to *Ritter* in the image should take us to the heart of Dürer's "artistic concept," the supposed indissoluble unity achieved in an involuntary association when Erasmus's Christian Soldier of 1504 somehow coupled in 1513 with the image of the knight based on the costume study of 1498. But the only credible evidence of this marriage would be the "integral unity" of the engraving itself, in particular its supposed formal unification of the central image and the subsidiary figures. To dispute that unity must be to question the full communication between expressive and symbolic significance. In fact, and to recall Panofsky's effort to bind the *visual* image and the *mental* image, it must be to question the very possibility of a wholesale interconversion between pictoriality and visuality. And this is precisely what Wölfflin had done.

∎ 5

It is not surprising to find, then, that Panofsky's inquiry was displaced yet again. Rather than showing how the Rider became a Knight, the process at the center of the image of horse and rider identified by Wölfflin, Panofsky tried to show how the Knight became a *Christian*, a process vested in the figures of Death and the Devil. There is no need to pursue these elaborations here. I have already made it plain enough that Panofsky's iconographical and iconological reconstruction of the engraving was severely biased.

It suffices to note that Panofsky's interpretation of the engraving has suffered considerably since 1943. In particular, many iconographers have discovered no Christian identity or attributes whatsoever in the Knight. To be sure, Panofsky recalled that Dürer's tradition provided him with a well-known type of the Christian soldier, though always a single figure, girding himself for battle or even mounted for war (Fig. 8.5), as well as the equally familiar type of the Pilgrim beset by Death, the Devil, or other fiendish adversaries (Fig. 8.6).[22] According to Panofsky, "the two ideas intermingled . . . and a complete fusion of Soldier's March and Pilgrim's Progress . . . is seen in woodcuts and etchings of the sixteenth century where the *miles Christianus* climbs the ladder which leads to God, hampered but not discouraged by the strings of Death, Luxury, Disease, and Poverty" (*LAAD*, 152).[23] But the fusion in these pictures does not equate with the fusion achieved in Dürer's engraving. Neither the fully armed knight nor the rider need appear in them; the protagonist can simply be

an ordinary footsoldier or a humble pilgrim. And where the knight *does* appear in a symbol of the Christian's struggle with death and the devil (for instance, on the title page of the German translation of Erasmus's *Enchiridion* printed in Basel in 1520 [Fig. 8.7]) he is not a rider. In other words, a "Knight, Death, and the Devil," it seems, was not a traditional type in Panofsky's own sense.

Of course, adding the available types of Christian Soldier and Pilgrim's Progress to the image of a mounted knight could convert him into the Christian *Reuter/Ritter* of Dürer's image. According to Panofsky, this fusion occurred in artistic conceptualization: "The visual image of the perfect horseman merged with the mental image of the perfect *miles Christianus* into an artistic concept, an integral unity" (*LAAD*, 153). Panofsky took care to say that the "visual image" of the horseman merged with the requisite "mental image" because Dürer had actually produced no such image *qua* picture. But the evidence for all of the required association and merging of these images, as already noted, is simply the "integral unity" of the print—even though the fusion must have constituted its formal-pictorial unity in the first place.

In view of Panofsky's methodological tautologies and theoretical gyrations in constituting an iconological horizon for Dürer's *Knight, Death, and the Devil* (not to speak of his chronological, philological, and bibliographical sleights of hand), most subsequent objections to his interpretation of the print have been strictly *iconographical*, as if recognizing Panofsky's basic failure to find traditional or contemporary iconographies (whether Christian Soldier and Pilgrim's Progress or other types altogether) that underwrote Dürer's synthesis of them in the engraving. According to Edgar Wind, for example, Dürer depicted the Knight, described as a "cold, brutal, efficient warrior," in the "final vanity of [his] martial prowess." As far as Wind could tell, iconographically the Knight had no Christian identity whatsoever.[24] Along similar lines, E. H. Gombrich considered the Knight to be a German soldier whose "need for contrition" was visible in his physiognomy.[25] To cite the interpretation offered by sociologically-minded iconographers, the image of the armed rider possibly relayed Dürer's pictorial "protest against the brutal and unscrupulous ravagings of the robber-knights" who plagued his country.[26]

Figure 8.5.
A Spiritual Knight, woodcut in *Der Fusspfadt tzuo der ewigen seyligkeyt* (Heidelberg 1494). From Paul Weber, *Beiträge zu Dürers Weltanschauung* (Strassburg 1900) 31.

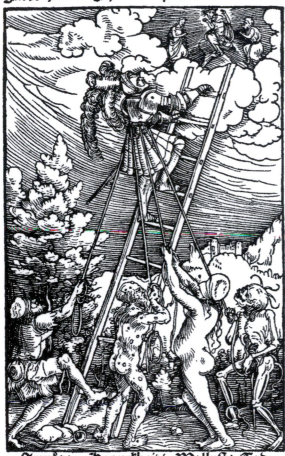

Armůt/ Kranckheit/ Wollust/ Tod.

Figure 8.6.
A pilgrim with Death and other adversaries, woodcut, c. 1490. From Richard Muther, *Die deutsche Bücherillustration der Gothik und Renaissance* (Munich and Leipzig 1884) vol. 2, pl. 169-right.

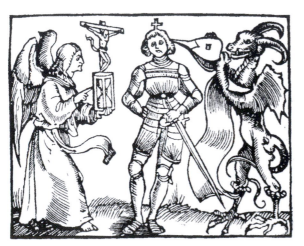

Figure 8.7.
Urs Graf (1485–c. 1530), woodcut depicting a Christian knight, from Desiderius Erasmus, *Handbüchlein des christlichen Ritters* (Basel 1520). From Paul Weber, *Beiträge zu Dürers Weltanschauung* (Strassburg 1900) 28.

An alternative to any such strictly iconographical analysis of the engraving—Panofsky's, Wind's, or others'—has been developed in an elegant analysis by Heinrich Theissing. Theissing attended in close detail to what he called *Bildsinn* (what I call "pictoriality") and *Sinnbild* (what I call "visuality") in the engraving.[27] He proposed that the more or less traditional and typical symbolism of the overcoming of Death (the Knight seems to forge ahead despite his adversaries) can be seen to mesh with Dürer's display of the formal devices of art (the feature of the print emphasized in Panofsky's early investigations of the artist's so-called aesthetics and theory of beauty). Theissing's account does not depend on identifying the Rider as a Christian Knight or a Robber Knight in *iconographic* terms. Instead, the Knight (according to Theissing) relayed Dürer's concept that Beauty, the artistic *locus* of Culture, can overcome Nature and in particular the necessity of Death. In turn this visualization can be taken to have been a reflection and a relay of the artist's Christian spirituality—even to have originally helped constitute it.

Theissing's ingenious analysis fully acknowledged the disjunction between formality and pictoriality originally observed by Wölfflin. His investigation reminds us that Panofsky's attempt to overcome the iconographic succession need not wholly accord with the involutions of the succession. But like Panofsky, and unlike Wölfflin, Theissing continued to suppose that the succession accomplished in the art of the engraving unified form, motif, and symbolism in a configuration that self-consciously gathered itself wholly together in a coherent and complex double allegory. To that extent his iconology differed from Panofsky's only in the contents and particulars of its results. In its method and aim, it remained faithful to the Panofskyan ideal of a positive hermeneutics of the iconographic succession that will capture its immanent and ultimate totalization. More exactly, Theissing's approach (whether or not he explicitly intended it to do so) reconciled the disjunction between formality and iconography that bedeviled Panofsky's iconology. Thus it exemplified an ideal of wholesale totalization in aspective interdetermination—the Holy Grail of the study of visual culture.

▪ 6

To be fair, Panofsky's method incorporated the resistance of depiction in an indirect way. Panofsky urged that in examining historical pictures—pictures made by people in the past, subjects of a visuality different from our own—we must correct *our* seeing. We must reconstruct the expres-

sive, the traditional, and the symptomatic meanings of pictorial configurations produced in the past. This so-called contextual knowledge (or what Panofsky called knowledge of *Zeit und Ort* [time and place]) derives from the history of formalization and style (*Gestaltungsgeschichte*), from the history of motifs and types (*Typengeschichte*), and from the history of spiritual or cultural significance (*Geistesgeschichte*). In one sense we must correct our seeing because at each stage of historical interpretation (namely, at the stages of *Gestaltungsgeschichte*, *Typengeschichte*, and *Geistesgeschichte* respectively) a pictorial configuration can resist our understanding. But in another sense these corrections, Panofsky believed, can be successful in taking us to the *next* stage, that is, in forwarding the iconographic succession to its supposed end, which in this context cannot be defined so much as the symptomatic cultural significance that was seen by original beholders of the picture as the putative significance that is apprehended *by us* after the correction of our seeing. At no stage did Panofsky care to admit that any quotients of pictoriality, from formal expression to cultural symbolism, might remain unrecognizable.

To be specific, the history of style, as noted in Chapter Seven, enables us to correct our primary expressional recognition of the objects and events we make out in pictures. But this analysis cannot be allowed to suggest that the picture might remain partly *unrecognizable* in terms of *Typen-* and *Geistesgeschichte*. By the same token, the history of traditional types in the rendition of images enables us to correct our recognition of imagistic themes and concepts, especially when the full passage of our recognition seems to be blocked; that is, in cases where we can see the motif and nonetheless remain "unable to recognize the subject" (*I & I*, 7). Presumably these cases are commonplace even if they are difficult to identify or recognize as such. At the same time, however, *Typengeschichte* cannot be allowed to suggest that the image might remain partly *unintelligible* in terms of *Geistesgeschichte*.[28] Finally, the history of pictorial symbols conceived as cultural "symptoms" (*I & I*, 8, 14, 16) enables us to correct our recognition of image-types, especially, and again, when the full passage of our recognitions (of the picture's theme as a cultural symptom, for example) seems to be blocked. Again, such cases are common in art-historical research. At the same time, however, *Geistesgeschichte* cannot be allowed to suggest that the pictorial symbol might remain partly *unexpressive* of a context-specific cultural attitude relayed by an individual artistic personality in a work of pictorial art (*I & I*, 7).

In the end, our suitably corrected familiarity with the "general and essential tendencies of the human mind" (*I & I*, 16) must reconnect with the familiar world-recognitions that we brought to the elementary for-

mal expressiveness of the picture in the first place. In the end, as already noted, we should be able to identify the past *world-representations* that constitute the ground of the primary *picture-recognitions* with which we ourselves began. In practice, of course, unrecognizability of all kinds seems to persist. But supposedly the problem is empirical rather than essential: supposedly we simply lack appropriate evidence for *Gestaltungsgeschichte* or *Typengeschichte* or *Geistesgeschichte*. For Panofsky and later contextualists in cultural history and visual-culture studies, in principle the resistance of the picture in its configurations and contents could be overcome (in a world of perfect historical evidence) by the reduction of our ignorance of its circumstances and contexts.

Indeed, what might be called extreme or high contextualism in cultural history and visual-cultural studies systematically *reifies* intrinsic meaning. In terms of the general theory of visual culture proposed here— that is, in terms of the general model of aspective interdetermination, succession, recursion, disjunction, and resistance—such extreme or high contextualism is the exact analog of extreme or high formalism in the study of configuration (Chapter Three) and of the twinned reifications of pure reflexive style and pure stylistical rhetoric that can be found in stylistic analysis (Chapter Four), even though high contextualism has often advertised itself as the antidote to high formalism and to connoisseurships. High contextualism systematically deploys the terms of circumstance and context in order to *displace* aspects of configuration and content, partly unrecognizable as they must be. For if aspects of configuration and content could not have been recognized by beholders at the time, they *cannot* be contextualized in the way preferred by high-contextualist visual-cultural historicism. On the other hand, if we assume the contemporary intelligibility of the putative iconological content from the outset, high contextualism only needs to address such self-evident matters as the generic or narrative forms and modes, and sometimes the aesthetic manipulation, of the configurative and stylistic relay of the content in a given time and place. In other words, high contextualism is categorically predicated on the historical existence of a fully-attained visuality or totalized visual culture. And as such it must be contrasted with a contextualism, equally historical, that addresses the inherent ambiguities and partial unrecognizability of supposed intrinsic cultural meaning in its supposed succession, even at the time of its original visibility and certainly in *our* seeing of it, however corrected. Such a negative hermeneutics of visual-cultural meaning always allows the possibility that a historical artifact in vision might have been partly outside visual culture *at the time* in just the same way as it is now inherently outside our *own* visual culture, and for

precisely the same reasons in the succession. (A full critique of present-day academic visual-culture studies as a high-contextualist reification of visual culture in the theoretical sense is outside the purview of this book: it would lead us much too far away from general theory.[29])

Wölfflin thought he had seen a lack of unity in Dürer's print. Panofsky, however, was pleased to denigrate Wölfflin's observation: it was merely "*pseudo*-formal" (*I & I*, 14; my emphasis). This was because it failed as *Gestaltungsgeschichte* in Panofsky's sense. From Panofsky's point of view, Wölfflin had apprehended Dürer's print not only pre-iconographically. He had also apprehended it, as it were, pre-pictorially. And such an error, though understandable in a modern art historian, would have been impossible for Dürer and for an original culture of viewers of the engraving. Or so Panofsky supposed.

The deepest dispute between Wölfflin and Panofsky cannot be seen, then, as a simple opposition of form (Wölfflin's supposed object) and content (Panofsky's supposed object). Instead their distinctive approaches juxtaposed a pictoriality more or less uncorrected by visuality, identified in Wölfflin's formal analysis, with a visuality conceived more or less entirely *as* pictoriality, identified in Panofsky's iconology. And where Wölfflin (according to Panofsky) did not acknowledge enough pictoriality in Dürer's image, Panofsky as it were *over*pictorialized it. Either way, the methods in question drained away the essential tension of the image. They do not really allow us to identify the mutually resistant interactions of pictoriality and visuality—their disjunctive, perturbed aspective interdetermination, however managed by the artist—at the intersections of recognition and representation.

■ 7

Panofsky's program for *Kunstwissenschaft*, for the methodological self-correction and ultimate attainment of iconological understanding, closely resembled the conception of the progress of science promoted by neo-Kantian philosophers in the preceding generation, notably by Cassirer. Their doctrine has been well described by Michael Friedman:

> [M]ore and more layers of "form" are successively injected by the application of our scientific methods so as gradually to constitute the object of empirical natural science. In this methodological progression we find . . . only an infinite series of levels in which any two succeeding stages relate to one another relatively as matter and

form. The object of knowledge itself, as "reality" standing over and against pure thought, is simply the ideal limit point—the never completed "X"—towards which the methodological progress of science is converging. There is thus no "pre-conceptual" manifold of sensations existing independently of pure thought at all.[30]

Panofsky himself did not quite assert that the symptomatic cultural meaning of a picture subsists in our historical method in the same fashion as the object of science (that is, "reality")—namely, as a "never completed 'X'." Nonetheless the methodological correctives of *Kunstwissenschaft*, like the methods of science, should progress toward the reality of culture as such; namely, the identity of apperception and discursivity described by Cassirer in his philosophy of symbolic forms. Cassirer developed his system in the early 1920s in close association with Panofsky. And in a book published soon after Panofsky's "Iconography and Iconology" had appeared in English, Cassirer investigated the methodological succession deployed in humanistic research, including art history.[31] It would seem that Cassirer's reflections at least mirrored Panofsky's conclusions.

In the same years, Rudolf Carnap's constructivist philosophy overlapped Cassirer's phenomenology of knowledge and Panofsky's history of culture. Carnap tried to characterize our empirical knowledge of the world as a series of steps leading from the "autopsychological" realm (the subjective world of sensation) through the "physical" realm (the public world of external objects) to the "heteropsychological" realm (a transpersonal cultural world).[32] Carnap's logical positivism (as distinct from the cognitive idealism of Cassirer and Panofsky) did not treat each of the steps of the construction of our world (*die Aufbau der Welt*) as phenomenal experiences, as Cassirer and Panofsky usually did. Rather they were characterized as logical types—derivative or dependent classes of and relations between objects derived from the objects constructed at the preceding level. For this reason, as Carnap tried to show, the "never completed 'X'" of a real object nonetheless can be effectively attained by the knowing subject "in finitely many determinations . . . [that provide] its univocal description among the objects in general." As Carnap continued, "once such a description is set up the object is no longer an X, but rather something univocally determined—whose complete description then certainly still remains an incompleteable task."[33]

In other words, the putative noncompletion of "X" is metaphysical. Despite the unavoidable possibility of phenomenal indiscernibility (a problem to which Carnap himself did not pay much attention), human beings effectively know *this* thing from *that* thing precisely because they

have constructed both of them *qua* things in relation to one another or at least in relation to prototypes and part-correlates constituted at earlier stages of the succession of world-construction. This brilliant idea spelled the end of Cassirer's and Panofsky's branch of idealism. If the Idea, for them, had been chased back to a "never completed X," in Carnap's system it had reappeared as a perfectly definite and discriminable logical construct.

Regardless, in Carnap's system, just as it had been in the idealist hermeneutics advocated by Cassirer and Panofsky, the catch was not so much that the progress of knowledge would never reach completeness. It was its seeming *tautology* at the sociocultural or transpersonal level. (Carnap rightly did not assume the relevance of sociological analysis; he wanted to *build* to it.) The world-reports of other people become available to a percipient at a relatively advanced noetic stage in the construction of its world. Nonetheless these reports would also seem to constitute a basis for that very construction. Somehow this substantive circularity (the tautology of human languages and cultural history) must be grasped in the methodological tautology of its analysis.

In this regard, Carnap acknowledged and tried to accommodate an obvious difficulty that Cassirer and Panofsky usually avoided. He acknowledged that in principle an individual subject can build his knowledge of the world from his elementary visual experiences, more or less in the way Panofsky proposed; the recursions of autopsychological and physical recognitions and constructions enable this succession. In describing the heteropsychological (transpersonal, cultural) level of world-construction, however, and in order to construct an *intersubjective* world, we must effect an "abstraction (via an equivalence relation) from the resulting diversity in 'points of view.'"[34] Panofsky's work on the history of perspective prepared him to grasp the logical necessity, and perhaps even the cultural-symbolic mechanism, of this abstraction as it might function in the visual field.[35] But in his historical work Panofsky simply assumed (even reified) the convergence of viewpoints that must constitute transpersonal meaning or human culture.

Indeed, systematic explication of the analytic problem and possible solutions to it had to be developed *outside* art and cultural history in psychoanalysis and elsewhere, notably, for example, in Jacques Lacan's theories, developed in the early 1930s, about the "mirror stage." This divergence has marked (and probably marred) the intellectual history of visual studies from the time of its theoretical formulation in the 1920s to the present day. Cultural studies in the strict sense must be the study of transpersonal meaning; it assumes the abstraction from the diversity of

standpoints of the requisite equivalence. To study the disruption of this equivalencing must be to study something *outside* culture—a process of formation, coordination, and false starts in the individual subject (his equivalencing to another subject can only occur recursively in the frame of a heteropsychological representation that has yet to be achieved by him) or among the members of a social group apart from their mutual succession to culture. At the very least, the positive cultural succession (that is, the succession to culture) that is assumed by cultural history must be accompanied at every turn by its negative hermeneutics—an account of culture as "never completed 'X.'" I turn to these issues in Chapter Nine.

■ **8**

In any event, Panofsky explicitly conceived his method of art-historical recognition-correction as a *circulus methodicus*, a methodological circle. In formulating it, he relied on the work of his friend Edgar Wind, Cassirer's first doctoral student in Hamburg; though fully acquainted with neo-Kantianism and its discontents, in 1932 (*PB*, 93) and again in 1938 (*I & I*, 11) Panofsky cited only Wind. Wind attempted to compare—even to equate—the methods of natural science and cultural history, which had usually been rigorously segregated by neo-Kantian philosophers of knowledge.[36] But he did not urge a scientization of cultural history. Instead he argued that in both science and history "the investigator intrudes into the process he is investigating," and that "every [scientific] instrument and every [historical] document participates in the structure which it is meant to reveal."[37] Thus we cannot but "preconceive the universal, physical, or historical constellation" of which the instruments and documents form an inescapable part and then attempt to correct our assumptions about it through experiment. According to Wind, then, "what [had] first appeared as a logical circle, and, therefore, as self-contradictory . . . turns out to be a methodical cycle, and, therefore, self-regulating."[38] Panofsky repeated this point with reference to the correction secured through *Gestaltungsgeschichte*. "To control the interpretation of an individual work of art by a 'history of style' which in turn can only be built up by interpreting individual works," he wrote, "may look like a vicious circle." As he immediately added, however, "It is, indeed, a circle, though not a vicious, but a methodical one" (*I & I*, 11, n. 3).[39]

Panofsky hoped that the *circulus methodicus* of iconology could be distinguished from its analytic *Doppelgänger*, the vicious circle, because the representations identified in our ultimate anthropology of visuality

(iconology) are not the same as the expressions recognized in our initial hermeneutics of vision (Wölfflin's formal or "pseudo-formal" analysis) even though they might *look* identical at the level of configuration. In particular, the built-in successions and correctives of the *circulus methodicus* take us from the *depictive stylization of symbolic form*, encountered in our formal apperception of a picture, to the *symbolic formalization of depictive style*—what we come to recognize as the very ground of apperception in its specifically historical contents and contexts. In the initial moment of the loop, expressive form must be located in the picture recognized in our spatiotemporal and causal world-order (*I & I*, 16). In the ultimate moment of the loop, however, expressive form must be located in the picture understood to derive from a historical spatiotemporal and causal world-order—from *another's* world.

Nonetheless, as I have already noted, the methods of Panofskyan *Kunstwissenschaft* can never wholly reach this visual-cultural reality in the sense that the historian cannot actually come to *see* the world with the same eyes as the makers and observers of a visual culture in the past. Panofsky did write that when an art historian has made the objective corrections of *Gestaltungsgeschichte, Typengeschichte,* and *Geistesgeschichte* "his aesthetic perception as such will change accordingly, and will more and more adapt itself to the original 'intention' of the works."[40] But this statement does not quite go all the way. We can correct our world-seeing as we apply it to historical pictures. But this new adaptation does not give us the ability to see the pictures as it were *uncorrected* in a visual world now inaccessible to us. It only gives us the ability to enter the great loop of visuality at the opposite end from historical participants in a visual culture. At best we can "think" the pictures "seen" by them. As the project of *Kunstwissenschaft* in Panofsky's day and of visual-culture studies today, this "thinking" claims to identify the syntheses effected by the human visual imagination in a concrete configurative practice that is historically removed from us.

To put the matter another way, the primordial analytic difficulty of iconology lies in the fact that our *method* must assume a passage—a conversion between our world of seeing and a historical world—precisely where our *theory* asserts an essential nonidentity, a historical difference. The methodological situation of the present-day historian and the practical experience of the original observer are not mirror-images of one another. We must preserve the difference between seeing the world and seeing pictures; it enables us to pass from apperceptive recognitions to symbolic and symptomatic interpretations. But in the historical context, this difference had been sublated. In any past visual culture, apperception

is interpretation, and both functions would be disabled by their absolute distinction. In this sense art-historical method shelters a cleavage of form and content that in theory could never be discovered in the original historical situation of visuality.

This does not mean that nothing at all can be said about partly unrecognizable and unintelligible pictorial objects in our vision. It means that our analysis consists in finding the irreducible tension between a formal expressivity that might be open to us and depictive significances "whose secret remains impenetrable to the mind," to revert to Wölfflin's remarks on Dürer's engraving of 1513. We probably do not need the extensive detours of the neo-Kantian methodological circle in order to become aware of the historicity of our *own* vision. The continual resistance of many pictures to the methodological program of iconology shows us that the recognitions we apply to the picture and the representations that it relays to us remain divided. They are distinct historical kinds. But the very fact that our vision is historically located (we see that we have *not* seen what others saw in the picture) implies that we might reconfigure our vision to see differently—and perhaps to see things somewhat more in the way others have done. Although visuality is historically relative, it remains historical relative *to us*. It is a definable difference *from us*. And in iconological method this distance can be traversed. If it were historically "other" in a more radical sense, the sense that Wölfflin indicated in pointing to the "impenetrable secret" of Dürer's engraving, the iconological program of cultural studies could not identify it.

■ **9**

In the German publication of his iconological method in 1932, Panofsky wrote that art historians initially approach the intrinsic cultural meaning of a historical picture, what he called *Dokumentsinn* or *Wesenssinn*, at the level of its expressive significance apprehended in their *vitale Daseinserfahrung*; that is, "our living experience of existence [*Dasein*]" (*PB*, 95). (In the English text of 1939, this is the "pre-iconographical" level of "primary expressional significance" or "'what we see.'") In using this terminology, as I have already noted, Panofsky explicitly relied on Wind's philosophy of science and history. But in part Panofsky's choice of words implicitly invoked the philological and documentary methods of many German art historians, such as Herman Grimm and Paul Weber, whose results he had used in his iconology of Dürer's picture making.

Of course, the documentary or textually-justified meanings pursued by positivist philologists and the intrinsic meanings pursued by neo-Kantian cultural historians in the Hamburg School—by Panofsky, Wind, Fritz Saxl, and others—were not always the same. The positivist historian's specifications of the once-contemporary significance of a pictorial motif, what Panofsky would call a specifically iconographic significance, typically had not shown it to be a *visuality* intrinsic to the primary formal expression. A demonstration of that kind was specifically iconological.

Panofsky seems to have been trying, then, to have things both ways. On the one hand, he recognized the positive contributions of documentary art history to iconography and iconology. In fact, in his attempt to identify the intrinsic cultural meaning of *Knight, Death, and the Devil* he would add little new historical scholarship to the corpus of textual and pictorial evidence collated by Weber and other scholars—the evidence drawn from Dürer's writings, for example, and from the *comparanda* of then-contemporary pictorial prints. On the other hand, he embedded these findings midway between the pre-iconographical moment of the methodological circle, which he explicitly identified with Wölfflin's formalism (in itself conceived as an antidote to positivist art history), and cultural history or the iconological moment of the methodological circle. For according to Panofsky, the *Sinn* or "sense" of the *Dokument* should be distinguished from its *mere* content, its denotation or reference as revealed by documentary art history. The *Dokumentsinn* in his sense lay in form and meaning—that is, in "visual image" and "mental image" respectively—synthesized as a visuality, the ultimate horizon discovered in the recursion of the methodological circle.[41] If iconology approaches the *Dokumentsinn* of the historical picture on the basis of our *Daseinserfahrung* (*PB*, 95), then, it has not only been a dispute between Wölfflin and Panofsky, or between "form" and "meaning." It has also been a dispute between Wölfflin and Panofsky on one side (both art historians sought to discover visuality) and positivist art history on the other side.

Is it possible to reach the *Dokumentsinn* while remaining *within* the existential limits of *Daseinserfahrung*? Panofsky obviously believed that it was: he tried to accommodate the iconographical results of documentary art history both to pre-iconographical formalism, which he identified with the subjectivity *of* the historian, and to his specifically iconological contextualizations of iconographic tradition, which he identified with objective knowledge secured *by* the historian. But precisely because this calibration involved a fundamental distinction between *Dokumentsinn* and *Daseinserfahrung*, it opened the question of an irreducible con-

frontation between them. Despite the familiar binary of subjectivity and objectivity, a virtually colloquial or common-sensical opposition, there might be no philosophical reason to treat *Daseinserfahrung* and *Dokumentsinn* as categorical equivalents positioned at opposite ends of a spectrum of phenomenological and epistemological possibility. *Daseinserfahrung*, we have to say, *is unequivocally primary in methodological and substantive terms*. By contrast, *Dokumentsinn* might literally be epiphenomenal, a construction always achieved wholly *within* the horizons of *Daseinserfahrung*. This issue was the subject of a profound dispute between Cassirer and Panofsky on the one hand and Martin Heidegger on the other. Indeed, it seems that Panofsky's description of the first stage of iconological method in 1932 was intended directly to invoke the privilege Heidegger accorded to concrete human being-in-the-world, or *Dasein*, as he had characterized it phenomenologically in the first part of *Sein und Zeit*, published in 1927 (the other parts were never published).

Heidegger was well aware of the art- and culture-historical research that had framed Cassirer's philosophy of symbolic forms. As early as 1923, at the age of thirty-four, he lectured at Hamburg on phenomenology; at Hamburg, Cassirer (then forty-eight) was the professor of philosophy and Panofsky (then thirty-one) the leading art historian. On this occasion, as Heidegger wrote in *Sein und Zeit*, the younger philosopher came to "an agreeement [with Cassirer] as to the necessity of an existential analytic which was sketched out in the lecture."[42] In 1928 he reviewed the second volume of Cassirer's *Philosophie der symbolischen Formen*, published three years earlier, which treated "mythical thought"; indirectly he also addressed Cassirer's influential essay of 1927 on "The Problem of the Symbol and Its Place in the System of Philosophy," a virtual *summa* of the cultural-historical studies advocated by Cassirer and Panofsky in the Hamburg School. Finally, Heidegger's meditations on the "origin of the work of art," which originated in lectures at Freiburg in the mid-1930s, refined his existential phenomenology as it applied in particular to the question of *Daseinserfahrung* in iconology—in other words, to the element in iconological method that Panofsky tended to circumvent (or to correct) in his drive to discover the *Dokumentsinn* of a pictorial symbol, its intrinsic cultural-historical meaning.

For his part, Cassirer responded in several forums to Heidegger's existential phenomenology. In the third volume of *Philosophie der symbolischen Formen*, published in 1929, for example, he included several brief comments on *Sein und Zeit*. Most important, at Davos in 1929 Cassirer and Heidegger publicly disputed the grounds, aims, and results of Kant's critical system. A few weeks later Heidegger published *Kant und*

das Problem der Metaphysik. Panofsky studied this book carefully and quoted it in his initial formulations of iconography and iconology (that is, in *PB*). And Cassirer published a long, hard-hitting review of it in 1931; it was one of the older philosopher's most powerful and useful summations. Soon thereafter, in an address at the Fourth Congress of Aesthetics and the Science of Art (*Ästhetik und Kunstwissenschaft*) in 1932, Cassirer sketched an alternative to the phenomenology laid out by Heidegger in *Sein und Zeit* and *Kant und das Problem der Metaphysik*. Panofsky would have been aware of all stages of this dialogue, and he participated directly in several of them. In the 1930s his essays continued the conversation at several levels—both theoretical (as in *PB*) and art-historical (as in an essay on Nicolas Poussin's painting *Et in Arcadia Ego* [1637] that he contributed to the *Festschrift* for Cassirer in 1936). All of these interactions—a clash of philosophical systems—were followed with deep interest by readers in art theory at the time. Because of the great importance of the intersection of phenomenology and iconology in any general theory of visuality, I deal with these exchanges in detail elsewhere.[43]

For the purposes of the present chapter, it suffices to note here that Heidegger did not engage any particular iconological interpretations that had been proposed in professional art-historical scholarship. But in offering existential identifications of the Being disclosed in certain works of art, he pointed to the essential subjectivity of iconology, that is, to its primary ground in existential phenomenology. It is clear that for him the methodological circle accepted by Panofsky (and described in *PB* as a set of irreversible steps or a ladder of thought) properly would have to be understood to address an *ontological* circle or loop. From Heidegger's vantage point, *Daseinserfahrung* must be the beginning *and* the end of iconology—its horizon in all directions *regardless* of its discovery of *Dokumentsinn* using the methods of correction recommended by Panofsky.

In light of the challenge posed by Heidegger's thought, Cassirer and Panofsky wished to uphold the sense in which representations of the world could be taken to construct and to relay transpersonal ideation. According to the Hamburg School, shared traditional or cultural symbols primally *mediate* the concrete historical existence of a human individual, or *Dasein*. The most important of these symbols are taken to describe or depict reality, and to possess a high degree of truth in doing so. This fact of culture, of the symbolic form of human forms of life, applies to the methodological situation of the *art historian* as well as to the historical form of life of original image makers. In these terms, the experience of the art historian consists not only in his *vitale Daseinserfahrung*, his living experience of (his own) existence. It also consists in his educa-

tion and expertise in securing and evaluating evidence for the historical experience—the being—of other human beings. As we have seen, Panofsky would apply a series of correctives to "pseudo-formalist" *Daseinserfahrung* in order to show that the historical documentation attained by iconography can lead to the identification of a historical visuality—that is, to the seeing of others.

Equally important, the correctives also work to counteract the subjective arbitrariness thought to be risked in Heideggerean phenomenology. In general, the history of cultural tradition should limit the interpretive "violence" (*Gewalt*) inflicted by the "objective" methods of documentary or positivist scholarship and the "subjective" ones of formalism and existential phenomenology when practiced naively or when taken to extremes. As Panofsky put it in a response to Cassirer's lecture of 1932, sometimes we cannot say within the limits of our own *vitale Daseinserfahrung* what things in a picture might *be*, or as Heidegger would put it "what *is*" in the picture—what is *being* there (*was da ist*). But cultural history, Panofsky argued, reveals their "time and place" to us, their *Zeit und Ort*.[44] In other words, the primary existential time (the *Sein und Zeit* of Heideggerean *Dasein*) that constitutes the *Daseinserfahrung* with which we begin looking at pictures and artworks can be converted into the *Zeit und Ort* of objective historical context—even as this new way of seeing continues to be compatible in favorable circumstances with the temporal horizons of present-day *Dasein*. Panofsky identified these circumstances as the self-critical avoidance of interpretive violence—of the "madness" (*Irre*) of a naïve or extreme solipsism that he implicitly attributed to Heideggerean existential-ontological phenomenology and to a lesser extent to Wölfflinian formalism. Essentially he asked the art historian's unavoidable subjectivity, necessary in a definite moment, to become more rational (less mad) by entering the *circulus methodicus* in good faith and by making critical judgments governed by evidence in pursuing its self-correcting circuit.

In this way, and true to his intellectual character, Panofsky tried to have his cake and eat it too. Rhetorically he shifted Heidegger's emphasis on primary existential time, essentially subjective, to a historical locatedness that is provisionally objective. The conversion involves not simply putting the image into its original *time*, but also and in particular putting the image into its *place* objectively over and against us—distant from us. If Heidegger emphasized what is *being* there in the picture before us (*was da ist*), Panofsky emphasized what is being *there*. When the loop closes, to experience this visuality as my own being-in-the-world must be to move *Dasein* from its original time toward the cultural-symbolic form of *an-*

other's spatialized world-perspective. In promoting the self-distancing of *Dasein*, then, Panofskyan iconology (including the visual-cultural studies descended from it) promotes a recognition of the Other—an other essentially like oneself *qua* human being—by way of a cultural history intended to expand our objective horizons and to reduce our subjective involvements.

Maybe the project is laudable. As in the 1920s and 1930s, today it serves a fitfully progressive liberalism, humanistic and antiauthoritarian. The problem with it is not that it requires our historical interpretation of images to be secured in an analytic circle, bootstrapping out and away from original temporal self-involutions of *Dasein* even as we return to unfold and enrich them. Rather, and reverting to the principal theme of this chapter, the disjunction of recognitions—and the resistance of the picture—means that the existential time of the picture as a world-object (what I have called pictoriality) remains essentially divided in visible respects from the significant spatiality of its object-world (or visuality) *even in the original context in which the image was made*. Panofsky hoped (and in his method he presumed) that in its proper historical time and place, in its original historical context, the synthesis of pictoriality and visuality occurred immediately and imperceptibly—like the wholesale merging and binding we have considered in the paradigmatic case of Dürer's engraving of 1513. The problem, if any, is supposedly empirical, a question of evidence and method, rather than essential, a question of the general theory of visual culture—that is, of the very nature of visual culture.

But Panofsky had to invent the identification of what he called Dürer's visual and mental images. Dürer's supposed Erasmian visual culture appeared out of nowhere in Panofsky's method in a fashion that can be said to be paralleled by the seemingly arbitrary emergence of an anonymous peasant woman's rough, worn shoes in Heidegger's projection of the existential significance of the objects depicted in a painting by Vincent Van Gogh (his *Shoes* of 1888), even if Panofsky's identification of the *Zeit und Ort* of *Knight, Death, and the Devil* was intended virtually as the opposite of such existential identifications. In the final analysis the interpretive *Gewalt* inflicted by Panofsky at the far culturological end of iconological method (an armed rider somehow becomes a Christian soldier and equestrian knight) seems no less dramatic, subjective, and "mad" than the *Gewalt* inflicted by Heidegger at the supposed phenomenological and formalist beginning (a pair of shoes, possibly the artist's own, somehow become a peasant's shoes, and a woman's at that).

Throughout their interaction, in short, *Daseinserfahrung* and *Dokumentsinn* are equally and reciprocally caught up in the recursion, resis-

tance, and disjunction of the iconographic succession. It would be tempting to suppose that Heidegger's existential phenomenology has the upper hand for this very reason. Whereas iconology, as noted in Chapter Seven, cannot always navigate the succession smoothly, phenomenology would seem simply to let it be—to be *in* it. But "what we see," our recognition of "what *is*" in the picture, encounters the resistance of the succession *regardless* of iconological method and outcome. It never escapes the primordial possibility of recognitional and depictive disjunction. Stated another way, visual-cultural *Daseinserfahrung* simply *is* the question of the picture as such, that is, of the iconographic succession—its recursion, resistance, and disjunction.

None of this implies that there are no determinate relations between pictoriality and visuality. Quite the opposite. We can critically investigate the mutual resistance of pictoriality and visuality rather than their ideal, mythic synthesis and identity. Still, it is not obvious what a visual culture could be if it is the cohabitation of irreducibly disjunct recognitions and, potentially, their mutual negation. How does it hold or come to hold together at all? I will turn to this difficult question, perhaps insoluble, in Chapters Nine and Ten. Here I note that the coherence of a visual culture does not depend on the fact that a representation looks like any one thing, relaying a particular *being* in Heidegger's sense—that it depicts either an armed rider *or* a Christian soldier *or* an equestrian knight in the case of the engraving by Dürer investigated by Panofsky; a peasant's shoes *or* a peasant woman's shoes *or* the painter's shoes in the case of Van Gogh's *Shoes* as seen by Heidegger. Conceivably it has the aspects of *all* of these things, and many other things. At one time and in one place of the *being* of the image, the picture we see, it might look like one or some or none of them. And at another time and in another place, it might not: it might look like some one *different* thing or like many different things. No existential or iconological presumption can deflect the unpredictable succession of formality, style, and pictoriality.

■ 10

We can readily guess Panofsky's motivation for supposing in the 1940s that his iconology could *think* the Erasmian culture of Dürer's visuality—the Erasmian significance of Dürer's depicted Knight—even if it could not actually *see* the engraving with sixteenth-century eyes. Scholars before Wölfflin and Panofsky had often identified the Knight as a protagonist of a northern *Rittertum*. He could be seen as a legendary hero of Teu-

tonic saga or as an actual German warrior of the sort familiar to Dürer and his contemporaries. He could be seen as strong and pure (as spiritual or *geistlich*) or he could be seen as evil and doomed, a horror—a phantom (equally *geistlich*) like his companions. But in any case he was seen as "a German, national hero," as one historiographer has written, an exemplary figure "incorporating all the conflicts, desires, tragedies, and *malaises* of the German soul."[45] The most influential version of this interpretation of the print had been propagated by Friedrich Nietzsche and his followers, especially Ernst Bertram, whose popular book on Nietzsche contained an entire chapter on Dürer's print. In the 1870s Nietzsche took the Knight to be an emblem of pessimism, a man "isolated and totally without hope who goes on his dread journey in a longing for truth."[46] And writing during the First World War, Bertram associated the Knight's supposed Nietzschean "will-to-pessimism" with a "fateful 'protestant' isolation of the individual," especially spiritual solitude in the face of inexorable Death.[47] Bertram provided the old Germanic symbol with a new Nietzschean gloss.

Panofsky made no mention whatsoever of this interpretive possibility. In his doctoral thesis on Dürer's art theory, he only went so far as to remark the German Late Gothic aspect of the engraving. By this he meant its naturalism, "stylized in accordance with a 'classic' canon of pose and proportions" (*LAAD*, 152). In studies of the artist published in the 1920s and 1930s, he went on to address Dürer's relation to Italian art and its antique prototypes; that is, to what was sometimes called "classic art" at the time. But in 1943, when Panofsky dealt with the engraving in his artistic biography of Dürer, the northern *Rittertum* proposed as a tradition for the print had been reconstituted in terms of the German nationalism of the 1930s. An emblem deployed in National Socialist propaganda, Dürer's Knight had become, in the words of the art historian Wilhelm Waetzoldt, a "forefather of the Prussian officer."[48] Indeed, the main portrait of Adolf Hitler at the Great German Art Exhibition at Munich in 1937, Hubert Lanzinger's *Bannerträger* (*Standard Bearer*, Fig. 8.8), depicted an equestrian Hitler carrying the Nazi standard and posed and equipped like the Knight. Completely ignoring Panofsky's subtle researches on the Italian affiliations of Dürer's art, several German writers in the 1930s reduced all aspects of Dürer's pictorial investigations to "German Form," as Theodor Hertze put it in *Die Rasse*, the new periodical of racial anthropology.[49] It was against this portrayal of the artist that Panofsky seems to have reacted in the early 1940s. At this point resettled as a Jewish refugee in the United States, he tried to construct Dürer in the "universal image of a cosmopolitan humanist."[50] If the Knight was not to be an *Ur*-Nazi, he almost *had* to be an Erasmian Christian.

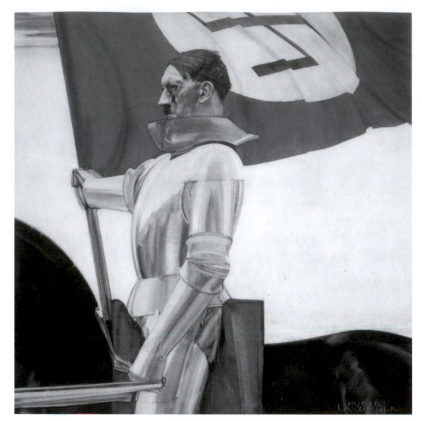

Figure 8.8.
Hubert Lanzinger
(1880–1950), *Standard
Bearer*, 1937. German
War Art Collection,
Army Art Collection,
Washington, DC.
Photo courtesy Army
Art Collection, US Army
Center of Military
History, Washington,
DC.

Panofsky's and Cassirer's earlier tangle with Heidegger blended with this ideology. Panofsky wanted Dürer's print to be a transpersonal symbol: it had to lead into the pan-European humanistic culture of the early sixteenth-century Reformation if not into the universal *Ideenwelt*. Heideggerean phenomenology might consider Dürer's image to have been existentially grounded in ways partly unintelligible to the art historian even though its secret, to use Wölfflin's word, seems to be visible to us in the medium of pure form in Dürer's visualization of the mysterious horseman. If we follow Panofsky, however, in apprehending this image the art historian enters the visual world of Dürer's engraving by recognizing the *binding* of the formal expression and the symbolic content to constitute both the existential *and* the cultural meaning of the engraving: the form of the existential image merges with the traditional allegory. Still, these representations must be recognized in diverging registers. Somehow, then, the print must leap through its disjunction. In the end, the picture subsists not only in the formal, the stylistic, and the symbolic recognitions considered separately—in the formality, stylisticality, and pictoriality recognized by the art historian for hermeneutic and heuristic

purposes as autonomous aspects. It also consists in their *mutual correction*, the intersection, interaction, and mutual resistance of the several successions of configurative aspectivity.

As Wölfflin had seen it, Dürer worked *within* the disjunctions; he could not overcome them. In particular, the print was forever marked (and marred) by the division, an original rupture and persisting disunity, between the personal *imago* of the mysterious horseman and the traditional allegory of the Christian soldier. But as Panofsky wanted to see it, Dürer proceeded *through* this disjunction: he reconciled it. The print transcended the disjunction of pictoriality and visuality that marked its history as an image stretched between existential *imago* and conventional allegory. In this sense it *displayed* the objective self-correction (in Panofsky's Cassirerean sense of objectivity) of subjective-temporal meaning-involution (in Heidegger's existential terms). In turn it could literally stand for the project of Panofskyan art history itself. More exactly, it was the perfect theoretical object for iconological method.

In *Die Kunst Albrecht Dürers*, Wölfflin had noted that there was only one direct prototype for the trotting pose of the Knight's horse, which lifts its diagonally opposite feet (its left forefoot and its right hindfoot) off the ground: Leonardo da Vinci's equestrian monument for Francesco Sforza in Milan. The pose of Leonardo's and Dürer's horses differed palpably from other Italian prototypes that had sometimes been cited (the classical horses on San Marco in Venice, Pollaiuolo's studies for an unexecuted monument to Sforza, Verrocchio's monument to Bartolomeo Colleoni also in Venice, Donatello's *Gattamelata* in Padua), and Wölfflin concluded that Dürer had appropriated the "most modern" of these images (*KAD*, 246).[51]

Oddly enough, however, Wölfflin nowhere mentioned that in making the engraving Dürer corrected the hind off leg of the Knight's horse, lifting it further from the ground and bending it more acutely. The change remained clearly visible in the print even though Dürer did his best to disguise it as a tuft of grass crushed below the horse's hoof (Fig. 8.9). According to Panofsky, this "last minute" correction helped intensify the movement of the horse (*LAAD*, 153). Perhaps this befitted Dürer's supposed narrative of the Knight's progress on his Path—that is, Panofsky's reconstruction of the symbol. But the correction would seem equally to support Wölfflin's emphasis on the original image of horse and rider. Indeed, in his dissertation Panofsky himself had shown that the right hindfoot of the horse (as corrected) helped to portray the animal according to an overall proportional canon; Dürer had worked it out in a "characteristically personal system" in his theoretical investigations, as

Figure 8.9.
Detail of Albrecht Dürer (1471–1528), *Knight, Death, and the Devil*, 1513. Digital scan by the author.

can be seen in a study of the horse on the sheet of drawings in Nuremburg (Fig. 8.3). Virtually all aspects of the pose and movement of the horse in the engraving conformed to this canon (Fig. 8.10).[52] As Panofsky wrote in 1943, then, "Dürer's equestrian group [in the engraving] bears all the earmarks of a scientific paradigm" (*LAAD*, 154).

To be fully specific, when Dürer raised the hoof on the horse's right hindfoot he ensured that it touched a crucial construction line of this canon: a line ("E" in Panofsky's diagram) that could be drawn through the upper limit of the hooves on the right forefoot and the left hindfoot of the horse. The lower limit of the hoof on the left hindfoot rests on the so-called standline (*Standlinie*) itself (Panofsky's line "F"), which is almost identical with the bottom edge of the sheet. The vertical distance EF, then, is the height of the horse's hoof. It is also exactly one-quarter the height and width of the basic constructional quadrant used throughout the canon. Indeed, one wonders if it was the actual *module* of the canon. So far as I can see, Panofsky did not recognize this seemingly obvious possibility, probably because he did not explore the pictoriality of the correction.[53] That aside, Dürer's correction clearly helped to make visible the proportional construction of the entire picture, confirming his persistent and pervasive interest in this formality throughout its construction in the engraving, just as Wölfflin had suggested.

If we adopt Heidegger's terminology, the artist's anxiety to preserve the primal image and to effect its visible demonstration drove the care that he expended on the correction of the horse's hoof in order to stabilize the formality of the picture of horse and rider—the very secret of the image in Wölfflin's terms. But whence, then, the crucial objectification

of the artist's anxiety and care, the transcendence of solipsism Cassirer demanded of Heideggerean existential ontology? Whence the Panofskyan *distancing* of *Dasein* from itself? In Panofsky's sense of the picture, Dürer's correction could not serve exclusively to preserve the Wölfflinian formality. It should also serve to mediate its cultural-symbolic significance; that is, the allegory.

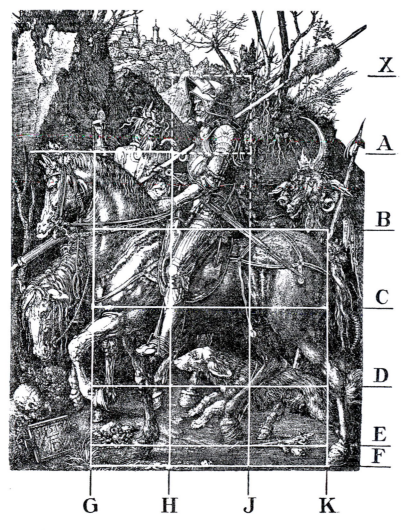

Figure 8.10.
Reconstruction of the canon of proportions in Albrecht Dürer's *Knight, Death, and the Devil*, 1513. From Erwin Panofsky, *Dürers Kunsttheorie* (Berlin, 1915) 203.

X = Linie der Helmspitze.
A = „ des höchsten Punktes des Pferdes.
B = „ der Kruppenhöhe.
C = „ des Ellenbogengelenkes (Schildchen).
D = „ der Vorderfußwurzel des Standbeins.

E = Linie des Hinterhufes.
F = Standlinie.
G = Linie des Brustmuskels.
H = Linie des Widerrists (Sattelknopf).
J = —
K = Linie der Schwanzwurzel.

Consistent with his earlier research, Panofsky accepted that the formality of the engraving replicated Dürer's proportional investigations. "It is quite true," he acknowledged, that in the engraving "Dürer was anxious to find a subject which would permit him to demonstrate the final results of his studies in the anatomy, movements, and proportions of the horse" (*LAAD*, 153). But when Wölfflin illustrated this formality (Fig. 8.4), Panofsky contended that the elimination of the background made the horse and rider look like a "stiff and over-elaborated imitation of an equestrian statue à la Pollaiuolo, Verrocchio and Leonardo da Vinci" (*LAAD*, 154, cf. *MVA*, 49)—this despite the fact that he *accepted* these prototypes at the strictly iconographic level. Wölfflin's illustration had not included the landscape background in the pictorial field. When we do so, the image does not simply replicate the formality of the Italian equestrian prototypes or the posture taught in a late-medieval riding school. By contrast, it can be seen to be "endowed with a definite meaning" particular to its national, cultural, and spiritual context. As Panofsky wrote:

> Contrasted with the twilight and the specters of a Northern forest, the very articulateness and plastic tangibility of this moving monument suggests an existence more solid and real than that of Death and the Devil who appear as little more than shadows of the wilderness. . . . [C]ontrasted with the jerky obsequiousness of the Devil and the pitiful weakness of Death and his worn-out horse, the measured gait of the powerful charger [of the Knight] conveys the idea of unconquerable progress (*LAAD*, 154).

As Panofsky put it in the later essay, the rider in Wölfflin's illustration seems to be "expressionlessly moving no one knows whence, no one knows whither" (*MVA*, 49). Set in his narrative context in the engraving, however, the rider exhibits indomitable assurance in a world of "spooks and phantoms," "suggest[ing] quiet, unchecked progress in one direction." This significance was constructed formally by means of the profile orientation and the spatial substantiality of the horse and rider, the striking image against which Dürer deliberately set off the "violently foreshortened" figures of Death and Devil. As Panofsky explained in 1951 in an explicit refutation of the purely formalist approach embodied in Wölfflin's illustration,

> [Dürer] wanted to *integrate* the strongly modeled, unforeshortened group with the rest of the composition; this meant to him, an artist of the sixteenth century, that both plastic relief and full profile view had to justify themselves before the tribunal of rea-

son. And this is what they do as soon as we restore the "odds and ends" [that had been eliminated in Wölfflin's illustration] and ask ourselves their meaning (*MVA*, 49; my emphasis).

In other words, far from motivating the secondary allegory of the picture and persisting in it as a secret or unknown meaning, the formality of the image followed naturally from the representation of Christian fortitude before Death. The engraving seemingly achieved a transreflexive integration of the immanent and still visible disjunctions of formality and representationality, expressive form and cultural meaning, and pictoriality and visuality.

We might even say that the merging of the form and the symbol, their integration, occurred *because of* the correction of the engraving, and especially in its persisting, obdurate visibility. For one thing, the uncorrected hoof could not be included in Wölfflin's illustration of the putatively original image—even if it was that version of the hoof which belonged to this image. And for another thing, the visible correction of the horse's hindfoot, an element of the putatively original image of horse and rider, partly belongs to the supposedly secondary "odds and ends" in the background: it has become the crushed grass beneath the horse's hoof. As a pure form of depiction, then, the correction subsists *between* the Wölfflinian form relaying Dürer's artistic *Dasein* and the Panofskyan background constituting the cultural symbol.

Here I go beyond anything claimed by Wölfflin or Panofsky. When Dürer modified the horse's hoof in order better to display the primary pictorial construction of the horse and rider as formality, he was forced to transform the residue, which could not be wholly erased, into a "background"—perhaps the entire background we can now see in the engraving. In order to absorb the correction, as late-nineteenth-century commentators pointed out, the artist probably had to rework the entire plate so that the blackness around the correction would not leap into view; the correction as it were consumed and in the end virtually constituted the entire engraving in its finished state. By the same token, however, we might imagine that the correction occurred *because of* the merging of the pictorial formality into symbolic form or visuality, the cultural significance in what is seen. When Dürer began to surround the original proportional construction with a background and to build the allegory, in order to *retain* the primal construction he was forced to transform the horse's hoof.

The correction subsists in both domains and it pulls in both directions. It seems to consolidate a visuality: the correction intensifies the

fearless forward progress of the Christian Knight (or indeed *any* knight) required by the emergent narrative symbol. At the same time it displays the work of pictoriality in the artist's efforts to realize an existentially significant image, the perfectly posed horse and rider. (We must remember that these envisionings devolved at different points in the artist's career; they were relayed into the making of the engraving in discrete if converging chains of replication.) Pictoriality and visuality, then, occurred at the same time: they are simultaneously within our sight. *But they do not occur exactly in the same place.* Our visual inspection of the engraving can immediately tell the difference between the two activities. Pictoriality was at least partly retained in the uncorrected subject matter and material substance, however transformed; while visuality was at least partly displayed in the transformation, however corrected.

To be sure, in the history of the making of the engraving Dürer's correction would seem to have moved the original image and its existential secret, embodied in its pictorial formality, toward allegorical world-construction and cultural world-recognition—constructions and recognitions to be recognized and reconstructed by beholders who could not possibly have known the existential basis of the founding depictive formality. The correction seems to effect a translation from a specifically *pictorial* artistic problem to a specifically *visualizing* artistic problem or to visual culture—a translation from what we can actually see to what we should *view*.

To use Panofsky's terms for Dürer's activity, the correction submitted itself "before the tribunal of reason" (*MVA*, 48). In this function it could have provided Panofsky's best evidence (though Panofsky nowhere considered it explicitly) for the real conversion of the self-involved existential meaning of the image into the rational transpersonal symbolism of the picture. When Dürer placed the right hindfoot hoof on Line "E" in his correction, he also visualized "EF," the height of the hoof on the picture plane (see Fig. 8.10). In turn, this measure (one-quarter the height and width of a constructional quadrant or proportional module) is exactly equal to the distance between the forward and the rear planes of the horse in depth. In other words, it is the perspectival measure of the virtual space occupied by the knight's horse in the very same (and spatially pervasive) foreshortening in which the figures of Death and the Devil likewise appear in the picture.

In terms of pictorial construction, "EF," a measure achieved in the correction, calibrates the vertical distance on the picture plane between the horse's two hindfeet hooves; it relates the height off the ground of the right hindfoot hoof and the on-the-ground height of the left hind-

foot hoof. We can see that it equals the vertical distance on the picture plane from the rear hooves of the horse to the dog's left foreleg as well as the vertical distance on the picture plane from the dog's left foreleg to the bottom of the left hindfoot hoof of Death's horse. In other words, it calibrates certain measures and distances (or sizes and scales) not only in the profile-silhouette image of the horse and rider. It also calibrates the overall topography, including the landscape and the other figures or players in the narrative—even if this depictive material was mostly "added" as "background" to the original form. This emergent diagonal of fictive visual depth, and thus of narrative space and the full visuality of the allegory, is identical to the proportional quadrant on the pictorial plane. If we endorse the Panofskyan logic of visuality (that is, its organization in what I have called the iconographic succession and a transreflexive relay of recognitions), Dürer subjected the image-form constituted in his artistic investigations to the very same spatialization recognized in the image-symbol constituted in his cultural tradition. These images were measured out and hence graphically constructed and visually recognized *both* by the spatial construction of the picture *and* by the spatial relations imagined in the world it visualized.

But this correction and calibration, this reconstruction, is not quite the same thing as the wholesale binding and merging of the "visual image" and the "mental image" that Panofsky wanted to discover in the engraving. The problem I have traced in the case of Dürer's supposed Erasmian visual culture continues to appear here too. The conjunctions noted in the previous paragraph might be taken to be a product of Dürer's supposed science; certainly they are fully compatible with the artist's self-conscious theoretical investigations. But were they actually determined—aspectively interdetermined—therein? According to Panofsky, in the historical time and place in which the engraving was made "both plastic relief and full profile view [in Dürer's engraving] had to justify themselves before the tribunal of reason." But in the absence of such a visuality, such a visual culture of "reason," they could equally be seen as purely pictorial creations subsisting exclusively in the disjunction of a correction—habits and choices of the artist that require no culture-historical image-symbolic interpretation on our part.

When Panofsky supposed that the early-sixteenth-century artist intended to justify his formal inventions "before the tribunal of reason," essentially he asserted that the most recalcitrant and involuted recursions in representation tend ineluctably toward consolidating an intelligible world-recognition that coordinates existential significance and effectively supersedes it. What is this tribunal, however, but the art historian's

iconological conclusion transferred to Dürer and his contemporaries; that is, into the supposed historical context of the image? In order to identify the traditional cultural symbolism of the image, the visuality of the picture (including the supposed reason that governed its formality), Panofsky systematically had to overlook what we can actually *see* at the places of the correction, namely, Dürer's picture making as such and its entirely visible resistance to the pure visualization of that very world, that virtual space of narrative and allegory. The visibility of the correction as an historical event on the picture plane does not *disappear* in our vision because a virtual space of narrative and allegory had been constituted in the correction, because a visuality had been constituted in the pictoriality.

As I will put it in Chapters Nine and Ten, the picture might well have succeeded to culturality, whether the culture of classicizing or Italianate proportion (as Wölfflin implied) or the northern culture of Protestant piety (as Panofsky insisted) or possibly both or neither of these affiliations (as my own considerations suggest). But all the same *the succession itself remains visible* as Dürer's historical relation in his engraving to all contemporary visual cultures—visible both as the partial definition and delimitation of the picture within them *and* as its partial disjunction and departure from them. Stated in more general terms, the visible resolutions and irresolutions of pictoriality and the accompanying (if sometimes counterthrusting) registers of formality and stylisticality display the succession of visuality. But these calibrations do not document the full success of visuality, nor do they prove it. Rather they tend to display—to exemplify and to incarnate—the struggle of an emergent visual culture recursively to coordinate the fundamental aspective interdeterminations from which it must be precipitated. In sum, pictoriality and visuality circle around each other.

What Is Visual about Culture? **PART THREE**

Chapter 9

How Visual Culture Becomes Visible

■ I

In setting out a general theory of visual culture, so far I have addressed *what is cultural about vision*—namely, the partial successions of vision to visuality, focusing on artifacts specifically configured to be used *within* such successions; that is, on items of visual culture such as paintings and sculptures. But for general theoretical purposes this focus and these items can be misleading. We must also ask (and it should be asked continually in any study of the aspective successions) *what is visual about culture*— even (indeed especially) what is visual about so-called *visual* culture.

Is a visual culture visible? Is a visible culture visual? What is the relation between the visibility of formality, style, and pictoriality (recursively interdetermined aspects of configuration that might be recognized and coordinated in a visuality) and the culturality of vision—the fact that whether or not this culture is *visible* as such, it must be situated in a historical form of life and it must respond to visible things as encountered in historical forms of life (and this, again, regardless of the specifically *visual* recognizability of these contexts)? If crucial aspects of visual culture are not wholly visible to agents who do not belong to the culture, how does visual culture become visible to them, if it ever does? Does the "visibilizing" of man-made visual artifacts depend entirely on visual functions, on seeing their visual aspects, or even principally or primarily?

Like high formalism in art theory and criticism (Chapter Three), a high visualism in art history and visual-culture studies has tended to answer these questions in a one-sided way: it says *a priori*, for example, that visual culture is visible *tout court* and *prima facie*. (High visualism in visual-culture studies is the analog of high formalism in art criticism, even the direct heir of high formalism.) In this and the next (and final) chapter of this book, however, I will go in a different direction. In this chapter I will show that exclusive or even primary focus on "the visual" and its visibility, the usual method of visualism, cannot be the entire *method* of visual-culture studies even if visuality is its proper object.

It seems reasonable to say, of course, that visual aspectivity is the essential content and context of visual culture—of visible things made by people to be seen *as* visual (to be used visually) or in which visual aspects should be seen. But this attractive presumption, unquestioned in much of art history and visual-culture studies, must be approached with great caution. If visual culture or visuality is often the ground of seeing in ordinary human forms of life (even as this very seeing must succeed to visuality or visual culture), there is no reason to suppose that it must always be *visible*. Indeed, visuality effects the very *constitution of* the visibilities of configuration; this has been the very point—the deepest point—of most histories of visual cultures. Moreover, visuality finds its grounds and parameters in modes of *aisthesis* or sensory awareness and in operations of thought, in comparisons and calibrations, that do not always involve visual functions even if they recursively coordinate vision—the particular recursion that has been my principal topic so far.

As a directly relevant parallel, we might recall that we do not see *images* even though we do see pictures or artworks.[1] Rather, we see pictures or artworks and everything else *with* images, that is, in the "imaging" functions of seeing that extend from retinal proprioception to cortical visual processing and sensuous mnemic representation—functions that are not *visible* to us even though we can be partly aware of them in certain optical and epistemic circumstances. As picture is to image or imaging, so visible configuration is to visuality. In these terms, visuality transpires—it becomes a transreflexive accession in vision—as the imaging that sees visible things to have certain relevant aspects in part in virtue of its own *invisible* determinations.

These grounds and parameters can sometimes be anticipated recursively in visible things that have been made as cultured configurations specifically for this very visuality. And they can be exemplified reciprocally in these artifacts, these items of visual culture in the full totalized sense. But this particular interaction and coordination of visuality and

visibility, this anticipatory succession of visible artifacts of "visual culture" in visuality, is not at all required for many aspects of most things to be fully visible to us. Indeed, the main reason for the partiality of all the aspective successions in the seeing of configuration in artifacts is the fact that a complete intersection and wholesale identification of visuality and visibility is probably not even the norm; empirically, and as we have seen in Chapters Seven and Eight, visible things (including visual configurations that anticipate and solicit visuality) are routinely resistant to full recognizability in visuality. Such intersection and identification has not even been the norm in many historical forms of life, notably the prehistoric forms in which the hominid and human visual system was adapted (see Chapter Five)—for these forms of life largely *lacked* artifacts of visual culture in the sense of configurations produced specifically to anticipate a visuality or a materially consolidated visual culture. A visual artifact does not constitute its visuality as such. At most it can afford horizons of possible visibility for any visuality that happens to attend to it.

Stated another way, a visuality—a way of seeing—can be trained on visible things that sometimes have been made precisely for its very own moment of accession in seeing; that is, for this very visuality. But empirically a visuality (whatever its origins and objects) must look at many things that are not so configured. This disparity must be especially palpable when we find ourselves looking at *new* worlds of natural phenomena or man-made things and practices—unfamiliar visible objects or states of affairs. By the same token, things can be made such that certain immanent visual aspects only become fully visible in a succession in seeing that attends to this very culture in the making of the thing. But empirically it remains the case that much of the artifact can be plainly visible to anyone *without* this seeing; the artifact can be seen perfectly well *outside* any particular visual culture within which its configuration specifically unfolds visually in an accession of the visuality anticipated by the maker. This disparity might become especially palpable when the artifact has been relocated into worlds of human visual use that are removed from the form of life in which its maker had made it to be seen.

In sum, the *visibility* of things and the extent to which they are wholly visible in *visuality* are often poles apart. Empirically they are inherently disjunct. We should not try to downplay this empirical fact, or to avoid it. Indeed, it is the very engine of visuality. Human agents make visual sense of what they can see by relating it not only to its morphological or configurative aspectivity—that is, to what is visible about it. They also relate it to correspondences and comparanda in syntheses that might not be visual.

In the end, then, it would be misleading to place all of our emphasis on the visibility of formality, style, and pictoriality as the ground of visual culture. And it would be especially misleading to reify their visibility as visuality, as if to suppose that visuality is simply a cultural interpretation of what is seen. (Admittedly this reification might be the assumed general theory of much of what has been published as visual-culture studies.) Visuality is *not only* a cultural interpretation of what is seen—what was seen, for example, when an appropriately educated ancient Egyptian observer saw one shape as a hieroglyph and another shape (morphologically identical to the first shape) as a portrait (Fig. 7.2). At a deeper level, visuality is *also* a culture that determines what it is that is seen when the visible attains aspectivity: in this case, when shapes that could be hieroglyphs *and* portraits (and that could be hieroglyphs *or* portraits) are discriminated *regardless of their visible identity*. The remainder of this chapter concerns the grounds of this paravisual interpretation of previsible relations. What is this noetic activity that *visibilizes* certain respects of configuration as what is seen in it or about it—seen by visuality?

■ 2

For the moment, we need only notice that the successions of aspectivity in the constitution of visuality (and any correlated items of visual culture) are not always visual processes entirely. As we have seen in earlier chapters, they involve recognitions of *likeness*. Therefore they are embedded in the networks of analogy, visual or not, that enable human beings to understand their world by concluding that within it X is like Y, or that if A is like Y it can also be likened to X, or that if X is like B then B can be likened to Y and A (though perhaps in different respects), and so on.

In part, as I have assumed in the preceding chapters, these likenesses are matters (sometimes questions) of *morphological resemblance*—of similarity between the shapes, colors, textures, and other sensible aspects of different things (however these aspects are themselves intercollated or interdetermined) and despite visible variations in their orientation, illumination, distance, or scale relative to different observers at different standpoints. Nonetheless, a painting or sculpture, X, and other objects in the real or imagined world, A, B, and C, might not always *look* like one another in any well-defined visible respect or to any specified degree. A Cézanne-esque picture of an apple, X, might not look quite like an apple, A. It might not look quite like a Cézanne, B. And in some situations it might not even be taken to be a picture, C. Alternately X might look like

many things, such as an apple, a Cézanne, and a picture, A, B, and C. Or it could look just like *one* particular thing, such as an apple-picture by Cézanne, Y. Nonetheless one can say that in certain respects X is like A, B, and C, and perhaps especially Y, in the features that (in X) are made visible in formal and stylistic and pictorial aspects of the configuration, whether or not X resembles Y, and A, B, and C, in every morphological detail in each of these registers of aspectivity, or in most, or even in any of them. For how much and in what way does X have to look like A, B, C, or Y in the scenarios just mentioned for X to be "Cézanne-ish"?

The *global* aspectivity of a configuration really lies not so much in each and every morphological resemblance to other things that it might have in this or that respect. It lies in the likenesses accepted within a particular form of life that enable people to do something they want to do with the configuration (and with the artifact that embodies and manifests it) in creating, maintaining, and extending their "steady ways of living [and] regular ways of acting," as Wittgenstein once put it.[2] It is obvious that we can take a picture of an apple by Cézanne to *look* like a picture of an apple by Cézanne. It *is* a picture of an apple by Cézanne. But it is equally true that we can say that a picture of an apple which is *not* by Cézanne looks like it is, that a picture by Cézanne which is not an apple-picture looks like one, that an apple which is not a picture by Cézanne looks like it is, and so on. These possibilities are just as important in visuality and visual culture—and to a general theory of visual culture—as the fact that ordinarily a picture of an apple painted by Cézanne also looks like a picture of an apple by Cézanne (as previous chapters have suggested, we cannot simply take this equation for granted), however refined our analysis of the painting's formality, style, or pictoriality. The crucial paravisual facts about the apple-picture by Cézanne (at least insofar as it has been visibilized in a visuality or functions in a visual culture) are not only or not really that it looks like an apple-picture by Cézanne. It is that it is like such things as pictures of apples (and other things) that are sometimes *not* by Cézanne, that it is like pictures in which apples look like Cézanne painted them, that apples are *not* always like the things that Cézanne pictured them to be, etc. (For is it entirely the "picture-by-Cézanne" or in some degree also the "look-of-the-painted-apples," or both or neither, that we care about in the artifact? Would we even be able to recognize a picture of apples by Cézanne in which they did not have the "Cézanne look"?) There exists a network of resemblances, correspondences, disjunctions, and disparities that enables the apple-picture by Cézanne to look the way it does in this particular visuality, to be visible in this particular visuality as "an apple-picture, yes—but one by Cézanne." For in

this form of life, perhaps a high-formalist aesthetic ideology of modern art (Chapter Three), what we usually do with paintings is to *see* an individual artist's particular way of making depictions of simple, familiar things. We see, as it were, his way of seeing them—not so much to learn, for example, about the material properties of fruit discovered by painters (who could be quite wrong about such botanical matters) or even to see how the fruits might not fully submit themselves visually to Cézanne's pictorial technique (though this revelation could be relevant to advanced criticism of Cézanne's art).[3]

In the previous paragraph, admittedly, I have described the relations of likeness that could emerge between nonidentical things partly in terms of visible morphological resemblance. And indeed our awareness of an analogy between things that might be entirely different from one another in their ordinary contexts of visibility might devolve in part from our perception of morphological resemblance. There has to be something Cézanne-ish about the apple—something we could describe, at least in part, in terms of shape, color, and so on—that causes us to say that it looks like a picture of an apple by Cézanne.

But in part it is our knowledge of analogy that enables us to *see* the salient aspects of morphological resemblance between things. If we are aware that both fruit and mountains can be pictorially characterized in terms of colored planes having roughly the same virtual size and surface area though somewhat different polygonal shapes one to the next (all of them more or less facing the beholder at angles that appear to diverge more than thirty degrees from the perpendicular to the line of sight only about thirty percent of the time), we might find Cézanne-ish features in *this* real pile of fruit right here on the table in front of us as well as *that* real mountain over there across the valley. Indeed, in using the apple-picture-by-Cézanne visually in the way that we do in the form of life described in the previous paragraphs this circularity must be essential. *We understand the analogies in the visible configuration that we recognize just as we apprehend the visible configuration in the analogy that we recognize.* Networks of the analogies of visible morphology succeed in vision cross-wise (or zig-zagging) through the recursions of this circularity. For example, we might not only discover a visual culture that consists in depicting both fruits and mountains as if seen as colored planes facing the beholder in a way defined by angular deviation from the line of sight. Inversely we might also encounter another visuality that consists in seeing somewhat abstract—almost painterly—effects of geometrical optics in the natural conformation of things as different as fruits and mountains.[4]

Chapter 9

In visual culture, the forms of likeness—the morphological identity of configuration and its analogy—are complex and constantly shifting. Despite their variety and mutability, however, they create a kind of certainty in us, even if it should not be conflated with logic or truth. As we have seen in preceding chapters, the transreflexive relays of recognition sometimes ramify in the formal, stylistic, and iconographic successions. Sometimes they disrupt and derail them. But the interdetermination of aspective successions, however intricate or incomplete, confers coherence on a form of life. More exactly, it confers such coherence as a particular form, style, and picture *of* life has. It holds things together. When things mesh with each other as recognizable analogs in some respect, we consolidate a sense of the world (we visibilize a world) that has overall formal, stylistic, and representational coherence, that relays a globalized knowledge of "what things are like" and "how life is." (We might best say that "how life is" follows from "what things are like": ontology recapitulates analogy.) Even if aspective successions have complex histories of resistance and disjunction, they must be experienced by us *as* complete and whole, as constituting a world that we recognize—indeed, as giving *the* world. This world is full and whole even in the fissures and failures of our recognition and in its many aspective disjunctions and disparities. And throughout this history, morphological and analogical likeness thread together. But without the analogical thread the morphological thread could never stitch visible things into the visual world of their visibilized aspects—into our visuality as our seeing of a full visible world.

The cultural successions in visuality, then, are the accessions of analogy in visibilizing configuration—the features that become its visual aspects. At first sight (or on first read) this might seem to be a dense proposition that assumes a baroque ontology and entails a labyrinthine epistemology. It is, but it does not. Empirically the phenomena in question are straightforward even if our explication cannot be anything but somewhat involuted descriptively.

To use an example to which I will return in the following sections, building a building in a certain way might, for its builders, be like buying or selling goods in the marketplace. Perhaps building the building is like buying and selling goods because the builders have created the visual impression that the building is price-conscious and readily marketable. It looks to have "quality" for the "value." We see this in the windows and the trim and the roofing. But we see it not only in the windows, trim, and roofing. And the windows, trim, and roofing are not only seen as marketplace transactions. Indeed, there might be little or nothing of any

particular aspect of buying and selling that is visually reproduced in any particular feature of the building, at least in terms of what art historians ordinarily mean by form, style, and depiction. In what sense does a window *look* price-conscious? ("This house was built on the cheap—look at that shoddy window.") In what sense is marketability a *visual* aspect of the shape or color of door trim or roofing tile? ("It looks like I can sell the house more easily if I don't paint the trim lime-green.")

Nevertheless, we can properly say that the building (or even a particular feature of its construction and configuration) relays the form, style, or image of buying and selling; it has a formality, stylisticality, and pictoriality analogous to things, processes, and practices in the marketplace. If pressed to say what the building "means"—even how it might best be *seen*—the builders can coherently say that it is like buying or selling goods. More exactly, they can say that it is like a certain practice in a certain respect (perhaps visually); that in a second respect it is like a second practice (though this likeness might be nonvisual); that it is like a third practice in a third respect; and so on.

(Of course, we are dealing with a recursion here. If it is the case not only that I use such-and-such a kind of wooden trim in building a house, or this-or-that tint of paint, but also that I trim *and* paint in a way that looks shoddy and cheap, then the analogy might only be recognized by some participants in my form of life: they recognize—they *see*—that I build like I trade and vice versa; that is, with considerations of economy and a quick profit uppermost in mind. But virtually *anyone* can see that the trim and the paint on the house are coming apart in a way that visibly resembles degraded commodities in the market in the same respects: pretty things nonetheless crack and peel. Without this inherently visible basis for the analogy it might simply be an assertion that I have built like a market profiteer, and vice versa. Without the likeness of forms there could be no *visual* culture in this equation. There could be no recognition that the likeness is a visible aspect of building and trading. In all of all this—a recursion and interdetermination of recognitions—the seeming paradox is that the analogical likeness, the form of likeness, eventually trumps the morphological likeness, the likeness of form, that helped to give rise to it. The degraded trim and paint on my building can be seen to be caused by bad weather: anyone can plainly see the sun blistering the paint job and the rain eating into the wood. Even so, these damages should be seen *as* the results of my building like a market profiteer; my market profiteering must be seen in my application of the trim and paint. Otherwise wouldn't I have built a sturdier and more expensive house to ward off the elements?)

The kind of complex statement about aspects of the building that I have just noted might be entirely open-ended. At no point does it have to issue or to conclude in identifying an overarching *master* likeness. Certainly it need not identify one single dominant morphological resemblance. (Indeed, it is unlikely that the builders will say that the building looks like buying and selling in this or that *one* respect; *overall* the building is like buying and selling.) But all the same it might be the builders' salient recognition regarding the appearance, the history, and the significance of their practice—of the building they have built. In fact, it might be the deepest recognition they can make of the building. If it is the very foundation of their most knowledgeable, appropriate, and effective use of the building and response to it (not least in buying and selling it), they cannot really make any *deeper* statement about its significance. For all intents and purposes the network of the likenesses of the building, its identity and relations in analogy, simply *is* its visible significance in this case. (Of course, this significance is not *limited to* the visible aspects of the building; it likely could be extended to such nonvisible features as wiring and plumbing inside the walls, a point that a buyer inspecting the building visually will want to recognize.)

Reverting to the main point made so far: when it comes to analogical relations of an artifact of visual culture, the artifact need have no special morphological configuration or peculiar visual substance. It is the *analogies* of a visible morphological aspect of configuration that tell us whether or not it is completely different from something it looks exactly like, whether or not it is exactly like something from which it looks completely different, or something in between (perhaps both or neither in certain respects, or both *and* neither in different respects). Analogy sorts and specifies all of these visible and visual distinctions as recognizable aspects of resemblance and relatedness. Stated another way, artifactual configuration is seen *as* something or something is seen *in* it—it is visible in visual aspects—not only because of its visible appearance, its "look," but also, and primordially, because of its analogical calibration, its "like."

Paradoxically enough, and for reasons that will become plain, this history is most palpable to us in the peculiar case (broached throughout this book) of absolute perceptual indiscernibility or virtual morphological identity between things that could be taken, on analogical grounds, to be quite *different* from one another—that is, not at all "like" despite their "look." In fact, the resolution of *resistance* of the visible field to relations of likeness (that is, the recursive integration of the visible look in a network of particular likenesses) is our key to the succession of vision to culturality—our key, in other words, to the seeing calibrated in the analo-

gies coordinated in a form of life, or a visuality. Visibility only gives way to visuality when its ontology recapitulates analogy.

■ 3

As I have already mentioned, what might be called the phenomenon of *seeing-like* in vision—*as* visuality—may be empirically straightforward. But a demonstration and illustration unavoidably must be quite technical. Fortunately we can turn to a theoretical resource of immense suggestiveness even though it has rarely been deployed in art history and visual-culture studies. In its own way, it will help us to synthesize several elements of the general theory that I have reviewed so far: the ground of a "culture" or historical form of life; its succession and recursions as a network of analogies; the role of this network in differentially visibilizing the visual aspects of configurations that are practically used or salient in the form of life in question and that constitute (in my terms) its visuality and visual culture, regardless of phenomenological identity, similarity, and disparity among them in the field of visibility; the disjunctions and resistances that must continue to be resolved when newly-emergent visible aspects of configuration need to be recognized in practical affairs; possible changes in (even loss of) the coordination between the visibility of configuration and the correlated visuality that confers a specific visual *aspectivity* on the same configuration. I refer to Wittgenstein's "parable of the builders" (as it has been called, and to which I have already alluded) in the first sections of his *Philosophical Investigations*. Wittgenstein's parable models human culture—culture that often is visible, at least in part, and that is partly mediated visually. And it dramatizes analytic devices for understanding it.

In the remainder of this chapter, I will build on Wittgenstein's parable (really, a nested series of parables) in order to refine and, I hope, to resolve, at least in part, the questions that I have raised so far. My aim is not to be faithful to Wittgenstein's model in every respect or to attempt to explain all of its peculiarities and obscurities. Rather, I will use Wittgenstein's parable for my own purposes at this stage in the exposition of a general theory of visual culture. I will, in fact, identify assumptions in the parable and elaborate certain implications that Wittgenstein ignored because they did not bear directly on the demonstration he intended. My somewhat different intention is to clarify the way in which visual culture becomes visible in visuality (the phenomenon we must explicate if we are not to fall into mere tautology and vacuity)—the way, and to repeat, that

we come to see a visual configuration as having specific aspectivity that is practically salient in a historical form of life despite the fact (indeed in a well-defined way *because* of the fact) that the configuration always remains visible in other ways as well.

This was not, of course, Wittgenstein's stated topic. As the very first section of the *Investigations* made clear, he wanted to address puzzles in the philosophy of language and specifically the question of the origins and grounds of language in its social relations of use. Still, for my purposes it is not irrelevant that Wittgenstein's parable of the builders concerns the relations between a notional language, certain human activities in building a building, and what the builders can say and see about what they are doing. Indeed, whether stated by Wittgenstein or not, the parable inherently concerns the visibility and visual recognizability of the building and what we can define as the visuality and the visual culture of the builders in building it. And it is not irrelevant that Wittgenstein presented the parable at the beginning of a treatise that turned later to the phenomenology of aspect-perception and the process of seeing-as, although he did not make a direct theoretical link between his anthropology of language and his psychology of visual perception. Given all this, it will be necessary to follow Wittgenstein's parable in close detail, explicating some of its terms and turns, in order to extract what it has to offer to the general theory proposed in this book.

■ 4

In Section 19 of the *Philosophical Investigations*, Wittgenstein wrote that "to imagine a language is to imagine a form of life," a *Lebensform*. This cryptic statement occurred in the context of a consideration of the basis and development of a "complete primitive language" or symbol system.[5] If Wittgenstein had particular historical examples in mind, he might have recalled the avant-garde styles of Viennese artists he had known in the 1920s and 1930s, such as the sculpture of his art teacher Michael Drobil or his sister Margarethe's favored artist, Anton Hanak, or he might have referenced the modernist architectural revolution to which he himself contributed in the 1920s in collaboration with his close friend, the architect Paul Engelmann. He certainly responded to scholarship on the origins of language and the comparative anthropology of ritual, notably the many volumes of Sir James George Frazer's *The Golden Bough*.[6]

By the term *complete primitive language*, Wittgenstein did not mean a *crude* language—a language primitive in the sense of being undevel-

oped, incomplete, or inadequate to its situations and tasks. Instead he wanted to denote the core system of linguistic communication (and the nonlinguistic activity coordinated with it) that enables a human interest such as trading goods, building shelters, or painting pictures to be fulfilled socially. This communication system is *complete* in the sense that evidently it is necessary and certainly it is sufficient for people's purposes in conducting the activity; it can be described as the minimum language needed to realize people's interests and purposes in their activities and tasks. It is *primitive* in two senses. First, there are no forms of communication that are more elementary but equally or identically sufficient for conducting the very same activity. (There might be more elementary forms of communication sufficient for carrying out *other* activities, and they might provide building blocks for the complete primitive language that has been coordinated with any given activity.) Second, the complete language is a self-contained system in a wider field that involves many other activities and the complete primitive languages coordinated with them. Each of these complete languages might be regarded as the primitives (or building blocks) of more general languages of the society as a whole.

In developing the notion of a complete primitive language, Wittgenstein wanted to criticize a view of language that he took to be the ordinary one. According to Wittgenstein, Augustine of Hippo (like many other writers) believed not only that every word, W, "has a meaning" correlated with it, but also that the meaning "is the object for which the word stands" (*PI*, 2e). According to Augustine's recollection of his childhood education, when one of his elders named some thing, an object such as a table or chair, "and accordingly moved toward something," the child saw the action and "grasped that the thing was called by the sound [the elders] uttered when they meant to point it out." As Wittgenstein noted, however, this kind of ostensive definition or pointing could not provide a child with full and flexible access to the language used in the social group of his elders, real mastery and fluency, until it enabled him to grasp that the same sound (or, we can add, the same visual configuration or motif) might have "completely different functions" (*PI*, 4e). In turn, to understand that W is A here and B there, or C then and D now, or E for you and F for me would seem to require the child to learn to navigate the many situations or activities in which these functions of W would become manifest. Likely enough, the child would discover no single activity (with the possible exception of the odd activity of making and consulting a dictionary of his language or an iconographical and iconological handbook of its pictorial motifs and styles) devoted to pointing out all

the different correlations that W might possess in all different situations. Instead he would encounter salient variations in practice. And he would modulate his uses of W accordingly.

Wittgenstein extracted far-reaching implications from these elementary and familiar considerations. In particular, he developed a subtle parable of a complete primitive language, a system of calls, gestures, and other signs (in theory they could include the use of configurations meant to be seen and to be used visually in the complete primitive language) that are "meant to serve for communication between a builder A and an assistant B." As Wittgenstein described the language of these builders in Section 2 of the *Investigations*:

> [Builder] A is building with building-stones: there are blocks, pillars, slabs and beams. [Builder's Assistant] B has to pass the stones, and that in the order in which A needs them. For this purpose they use a language consisting of the words "block," "pillar," "slab," "beam." A calls them out; B brings the stone which he has learnt to bring at such-and-such a call (*PI*, 3e).

Wittgenstein noted that "we could imagine that [this] language was the *whole* language of A and B; even the whole language of a tribe" (*PI*, 4e). The tribe might be a social group in which the *only* activity of its members as a group is the building of the buildings for which the complete primitive language imagined in Section 2 of the *Investigations* would be necessary and sufficient. If Builder A and Builder B never needed to interact with each other in any other context, they would never need to engage in any other kind of communication. Indeed, they might well belong to different "peoples" or *Volk* in the ethnological sense, and we might not be inclined to say that these different peoples possess a shared culture, a network of interlocked complete primitive languages that includes the language of the builders A and B. In these circumstances, and to speak in the strict terms that Wittgenstein always preferred in his considerations of these matters, the builders' language as the necessary and sufficient language of these two builders working together would be their whole language—the complete primitive language of a tribe consisting of Builder A and Builder B, a context-specific language operating between them regardless of their other interactions and affiliations.[7]

Whether or not it is the "whole language" between A and B or of a tribe, the members of a group must learn the group's complete primitive language or languages for the activities they wish to carry out. As Wittgenstein put it, "children are brought up to perform *these* actions, to use *these* words as they do so, and to react in *this* way to the words of oth-

ers" (*PI*, 4e). For this reason the complete primitive language is internal to the particular activity or activities within which it is learned and *for* which it is learned. (Of course, we might find that it can be carried into other activities as well, or that other activities might emerge as its effects, though there might be ambiguities and resistances to resolve here.) The language-user learns the "meanings" of the words, that is, which words stand for which objects, in conducting an activity: carrying out a task of building or trading or painting as the case might be.

To use the famous metaphor advanced by Wittgenstein, the language-user learns to "play the game" of building, trading, or painting. According to Wittgenstein, "the whole, consisting of language *and* the actions into which it is woven, [is] the 'language-game' [*Sprachspiel*]" (*PI*, 5e). In the case of building, the assistant builder B learns that for A, the master builder, such-and-such a call from A requires him specifically to bring a block as opposed to the pillar, slab, or beam that might be required from him if their language-game (and their complete primitive language) had been differently organized (and even if they were building the same building). In the case of painting, an apprentice painter learns that such-and-such a call from the master painter requires him to prepare a red pigment (as opposed, say, to a black one) or to procure a fine brush (as opposed to a coarse one) or to prime a particular area of ground (as opposed to leaving it untreated). The language-game of the painters consists in designations for the raw materials of red and black pigments, fine and coarse brushes, and untreated and treated parts of ground, as well as for the actions required on the part of the two participants (or "players") to order them in a specific way to make particular (kinds of) paintings—paintings, for example, that call for using the coarse brush before the fine or for using red pigment on treated ground and black on untreated.

As in the case of the special notion of the "whole language of a tribe," Wittgenstein's *Lebensform* and *Sprachspiel* are not quite equivalents of a more familiar concept of culture that arose in British and French social studies at the end of the nineteenth century. E. B. Tylor and other writers had conceived the "culture" of a human community to be the sociopsychic equivalent of the breeding isolates of bacterial populations; that is, as analogs to "culture" in Louis Pasteur's sense of the word.[8] According to this cultural anthropology (it might equally be called a bacteriology or epidemiology of human ideation), a culture is a colony of interbred or shared meaning, what Tylor tended to call "custom." Because this community supposedly has relatively impermeable social boundaries in part defined and reproduced by its cultural formation, the recognizability and intelligibility of its signs and symbols—its customs of making

sense—cannot be transferred readily to communities beyond its boundaries (though perhaps they can sometimes be *translated* into the signs and symbols of other cultures). Admittedly, many turn-of-the-century anthropologists and psychologists did not accept this restriction; comparativists like Frazer, Aby Warburg, and Carl Jung were specifically interested in the *trans*cultural transmission and intelligibility of certain symbols and images and by implication in their human universality or archetypicality. But most of these nonculturalist anthropologies were swept away by culturology. As mid-twentieth-century cultural anthropologists frequently asserted, culture has a high degree of contextual or temporal-spatial specificity, which is defined by language, custom, law, and belief, and in turn typically will be correlated with such gross sociological attributes as common ethnicity and shared habitat.[9]

Wittgenstein's examples remind us, however, that we could find the same cultural practice among peoples who do not share a form of life. (In due course we will see why this matters in a general theory of visual culture; for the moment, I focus on Wittgenstein's terms.) The same institution of musical performance, the same architectural style, or the same type of pictorial naturalism might be found among different groups of people, each of which has a distinct way of living. By the same token, we might find that people who have a single, consistent form of life can adopt many different cultural practices. Both classical and avant-garde practices in music, architecture, and painting coexisted, for example, in Wittgenstein's Vienna among people (including Wittgenstein's family) who broadly affiliated themselves with one and the same Austro-Hungarian heritage. Although Wittgenstein once contrasted his own "proletarian" way of living with the "luxuriant" lifestyle of his sister Margarethe, and certainly their aesthetic tastes and cultural interests diverged, it is likely that brother and sister regarded themselves as sharing a form of life. At any rate it seems that they played certain language-games within it that perhaps only they could understand. One of these activities, in fact, was the building of a house for Margarethe; Wittgenstein designed the building with his friend Engelmann, who noted that the building "fit her like a glove," that it "radiated" her person.[10] By the same token, the possibility that they could play certain language-games that only the two of them could understand would suggest that they shared a form of life, and at least one complete primitive language correlated with it, regardless of their diverging aesthetic and cultural involvements.

A human form of life might best be described as a network of language-games, perhaps an immense one (though it is logically possible to conceive a form of life that involves only *one* language-game). According to

Wittgenstein in a posthumously published essay, a form of life "consists of steady ways of living, regular ways of acting."[11] It is the ways in which things have been done or are to be done, the ways in which things have been and in practice do get worked out, in a fashion that is "beyond being justified or unjustified," "as it were something animal"[12]; "what has to be accepted, the given, is—so one could say—*forms of life*" (*PI*, 226).[13] The intelligibility of statements and the mutual intelligibility of the people who make them is internal to the form of life. For this reason, then, "to imagine a language" such as the complete primitive language of the builders "is to imagine a form of life," namely, the world in which the builders can build a building in their own particular way.

■ 5

We can now begin to adapt Wittgenstein's concerns to the questions of visibility and visuality broached earlier in this chapter and in this book.

The builders could make *many* buildings in the particular way that Builder A requires. Some of these buildings might look just like one another, possibly because (though not *always* because) the builders can place exactly the same elements in exactly the same spots in the structures. (Here they might be playing the same language-game in the same way every time, that is, with identical outcomes—as if there were only one way the game could unfold when played.) But as in the case of the word W with its functions A, B, C, D, E, and F, even the look-alike buildings need not "mean" the same thing.

In a group of buildings A, B, C, D, E, and F, suppose that C is taken to be like B, D, and E in certain respects (perhaps including the value of the materials), and suppose that it *looks* like A and F. (For added complexity we can suppose that B, C, D, and E do *not* look alike; their crucial respect or respects of likeness are not visual, even if the analogy that binds

them is visible.[14]) At the same time, suppose that A and F, which look like one another and like C, are not taken to be like B, D, and E in the respects that C is—or perhaps in *any* respects—with the exception of their looks in one case (namely, in their likeness to C). In building A and F, the builders (we might think) have perhaps not played quite the same language-game as they played in building C; at any rate, Buildings A and F must have respects of likeness different from the likeness of Building C with Buildings B, D, and E. If we recognize these different aspects in A, C, and F respectively, we will see that either Building C (like Buildings B, D, and E) plays a different game than Buildings A and F or that it plays the same game as they do with different results (insofar as it is like B, D, and E while A and F are not); if we recognize that Buildings A and F play a different game than Building C or play the same game with different results, we will see how C differs in some respects from A and F, despite its apparent likeness. Of course, there must be considerable tautology (as well as unreliability and unpredicability) in these discernments and discriminations. In principle, some of these relations are organized in terms of strictly logical implications. There is no reason to suppose, however, that everyone will always seize and apply them or that there will never be reason to subvert them. And other relations depend on inferring from unknown variables, on assuming the consequent, or on making guesses about what can be seen and what might be invisible, at least on the first pass. But that is just the point here. No amount of merely morphological (ir)resemblance between outcomes, however great, proves that a particular game is (or is not) being played in all cases or that it unfolds materially in the same way every time. This is true even though a particular game, when played appropriately regardless of the number, variety, and contexts of its iterations and their morphological similarity or difference one to the next, always observes *certain* respects of likeness in every one of its functional replications in practical and social life.

To sort this out, however, we need to identify the logically possible kinds of causal context for morphological indiscernibility between the outcomes—for their *apparent* absolute look-alikeness regardless of the aspects (the respects of likeness) that actually determine the intelligibility and functionality of each outcome. Despite the fact that this analytic exercise depends on the unusual and unrealistic case of indiscernibility, it will take us to the heart of the matter.

First, morphological indiscernibility can derive from the fact that the players have played the same language-game in a series of iterations. Second, it can be created by playing different language-games in the same form of life. And third, it can be created by playing the same or different

language-games in *different* forms of life. These situations involve distinct histories. While the first situation seems to be quite ordinary, the third situation would appear to be rather extraordinary. If a form of life is different from ours, how is it that a language-game played in it *looks* indiscernible from one of our games or an iteration of it? But in fact the third situation might be quite common, though occluded by culturological tendencies to find shared culture in (or behind) morphological similars. And the *first* situation might be rare in its pure form, though highlighted by the same culturology and its tendency to find morphological similars in (or behind) shared culture. Even though we play the same language-games over and over again in our form of life, how is it that any playing is indiscernible from any other? Overall, it is not surprising that at any given point or in any given context it might be difficult to see what kind of successions and recursions might actually obtain. Are we playing the same or very different language-games in the same or very different forms of life when the practices or the products of the language-games appear to us to be indiscernible from one another?

In a general theory of culture, as distinct from the special case of *visual* culture, it is clearly a matter of consequence whether people are playing the same or different language-games in the same or in different forms of life. If people play the *same* game in the *same* form of life, they probably share a culture in the full Tylorian sense of the word—a set of customs and beliefs about the point and value of what they are doing. This does not, of course, explain *why* they play the same game; it simply (re)describes the fact that they do play it.[15] Mutual intelligibility has been secured, and henceforth it can be assumed among them at least within the purview of the language-game and its recognized cognates and analogs. The territory in question might be wide and deep because the respects of likeness that organize the language-game and its cognates and analogs might ramify widely and deeply in social life. By the same token, when people are playing different language-games in very different forms of life, regardless of the similarity or indiscernibility of the practices that are involved or the products that are generated, we might suspect that communication between them would be quite difficult—perhaps most slippery, paradoxically, when they seem to be doing things alike.

Consider an instance of the complete primitive language-games imagined in the opening sections of the *Investigations*. Here it is worth actually trying to build the buildings imagined by Wittgenstein, even though we must go beyond some of his specifications in order to do so. In Section 2, Builder A, as we have already seen, calls for slabs, columns, beams, and blocks "in the order in which he needs them." The assistant,

Builder B, produces the elements from the stock, brings them to the site, and helps A to erect them.

Let us imagine a quarry or stockyard of building elements (Fig. 9.1), and that Builder A calls for slabs, beams, blocks, and columns from this source in the following sequence of seven requests directed to Builder B, in turn allowing Builder A and Builder B to erect the elements into a seven-tiered structure:

"Slab," "Slab" [Level I] (Fig. 9.2)
"Beam" [Level II] (Fig. 9.3)
"Block," "Block" [Level III] (Fig. 9.4)
"Beam" [Level IV] (Fig. 9.5)
"Column," "Column" [Level V] (Fig. 9.6)
"Beam" [Level VI] (Fig. 9.7)
"Block," "Block," "Block," "Block" [Level VII] (Fig. 9.8)

It so happens (as I have specified the case) that the elements have different colors, namely, black, white, or red. In this language-game, however, the builders are indifferent to this fact. Builder A needs a slab (in Level I of the building) or a beam (in Levels II, IV, and VI of the building), not a *white* slab or a *black* beam. Where Builder B brings a white slab, he could have brought a black one, and so on; A and B could play the language-game and build the intended building, if elements identically placed in the array had colors different from the ones they do, in fact, happen to have here (that is, black rather than white or red, red rather than white or black, and white rather than black or red). But we can readily see the first kind of causal context for morphologically indiscernible artifacts: it is *also* true that whenever A and B play this particular language-game, morphologically indiscernible buildings *can* result if A and B repeat their way—just this way—of calling for and bringing slabs, beams, and so on, and putting them together in Levels I through VII. And indiscernible buildings would *always* result if we tightened up the parameters of the game (we could add specifications for the color of the elements) or placed constraints on the environment and the task to be undertaken. If all the blocks were white, for example, then all the buildings built in the sequence and array noted above would look exactly the same.

Many morphological indiscernibles in human lifeworlds must be produced in this kind of causal context: if people play the same language-game, they can tend repetitively to get the same or closely similar results. This need not be animated by a technology of reproduction, and people

need not intend to produce duplicates. There need only be constancy in the game. Over time, the world of these people will tend to have a visible self-likeness, a style. And this will feed recursively into further replications of the practices in question: people can accommodate or conform practice to its usual look.

In *The Shape of Time*, his reflections on taxonomy and sequence in artifacts (what he called "man-made things"), George Kubler supposed that a so-called prime object and a chain of succeeding replicas might have a fair degree of internal variability (even a high degree) because the game at any given point might not appreciably limit the players' options, their repertory of possible moves, even if it did direct and refine them. Kubler's "rule of series" modeled the "history of things," as he called it, as something like a game of bridge or chess, in which it is notionally conceivable to play exactly the same game twice but virtually impossible to do so in practice. Conversely, it is notionally conceivable but virtually impossible for anyone but masters of the game routinely to break away from a path— a trend in the game—that has begun to be laid down. In particular it is difficult for most players, even accomplished ones, to overcome a structurally unfavorable position (relative to the array of real options available to the other players) generated along that path. According to the rule of

Figure 9.1.
The "Quarry" of building elements (Slabs, Columns, Beams, and Blocks). Red is indicated by stippling and green by hatching. Illustrations for Figs. 9.1– 9.35 are by Jennifer Mahoney, based on photographs by Michael Schreyach of a conceptual experiment conducted by the author in cooperation with Sherrie Levine, Getty Research Institute, 1999.

series, then, as the game of making things goes on (Kubler considered series of artifacts generated, for example, in the game of "landscape painting"), it will become more difficult to produce plays in entirely new directions, or to defeat an opponent or outdo a rival who holds a stronger or better position, especially an *earlier* position. What has already been done imposes strong constraints on later moves, and as the game goes on the actions taken or the things made will tend to look more and more like what has already been done. In Kublerian terms, playing the same game will result *over time* in increasingly similar or familiar iterations—as it were, the "shape" of time in the history of man-made things. (It is worth remarking that Kubler's book was essentially a contribution to the theory of style, not a meditation on the philosophy of mind or language. But as a theory of style it is pertinent for my purposes here.)

Kubler's suggestive model might be true and useful so far as it goes. But a language-game in Wittgenstein's sense does not in general appear to be much like a game of chess or bridge, even though a game of chess or bridge is a highly specialized language-game. In a language-game there is not so much a Kublerian "rule of series" in the history of things (a narrowing of the options of replication, and consequently a dwindling of primal originality as the playing of a game goes on) as there is a "rule of

Figure 9.2.
"Slab," "Slab" (Level I).

Figure 9.3.
"Beam" (Level II).

likeness." In order for the game to be played again it must replicate the respects of likeness that organized the playing of the game in the first iteration or that define the playing of the game throughout all iterations. Morphological indiscernibility can result from—it can be an emergent property of—any two such iterations, regardless of when they were played or how close they might be (or far apart) in a series organized by a "rule of series." (Indeed, if a taxonomy places them close together specifically on the basis of morphological similarity—a technique employed in many seriations in archaeology—it could occlude the fact that they are far apart in the series; indiscernibility can be generated in widely spaced iterations. Of course, these indiscernibles need not be synonymous; they just *look* the same.)[16]

In other words, language-games in Wittgenstein's sense are not only *games*. Although they might not always be much like natural human speech, they are *languages* or sign systems, real human systems of referring to things and communicating about them. It was part of Wittgenstein's basic point that a word or other sign, W, can have "many different functions." Section 2 of the *Investigations* asserted, however, that W must have a *specific* function in this or that language-game, or no sense can be made of using it in the situation. Whether or not it was Wittgenstein's

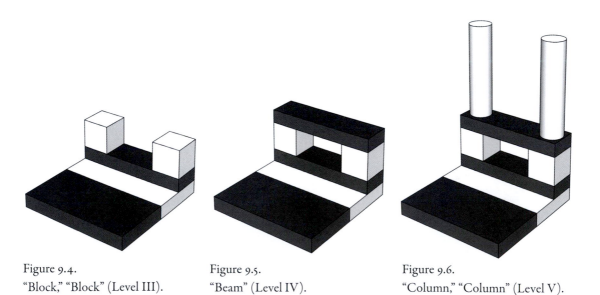

Figure 9.4.
"Block," "Block" (Level III).

Figure 9.5.
"Beam" (Level IV).

Figure 9.6.
"Column," "Column" (Level V).

Chapter 9

own view, the human lifeworld seems to contain many language-games like the simple and tightly constrained instance imagined in Section 2 (that is, the language of the builders that I have described so far). A simple traffic-regulation system would be an example. It consists in a red light for "stop" and a green light for "go," along with simple specifications for driving on a given side of the road at certain speed limits and other parameters. These rules of the road are social conventions, practical accommodations enabling the participants to accomplish routine tasks with high degrees of predictability and similarity in every replication of the activities involved. If the rules of the road are to function at all, a red light or stop sign must always require a driver to stop; a driver must always stop at a red light or stop sign if he is observing the rules of the road; that is, if he is playing the language-game of functional driving. Moreover, the red light or stop sign, in order to be effective under these conditions, must always look like itself (that is, a token of the type Red Light or Stop Sign) wherever it is encountered, lest it fail to be seen as a red light or stop sign in the first place.

Consider, however, one of Andy Warhol's *Brillo Boxes*, made in the early 1960s: a silk-screened wooden box that in some respects closely resembles a cardboard warehouse carton containing packages of Brillo-

Figure 9.7.
"Beam" (Level VI).

Figure 9.8.
"Block," "Block," "Block,"
"Block" (Level VII).

brand scouring pads (see Chapter 6).[17] Or consider Warhol's *Campbell's Soup Can* (1962): it actually *is* a Campbell's soup can. It has been suspected that in showing these artifacts in art galleries Warhol was not playing the game played by the original designers and the usual buyers of supermarket Brillo boxes and Campbell's soup cans. He was playing some *other* game. It is not strictly relevant here (though it has been relevant to art critics and collectors) whether this was a game that could be called "art." Warhol might not have been playing that game either. The *name* of his game is not especially important. (Perhaps Warhol specifically tried to play a game in which the ramifications of likeness did not allow anyone to venture a straightforward classification in any particular already-named direction thereof.) Whatever his game might have been, and in an involution exploited by Warhol, notionally it could produce an artifact that was morphologically indiscernible from (even materially identical with) objects produced in games where the intent was to make identical replicas—games in which all instances of a branded commodity must visibly belong to the same brand and in which all goods sold at the same price *as* the same thing must *be* the same thing.[18] Therefore we need to look at situations in which *different* language-games (such as the supermarket's language-game on the one side and Warhol's language-game on the other side) can produce highly similar, even indiscernible or identical, objects, regardless of whether each game individually does so when it is played.

In Section 8 of the *Investigations*, Wittgenstein imagined what he called an "expansion" of the language-game of the builders described in Section 2. (Still further refinements were proposed in Sections 20 and 21, but I will not need to pursue those complexities.) This second complete primitive language embeds the same four words and the same correlations with the same building elements as the first language: "slab" produces a slab, "beam" produces a beam, and so on. But the second language-game adds both color terms with correlated color samples and demonstrative pronouns with correlated gestures of pointing, as well as other features. (For the sake of economy in what follows, I set aside all of these additional parameters of the language-game except for the color-selection feature.) As Wittgenstein describes it, in this game:

> Builder A gives an order like: "d—slab—there." At the same time he shows the assistant a [d-colored] sample, and when he says "there" he points to a place on the building site. From the stock of slabs, Builder B takes one . . . of the same color as the sample, and brings it to the place indicated by A. On other occasions A gives the order "this—there." At "this" he points to a building stone. And so on.[19]

Let us perform a version of this game. As before, Builder B selects the elements and brings them to the site "just in the order in which A needs them." But here Builder A specifies what color some of the elements must be:

"Slab" [Level I] (Fig. 9.9)
"*Black* Slab" [Level I] (Fig. 9.10)
"*Black* Beam" [Level II] (Fig. 9.11)
"Block," "Block" [Level III] (Fig. 9.12)
"*Black* Beam" [Level IV] (Fig. 9.13)
"Column," "Column" [Level V] (Fig. 9.14)
"Beam" [Level VI] (Fig. 9.15)
"Block," "Block," "Block," "Block" [Level VII, Version 1] (Fig. 9.16)

The resulting building (Fig. 9.16), it is plain to see, has a striking color scheme. Seen from the front, black levels alternate with white levels from bottom to top. Depending on how the parameters of the language-game have been set, this specification might be a loose constraint or an extremely tight one. In the sequence reviewed, let us suppose that whenever

Figure 9.9.
"Slab" (Level I).

Figure 9.10.
"*Black* Slab" (Level I).

Figure 9.11.
"*Black* Beam" (Level II).

A calls for a "black" element, B brings a black one. But whenever A does not specify black, B brings an element colored *anything but* black (let us say that they could be white, red, or green). It so happens that in the sequence reviewed he brought white and red elements, though he need not have done so. Doing so or not doing so is not part of the language-game he is playing with Builder A. In this loosely constrained (though expanded) language-game, the building could have turned out differently. At the end of the construction sequence, for example, B could have brought some green rather than all red blocks to the site, whether or not he had particular reasons in mind in so doing; A's requests were indifferent to the color of the four blocks placed in the building at the end of the construction sequence (i.e., in Level VII). Thus:

"Block," "Block" [1 red top, 1 red bottom] [Level VII, Version 2, first stage] (Fig. 9.17)

"Block," "Block" [1 green top, 1 green bottom] [Level VII, Version 2, second stage] (Fig. 9.18)

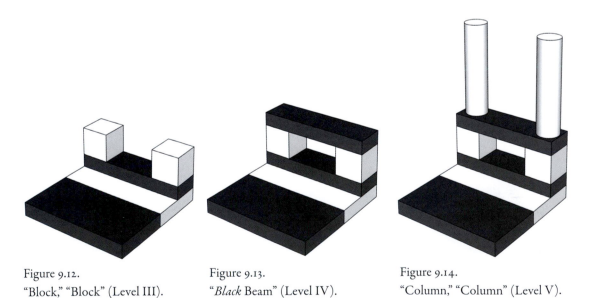

Figure 9.12.
"Block," "Block" (Level III).

Figure 9.13.
"*Black* Beam" (Level IV).

Figure 9.14.
"Column," "Column" (Level V).

But in the actual sequence of construction, let us say, all four blocks that Builder B brought at the end of the construction sequence happened to be red:

"Block," "Block," "Block," "Block" [all 4 red] [Level VII, Version 1] (Fig. 9.16)

The other elements all happened to be white except when A called for them to be black. And so, this color-schemed building turns out to be indiscernible from the first building (Fig. 9.8)—*a building that had no color scheme at all*.

We could tighten the parameters of the expanded language-game such that there would be no leeway for coincidence. If Builder A requested not only black but also white and red elements in a particular way that he (or the game) could specify, the second building (Fig. 9.16) would not just *happen* to be indiscernible from the first building (Fig. 9.8). It could not be *anything but indiscernible*. In this case, we might be tempted to suppose that in the expanded language-game the build-

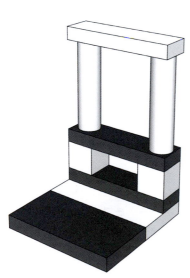

Figure 9.15.
"Beam" (Level VI).

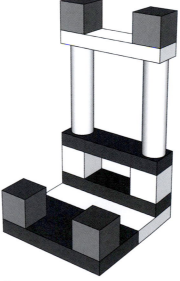

Figure 9.16.
"Block," "Block," "Block," "Block"
(Level VII, Version 1).

ers deliberately built a building that looked exactly like the building in the first language-game in order to refer to it, to take account of it, or otherwise to duplicate it. But in fact they did not do so. In the expanded language-game they simply built a building with a certain color scheme. Prescribed with greater or lesser specificity depending on how the parameters of the game are set, this color scheme was presumably intended by the builders within greater or lesser tolerances of variation permitted by the game as set. (Fig. 9.16 is visibly different from Fig. 9.18, yet both count as buildings generated in the expanded language-game, because the game as defined did not prescribe any particular color *but* black, and black was only prescribed for *some* elements.) Or at least the color scheme emerged for the builders in the buildings in their recursive recognition of its visibility. Builder B did not quite intend Fig. 9.18 to *look* different from Fig. 9.16 or to make buildings with red blocks only in Level VII (as he did in Version 1, Fig. 9.16, and perhaps Fig. 9.17) or with some green blocks as well (as he could have in Version 2, Fig. 9.18), but only to avoid bringing black elements whenever A did not specifically call for them. In doing

Figure 9.17.
"Block," "Block" (1 red top, 1 red bottom) (Level VII, Version 2, first stage).

Figure 9.18.
"Block," "Block" (1 green top, 1 green bottom) (Level VII, Version 2, second stage).

this, he helped make a building with alternating black and white levels—a color scheme realizing A's intention, and the game's prescription, that every other level of the building be black, at least in the lower part of the structure. At this stage in the argument, the most important point is simply that *any* color scheme—governed by the criterion introduced when Builder A calls for some specifically black elements—would distinguish buildings created in the expanded language-game from buildings created in the first language-game, where color is not a criterion of any building, part of its visuality, even if it is plainly visible.

Here we have encountered the second causal context for morphological indiscernibility between man-made artifacts. It is logically possible, and materially and perceptually routine, for discriminable language-games to produce indiscernible results, or indiscernible results in certain visible respects of morphology. The first pair of builders built a building without a color scheme (prescribed, intended, or emergent), and the second pair of builders built a building with one. In part the second building is like the first building for obvious reasons: it uses the same building elements erected in the same order. Indeed, it looks just like the first building. In no sense, however, does it reproduce it. In fact, the second building does not even represent or refer to the first building. Some commentators would profess to be puzzled by this finding. Why would Warhol, for example, make his *Brillo Box* if he did not intend to replicate and represent a Brillo box? But it is not a mystery. Setting aside the question of Warhol's replicatory intentions (Chapter Six), the indiscernibility generated in the expanded second language-game relative to the first (that is, the identity of Fig. 9.8 and Fig. 9.16 as visible things) was certainly a coincidence (for Fig. 9.18 could have been made instead). But most likely it was not simply an accident.

In going from the first to the second, expanded language-game, the builders maintained their "regular ways of acting." Moreover, the environment of resources, tasks, and habits within which they operated remained stable. It need be no surprise, then, that in many arenas of the project of building they must have done many things in constant ways. In other words, the builders had not changed their habits and routines in their form of life, except in the fact (for whatever it turns out to be worth) that the building produced in the second and expanded language-game differed in one major respect of likeness from the building produced in the first language-game, even though the very same kinds of materials were built into exactly the same positions in each case.

If "to imagine a language is to imagine a form of life," as Wittgenstein proposed, the builders of Section 2 and the builders of Section 8 (they

might well be the very same people) differed in their form of life *only in this one respect*. Thus the question arises whether this difference might be enough to imagine different forms of life. We have supposed that the two language-games belong to the same overall form of life: this constant background accounts for the convergence of indiscernible objects despite their generation in discriminable language-games. Should we conclude, instead, that the color-coding of the second building occurs in another world, an altogether different form of life—indeed, that the color-coding suffices to *make* a visual world, a visuality, that is distinct from the first, regardless of what is visible? What might decide the question?

■ 6

We have now come to the heart of the matter. Let us look again at the second language-game. In it, Builder A requires specifically black elements at certain stages in the sequence of construction. Responding to A's requests, Builder B selects them from the stock along with the other elements requested by A. As described in Section 8 of the *Investigations*, this language-game is complete and primitive for its own purposes. Relative to the language-game described in Section 2, however, it can properly be characterized as expanded because it embeds *three* primitive language-games. Each of these primitives can in turn be described as complete relative to its own embedded task.

First, the expanded language-game (like the first language-game) contains the four calls by which Builder A requests slabs, beams, pillars, and blocks. Second, it contains pointing gestures that A uses to indicate which things go where. (For the sake of economy I have ignored this feature here.) Third, it contains a symbol-using procedure for selecting the color of items. According to Wittgenstein's scenario, Builder A shows Builder B a color sample; "from the stock of slabs, B takes one . . . of the same color as the sample, and brings it to the place indicated by A." In the previous section I assumed this feature of the language-game and simply noticed its results in the completed building. I did not specifically characterize its likenesses. But in his specification of the imaginary scenario, Wittgenstein compared it to the action of a shopkeeper who correlates color-samples displayed on a buyer's chart with similarly-colored objects in the stock of his store. When Builder A and B select black elements at particular stages of the building and for certain levels of the structure, they proceed like the buyer and seller picking out colored things in the shop. The same kind of language-game is played at the shop *and* at the

site. At the site, it is embedded in a distinct super-language-game, as we might call the expanded language-game described in Section 8. Despite its likeness to a certain form of shopkeeping, the super-language-game is unique to the building site: it constitutes the builders' way of building in a way which in one respect (and maybe only in one respect) is like keeping shop.

Now let us imagine the embedded color-selection language-game being played in two situations, a quarry producing dressed stones of various kinds and a market selling different kinds of fruit (Fig. 9.19). (Again I must slightly modify Wittgenstein's scenario to make the salient point.) At the building site, Builder A obtains black elements at certain stages of construction by showing color samples to Builder B. And in the shop, the buyer (suppose it is Builder A himself) chooses red-colored foods for a meal he intends to prepare by showing color samples to the shopkeeper, who fetches matched items. We will run the two series of calls and responses, at the site and at the shop, in parallel with one another; and

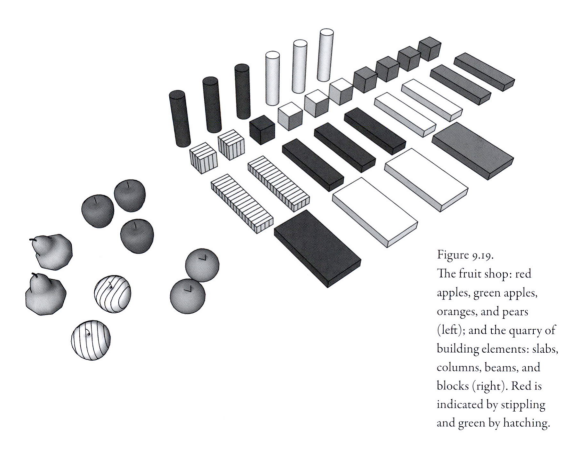

Figure 9.19.
The fruit shop: red apples, green apples, oranges, and pears (left); and the quarry of building elements: slabs, columns, beams, and blocks (right). Red is indicated by stippling and green by hatching.

in our illustrations (Figs. 9.20–9.27) we can watch Builder A calling for appropriately-colored elements in the shop in the left-hand panel, and at the building site in the right-hand panel.

"Slab" = Green Apple // White Slab (Fig. 9.20)

"Black Slab" = (---) + *Red* Apple // (---) + Black Slab (Fig. 9.21)

"Black Beam" = (---) + *Red* Apple // (---) + Black Beam (Fig. 9.22)

"Block," "Block" = (---) + Pear // (---) + Block, Block (Fig. 9.23)

"Black Beam" = (---) + *Red* Apple // (---) + Black Beam (Fig. 9.24)

"Column," "Column" = (---) + Orange // (---) + Column, Column (Fig. 9.25)

"Beam" = (---) + Pear // (---) + Beam (Fig. 9.26)

"Block," "Block," "Block," "Block" = // (---) + Block, Block, Block, Block (Fig. 9.27)

In the broadest sense, this analogization between shopping and building in the matter of the selection of colors constitutes what life is like *across* the range of super-language-games in which certain complete primitive languages have been sedimented, in this case the procedure of color-selection. In this form of life, building in this way is like shopping in that way—and vice versa. They have a form of likeness, namely, a way of sampling and selecting the colors of things. The builders can say, "Building this color-schemed building is like shopping to prepare a meal." Conversely, the buyer in the shop can say, "Shopping to prepare this meal is like building a color-schemed building." In fact, they might simply say that both building and shopping for a meal are done "in our way," in *this* way, because they are like one another in one major recognizable respect.

Obviously the relations of likeness in this case might have been organized differently. The way in which the builders select black elements at the site might *not* be like the way they select red-colored foodstuffs at the shop. Instead, let us suppose that it might be like the way they choose *apples* at the shop, indifferent to the red or green color of the fruits in the same sense that Builders A and B were indifferent (in both the first *and* the second language-games) to the white, red, or green color of any building elements not specifically required by A to be black. Wherever A selects a black element at the site and directs B to fetch it, he could, then, choose an apple, red or green, at the shop and direct the shop-keeper accordingly. He could not, however, use *color-samples* to do this. The likeness between choosing black and choosing apples must have *other*

Figure 9.20.
"Slab" (Level I) = Green Apple // White Slab.

Figure 9.21.
"Black Slab" (Level I) = (---) + *Red* Apple // (---) + Black Slab.

Figure 9.22.
"Black Beam" (Level II) = (---) + *Red* Apple // (---) + Black Beam.

How Visual Culture Becomes Visible

Figure 9.23.

"Block," "Block" (Level III) = (---) + Pear // (---) + Block, Block.

Figure 9.24.

"Black Beam" (Level IV) = (---) + *Red* Apple // (---) + Black Beam.

Figure 9.25.

"Column," "Column" (Level V) = (---) + Orange // (---) + Column, Column.

Figure 9.26.
"Beam" (Level VI) = (---) + Pear // (---) + Beam.

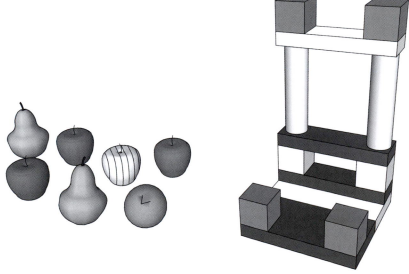

Figure 9.27.
"Block," "Block," "Block," "Block" (Level VII) = // (---) + Block, Block, Block, Block.

grounds than color—perhaps a symbolism that black and apples share in the cultural traditions of Builder A. Thus:

"Slab" = Orange // White Slab (Fig. 9.28)

"Black Slab" = (---) + Red *Apple* // (---) + Black Slab (Fig. 9.29)

"Black Beam" = (---) + Green *Apple* // (---) + Black Beam (Fig. 9.30)

"Block," "Block" = (---) + Pear // (---) + Block, Block (Fig. 9.31)

"Black Beam" = (---) + Red *Apple* // (---) + Black Beam (Fig. 9.32)

"Column," "Column" = (---) + Orange // (---) + Column, Column (Fig. 9.33)

"Beam" = (---) + Pear // (---) + Beam (Fig. 9.34)

"Block," "Block," "Block," "Block" = // (---) + Block, Block, Block, Block (Fig. 9.35)

What life is like in building the second or "Choose Apples" building (Fig. 9.35) differs from what life is like in building the first or "Choose Red" building (Fig. 9.27), even though the two resulting buildings, it is plain to see, can be morphologically indiscernible. This is because the complete primitive language of choosing black elements, though it is identically embedded in the same super-language-game at the site in both cases, is analogous to quite different things at *other* times or places. In one case its analogy lies with Choosing Reds, and in the other case its analogy lies with Choosing Apples. Though Choosing Black produces identical-looking buildings, then, it really is a quite different thing in each of the twinned cases relative to the other.

In this scenario, indiscernible buildings derive from different forms of life, discriminable medleys or garlands of the relations of likeness constituting what life is like.[20] This is the third kind of causal context of indiscernibility between artifacts, and for theoretical purposes by far the most informative. It is not an indiscernibility, however, that we should derive from *shared* culture, or attribute to it: the succession of Choosing-Black-like-Choosing-Red is *different* from the succession of Choosing-Black-like-Choosing-Apples. The indiscernibility devolves from a morphological overlap in the language-games (that is, Choosing Black in both cases) but not from a shared form of likeness that is recognized in both of them. The form of likeness in each case (one constituting a form of life in which one chooses black in *this* way and the other a form of life in which one chooses black in *that* way) is discernibly different if we pursue

Figure 9.28.
"Slab" (Level I) = Orange // White Slab.

Figure 9.29.
"Black Slab" (Level I) = (---) + Red *Apple* // (---) + Black Slab.

Figure 9.30.
"Black Beam" (Level II) = (---) + Green *Apple* // (---) + Black Beam.

Figure 9.31.
"Block," "Block" (Level III) = (---) + Pear // (---) + Block, Block.

Figure 9.32.
"Black Beam" (Level IV) = (---) + Red *Apple* // (---) + Black Beam

Figure 9.33.
"Column," "Column" (Level V) = (---) + Orange // (---) + Column, Column.

Figure 9.34.
"Beam" (Level VI) = (---) + Pear // (---) + Beam.

Figure 9.35.
"Block," "Block," "Block," "Block" = // (---) + Block, Block, Block, Block.

it as such. To *see* this, of course, we have to shift our focus decisively away from the intrinsic morphology of the particular artifact in view (a color-schemed black-and-white building) to identify its external aspective relations or analogies in each situation—its forms of likeness. Although these have visual attributes (we see the color scheme), they are not, for all that, simply visible *as* the building—for the building simply looks to be Choosing Black whether it is like Choosing Reds or like Choosing Apples. Its context (what Panofsky would have called its *Zeit und Ort*, its time and place) is to be found elsewhere, in *other* times and places. In these times and places, one chooses Reds *or* chooses Apples like choosing Black in the building, regardless of the fact that in the times and places of the artifact that is directly in question one *always* chooses Black. In this sense a true contextualism in visual-culture studies could not simply treat the time and place, the *Zeit und Ort*, of a given practice or artifact without *also* studying the times and places of its relevant analogies—of the other, of *all*, salient uses of the forms of likeness relayed by the practice or artifact in view.

These relations have complex ramifications and recursions that cannot be neatly compartmentalized. Forms of life organized in forms of likeness probably do not entirely cleave apart from one another for the simple reason that likeness (whatever its criteria) is neither identity nor wholesale nonidentity. It is unlikely, then, that forms of life could easily become utterly incommensurable in every respect. They blend or shade together in intricate ways. Like language-games, they have a family resemblance. Indeed, one of our grounds for assuming this—for proceeding to apply this assumption worldwide—is simply that everywhere things look somewhat alike. We can use this feature of the world to enter the forms of life that order it, even as entering these forms of life causes us to see this feature under new aspects.

To stick with our example, the form of life in which color-schemed building is like Choosing Reds is not absolutely different from the form of life in which color-schemed building is like Choosing Apples. It is *somewhat* different: it is different in certain identifiable respects. Of course, these respects might range widely and deeply. They partly organize building, shopping, cooking, and possibly many other practices in these forms of life. Therefore they can be said to define distinct cultural successions (they take different turns at a particular node in the relay of respects of likeness) or two cultures, so long as this term does not imply that the cultural successions in these two forms of life must be essentially discrete even if they have become historically disjunct. Nonetheless, we can readily construct a scenario in which Choosing Reds and Choosing Apples (regardless of their common analogy with Choosing Black)

would themselves be analogized in (or more exactly *as*) the same overall form of life. In this form of life (say, the culture of an oenophile), Choosing Reds would be like Choosing Apples. Insofar as both practices might be analogized with the Choosing Black that can be found in either way of building, this form of life would present the second kind of causal context of any morphological indiscernibles generated in it. Choosing Black is not always exactly the same thing in this form of life—the opposite, in turn, of the *first* kind of causal context of indiscernibility, which, as we have seen, is explicitly replicatory and often creates duplication. Nonetheless it might not be salient to cite this difference, indeed to *see* it, every time we encountered Choosing Black. In Choosing Black in this form of life we might well be indifferent to its internal differences unless Choosing Reds and Choosing Apples, its *external* aspective relations or analogies, also have to be distinguished for some reason.

■ 7

As far as I can tell, Wittgenstein wanted to be able to move back and forth between forms of life conceived as small-scale local coordinations of usages or practices (there must be innumerably many of them) and *Lebensform* conceived as the general human form of life. As Stanley Cavell has observed, the term *Lebensform* can be construed "horizontally" to refer to "differences within the plane, the horizon, of the social, of human activity." Here we might attend to the difference (considered in the previous section) between builders who Choose Black like Choosing Red and builders who Choose Black like Choosing Apples. But *Lebensform* can also be construed "vertically" to refer to "differences between the human and so-called 'lower' or 'higher' forms of [biological] life." In examining "steady ways of living [and] regular ways of acting" among human beings, we might need to consider factors that are common to *both* sets of (human) builders just mentioned, such as "the upright posture and the eyes set for heaven [and] the specific strength and scale of the human body and of the human senses and of the human voice."[21]

Most important for the most general purposes of the most general theory, however, is the fact that the builders who make a building in which they Choose Black like Choosing Red *or* like Choosing Apples are quite unlike the creatures—the honeybees—cited by Hegel in his description of their entirely nonconscious (though perhaps not insentient or nonsemiotic) building of a beehive as a precursor of human "artificing," or perhaps as a life-form wholly alternative to it.[22] All the builders

who make analogically aspective buildings are *human* builders, regardless of the specific cultural succession within which the forms of likeness coordinate Choosing Red (and *not* Choosing Apples) as the aspectivity of Choosing Black (or vice versa). Wittgenstein wrote that *Lebensform* is a specifically "natural-historical" fact (*PI*, 230). And this might warrant the view that there is one human *Lebensform*, one canine *Lebensform*, one feline *Lebensform*, and so on.[23] (For convenience of designation in English, we might call these *life-forms*—"human," "canine," and so on.) But in theory the natural history of the cultural successions of aspectivity in vision (or in any other domain of human proprioception and corporeal awareness or self-regulation) allows for many *Lebensformen*, or "steady ways of living and regular ways of acting," within the human life-form, however they have emerged, ramified, persisted, mutated, interacted, subsided, and disappeared. Everything depends on the particular respects and routes of the forms of likeness that we identify (that phenomenally we "live") in emergent successions—whether they are specifically infra-human or panhuman, whether specifically panhuman or panhominid, whether specifically panhominid or infraprimate—and on the weight we give to them.

For my purposes, then, the question of one or many *Lebensform(en)* in the human life-form can be sidestepped. Empirical distinctions in visual culture can be made between discriminable contexts in the sense I have given; that is, between particular networks of like and unlike usages ordered in particular forms of likeness. Whether we call these networks different "forms of life" or "cultures" or "subcultures" or apply any one of the other labels invented in the baroque ontology of sociocultural theory is an entirely secondary issue. For all it really matters, in fact, we could simply call them A, B, and C.

Indeed, greater descriptive neutrality of this kind would be helpful in cultural studies. Such categories as "Athenian symposiasts in the late fifth century BC" or "visitors to the Salon in Paris in the 1860s"—typical art-historical definitions of the horizons of visual culture—tend to assume far too much in the way of a putatively shared culture correlated with a mere clump of sociality. When deployed as the designations of real cultural formations, in fact, such labels occlude the *many* cultural successions likely to be found in the forms of likeness replicated and recognized by symposiasts and Salon-goers, and in the several distinct forms of life that these successions might sustain and from which they might recursively have been precipitated: cultural successions A, B, C . . . might be found among Athenian symposiasts in the fifth century BC; cultural successions P, Q, R . . . might be found among Salon-goers in Paris in the

1860s. (And it is historically possible, though not the usual assumption of cultural studies, that succession A could be found in Paris in the 1860s, or even that succession P could be found in Athens in the fifth century BC.) Laborious as the investigation must be, we have to look at what life was like (in particular at what such putatively cultural artifacts as painted vases or canvasses were like) for each and every participant in the social group in question; that is, for each symposiast and each Salon-goer. Our critical assumption has to be that *it did not look quite the same for any two of them*. Any history of visual culture that fails to pursue this assumption as fully as possible, especially one that tries to circumvent it, fails to offer a realistic history of the aspective successions and their interdetermination. And, as I have argued throughout this book, aspective succession and interdetermination *is* the substance of visual culture, if any there be.

Visuality is not the collective seeing of a social group, though it has sometimes been treated this way. In human forms of life within the human life-form, the group does not have only one pair of eyes. Visuality is the seeing of *each* human agent when he has succeeded to a network of likeness in the visual affordances of visible configuration—a visual culture in the theoretical sense. Of course, the aspects of things in this network of likeness can be coordinated with other people and communicated to them, but only as a representation of what life is like (what life is like for him, as the others might see it; what life is like for others, as he sees it) and *not as a seeing of the very same visible world*. For it is clear that what the visible world is *visually* must differ for each and every one of us. We see it from different real standpoints. Its *visual* aspects for us must be visibly anamorphic from any other vantage points; that is, in the visual aspect-seeing of other people. (To be sure, anamorphosis is a tricky phenomenon: in peculiar optical circumstances, entirely different things could look exactly the same from different vantage points, just as the same things—a more common situation—can look quite different.) But because of the analogies of the visible world, its relation to common criteria, we can recognize other people to recognize the same world, even if we realize that it must *look* somewhat different over there.[24] And, of course, vice versa: the fact that other people seem to recognize the same features as we do in visible worlds that must be different from our own suggests that they apply analogies quite like our own, overlapping with ours in many ways—that they *see* things in the way that we do.

Visuality, then, is not simply the seeing of morphology and its analogies, although it certainly is this when it has been fully constituted as visuality. *It is recognizing the analogies regardless of the inherent and inevitable divergences of morphology—of inherent anamorphosis in the visual*

field. This is the *general* case within which indiscernibility is a special case. It is likely, however, that we cannot fully succeed to this complex recursion, differentiation, and ramification without passing over thresholds of indiscernibility, a ladder that can be discarded even as we are climbing it. (Like the young Saint Augustine, we have to discover that W is not always A, or better that A and B, though W acoustically or epigraphically, are not the same—a discovery more important than the self-evident sensuous fact that A, B, . . . F are W and, say, G is X.) Things that are the same look to be the same, at least in certain respects; things that look the same are the same, at least in certain respects. And it is only when a visual culture has been constituted, as I have insisted, that these relations can be inverted or surmounted. The constitution of forms of likeness outside visibility seems to trade on a likeness of form *in* the visible—a likeness that cannot be said (at least without vicious circularity) to be wholly a function of the visuality that emerges from it.

■ 8

No sociological program or culturalist dogma provides an infallible guide to judging when we are dealing with shared forms of likeness in the same form of life, with different forms of likeness in different forms of life, or with any of the intermediate, overlapped, or exclusive possibilities. It is the burden of historical and critical tact—even personal and social sensitivity, no doubt—to make these discriminations in light of our knowledge of the emergent aspective successions and their possible interdeterminations in each case.

Needless to say, then, we must be careful with the heuristic model that I adopted in the previous four sections of this chapter. In the ordinary course of events, the aesthetics of indiscernibles does not provide a royal road to cultural understanding. In fact, supposed indiscernibles tend to distract our attention from *the family resemblance of their functions* within the networks of likeness to which they might belong: to displace attention onto *the manifest similarities or putative identity of their appearance*. In the ordinary course of events, indiscernibles create puzzles in a form of life rather than promote our certainty about its perspicuous coherence. Considering that few things really are indiscernible from other things, we do not ordinarily seek to understand the unlikeness of like things. Like is like. Rather we seek to understand the likeness of unlike things; for us some *unlikes* are deeply like. In other words, the history of forms of likeness explains phenomena of indiscernibility in culture and

not the other way around. In this regard the aesthetics of indiscernibles is not so much an intrinsic feature of aspective successions, and specifically of the successions of vision to culturality (visuality), though sometimes it might be. It is a *method* for discovering them and making discriminations within them or distinctions about them.

When we are trying to discover what something is all about, we probe its changing aspects as they appear to us when we imagine it being like (even the same as) a range of other things to which it might be analogized. Even though its features might not change at all, in this process they can certainly appear in a new light. And it is likely that when something appears in a new light its aspects visibly do change. (New visual aspects have "dawned.") We think our way through apparent indiscernibles (they are *merely* apparent) in order to discern and discriminate particular identities and their part-similarities and part-differences with other things—similarities and differences recursively reconstituted as visible morphology. If we return to the example considered at length in Chapter Eight, Dürer's Knight comes to *look* different when we see him as a Christian Soldier, or see a Christian Soldier in him, rather than an aristocratic Prussian or a later Nazi officer (or vice versa). Of course, it is difficult to say exactly how this particular identity (and its specific difference from its apparent indiscernible) is seen by us; that is, in respect of what visible features in the engraving itself. The Knight's expression? His pose? The size and orientation of the other figures relative to his? But that is precisely the point. The *visible* features of the salient visual culture are embedded in a network of forms of likeness including external aspective relations, or analogies, that are not directly in view when we look at Dürer's engraving—when we are looking, that is, with a vision specifically cultured in these aspects.

Stated another way, visual culture will be visibilized *qua* culture only when our vision of configuration succeeds to aspectivity that is not only visible. The aspects of configuration (what it is seen as, what is seen in it) are also the visual face of analogies recognized in the configuration, and visually (if not always *visibly*) reconstituted there: the recursive (no doubt unreliable and resistant) interdetermination of seeing-as because of seeing-like, seeing-like despite seeing-as, seeing-as despite seeing-like, and seeing-like because of seeing-as. This is the general tautology of vision in the cultural succession.

Chapter 10

Visuality and the Cultural Succession

■ I

In visuality, culturality becomes a recognizable horizon of things seen. We recognize the analogies of visible things, whether or not the objects of our vision were made as things specifically to be seen and whether or not all poles or nodes of the analogy are visible or concern visual relations. But how do the recursions of seeing-like stabilize as a visuality that coordinates all registers of visual culture even as it emerges from them? In other words, how do the aspective successions unfold in what could be called, overall, the *cultural succession*—unfold, that is, from the seeing and the making of things that can look like other things (and that certainly have their own recognizable visible "look") (Chapters Three and Four) to the seeing and making of things recognized to be like (say) buying or selling things in a market or counting or computing things in a calculation, or culturality (Chapter Nine)?

My use of the terms "cultural succession" and "culturality" are not *culturological* uses. They do not designate a reified culture (visual or otherwise) in the way that a conventional art-historical iconologist might say, for example, that Dürer's Protestant or specifically Erasmian culture (even his *visual* culture) determined his visuality as well as the recognizability and intelligibility of his engraving of *Knight, Death, and the Devil* (Fig. 8.1) to people who shared his visuality (people cultured just like

him, or in his visual culture) (see Chapters Seven and Eight). Rather, I refer to passages and phases of the interdeterminations of the aspective successions, described in Chapter Nine as analogy passing cross-wise or zig-zagging through the aspects of visible morphology in the registers of formality, style, and pictoriality. Full culturality in a configuration (especially a depiction) can only be attained, as iconology has assumed, when formality, style, and pictoriality are wholly absorbed by a visuality—when it is a particular visuality, a particular network of recognized forms of likeness, that constitutes a configuration as fully recognizable, thereby rendering it visible as an item of visual culture. For all the reasons already reviewed, this succession cannot always be completed. Sometimes it wholly fails (see Chapter Seven).

In other words, the concept of culturality in the successions in vision is not culturological because the general theory assumes neither the established existence of visuality (and visual culture correlated with it) nor its eventual emergence. Indeed, it assumes neither the established existence nor the eventual emergence of culture in the received sense of a socially shared matrix of meaning within which particular practices (including the seeing and the making of things) always make visual or other sense. The cultural succession—like the successions of formality, style, and pictoriality through which it threads—need not proceed at all. Some participants in the social group that sees and makes the relevant artifacts—the possible or potential items of visual culture—may not accede to it. Perhaps only *one* agent fully succeeds to (his own) visuality with regard to what he sees in his form of life—in its visual world of visible things—or with regard to what others have made to be seen there. And the visible things that visuality depends on and that have been produced specifically for it do not sustain it alone; that is, do not sustain only it. They can continue to remain visible to people who succeed to visualities that coordinate this visibility in *different* ways in relation to things with different likenesses, both morphological (and therefore visual) and analogical (and possibly nonvisual).

Just as vision, then, has a history in culture (the question of what is cultural about vision addressed in Part Two), so culture has a history in vision (the question of what is visual about culture, addressed in this and the previous chapter). In Chapter Nine, I offered a description of this interaction—a model of the interdetermined morphological and analogical aspectivity that is recognized in the visible, and that enables us to sort it out visually. The theory of the cultural succession in vision offers the explication. (The full *explanation* must be found in autogenous features and processes of the human visual system, including not only

the visual system's optical investigation of visible ambiguities but also its categorical calibration of invisible affiliations. A general theory of visual culture likely must assume such a visual system—a system intensively investigated by neuropsychology, vision science, cognitive anthropology, and other disciplines. But it also seems that many elements of the system in question are not well understood at the moment *without* a general theory of visual culture explicitly presented as a theory of human vision.) In investigating this history, and as I have insisted throughout, we must proceed without assuming the consequents. We cannot assume that inaugurally the succession is wholly cultural (that it proceeds from an established visuality that coordinates the forms of likeness seen in visible configuration, or that an established visual culture already guides the seeing of visual affordances). Nor is it a given that the successions are entirely unitary (that all aspectivities of the visible have converged or will eventually converge in a single coordinated visuality that relays only the forms of likeness apposite to a form of life). Finally, we cannot assume that the succession has been fully completed (that visible configuration has wholly succeeded or will wholly succeed to the forms of likeness, the seeing-like, constituted in the visuality of a form of life).

The theory of the cultural succession in vision admits these visual histories. But it admits many other visual histories as well—histories in which seeing-like, let alone seeing-like-us, is just one possible outcome. For this reason, there could be cases in which a form of life that *looks* to us to be like our own is in fact unimaginably different. The historical scale and scope of these cases, though probably vast, is indeterminate and unknown. It has been occluded by culturological imperatives to find widely shared culture. Because we are tempted to discover shared culture, we readily overlook the cases in which *different* forms of life seem to be morphologically similar.

Suppose that I find a black postcard in my mailbox. I might have no idea what it signifies; let us suppose that it is neither addressed to me nor signed by anyone, and that it has neither a message nor a postal stamp. In your culture, the postcard might signify the malevolent intervention of a hostile deity. For someone else, it might signify a threat of death. But suppose these are not my cultures. I might recognize practices that I could take the postcard in my mailbox to be *somewhat* like, such as the practice of mailing postcards with pictures of faraway places to friends back home or the practice of displaying black emblems in tragic situations. The black postcard could be parallel to these practices in certain respects. But in the end it means nothing to me because in my culture there is nothing

sufficiently like the act of putting anonymous black postcards in people's mailboxes.

For me, then, the postcard is "wooden," to adapt Simon Blackburn's term.[1] Despite possible likenesses to many things that I do, it diverges from anything that makes full sense to me *even in analogy*. Rather than being able to say "it's like a greeting mailed to me by a friend far away" or "it's like a display of funeral insignia," I have to say (at least in the terms of this thought experiment) that it's simply *not* like these things. And what it *is*, then, is moot. As we might say, "it just happened." (Strictly speaking, such a pure event might still be analogous to *other* happenings that we could position as "Wooden" in our form of life. In this case, our form of life might succeed to—it might include—a particular culture of Wooden Happenings: we actively recognize a domain of mysterious, one-off things as such, analogous in this one respect regardless of morphological aspects, and to which we might assign a name in our ontology *qua* Wooden. But in the terms of the thought experiment, the black card in my mailbox is not Wooden. Rather, it is brutely wooden, or wooden *simpliciter*. We "don't give it a thought." Or if we do, we cannot "think" it in the full iconological sense discussed in Chapter Seven.)

What if everything—the world—was like this? Needless to say, *our* world is not. But someone else's world (though it might look just like our own world) could be wholly wooden. What would count as a cultural practice or tradition in our world could turn out in this person's world simply to be a natural occurrence, such as vulcanism, or a behavioral reflex, such as coughing—even if *we* would describe the activity in question as Building, Trading, or Painting, at least in our world, because we can say what these things are like for us (for example, our buildings are like the way we paint). (Conversely, and by the same token, our world could be wooden through and through for the person whose world seems wooden to us: nothing about it makes any sense to him.) Despite the postcard, however, we know that our world *does* make sense up to a certain extent; namely, the limit in part defined by the palpable difference (for me) between friendly postcards and funerary emblems on the one side and the black card in the mailbox on the other. Therefore we do not seem, at least from our point of view, to be in the same position as the "wooden" person. His world makes no sense to us even though it looks just like ours: he makes shelters, he exchanges objects, and he makes marks, but they cannot be buildings, trades, or paintings as we constitute them. While we have succeeded to (our) culture, apparently he has not succeeded to it. Perhaps he has not succeeded to any culture whatsoever.

Needless to say, the other person's wooden existence—if it is wooden *simpliciter*, a brute culture—must seem absurd to us when it looks just like the life we ourselves are living. What could his world possibly be like? The answer is simply that it cannot be *like* anything at all. But of course if *we* were living like that—living within a form of life that had only partly succeeded to culturality, or not at all—we could not know it. We would simply ape the visible culture of others, doing and making things that are visibly similar to (even identical with) the things they do and make—do and make, it is likely, in a cultural succession (that is, as having cultural-ity), though we cannot *see* this in what we are aping. It is possible that no situation could arise that would expose the gap between us and them—between our mere brute culture and their culturality. We would take our-selves to be the same as the others when we are different.

If these are deep and often unresolved puzzles or paradoxes that are internal to our form of life, or press on its edges when we confront its extremes, alterities, mutations, or challenges, it is easy to see why the an-thropologist or historian of visual culture—who conducts his analysis from a vantage point external to the culture—confronts an extraordi-nary methodological challenge. The challenge cannot be met, however, simply by assuming that there must be a cultural succession, culturality, to be found, pending the discovery of evidence for it. This overlooks the *historical* process of cultural succession as vital visual life.

■ 2

If the cultural succession *does* proceed, and if it succeeds recursively to comprehensive coordination and completion of the visible aspects of configuration in the analogy that it replicates, we must show how the *vis-ibility* of analogy (in *this* look, something is like *that*) succeeds to visuality (in *that* likeness, something looks like *this*). We must show, for example, and to take an example that has attracted the attention of paleoanthro-pologists and prehistorians, how something that has the look of tallying visible phenomena succeeds to *counting* them (Chapter Five)—a likeness that might now govern the visible look of all possible tallies as forms of counting things, visible or not. Or to return to the example considered in Chapter Nine, we must show how the builder who visibly Chooses Black in building sees it *like* Choosing Apples.

At one time and place someone might track the visible phases of the moon by adding stones to a pile. Suppose, for example, that every day after the moon is seen to be full (and starting on that day) he adds a stone

to the heap; when the moon is seen to be full again, suppose that he starts *another* pile of stones. At another time and place, he might track the rutting of game by notching a stick. Suppose, for example, that every time he observes the animals mating or that every time he sees a new calf in the herd he cuts a notch in the stick. (These scenarios, of course, need not be imaginary. As we have seen in Chapter Five, some prehistoric artifacts—artifacts of supposed visual culture—have been thought to have functioned in just such ways.) In principle, then, these practices and the artifacts that are produced in them could already lie in the domain addressed in Chapter Nine—the domain in which, for example, the building of a building and the marketing of goods could achieve full aspective interdetermination as analogies (building in this way is like marketing in that way, and vice versa). They *could* be in this domain. But now it is important to suppose that in fact they are not.

In the form of life of our imaginary heaper-of-stones and maker-of-marks, the activities I have described need not, for example, be forms of (what we would call) counting (in our form of life). This disparity might seem bizarre to us. In our form of life, piling stones and notching sticks that seem to keep track of passing days (for it turns out that the piling and notching can do this) would be deployed as forms of counting. They are analogous configurations in terms of relays and recursions of aspectivity. For example, one stone is to one day as one notch is to one day. And further, then, one stone = one notch = one day = "1." Recursively, a stone or a notch is seen as one, whether stone *or* notch.

By contrast, in the stone-heaper and mark-maker's form of life it suffices to track the phases of the moon by piling stones (here, say, he discovers how long each phase has lasted by how *big* the pile looks, not by how many stones it has) and to track the rutting of game by notching a stick (here, say, he discovers the frequency of daily sexual couplings or foaling among the animals, not *when* they couple or foal, by how *dense* the notching looks). He might eventually devolve a practice of "counting days" not limited to the periods of the moon or the scope of the rut by constituting an analogy between piling and notching. But tracking the moon and tracking the mating might well tally *different* numbers of lunar and faunal events. Therefore his activities might create a pile of stones that would not look very much like the notched stick (and vice versa) in one of the very respects of visible morphology that would be most salient for *us*, namely, the "number" of stones or notches that supposedly mark the days visually in the accumulation. Although he piles one stone and makes one notch at a time (that is, noting a new phase of the moon in one domain and another incident of sexual coupling or foaling among the an-

imals in the other domain), suppose that the stones are large and the pile is very big, and that the notches are small and the bunch very tight. At this point in the cultural succession—at this very primitive point—does their maker even *see* discrete integers, as we call them, in the stones and notches? Or does he simply see *pile* and *bunch*? And even more primally, and absent the aspect of integering, does he see pile and bunch to look like one another in any particular morphological respect?

The analogy of stone and notch as "1," and of pile and bunch as accumulations of "1s," the forms of likeness that constitute counting in our form of life and that would coordinate both piled stones and notched sticks as visible counts in our visuality, would have to develop on different grounds for him. More exactly, they have to develop on *some* grounds, whether or not they turn out to be the same as the grounds of our counting. Perhaps piling the stones is like notching the stick—perhaps they possess a primal likeness of form—in the fact that he does both things at sunrise, and thus eventually on the same day. (Imagine that the dawn washes stone and stick in the same golden-red light; now it is time to pile and to notch.) Then it might become clear—new aspects would have dawned—that he could track the moon by notching the stick (for here he has been keeping track of frequency all along) and track the mating or foaling by piling the stones (for here he has been keeping track of duration all along). And if one stone and any number of notches can equally betoken one sunrise, regardless of the existing tallies recorded in stone pile or bunch of notches, it becomes possible *always* to use one stone *or* one notch to tally one appearance of the moon *or* one coupling, that is, as "1." Yet another aspect has dawned. Now he can see that piling stones to find out how long each phase of the moon might last and notching sticks to find out how much mating has occurred among the animals are just like one another in the fact that every event he would record with a stone or a notch, whether lunar or faunal, can be recorded with any "1" thing, stone or notch or perhaps anything other one thing (anything else), and that finding "1s" in things can be the way he tracks everything. But equally they could be like one another in the fact that he piles and notches at sunrise. Whether one or many, they are (or they were) sunrise-time kinds of things—dawn-things.

■ 3

Because a form of life involves culture, defined simply as making tools, building shelters, and so on, does not entail that interactions of likeness

constitute the analogical relation in which, for example, building in a certain way (Fig. 9.8 or 9.16) is recognized to be like Choosing Red (Fig. 9.27) or like Choosing Apples (Fig. 9.35) or in which notching in a certain way is recognized to be like piling in a certain way, whether the likeness produces counting or dawn-things (or both or neither). Indeed, a complete primitive language in Wittgenstein's sense, such as the call-system of the builders imagined in Section 2 of the *Investigations* (described at the beginning of Chapter Nine), does not inherently involve such forms of likeness, although it might come to do so at some point. But an "expanded" language-game (what I have already called a super-language-game) such as the language-game imagined in Section 8 of the *Investigations*, at least as I have described it in Chapter Nine, clearly does involve such forms of likeness. As we have seen, here building was expressly likened by the builders to preparing food (and vice versa) in certain respects of the arraying of colors; in the expanded language-game or super-language-game of the builders in Section 8, *coloring* is the emergent analogy, equivalent to the *counting* in the example here. (If it is not coloring but something else—not Choosing Red but, say, Choosing Apples—then it might be equivalent to doing-sunrise-things.)

Of course, it would be possible to create an expanded language-game that does not involve such forms of likeness. If we removed the analogy to shopkeeping, the language-game in Wittgenstein's Section 8 would be such a case. And it would be possible to create a complete primitive language that *does* involve such forms of likeness. Here we could attach the analogy of shopkeeping to the language-game in Section 2. Wittgenstein did not address the ethological and anthropological status of the language-games in his examples as kinds of culture (having the potential to afford visible culturality); that is, in terms of their place in what I call the cultural succession. To be sure, he implied that the analogy to shopkeeping was recognized by the builders in Section 8, and therefore became an aspect of their building for them such as it could not have been for the builders in Section 2. But he did not pursue the aspective and recognitional histories of language-games in a systematic way, even though later sections of the *Investigations* turned to a subtle epistemological analysis of the psychological dynamics of seeing-as. He *assumed* the cultural succession as much as provided an explication of it.

Regardless of Wittgenstein's interest, however, the notable difference between the complete primitive language described in his Section 2 and the expanded language-game described in Section 8, beyond the mere difference in their linguistic scale, scope, and complexity, is their aspective status in the cultural succession. The first culture (Section 2) lacks

culturality. It could well be a culture of the kind found among nonhuman creatures—what has been called an "osteodontokeratic culture," a culture of using sticks, stones, teeth, and bones to do and to make things.[2] The second culture (Section 8 and elaborations) possesses culturality. It would seem to be a culture only to be found (so far as it is possible for us to say definitively) among human beings.

In principle, of course, we might find an expanded language-game among nonhuman creatures that lacks culturality. Such creatures would be like the builders in Section 8 *without* the analogy to shopkeeping in their activity. Indeed, they would be like the heaper-of-stones and maker-of-marks imagined in the thought experiment sketched in the preceding section of this chapter insofar as that imaginary agent has no visual culture of counting. By the same token, we might find a complete primitive language (simple and unexpanded) among human beings that has culturality. Such creatures would be like the builders in Section 2 with *the addition of* the recognized analogy to their visible activity. But the anthropological question is not only whether a language game is complete and primitive or expanded. It is also whether and how it attains culturality. While the language-game that lacks these relations of likeness is sufficient for osteodontokeratic or brute culture ("as it were something animal," as Wittgenstein put it in *On Certainty*[3]), a language-game that involves forms of likeness is necessary for any self-consciousness of it *as* a form of life; that is, for someone using it to see his form of life in it. (Mere awareness might be distinguished from self-consciousness in these terms. The builders in Wittgenstein's Section 2 are aware of building in the way that they do; certainly they are aware that they are building something. They are not fully self-conscious of it, however, because they have no *further* means or reason to relate it recursively to themselves. By contrast, the builders in Section 8, aware of building in the way that they do, can see and can say recursively how and in a sense why they do so, namely, "we do it like so . . . like this.")

In nonhuman and prehistoric human contexts we seem to find brute cultural activities, such as tool-making among apes. These activities do not inherently require analogical aspectivity in their replication and probably did not often employ it, though it is possible that such forms of likeness might emerge in these contexts—that brute culture might succeed historically to culturality, whether human or not. Wielding a tool to make marks, as apes will do in certain contexts, is a brute culture. If apes make *pictures* (as has sometimes been claimed in certain experimental situations), they enter the cultural succession: like formality and stylisticality, inherently pictoriality is a form of likeness. If asked, perhaps the

ape could say that the marks are like mountains (as they must be if the marks depict them, that is, if their pictorialization is grounded in seeing the mark as mountain [Chapter Six]). Regardless of what the ape might say, it must be aware of mountain-likeness in the marks, whatever mountains are for it, and it can recognize said likeness in *other* marks.

Of course, we will never enjoy the conversations with the ape that would be needed to answer this question. We must rely on other methods to investigate these visual horizons of its form of life, and to determine what is visible within it. None of them is reliable. Could *we* recognize the pictoriality that constitutes the marks as depicting something for the ape, especially if it is like nothing in *our* world? After all, we know virtually nothing about how mountains look to apes, let alone what they look *like* or what they *are* like. (In other words, could we enter the methodological loop—the loop envisioned in Chapter Eight—that would track the iconological succession in which the ape's picture has originally been constituted?) The marks might have an orderly conformation. But is it an ape formality (Chapter Three)? And though the marks must have a style (for they have a particular ape maker with his own ape habits), are they stylistical for the ape (Chapter Four)? Presumably the ape can see the marks that he has made. Is this a visuality? The answer to the last question would surely have to be affirmative if the marks, as we might somehow discover, have formality, stylisticality, and pictoriality for the ape, and especially if they have culturality—if making them in the way that the ape does can be likened by the ape to doing or seeing *other* things in the way in which he does or sees them.

These are fascinating questions for ethology and paleoanthropology. But historical inquiry into the primal emergence of cultural successions (and eventually of culturality) in the making of visible things should not be limited to osteodontokeratic culture in nonhuman or prehistoric human forms of life. The matter is essentially archaeological regardless of the times and places that our history must address (the deep past, the present moment, or anything in between) and regardless of what kind of creatures are involved (nonhuman creatures, prehistoric hominids, human children, and so on). Even in our present form of life, culture, defined simply as the brute activity of making tools, building shelters, and so on, is always succeeding to culturality when particular analogies of the visible morphology emerge for participants.

Conversely, culturality is always reverting to culture—the brute activity of making tools, building shelters, and so on—when forms of likeness of the visible fail to be recognized (Chapter Seven). It is even possible that sometimes or in some places the cultural activity or artifact itself,

the tool-making or building, would not itself be recognized. We might fail to recognize not only the pictoriality but also the *painting* (possible cases have been noted in Chapters Five and Six). This would not be a recognitional disjunction *within* the cultural succession (specifically in a certain interdetermination of formality, style, and pictoriality) but its complete absence or total collapse—what I have called the true depictive disjunction (Chapter Two). Still, nothing could be more ordinary. Much of the time we are not even partly within a cultural succession in which other people participate. We do not recognize the visible phenomenon, the brute event, artifact, or process, that *they* embed in complex analogy. And this is in large part because we do not have the analogy to identify it. We are defeated by the tautology to which they can succeed.

Moreover, and to revert to a point I have made throughout, we cannot be sure whether culture succeeds to culturality (or vice versa) simply by looking at the cultural activities in question. (In previous chapters we have seen that the same point must be made about formality, stylisticality, and pictoriality.) As I have already noted, the fact that, for example, building and preparing food might look like one another in certain respects (arraying colors) does not entail that they *are* like one another in that way, just as the fact that they are like one another does not entail that they must *look* like one another.

In Chapter Nine, my heuristic emphasis on the partly visual-cultural practices of Choosing Black in building and Choosing Red in preparing food so as to create alternate layers of color (and hence a color-schemed building and a color-schemed dish of food) was intended to demonstrate the partly *invisible* presence of cultural likeness, of culturality, in only *one* of the two morphologically indiscernible buildings (a mere black-and-white building on the one hand [Fig. 9.8] and a building schemed to be black-alternating-with-white on the other hand [Fig. 9.16]). It was *not* intended to suggest (nor analytically does it suggest) that the black-and-white-schemed building and the red-arrayed dish of food look like one another, even though likeness in the arraying of colors (a primal likeness of form vested in ambiguous and amorphous gradients of visible morphology) helps to makes sense of both the building *and* the food preparation. For the analogy here is not *visual*-cultural, or at least it is only partly visual-cultural, especially if the color-selection succeeds to stylisticality in the sense explored in Chapter Four, or to iconological pictoriality in the sense explored in Chapter Seven. In the former case, it indexes an unseen tradition of making that is both the cause of color-scheming and displayed by it; in the latter it could symbolize something nonvisible.[4] In the case of our two buildings relative to their respective cultural succes-

sions, in fact, the visual facts *occlude* the cultural facts if we try to compare the buildings in anything *but* visual ways. We can only discover whether a cultural activity, visual-cultural or not, has a recognized analogical aspectivity—whether it has culturality—by investigating its history of formation, variation, and use, and in particular its replication in as many instances and iterations as possible.

■ 4

As I put it in Chapter Nine, when pressed to say what the color-schemed building means, the builders (Wittgenstein's Section 8 and elaborations) can inherently say that is like preparing food with respect to arraying colors in a certain way. Such a statement cannot be made about the building that is built using the simple call-system (Section 2) unless and until it acquires such likeness. When pressed to say what the building built by way of the call system might mean, the builders would have no recourse but to say that this is simply how they have built it, *simpliciter*. Wittgenstein was deeply interested in this very fact, this simple or brute and public or social fact, about language-games in a form of life. They are, as he put it, just a way of "going on" (e.g., *PI*, §§ 198, 201). We do not need to appeal to their putative meaning, at least if it is conceived as an inner, hidden, or private condition of cultural consciousness and social interaction, in order to use them confidently in our affairs.

I too wish to be cautious about appeals to meaning conceived as an inner, private condition or causation of visible activity or visible artifacts. For the people who are aware of them, both morphological and analogical forms of likeness are *manifest* aspects of culture, its partly *visible* culturality in the case of visual-cultural activity.[5] Despite the way in which manifest visual facts occlude cultural facts in the case of discriminating the two morphologically indiscernible buildings, only one of which manifests culturality, people *see* the color-schemed building. What was visually occluded in this scenario (at least as I described it in Chapter Nine) was the salient *analogy* of the color-schemed building, not its morphology. Nevertheless, if its analogy is occluded or unrecognized it is likely that relevant morphology will go unseen too (though not in the case described). Moreover, analogy is no less manifest—no less a public fact—than morphology. It simply needs to be recognized in different ways on different grounds. Finally, morphology can sometimes be occluded because an *analogy* makes it difficult for us to see it, or visually irrelevant (and this, paradoxically, entirely regardless of the morphologi-

cal indiscernibility that an objective beholder might apprehend). When we fully attend to the color-schemedness of the Choose-Red building (Fig. 9.27), for example, we might not see that it has black and white layers just like the *non*-color-schemed building (Fig. 9.8): we might not see the morphological indiscernibility (which is perfectly visible to anyone else) precisely because it is analogically obvious to us that the building represented in Fig. 9.27 is entirely different from the building represented in Fig. 9.8.

Wittgenstein notwithstanding, then, I do want to notice the important distinction between the building produced *without* forms of analogical likeness and the building produced *with* forms of analogical likeness (or culturality) in the cultural succession. The two kinds of buildings can be used and often must be used in very different ways—a matter of their manifest intelligibility and functionality—despite their morphological indiscernibility.

In the form of life that involves the expanded language-game, a chef could not confidently use the merely black-and-white building (Fig. 9.8) to show an apprentice how to make a properly prepared dish of food. If he were to try to do so, the merely black-and-white building would have to succeed to color-schemedness (e.g., Fig. 9.16) for both participants, transmuted by an emergent analogy to a dish of food (e.g., Fig. 9.27) that has not yet been prepared properly by the apprentice; it would have to be seen as color-schemed, even though it is actually the dish of food that properly has this feature in this culture, not the building (or at least *this* building). Pointing at the merely black-and-white building (Fig. 9.8), the chef could say to the apprentice about the dish: "Do it like that." But looking at this building the apprentice might well ask: "Like what?" For in his phase of cultural succession in the kitchen, of course, *he* does not see the building as color-schemed. The chef would then have to apply the analogy of the dish (Fig. 9.27) to the building ("Do it in layers of color, like that building") in order to explicate the building in a way that would help the apprentice to understand how to prepare the dish. If the chef succeeds, this experiment might help the apprentice to create the dish, and to succeed to the culture of the chef's kitchen as well as produce a dish with the salient culturality. But it is unlikely that it would affect the way in which anyone else in this form of life understands the *building*, even if the chef and apprentice begin to see the building as having layers of color like the dish (though not an actual color-schemedness in its making, *unlike* the dish).

Of course, in this culture chef and apprentice would have the option—a more perspicuous option—of finding and inspecting an actual

color-schemed building with which the merely black-and-white building, conveniently close to hand, could be conflated for the sake of bootstrapping the analogy with the dish into visibility. To use the color-schemed building confidently requires awareness of its forms of likeness. But the apprentice already knows these. Therefore he could assimilate his dish to them more readily: he would already *see* what the chef is pointing at in this building (namely, its color-schemedness) when he recommends it as a model for the apprentice's dish. Analogical forms of likeness—culturality—must be involutions, integrations, and recursions in language-games in Wittgenstein's sense, or, to stick with the terms used here, phases in aspective succession and interdetermination.

■ 5

Like brute culture, culturality need not be socially shared. But socially-shared culture promotes the emergence of culturality because it often requires the conventionalization of activities and practices; that is, the accommodation of one's own activities and practices to the usages of other people. It thereby encourages the emergence of visible respects of likeness that might be discovered to be salient for the requisite coordination regardless of the original visual awareness of any of the participants. North Americans have solved the "coordination problem" of driving on their roads by adopting the solution, which can be defined as one possible "coordination equilibrium," of driving on the right side of the road at all times, though allowed their own devices on empty roads North Americans could well drive on the left side or down the center of the road. In arriving at this practice, each agent sees the behavior of the other drivers on the road, and each concludes that he had better drive on the same side as everyone else: he does it like the way they do it (namely, on the right) and they do it like the way he does it (namely, on the right) because for any of them *not* to do it in this way (to do it, for example, like the British; namely, on the left) would be dangerous for all of them.

Notice that we do not have to derive the end-result, the coordination equilibrium, from any *social* facts about the other drivers we see—that, for instance, they are all law-abiding North Americans and therefore can be counted on to drive on the right. Indeed, in some cases we would be better off *avoiding* judgments about social facts in solving brutely social coordination problems. The problems might be best addressed as brute conditions or demands that we face—in this case for driving safely in relation to others at any given time and place *regardless* of existing con-

ventions of driving in general. In solving social coordination problems we usually maintain "higher-order expectations" (in this case about the nonsuicidal aims of all drivers). But confirming these expectations in arriving at the first-order equilibrium must involve recursions and regress.[6]

Even if conventionalization is not required or does not occur, the integration of complete primitive languages in super-language-games can lead, as we have already seen, to the apprehension of likenesses. To some extent and in some cases, in fact, the expansion and integration of language-games seems to be a function of the emergence of forms of likeness. In Wittgenstein's example in Section 8 of the *Investigations*, the pre-existing likeness between building and food preparation underwrote the expanded language-game of building a color-schemed building; it was a pre-existing culturality in this form of life. But consider, again, the chef and his apprentice. They can try to create a dish with which the apprentice has been struggling by addressing themselves to a black-and-white building, perhaps conflating it with color-schemed buildings that the apprentice already understands and conveniently (if circularly) analogizing it to the troublesome dish. Overall the cognitive complexification and the communal coordination of brute cultural practices tends toward the emergence of culturality.

Someone might make a map of the routes of return to his permanent shelter and on that map record the tally of days that it takes him to cross the territory. Two hitherto discrete and disjunct representations, a map and a tally, have here been integrated. Each takes account of certain respects of the other in order to function in its usual way, that is, *as* map or *as* tally. And morphological transformations might flow from this development. In this instance, for example, in order to squeeze the calendar onto the cartography it might be necessary both to reduce the "numerals" from large strokes to small dots and to enlarge the "distances" from small gaps to large spaces, even though such configurations had not been required (and probably had never appeared) in the representations deployed in both of the complete primitive languages when used independently. With regard to this particular map (and perhaps this map only) one can say that such-and-such a line is like so many days and that so many dots is like such-and-such a distance. Indeed, one *must* recognize these likenesses in order to understand this map in its cultural succession—to see and make use of its full visual meaning. The integration attained in this case can in turn be transferred into mapping and tallying in other contexts and it can be put to use by other people. Many or all maps made in this emerging visual culture might eventually come to acquire a "scale" that tracks the durations of journeys, representing not only where

something is but also how long it takes to get there. In this cultural succession it will become possible to see that, overall, maps are like clocks and vice versa—to see, for example, that a map is a clock of space and a clock is a map of time.

Cultural practices tend to be expanded and integrated with one another in social coordination and communication; expansions and integrations of cultural practices tend to draw on representations produced by others, and to create representations that can be used by them. To the extent that the human form of life is a social one, then, it tends to constitute forms of likeness that issue in culturality. Still, we cannot simply assume that a cultural succession has a social matrix. Culture and especially culturality is not the same thing as the interaction of a particular social group. The mapmaker imagined in the previous paragraph made his drawing for his own use. In no wise did he try to accommodate the ways in which anyone else might use it. Other people might never have seen it anyway. Culturality requires only the agent's awareness of features of his form of life as analogies within it—*what life is like for him*. This is a world that only partly overlaps with the social and cultural worlds of other people. It emerges in his form of life regardless of its cognitive complexity and communal coordination: his thought, at least in some respects, might be simple, and his life, at least in some respects, might be solitary. If they occur at all, cultural successions occur in *his* history, to be communicated or not to others and to be coordinated or not with them.

Of course, we must always specify the relations between a cultural succession and the social matrix that might partly sustain it, just as we must specify the relations between a social group and the cultural succession that might partly constitute it. These relations require the painstaking social history of a visual or any other culture in its succession to and reversion from culturality, if any. But they are not specifically a matter for its general theory.

■ 6

Culturality reconfigures the visible world without necessarily adding anything to it or taking anything away from it. Indeed, in the first recursions and replications of culturality in the aspective successions we can sometimes say—and without any paradox at all—that someone's form of life would be exactly the same as it is without the horizon of culturality *except* for the fact that he himself can no longer see it this way, that is, simply see the visible world. In Wittgenstein's famous metaphor, "light

dawns gradually over the whole."[7] The world contains the same things and events, now illuminated in a certain way from a certain direction. And the light coming on in this way from this direction can be the full and the only extent of novelty, of change and difference in the life in question—that is, of its historicity.

By the same token, however, despite the fact that light dawns over a whole—everything illuminated by it becomes visibly different—the extent of this difference for life as a whole should not be overestimated. It should not be reified as the whole form of life of the agents in question. For one thing, when the light comes on, when forms of likeness including nonvisual analogies emerge as visual aspects of things seen, it does not illuminate everything that remains perfectly visible, including many things made to be seen. For another thing, just because visible things are illuminated—they have new visual aspects—does not inherently mean that an agent lives with them or uses them any differently. With regard to many things, there might be no conceivable consequences to having the light on; it is simply the case that the light happens to be on rather than off. In the example considered in Chapter Nine, when I see the building built by the builders imagined in Section 8 of the *Investigations* perhaps I only need to use it visually as Choosing Black (Fig. 9.16). Though I can see perfectly well (in virtue of the visuality to which I have succeeded) that the building is *also* Choosing Apples (the culturality it has attained in the cultural succession that constituted it and that its builders expected that it should constitute for me) (Fig. 9.35), I have no use for this visible fact in my form of life. A light is on. But for my purposes it might as well be off. Stated less metaphorically, in this case culturality enables nothing visually for me even though I recognize it: it is visible to me. To succeed to visuality does not mean that *everything* I see requires recognition in it.

And we should be thankful for that. Almost everything we care about in life—at least in the life of seeing; that is, of images and imaging—entirely depends on the successions and recursions of vision in visuality and vice versa: on disjunctive and sometimes incomplete calibrations in the coordination and occasional uncertainty of aspective interdetermination. In other words, and regardless of evolutionary or sociological determinations (or both or neither), human perceptual awareness and valuation depends *both* on the autonomic drive *and* on the categorical imperative to see the world as a whole, or more likely and more specifically, to see a certain whole in it—the main topics of *both* vision science *and* visual-cultural studies. But if the world *is* a whole, visuality cannot wholly recognize it. It will only recognize those aspects of what is plainly visible that are salient for it. And if the world is *not* a whole, vision will

nonetheless see it so. It will see a plainly visible world that has no recognizable aspects. Neither of these self-evidently partial situations of real visual perception can be regarded as a human situation. They are theoretical and methodological reifications. For that reason, no science or history of either horizon—neither vision science alone nor visual-cultural studies alone—can claim human relevance. Neither can be realistic.

Vision succeeds to visuality when culturality can be visually ascribed to configuration—to formality, style, or pictoriality, and granting, as I have urged, that these horizons of configuration must be interdetermined as tautologous or self-fulfilling. Conversely, visuality succumbs to vision when visible configuration cannot be visually coordinated as formality, style, or pictoriality in terms of the self-fulfilling tautologies of cultured envisioning. These teleologies intersect—undoubtedly they interact—in any operation of human vision and in all interpretations constituted in human visuality. They overlap and recombine. Indeed, they are cross-wired in ways that sustain their dynamic disjunction—even *cause* it. They constitute the necessary matrix for visual adaptation, and they generate the resistance required for it.

In fact, as I have urged throughout this book, this dynamic disjunction must be identified as the fundamental material fact *both* of the biology of vision *and* of the history of visuality. It would be implausible to suppose (on the one side) that the human visual system has evolved only in order to see the worlds to which some historical visualities have adapted themselves, even though these worlds and the visualities calibrated to them have been the prime—often the only—topic of art history and visual-cultural studies. But it would be equally implausible to suppose (on the other side) that visual adapation to the world seen to have certain specific visible aspects should govern all historical orientations of human vision: that any world of seeing governs visuality everywhere else.

Vision without visuality is merely animal proprioception. The simplest pseudopod would have to be counted as cultured—even as *aestheticized*—to the extent that *aisthesis* primally designates the sensory perception of the organism as cultivated in the environment of its stimulations. In laboratories of vision science and in its offshoots (such initiatives as neuroaesthetics and perhaps "neuroarthistory") human beings tend to be treated as pseudopodical animals. By contrast, *visuality without vision* is merely quasi-robotic information-uptake. In narratives of visuality in visual-culture studies, human beings tend to be treated as cultural servomechanisms: they automatically adjust visually to visible worlds they have produced for such seeing, as a thermostat will adjust to the ambient temperature that it regulates. This self-fulfilling equilibrium, however,

does not in itself explain how the thermometer came to be set in the environment in the first place or account for the range, change, and differentiation of temperature that it can actually register—how visuality can recursively envision the visible world to which it is oriented.

Against these deep errors, a more general theory of visual culture models the real interdeterminations of vision and culture in interleaved aspective successions. It provides a resolution of the conceptual paralysis (as well as the disciplinary disputes and professional divisions) identified in the previous paragraph. Like form and formality (Chapter Three), like style and stylisticality (Chapter Four), and like pictoriality and depiction (Chapters Six, Seven, and Eight), vision and visuality (Chapters One, Nine, and Ten) continually interconvert into one another as precipitates of the aspective successions that I have heuristically identified in this book—of configuration to formality, of style to stylisticality, of pictoriality to depiction, of depiction to iconography, of visibility to culturality.

In this light, a general theory of visual culture is a moral project with political, aesthetic, and ethical implications. In the domain of vision, human beings cannot easily be constrained to see things other than in the way they *do* see them, regardless of the supposed natural adaptation or social conditioning of their vision. Of course, human beings can sometimes be treated like sheep slung in hammocks with their eyes forcibly fixed on certain visual targets (see Chapter Seven). But this cannot be regarded as a natural condition of vision, even if it is socially possible to govern human seeing in this way. The way most people see many things is substantially unconstrained. In its natural order and material activity, human seeing confronts adaptive or social functions of visuality with somatic and aesthetic concretions in vision, and vice versa, leading to the aspective successions, recursions, resistances, and disjunctions that I have considered in this book.

The interdeterminations and involutions of these successions constitute the general condition of vision in hominid and human natural and social history even though they cannot be described as the *cause* of seeing. A general theory of visual culture is not a theory of the human generality of visual culture, as the reification of culturality in vision would force us to suppose. It is a theory of temporary and unstable historical generalizations of culture in human vision, never completed or wholly comprehensive, and especially of emergent configurative consolidations of recognizable aspectivity—visual concretions of form, style, and depiction that coordinate the visible coherence and certainty of a form of life even as they spring from it.

Notes

Chapter 1: Vision Has an Art History

1 All phrases quoted from Michael Kelly, "Editorial Preface," in *The Encyclopedia of Aesthetics*, ed. Michael Kelly (Oxford: Oxford University Press, 1999) vol. 1, *xi*.

2 Heinrich Wölfflin, *The Principles of Art History: The Problem of the Development of Style in Later Art*, 7th ed. (1929) trans. M. D. Hottinger (London: G. Bell and Sons, 1932) 11. In the sixth (1922) and later editions of his *Kunstgeschichtliche Grundbegriffe*, Wölfflin wrote that "it is preferable to speak of modes of *imagination* rather than of modes of *vision*" (ibid. *vii*). Probably he was responding to debates about imaging that I will examine in Chapter 8.

3 In recent years material investigations of vision, imaging, and extrasomatic representation (such as Semir Zeki's *Inner Vision: An Exploration of Art and the Brain* [Oxford: Oxford University Press, 1999]) have attracted the interest of art historians. This has been due in great measure to the efforts of John Onians (see *Neuroarthistory* [New Haven and London: Yale University Press, 2008]). Of course, the modern cognitive psychology of mental imaging has had an impact on the work of some art historians, including my own. In this book, however, I venture no speculations about the neurological materiality of the succession of vision to visuality; I have no competence to do so. My analytic proposals are compatible, I hope, with a range of neuroanatomical and psychological models of seeing, imaging, and knowing.

Chapter 2: Vision and the Successions to Visual Culture

1 Arthur Danto, "Seeing and Showing," *Journal of Aesthetics and Art Criticism* 59 (2001) 9.

2 Arthur Danto, *After the End of Art: Contemporary Art and the Pale of History* (Princeton: Princeton University Press, 1997) 200.

3 Ibid.

4 Ibid. Wölfflin's classification of linear and painterly depictive styles and these examples of artists were presented in *Principles of Art History*, 2–6, 11–16. For unstated reasons Danto replaced Metsu with Gianlorenzo Bernini in his rehearsal of Wölfflin's presentation.

5 Marx W. Wartofsky, "Perception, Representation and the Forms of Action: Towards an Historical Epistemology," in *Models: Representation and the Scientific Understanding* (Boston: D. Reidel, 1979) 188–210; and see "Sight, Symbol, and Society: Towards a History of Visual Perception," *Philosophical Exchange* 3 (1981) 23–38. Though his work has not often been cited by art and cultural historians, Wartofsky can be read as one of the most explicit philosophers of visual culture. His work certainly predates the emergence of visual-culture studies in the discipline of art history.

6 Marx W. Wartofsky, "The Paradox of Painting: Pictorial Representation and the Dimensionality of Visual Space," *Social Research* 51 (1984) 864–65.

7 Ibid. 876.

8 Ibid.; and see Marx W. Wartofsky, "Visual Scenarios: The Role of Representation in Visual Perception," in *The Perception of Pictures*, ed. Margaret Hagen (New York: Academic Press, 1980) vol. 2: *Dürer's Devices: Beyond the Projective Model of Pictures*, 131–52.

9 Wartofsky, "The Paradox of Painting," 877.

10 Ibid. 864; and see Wartofsky's "Art History and Perception," in *Perceiving Artworks*, ed. John Fisher (Philadelphia: Temple University Press, 1980) 23–41.

11 Wartofsky, "The Paradox of Painting," 877–82.

12 Michael Baxandall, *Painting and Experience in Fifteenth-Century Italy: A Primer in the Social History of Pictorial Style* (Oxford: Oxford University Press, 1972). In his later work, Baxandall devoted more consideration to the specific kinds and directions of attention or attentiveness that we bring to pictures. He continued to assume, however, that the attentiveness had already been broadly conditioned socially.

13 Wartofsky, "The Paradox of Painting," 864.

14 Ibid. 877.

15 Danto, "Seeing and Showing," 7, my emphasis. This essay was written as an explicit response to Wartofsky's historical epistemology.

16 Ibid.

17 Danto, *After the End of Art*, 49, my emphasis.

18 Despite certain misleading features, I reproduce two watercolor "copies" of painted figures of animals from the decorated caves of Font de Gaume (Dordogne, France) and Altamira (Santander, Spain). The artist, Henri Breuil, was prone to dramatize the high naturalism of Upper Paleolithic painting and engraving; but his copies and descriptions had wide scholarly and popular influence on twentieth-century perceptions of prehistoric art. For an informative attempt to replicate and illustrate the lighting program of Lascaux, see Mario Ruspoli, *The Cave of Lascaux: The Final Photographs* (New York: Abrams, 1987); for a photographic survey of Altamira, see Pedro A. Saura Ramos et al., *The Cave of Altamira* (New York: Abrams,

1999). The popular thesis that depiction itself *originated in* or was *caused by* the natural object-resemblances of the rock supports cannot be correct, and anyway is not relevant here (though see Chapter Six); what is relevant is the high degree of optical lifelikeness apparent in many Paleolithic pictures.

19 See Iain Davidson and William Noble, *Human Evolution, Language and Mind: A Psychological and Archaeological Inquiry* (Cambridge: Cambridge University Press, 1996). Davidson and Noble have proposed that certain hominid behaviors (the most important are "pointing" with the fingers and "tracing" marks) led to the emergence of spoken language. These behaviors must have been picture making activities, however, if they had the effects that Davidson and Noble have claimed. In other words, Davidson and Noble left the origin of picture making (what I call the presence of pictures) unspecified or undetermined even if they successfully pinpointed pictorial antecedents to cave painting. But if they are right, spoken language was a by-product of picturing once pictures (in whatever medium or modality, not limited to making marks on surfaces) were present. In a suggestive study, Merlin Donald has argued that early hominid behaviors (such as the Mousterian marking considered in Chapter 5) should be understood as a "mimetic culture" that built on the foundations of the "episodic culture" of the great apes and fed into the "mythic culture" of modern humans and their activity of "external symbol storage" (*The Origins of the Modern Mind: Three Stages in the Evolution of Culture and Cognition* [Cambridge, MA: Harvard University Press, 1991]).

20 Merlin Donald makes elaborate suggestions about "hardware changes" and new "visiosymbolic" cognitive pathways laid down respectively at the origin of depiction in the Upper Paleolithic period, in the development of writing systems in the Bronze Age, and in the alphabetization of script in the first millennium BC (ibid. 269–360). Of course, archaeological evidence and neurological correlations for these supposed cognitive-historical transformations, which are quite plausible in theory, will be difficult to discover.

21 Danto, "Seeing and Showing," 7; and see Danto, *After the End of Art*, 49–51.

22 See further Whitney Davis, "Gombrich and the Pictorial Schema" in *Visuality and Virtuality*.

23 Danto, "Seeing and Showing," 2–3.

24 Danto, *After the End of Art*, 202–3.

25 Danto, "Seeing and Showing," 7–8.

26 In Gibson's *Perception of the Visual World* (Boston: Houghton Mifflin, 1950) and *The Senses Considered as Perceptual Systems* (Boston: Houghton, Mifflin, 1966), the example of the pilot was central: Gibson's seminal work on the visual control of spatial orientation in airplane flight had been supported by the U. S. Army Air Force during World War II. For the historical and theoretical background, see Edward S. Reed, *James J. Gibson and the Psychology of Perception* (New Haven: Yale University Press, 1988) 77–87.

27 John Ruskin, *The Elements of Drawing* (London 1857) 5. Disputing Ruskin, a crucial chapter of E. H. Gombrich's *Art and Illusion: A Psychology of Pictorial Representation* (Princeton: Princeton University Press, 1960) dealt with the "myth of the innocent eye." But it is not clear that Gombrich's emphasis on biologically-grounded perceptual schemata is wholly incompatible with Ruskin's notion of seeing that unfolds according to natural routines outside education. Gombrich modeled hu-

man vision on the completely innocent seeing of herring gulls and other creatures that supposedly orient themselves visually according to phylogenetically stabilized schemata or "stereotypes" (see Davis, "Gombrich and the Pictorial Schema").

28 Chiang Yee, *The Silent Traveller in London* (London: Country Life [?], 1938) 161–62. In turn Chiang Yee (ibid. 158), attributed the primary observation to A. P. Oppé, a scholar of Cozens (see "Chinese and English Landscape," *English* 1, no. 2 [1936] 115). For Cozens's blot and wash paintings (sometimes elaborated in pen and ink) and his method of making them, see *A New Method of Assisting the Invention in Drawing Original Compositions of Landscape* (London: J. Dixwell, 1785). The painting illustrated here seems to be a version of no. 2 of the plates in this publication.

29 Chiang Yee, *The Silent Traveller in London*, 162.

30 Arthur Danto, "The End of Art: A Philosophical Defense," *History and Theory* 37, no. 4 (1998) 138.

31 Gombrich, *Art and Illusion*, 84–85. Gombrich compared Chiang Yee's *Cows in Derwentwater* (1936) (my Fig. 2.8), supposedly highly "Chinese," to a prototypically British lithograph of 1826 depicting the same subject.

32 For seeing-as and seeing-in, see especially Richard Wollheim, *Art and Its Objects*, 2nd ed. (Cambridge: Cambridge University Press, 1980) 205–26, elaborating the ideas of Ludwig Wittgenstein in *Philosophical Investigations* (hereafter cited as *PI*), trans. G.E.M. Anscombe, 2nd ed. (Oxford: Blackwell, 1968) 193–229 (Bk. II, Pt. xi). Commentaries on Wittgenstein's remarks are plentiful, but my application is not intended to be specifically faithful to any particular Wittgensteinian or Wollheimian insight or doctrine. Wollheim considered seeing-in to be the special kind of aspect-seeing that enables (or *is*) seeing pictures, whereas seeing-as is the general condition of aspect-seeing. I do not always follow this, nor do I tailor my account of aspect-seeing to picture-seeing (as both Wittgenstein and Wollheim tend to do); I want to be able to address the configurative, stylistic, and cultural aspects of artifacts that interact with pictoriality. We need to be able to say both that Chiang Yee saw the blot of ink as a tiger (in Wollheim's terms, he saw a tiger in it) and that he saw the Chineseness in the painting. For approaches to aspect-recognition in pictorial representation that highlight the recursions of seeing the depicted object (usually in fictive depth) in interaction with the visible painting (on the material surface), see Maurice Pirenne, *Optics, Painting, and Photography* (London: Cambridge University Press, 1970); Michael Polanyi, "What is a Painting?" *British Journal of Aesthetics* 10 (1970) 225–36; Michael Podro, *Depiction* (New Haven: Yale University Press, 1998), esp. 5–28 on "sustaining recognitions"; and Dominic McIver Lopes, *Sight and Sensibility: Evaluating Pictures* (Oxford: Clarendon Press, 2005).

33 Ludwig Wittgenstein, *On Certainty*, ed. G.E.M. Anscombe and G. H. von Wright, trans. Denis Paul and G.E.M. Anscombe (Oxford: Blackwell, 1969) 21. Wittgenstein here intended to refer to our coming to believe (in) "not a single proposition" but "a whole system of propositions"—that is, in a world.

Chapter 3: What Is Formalism?

1 The term "close looking" sometimes seems to be interchangeable with the term "close reading." Art historians are sometimes said to conduct close readings of

paintings, or have been encouraged to do so. But the term "close looking" is preferable for this activity; unless the paintings contain notations, they cannot be read, closely or otherwise (see Chapter 5).

2 A vigorous argument for post-formalist art history can be found in David Summers, *Real Spaces: World Art History and the Rise of Western Modernism* (London: Phaidon, 2003) 15–17, 28–36.

3 Clive Bell, *Art* (London: Chatto and Windus, 1914); and see also *Since Cézanne* (London: Chatto and Windus, 1922).

4 See especially Fry's lectures on art history at Cambridge University in 1933–34: Roger Fry, *Last Lectures*, ed. Kenneth Clark (London: Cambridge University Press, 1939); for sensibility, 22–36. An essential guide to Fry's ideas and writings in this vein is Christopher Green, "Roger Fry's Canon—From African Sculpture to Maurice Vlaminck," in *Art Made Modern: Roger Fry's Vision of Art*, ed. Christopher Green (London: Merrell Holberton and Courtauld Gallery, 1999) 134–212.

5 Richard Wollheim, *On Formalism and Its Kinds* (Barcelona: Fundació Antoni Tàpies, 1995). Wollheim's interest in the problems of formalism and his arguments about its defects can be traced back to "Form, Elements, and Modernity," *British Journal of Aesthetics* 6 (1966) 339–45. In this publication Wollheim responded to an important essay by Michael Podro, "Formal Elements and Theories of Modern Art," *British Journal of Aesthetics* 6 (1966) 329–38. For additional comments on Wollheim's approach to formalism, see Whitney Davis, "Freud, Formalism, and Richard Wollheim," in *Queer Beauty: Sexuality and Aesthetics from Winckelmann to Freud and Beyond* (New York: Columbia University Press, 2010) 271–95.

6 Erle Loran, *Cézanne's Composition: Analysis of His Form with Diagrams and Photographs of His Motifs* [1943], 3rd ed. (Berkeley and Los Angeles: University of California Press, 1963); Rudolf Arnheim, *Art and Visual Perception: A Psychology of the Creative Eye* (Berkeley and Los Angeles: University of California Press, 1964) 22–26.

7 I reproduce the version used by Joseph Jastrow (*Fact and Fable in Psychology* [London: Macmillan, 1901] 295), which was in turn used by Wittgenstein (*PI*, 194), although Wittgenstein's version of Jastrow's illustration was simply an outline drawing that lacked interior shading or hatching.

8 This is not to say no rules have been used to make pictures from prehistory to the present day; for details, see Davis, *Visuality and Virtuality*. The point is that satisfactory analysis of the aspects that a configuration has for us cannot merely specify the rules used to make it, or even how the maker of the configuration applied the rules. Moreover, if we see algorithmicity in a configuration we are not simply seeing its pure formality in the high formalist's sense. We are also seeing a representational and probably a *cultural* aspect of the configuration. In ancient Egypt, for example, the canonical rules of depiction (such as a proportional system used to organize the form and manage the scale of depicted human figures) probably relayed an ideology of Egyptianness.

9 Representationality in Wollheim's special sense inheres not only in pictorial configuration. It also inheres in nondepictive or "abstract" configurations, such as the *Gestaltungen* explored by Hans Hofmann. But the point of abstract configurations like Hofmann's has often been to make visible a nondepictive representationality, not to reduce or occlude it. If there is a "retreat from likeness" in abstract painting,

then, it is a retreat from representing recognizable extrapictorial objects; that is, from mimesis. It has not been a retreat from the configuration of something to be seen as having conformation, depth, scale, and movement, or representationality in Wollheim's sense. My reference is to Frances Bradshaw Blanshard, *Retreat from Likeness in the Theory of Painting*, 2nd ed. (New York: Columbia University Press, 1949), one of the best treatments of the withdrawal of painting from mimesis, or what Blanshard calls "the copy theory" of painting. As Blanshard noticed, this withdrawal was not due only to abstraction in modern painting. It has been promoted by theoreticians of art for many centuries, for example, in the construction of "ideal" naturalism (see especially Charles A. Cramer, *Abstraction and the Classical Ideal: 1760–1920* [Newark, DE: University of Delaware Press, 2006]).

10 Fry, *Last Lectures*, 23, 58, and fig. 1. Fry did not identify the prototype (see *Paul Klee: Catalogue Raisonné*, ed. Josef Helfenstein and Christian Rümelin, vol. 5 [Bern: Benteli, 2001] 233, no. 4989); he probably had never seen the original. His tracing was based on a photograph, likely the one published by Carl Einstein in *Die Kunst des 20. Jahrhunderts*, 3rd ed. (Berlin: Propyläen-Verlag zu Berlin, 1931) 551 (my Fig. 3.5), which he reproduced along with his tracing (my Fig. 3.4). The original painting (67 x 50 cm.), now in Düsseldorf, was made with oil and chalk on plywood. The background is an uneven rust color, and the lines were painted in blue with the exception of two blue-black stripes on either side of the figure and two purple swatches below the man's hat—details ignored in Fry's tracing and not readily visible, or invisible, in the photograph from which Fry apparently worked. For the sake of economy here I will pass over the specifically photographic mediation.

11 Albert C. Barnes, *The Art in Painting* [1925], 3rd ed. (Merion Station, PA: Barnes Foundation Press, 1937) x. (This edition reprints the Preface to the 1st [1925] edition.) See also Albert C. Barnes and Violette De Mazia, *The French Primitives and Their Forms from Their Origin to the End of the Fifteenth Century* (Merion Station, PA: Barnes Foundation Press, 1931) and *The Art of Henri-Matisse* (New York: Scribner, 1933). For the collection in the Phillips Memorial Gallery, see Duncan Phillips, *A Collection in the Making: A Survey of the Problems Involved in Collecting Pictures* (New York: E. Weyhe, 1926), and *The Artist Sees Differently: Essays Based Upon the Philosophy of a Collection in the Making* (Washington, DC: Phillips Memorial Gallery, 1931). Phillips's aesthetic theory was taken over from George Santayana's concept of the objectification of pleasure in *The Sense of Beauty* (New York: Scribner, 1896), discussed in Chapter 4.

12 Roger Fry, *Transformations: Critical and Speculative Essays on Art* (London: Chatto and Windus, 1926) 183–84. This essay was originally published in *The Burlington Magazine* in 1923 in response to an exhibition of paintings by Van Gogh at the Leicester Galleries, London.

13 *The Complete Letters of Vincent Van Gogh*, ed. Vincent W. Van Gogh, trans. Johanna Van Gogh-Bonger and C. de Dood, 2nd ed. (London: Thames and Hudson, 1978) vol. 3, 56, no. 543; for the French text, see *Vincent Van Gogh: Brieven aan zijn Broeder*, ed. J. Van Gogh-Bonger (Amsterdam: Goede & Goedkoope, 1914) vol. 3, 195. As Martin Gayford has pointed out, in "describing the yellow of the sun that burnt in the sky above his house, Vincent accidentally wrote 'souffre' not 'soufre'— not 'sulphur' but 'suffering'—perhaps an insignificant slip" (*The Yellow House: Van Gogh, Gauguin, and Nine Turbulent Weeks in Arles* [London: Fig Tree, 2006] 19).

14 In his letter to Theo, Van Gogh simply described the painting as representing *la maison et son entourage*, although this specification is not a title in the strict sense. Later, he called it *La Rue*. The title *Yellow House* or *Yellow House at Arles* has been applied by curators and writers.

15 For Fry's appreciation of ancient Egyptian art, see especially *Last Lectures*, 49–63; for Mesopotamian and Aegean art, 64–74; for "Negro" art, 75–84; for "Amerindian" art, 85–96; for Chinese art, 97–149; and for Indian art, 150–69. See Christopher Green, "Expanding the Canon: Roger Fry's Evaluations of the 'Civilized' and the 'Savage,'" in *Art Made Modern*, ed. Green, 119–32. As Green shows, Fry knew the writings of anthropologists and archaeologists on these arts. In my view he tended, however, to accept psychologistic and essentially primitivizing models of premodern arts. For example, he preferred the parallel between ancient Egyptian art and children's drawing promoted by the Egyptologist Heinrich Schäfer (see Green, "Roger Fry's Canon," 163, though Green does not cite Schäfer's work) rather than the political-cultural and religious-ideological interpretation of Egyptian art developed by Henri Frankfort at the Warburg Institute in the 1920s and 30s, though Frankfort's writings—disputing Schäfer's comparisons—were surely known to him.

16 See Whitney Davis, "Revolutions of Rotation," in *Visuality and Virtuality*.

17 A haptic style produces a representation of a "self-contained" object as it might be apprehended (as if by touch) without the distancing, denaturing effects of *visual* perception, which cannot see all around the several sides of an object. By contrast, the optic style configures visual aspects of an object set in a substantial phenomenal space (as opposed to a mere void) and subject to the phenomena of shadowing, foreshortening, illumination, color gradients, and the like. For the terms and concepts, see Aloïs Riegl, *Historical Grammar of the Visual Arts*, trans. Jacqueline E. Jung (New York: Zone Books, 2004), a translation of two texts written by Riegl in the 1890s that deal in part with the transhistorical contrast of haptic and optic styles. Riegl's *Spätrömische Kunstindustrie* (Vienna: Österreich. Staatsdruckerei, 1901) emphasizes the contrast between lesser and greater *optic* configuration in earlier and later Roman art and the transition from lesser to greater opticism in the ideological transformations of the later Roman Empire.

18 For one reconstruction of the social basis and the ontological and epistemological grounds and claims for haptic configuration in Egyptian pictorialization, see Whitney Davis, *The Canonical Tradition in Ancient Egyptian Art* (Cambridge: Cambridge University Press, 1989) 192–224.

19 The quest to find such evidence in *Strukturforschung* has sometimes been equivalent to Fry's effort to understand the mental state of Van Gogh; *Strukturforschung* simply transfers the issue from the individual plane to the communal and social plane. In assuming a transpersonal worldview, however, *Strukturforschung* confronts even graver difficulties than do those formalisms that are devoted to discovering an individual's historical psychology in his forming activity. If *Kunstwollen* is a function of a putatively transpersonal *Weltanschauung*, formality and representationality are functions of an individual's aspect-seeing that should never be analytically conflated with the aspect-seeing of other people.

20 For an extended investigation of this dynamic in a case of pictorial analysis in the field of psychoanalysis itself, see Whitney Davis, *Drawing the Dream of the Wolves:*

Homosexuality and Interpretation in Freud's "Wolf Man" Case (Bloomington, IN: Indiana University Press, 1996), and for comments on Freudian formalism, see Davis, "Freud, Formalism, and Richard Wollheim" in *Queer Beauty*. An exemplary consideration of the interplay in Fry's criticism between a theory of "pure form" and an understanding of "psychological nuances" in the work of art can be found in Christopher Green, "Into the Twentieth Century: Roger Fry's Project Seen from 2000," in *Art Made Modern*, ed. Green, 12–30. As Green points out, "Fry conclude[d] the last article he published, in September 1934, by leaving unresolved what had become the central theoretical issue for him, the question of whether 'psychological' and 'plastic' (formal) responses can combine in the experience of paintings" (ibid. 14). But Fry's psychology did not systematically avail itself of the corrective established in psychoanalysis by the theory (and more important the practice) of countertransference. The methodological relation between Fry's psychologistic formalism and Freudian formalism took the form, then, of a methodological opposition (see Roger Fry, *The Artist and Psychoanalysis* [London: L. and V. Woolf, 1924]).

Chapter 4: The Stylistic Succession

1 There can be many definitions of what counts as an historical origin or the "production system" that is common to a group of artifacts, and there can be many ways to specify the set or sequence. Here I assume rough-and-ready understandings of these parameters of style. For detailed discussion on which this chapter is partly predicated, see Whitney Davis, "Style and History in Art History," in *Replications: Archaeology, Art History, Psychoanalysis* (University Park, PA: Pennsylvania State University Press, 1996) 171–98.

2 Illustrated here, Sir Richard Westmacott's "Achilles," the monument to the Duke of Wellington erected in Hyde Park in 1822 opposite the Duke's residence, was modeled on one of the two colossal figures once located outside the entrance of the Baths of Constantine and later moved to the Piazza di Monte Cavallo (Piazza del Quirinale) by Pope Sixtus V. According to tradition the statues were never buried or covered, remaining continuously visible since antiquity. Often called "the Horse Tamers," they have been identified as "Alexander and Bucephalus" or "Castor and Pollux" (the Dioscuri). For discussion of the ancient works and their modern replications, see Francis Haskell and Nicholas Penny, *Taste and the Antique* (New Haven and London: Yale University Press, 1981) 136–41.

3 For the bronzes of Luristan, see originally A. Godard, *Les bronzes de Luristan* (Paris: École française d'Extrême-Orient, 1931); for the geographic scope and stylistic definition and differentiation of the early Animal Style, see J. Deshayes, *Les outils de bronzes, de l'Indus au Danube (IVe au IIe millénaire)*, 2 vols. (Paris: Paul Geuthner, 1960). My Fig. 4.3 depicts a rampant ibex with a lion's head sprouting from each shoulder; Fig. 4.4 depicts a plant between two dragons. For the Animal Style in central and northern Europe, see especially the pioneering conspectus by Bernhard Salin, *Die altgermanische Thierornamentik* (Stockholm: K. L. Beckmann, 1904). My Fig. 4.5 shows two antithetical, intertwined animals looking backwards, each biting its hind foot; in the center the intercrossing lines also construct the face of a bearded man. An incisive but partial and now out-of-date summary of the "barbaric animal styles" can be found in Francis Klingender,

Animals in Art and Thought: To the End of the Middle Ages, ed. Evelyn Antal and John Harthan (London: Routledge and Kegan Paul, 1971) 95–141; in the purview of the Animal Style, Klingender included Sumerian (Jemdet Nasr) seals, Luristan bronzes, Scythian goldwork, early Celtic art, Germanic ornament, Hiberno-Saxon manuscripts and crosses, and Viking art.

4 A rough analogy might be made in this regard with the recognition of biological species by botanists and zoologists. Despite our present-day taxonomic achievements, there must be many unrecognized species, if only because variation and speciation continue to occur all around us. The same goes for styles: the landscape of the past and the present might be teeming with styles unnoticed by art historians in the same way that a jungle or wetland, even a familiar garden, could be teeming with species unidentified by biologists. In point of fact, botany and zoology probably have been more successful in finding species than art history in finding styles. Histories of human making have no theory as comprehensive as the genetic theory of evolution by natural selection, which shows how histories of self- and cross-fertilization produce the variation of hereditary characters in living organisms—variations retained or extinguished under selective pressures. To be sure, developmental accounts of style were proposed by nineteenth-century organicists and by twentieth-century sociologists of cultural fashion. But these accounts generally modeled themselves on stories of the life history of individual organisms, not on evolutionary accounts of morphogenesis in variation by natural selection. Strictly speaking, developmental accounts of style are based more on biographical than biological models. For a detailed historiographical treatment of these issues, see Thomas Munro, *Evolution in the Arts, and Other Theories of Culture Change* (Cleveland: Cleveland Museum of Art, 1963).

5 Petrie's "Sequence Dating" was designed to reveal the relative chronology (though not the absolute dates and durations) of various groups of artifacts by tracking the distribution and fluctuation of individual traits or clusters of traits. According to his theory, these traits had to index the time, place, and agents of their making; they were not, then, stylisticalities. On its own terms, Sequence Dating, like many other methods of diagnostic stylistic analysis in archaeology, was (and still is) readily defeated by the complexities of the stylistic succession. Most important, Sequence Dating cannot confirm internally on the basis of its evidence that the traits were *not* treated as stylistical by the original makers, though there may be other reasons to believe this: needless to say, the seriations must be integrated with (and checked by) such other forensic methods of archaeology as stratigraphy. For Sequence Dating, see W.M.F. Petrie, *Naqada and Ballas* (London: Quaritch, 1896) and *Diospolis Parva* (London 1901); for helpful discussion, see Bruce G. Trigger, *Beyond History: The Methods of Prehistory* (New York: Holt, Rinehart, and Winston, 1968).

6 For a range of historiographical, contextual, and theoretical commentaries, see *Giovanni Morelli e la cultura dei conoscitori*, ed. Giacomo Agosti et al., 3 vols. (Bergamo: Pierluigi Lubrina Editore, 1993).

7 *Italian Painters: Critical Studies of Their Works (The Borghese and Doria-Pamfili Galleries in Rome)* [1890–93], trans. Constance Jocelyn Ffoulkes (London: John Murray, 1893) 43–45 (my emphasis). If academic means self-conscious, conventional action (prescribed, intended, and the result of deliberate rule-following),

then the *Grundformen* cannot be academic. By *akademisch*, Morelli sometimes seems to have denoted a blind following of another's way of doing things—unknowing and unselfconscious. It is worth noting that Morelli contrasted his own forensic method with the supposedly "academic" procedures of art historians like Franz Kugler, J. B. Crowe and G. B. Cavalcaselle, and Wilhelm von Bode, a point to which I will return later in this chapter.

8 Peter Fenves, "Alterity and Identity; Postmodern Theories," in *The Encyclopedia of Aesthetics*, ed. Michael Kelly (New York: Oxford University Press, 1999) vol. 1, 187–88.

9 For analytic individuals, see especially a penetrating study by James N. Hill, "Individual Variability in Ceramics and the Study of Prehistoric Social Organization," in *The Individual in Prehistory: Studies of Variability in Style in Prehistoric Technologies*, eds. James N. Hill and Joel Gunn (New York: Academic Press, 1977) 55–108.

10 For the Nubian A-Group, see Hans-Åke Nordström et al., *Neolithic and A-Group Sites* (Stockholm: Scandinavian Universities Press, 1972). For their part, the "Beaker-folk can be recognized not only by their economic activities but also by the distinctive armament, ornaments, and above all pottery, associated together everywhere in their graves. Indeed, the inevitable drinking-cup, which gives a name to its users, may be more than a readily recognized diagnostic symptom; it symbolizes beer as one source of influence, as a vodka flask or gin bottle would disclose an instrument of European domination in Siberia and Africa respectively" (V. Gordon Childe, *The Dawn of European Civilization*, 6th ed. [London: Routledge, 1957] 223). Childe illustrated the "classical" or "pan-European" style of the Beaker Folk's typical beaker in examples from southern France and Sicily (my Fig. 4.9, nos. 3 and 4). But he could also cite examples from Portugal, Andalusia, Catalonia, Brittany, the Middle Rhine region, Bohemia, and Moravia, among many other places: "this classic Pan-European style is represented in nearly every region reached by the Beaker-folk" (ibid. 224). See originally Alberto del Castillo Yurrita, *La cultura del vaso campaniforma* (Barcelona: Sociedad general de publicaciones, 1928).

11 Archaeological diagnostics slides between studies of technique and style. Often it is impossible to discern whether the analysis investigates technique or style, or the style of technique, or technique in style—or all or none of these interacting phenomena. In theory, however, technique (or what is sometimes called "facture" when it has visible aspectivity) can be rigorously distinguished from style. Pure style precipitates from a maker's making *regardless* of his technique. Indeed, a good test of any attribution in connoisseurship addresses distinct *variations* in the attributed maker's technique: his style persists despite the fact (for example) that he used many different kinds of pencils and brushes (and the same pencils and brushes in many different ways) or the fact that he painted in fresco and encaustic as well as oils, even though the resulting artifacts might display the factures characteristic of these techniques. Similarly, archaeological diagnostics (if it is to individuate styles and thereby identify group-traditional makers) must identify likenesses across replications regardless of technique, and indeed despite it.

12 The best-known examples are Berenson's *Florentine Painters of the Renaissance* of 1896, considered at the end of this chapter, and Sir John Beazley's *Attic Red-Figure Vase Painters* of 1942 (2nd ed., 3 vols., Oxford: Oxford University Press, 1963) and *Attic Black-Figure Vase Painters* of 1956 (for Beazley, see further Chapter 5). They

continue to be produced. For example, Lawrence Richardson, Jr., has explicitly said that his method in attributing dozens of ancient Roman paintings to their makers is Morellian (*A Catalog of Identifiable Figure Painters of Ancient Pompeii, Herculaneum, and Stabiae* [Baltimore: Johns Hopkins University Press, 2000], *xii*).

13 Fern Rusk Shapley, *Catalog of the Italian Paintings* (Washington, DC: National Gallery of Art, 1979), vol. 1, no. 534. For the painting and its context, history, and connoisseurship, see *Raphael, Cellini, and a Renaissance Banker: The Patronage of Bindo Altoviti*, ed. Alan Chong, Donatella Pegazzano, and Dimitrios Zikos (Boston: Isabella Stewart Gardner Museum, 2003), and David Alan Brown and Jane Van Nimmen, *Raphael and the Beautiful Banker: The Story of the Bindo Altoviti Portrait* (New Haven: Yale University Press, 2005).

14 *Le Opere di Giorgio Vasari*, ed. Gaetano Milanesi, vol. 4 (Florence: G. C. Sansoni, 1879) 351; Giovanni Morelli, *Italian Masters in German Galleries: A Critical Essay on the Italian Pictures in the Galleries of Munich, Dresden, [and] Berlin* [1880], trans. Luise Marie Richter (London: G. Bell and Sons, 1883) 113; Johann David Passavant, *Raphael d'Urbin et son père, Giovanni Santi* (Paris: Renouard, 1860) vol. 2, 117. Oddly enough, the other sixteenth-century document pertaining to the painting is also grammatically ambiguous: Giovanni Batista Armenini, *De' veri precetti della pittura* (Ravenna: Francesco Tebaldini, 1587) 191, quoted in this regard by Passavant, *Raphael d'Urbin*, vol. 2, 117.

15 *Italian Masters in German Galleries*, 112–14.

16 Examples are cited by Frederick Hartt, *Giulio Romano* (New Haven: Yale University Press, 1958) 52.

17 Reading Vasari in one of the grammatically permitted ways, an early study of the self-portraits of Raphael by Giovanni Gaetano Bottari (1689–1775) assigned the picture to Raphael as his self-portrait, though supporters of the attribution to Raphael did not always accept this (e.g., Passavant, *Raphael d'Urbin*, 117). Hartt (*Giulio Romano*, 51) mistakenly blamed Carl Friedrich Rumohr for inventing the self-portrait theory; Rumohr simply accepted it. Hartt was also incorrect that Altoviti family tradition said that the sitter was Bindo. In the late sixteenth and early seventeenth century, perhaps it did. But in 1767, the painting was removed from the Palazzo Altoviti in Rome, where it had been hanging since Vasari's day, for exhibition in Florence, where it was labeled "the celebrated portrait of Raphael, painted by his own hand" (*Il celebre Ritratto di Raffaelo da Urbino, dipinto di mano propria*) (see Shapley, *Catalog of the Italian Paintings*, vol. 1, no. 534, n. 7). Presumably this label had the imprimatur of the owner at the time, Flaminio Altoviti. Whether Flaminio had accepted Bottari's view, or conversely whether Bottari had relayed Altoviti tradition or Flaminio's version of it, remains unclear. But the 1767 label seems to have been stating a putative fact known to all. In the early eighteenth century, the Altovitis sold the painting as Raphael's *Self-Portrait* to Crown Prince Ludwig (later Ludwig I) of Bavaria, who passed it to the Alte Pinakotek, Munich. It was so attributed and cataloged there in 1853, but later curators and catalogers in the gallery did not always endorse the identification, which had become contested in Morelli's day.

18 Sidney J. Freedberg, *Painting of the High Renaissance in Rome and Florence* (Cambridge, MA: Harvard University Press, 1961) 427 (repeated in later eds.).

19 Oskar Fischel, *Raphael*, trans. Bernard Rackham (London: Kegal Paul, 1948) vol. 1, 122. The National Gallery's position is stated in its current on-line catalog.

20 For Kugler and Burckhardt, see Christine Tauber, *Jacob Burckhardt's "Cicerone": Eine Aufgabe zum Geniessen* (Tübingen: Niemeyer, 2000); for Crowe and Cavalcaselle, see Donata Levi, *Cavalcaselle: Il pioniere della conservazione dell'arte italiana* (Turin: Einaudi, 1988). The Hegelian connotation of the term *geistige Gehalt* is self-evident; how Kugler and Burckhardt or Crowe and Cavalcaselle understood Hegel is a complicated matter that I cannot address here.

21 Morelli's most directly stated opposition to the notion of basing an attribution solely on the *geistige Gehalt* of a work of art appeared in his criticisms of the French art critic Charles Blanc and of his own professional nemesis in Germany, the curator Wilhelm von Bode (see further Manfred Ohlsen, *Wilhelm von Bode: Zwischen Kaisermacht und Kunsttempel* [Berlin: Gebr. Mann, 1995]). But throughout his treatments of the Italian paintings in Italian and German galleries, Morelli severely criticized the "spiritual" resolutions presented in the handbooks by Kugler and Burckhardt and in Crowe and Cavalcaselle's history of Italian painting.

22 George Santayana, *Lotze's System of Philosophy*, doctoral dissertation, Harvard University, 1889 (ed. Paul Grimley Kuntz [Bloomington, IN: Indiana University Press, 1971]); *The Sense of Beauty; Being the Outlines of Aesthetic Theory* (New York: Scribner, 1896). Santayana was thoroughly familiar with Lotze's work in aesthetics.

23 *The Sense of Beauty*, 13.

24 For further discussion, see Whitney Davis, "Queer Beauty: Winckelmann and Kant on the Vicissitudes of the Ideal" and "The Sense of Beauty: Homosexuality and Sexual Selection in Victorian Aesthetics," in *Queer Beauty*, 23–50 and 155–86.

25 See Florence Mary Fitch, *Der Hedonismus bei Lotze und Fechner* (Berlin: E. Ebering, 1903); G. Stanley Hall, *Founders of Modern Psychology* (New York: Appleton, 1924) 65–121; and John Gilbert Beebe-Center, *The Psychology of Pleasantness and Unpleasantness* (New York: D. Van Nostrand, 1932). For a review of contemporary psychophysiology known to Santayana, see Alfred Lehman, *Die Hauptgesetze des menschlichen Gefühlslebens* (Leipzig 1892).

26 See Whitney Davis, "Representative Representation: Schopenhauer's Ontology of Art," in *Queer Beauty*, 83–98.

27 George Santayana, "A Long Way Round to Nirvana; or Much Ado about Dying" [1923], in *Some Turns of Thought in Modern Philosophy* (Cambridge: University Press, 1933); see also "Two Rational Moralists" [1916], in *Animal Faith and Spiritual Life*, ed. John Lachs (New York: Appleton-Century-Crofts, 1967) 351–58.

28 *The Sense of Beauty*, sect. 12.

29 See especially George Santayana, "What is Aesthetics?" *The Philosophical Review* 13 (1904) 320–37 (reprinted in *Obiter Scripta* [New York: Scribners, 1936] 30–40); *Reason in Art* [1905], in *The Life of Reason; Or, The Phases of Human Progress*, 5 vols. (New York: Scribners, 1905–1906); *Scepticism and Animal Faith: Introduction to a System of Philosophy* (New York: Scribners, 1923); and "The Mutability of Aesthetic Categories" [1923], in *Animal Faith and Spiritual Life*, 418–29.

30 See especially Santayana's review in *The Psychological Review* 3 (1896) 677–79.

31 As Jeremy Melius has pointed out, Berenson might have been the first connoisseur to individuate historically *unknown* or unidentified artists (notably, as Melius has shown, the "Amico di Sandro" or "friend of Sandro Botticelli"), a practice that became common in later connoisseurship in the Berensonian tradition (for example, in the work of Beazley, who attributed Greek painted vases to artists

and workshops otherwise unknown [see Chapter 5]). Many archaeologists and connoisseurs had tried to find the works to attach to the names of *known* artists. Morelli often *de*attributed the works of known artists. But he did not usually attribute works to unknowns, though what I have called the Painter X who emerged in his analysis as the painter of the supposed *Bindo Altoviti* by Raphael might count as such a case.

Chapter 5: The Close Reading of Artifacts

1 See especially Jules David Prown, *Art as Evidence: Writings on Art and Material Culture* (New Haven: Yale University Press, 2001) and *American Artifacts: Essays in Material Culture*, ed. Jules David Prown and Kenneth Haltman (East Lansing, MI: Michigan State University Press, 2000). Of course, archaeologists have deployed the metaphor of reading artifacts as well; see Ian Hodder, *Reading the Past: Current Approaches to Interpretation in Archaeology* (Cambridge: Cambridge University Press, 1991). But here a more explicitly semiological or poststructuralist approach anchors the metaphor in cultural theory.

2 On these problems, see further Whitney Davis, "Planarity and Its Disjunctions" and "Immanent Virtuality and Emergent Virtuality" in *Visuality and Virtuality*.

3 An insightful theoretical discussion and erudite historiographical survey can be found in Carrie Noland, *Agency and Embodiment* (Cambridge, MA: Harvard University Press, 2009).

4 "Lunar Notation on Upper Paleolithic Remains," *Science* 184 (1964) 28–46; *Notation dans les gravures du Paléolithique supérieur* (Bordeaux: Impr. Delmas, 1970); "Cognitive Aspects of Upper Paleolithic Engraving," *Current Anthropology* 13 (1972) 445–77; and *The Roots of Civilization: The Cognitive Beginnings of Man's First Art, Notation, and Symbolism* (New York: McGraw-Hill, 1972; 2nd ed., Mount Kisco, NY: Moyer Bell, 1991). For one of the many critical reviews of Marshack's proposals, see Judy Robinson, "Not Counting on Marshack: A Reassessment of the Work of Alexander Marshack on Notation in the Upper Palaeolithic," *Journal of Mediterranean Archaeology* 2 (1992) 1–16. Fig. 5.1 is drawn after Marshack's 1985 diagram of an "engraved and shaped bone plaque" from the rock shelter of Blanchard near Les Eyzies in the Dordogne (for his close-up photograph, see *The Roots of Civilization*, fig. 7; for his original analysis, see *The Roots of Civilization*, 2nd ed., 41–50, 54–56); this "schematic rendition of the incised marks on the Blanchard plaque" purports to show that "[t]he 69 marks are made in 24 'sets' in different styles and by different tools, forming a serpentine image that matches the waxing and waning of the moon" (Alexander Marshack, *Hierarchical Evolution of the Human Capacity: The Paleolithic Evidence* [New York: American Museum of Natural History, 1985] fig. 11).

5 For the bones from Bilzingsleben, said to display "sequence[s] of engraved lines," see Dietrich Mania and Ursula Mania, "Deliberate Engravings on Bone Artefacts of Homo Erectus," *Rock Art Research* 5 (1988) 91–97; my Fig. 5.2, drawn after Mania and Mania's diagram, illustrates "Artifact 1," the spall of an elephant tibia. More recently, a find from Blombos Cave in southern Africa (c. 75,000 BC) has attracted considerable commentary; it is a flat piece of ochre with engraved X-shaped marks set into or integrated with a framework of three horizontal lines (for the initial publication, see Christopher Henshilwood et al., "Emergence of Modern Human

Behaviour: Middle Stone Age Engravings from South Africa," *Science* 295, no. 5561 [2002], 1278–80).

6 "A New Model and Its Implications for the Origin of Writing: The La Marche Antler Revisited," *Cambridge Archaeological Journal* 5 (1995) 163–206 (quotation from p. 163). For d'Errico's methods, see also "Study of Upper Palaeolithic and Epipalaeolithic Engraved Pebbles," in *Scanning Electron Microscopy in Archaeology*, ed. Sandra L. Olson (Oxford: British Archaeological Reports, 1988) 169–84; "Lecture technologique de l'art mobilier gravé," *L'Anthropologie* 92 (1988) 101–22; "Palaeolithic Lunar Calendars: A Case of Wishful Thinking?" *Current Anthropology* 30 (1989) 117–18; "Microscopic and Statistical Criteria for the Identification of Prehistoric Systems of Notation," *Rock Art Research* 8 (1991) 83–93; "Technology, Motion, and the Meaning of Epipalaeolithic Art," *Current Anthropology* 33 (1992) 94–109. Marshack's analysis of the baton from La Marche can be found in *The Roots of Civilization*, 2nd ed., 192–96; the differences between Marshack's observations and d'Errico's are summarized by d'Errico, "The La Marche Antler Revisited," fig. 18.

7 Ibid. 183.

8 If we use a handlens or a microscope to inspect marks, we are practically guaranteed to find differences among them (perhaps ordered in the apparent form of "sets" and groups of different sets) that will be visible at that degree of resolution, but not, perhaps, at the ordinary and original degree of resolution. D'Errico has claimed that the differences between marks that he has observed with a scanning electron microscope do not square with Marshack's identification (using a handlens) of groups and sets of marks supposedly made originally by different tools at different times. If correct, d'Errico's findings dispose of Marshack's decipherment. But they do not in themselves dispose of the possibility that the marks were readable. The readability of a tally or count, for example, depends chiefly on the visibility of the *discreteness* of marks (whether or not these marks are seen to vary one from the next or from one "set" to another)—the feature of readability that would be required for them to amount to a specifically calendrical notation using *visible groups of visible sets of discrete marks*.

9 James Elkins, "On the Impossibility of Close Reading: The Case of Alexander Marshack," *Current Anthropology* 37 (1996) 185–226. For Marshack's methods, see especially his "Concepts théoriques conduisant à de nouvelles méthodes analytiques, de nouveaux procédés de recherche et categories de données," *L'Anthropologie* 88 (1984) 85–100.

10 See Whitney Davis, "The Deconstruction of Intentionality in Archaeology," *Antiquity* 66 (1992) 334–47, reprinted in *Replications*.

11 See, for example, Lewis R. Binford, *In Pursuit of the Past: Decoding the Archaeological Record* (New York: Thames and Hudson, 1983) 8, 14.

12 See Lewis R. Binford, *Faunal Remains from Klasies River Mouth* (Orlando, FL: Academic, 1984) 9.

13 Leslie G. Freeman, Lewis R. Binford, and Randall White, "More on the Mousterian: Flaked Bone from Cueva Morín," *Current Anthropology* 23 (1988) 66–77.

14 *Attic Red-Figure Vase Painters* (Oxford: Oxford University Press, 1942; 2nd ed., 3 vols., Oxford: Oxford University Press, 1963) and *Attic Black-Figure Vase Painters* (Oxford: Oxford University Press, 1956). For the early, mature, and late productions of the Berlin Painter, and identification of vase paintings *not* to be attributed

to him but instead to his followers or school, see *The Berlin Painter*, 2nd ed. (Berlin 1947). For the concept of "analytic individuals," see further Whitney Davis, "Style and History in Art History" in *Replications*.

15 Richard T. Neer, *Style and Politics in Athenian Vase-Painting: The Craft of Democracy ca. 530–460 BCE* (New York: Cambridge University Press, 2002). Discussion of the possibility that the marks on the Bilzingsleben bones resulted simply from defleshing them can be found in the comments on the excavators' initial report (see note 5), including my own. In my comment I failed to notice the possibility that the resemblance between defleshing-marks and "deliberate" marks might itself be deliberate—a "pictoriality" in the marks not to be identified with notation.

16 See Paul de Man, *Allegories of Reading: Figural Language in Rousseau, Nietzsche, Rilke, and Proust* (New Haven: Yale University Press, 1979), and especially the pioneering analysis of "Hypogram and Inscription" [1981] in *The Resistance to Theory* (Minneapolis: University of Minnesota Press, 1986) 27–53.

17 G.-B.-M. Flamand, *Les pierres écrites (Hadjrat-Mektoubat): gravures et inscriptions rupestres du nord-africain* (Paris: Masson, 1921); see further Whitney Davis, "The Study of Rock Art in Africa," in *A History of African Archaeology*, ed. Peter S. Robertshaw (London: J. Curry, 1990) 272–74. In the illustrations reproduced here, Flamand tried to discriminate two different modes of incision—an outline cutting (linear incision) with a point (Fig. 5.4[a]) and an interior (concave) scraping with a wider and blunter point ([Fig. 5.4[b])—and examined the distinctive ways in which they dealt with the natural irregularities of the rock surface. Eventually, he distinguished four major types of incision with several subtypes or variants in each (Fig. 5.4[c] illustrates the sections and profiles of incisions correlated with the different types of engraving tool employed in what Flamand called the "sharp-furrow" technique used in North African petroglyphs). In turn, these different kinds of incision could sometimes be observed to be superimposed on one another in particular figures or in sets ("compositions") of figures; in other words, apparently more than one kind of tool was sometimes used to make a single figure.

Chapter 6: Successions of Pictoriality

1 H. P. Grice, "Utterer's Meaning and Intention," *The Philosophical Review* 78 (1969) 147–77 (quotation from p. 151); H. P. Grice, "Meaning," *The Philosophical Review* 66 (1957) 377–88.

2 Bernard E. Rollin, *Natural and Conventional Meaning: An Examination of the Distinction* (The Hague: Mouton, 1976), has systematically compared Gricean and semiotic vocabularies. For relevant writings by Peirce, see *Peirce on Signs: Writings on Semiotic by Charles Sanders Peirce*, ed. James Hoopes (Chapel Hill, NC: University of North Carolina Press, 1991); for Gell, see Alfred Gell, *Art and Agency: An Anthropological Theory* (Oxford: Clarendon Press, 1998), and Whitney Davis, "Abducting the Agency of Art," in *Art's Agency and Art History*, ed. Robin Osborne and Jeremy Tanner (Oxford: Blackwell, 2008) 199–219.

3 See "Utterer's Meaning, Sentence-Meaning, and Word-Meaning," *Foundations of Language* 4 (1968) 231–33; "Utterer's Meaning and Intentions," 147, 153.

4 Ibid. 177.

5 "Utterer's Meaning and Intention," 228; "Meaning Revisited," in *Mutual Knowledge*, ed. N. V. Smith (London: Academic Press, 1982) 223–43. Grice distinguished several *kinds* of meaning in a language, including "timeless meaning" and "applied timeless meaning" ("Utterer's Meaning and Intention," 148–49). But this entire genus of meaning will not be my focus. Therefore there is no need to enumerate its species here. For relevant commentary, see Dan Sperber and Deirdre Wilson, *Relevance: Cognition and Communication* (Cambridge, MA: Harvard University Press, 1986) 9–11.

6 This nice point is John Biro's in "Intentionalism in the Theory of Meaning," *The Monist* 62 (1979) 245.

7 There are *philosophical* efforts to develop a Gricean approach in the study of depiction: see David Novitz, *Pictures and Their Use in Communication: A Philosophical Essay* (The Hague: Mouton, 1977) 26–32.

8 For these examples, see further Whitney Davis, "Renaissance Virtuality and Modern Metaopticality," in *Visuality and Virtuality*. In the case of the figure of Jacob in the relief of Jacob, Isaac, and Esau, visible scale could be resolved pictorially both as the depiction of a really big man and as a depiction of the way he was pictorialized (what he was seen as, what was seen in him) by his sons—as looming large in both their visual and their psychic horizons. No amount of extrapictorial visual experience could discriminate these options, nor should they have been distinguished: they were interacting pictorialities on this depictive occasion.

9 For Baxandall's earlier, sociological approach to pictoriality, see *Giotto and the Orators: Humanist Observers of Painting in Italy and the Discovery of Pictorial Composition, 1350–1450* (Oxford: Oxford University Press, 1971) and *Painting and Experience in Fifteenth-Century Italy: A Primer in the Social History of Pictorial Style* (Oxford: Oxford University Press, 1972). For his later and as it were more Gricean approach, see *Patterns of Intention: On the Historical Explanation of Pictures* (New Haven: Yale University Press, 1985). The introductory sections of the later book contained a critique of the notion of a "language of pictures" that Baxandall had erstwhile partly accepted. Both Baxandall and Richard Wollheim (see below, n. 14) were colleagues of Grice at the University of California at Berkeley when their perspectives on pictorial representation were elaborated. I have been unable to determine, however, whether they were in conversation with Grice. Both writers found some of their arguments against the notion of a "language of pictures" in Michael Podro, "Formal Elements and Theories of Modern Art," *British Journal of Aesthetics* 6 (1966) 329–38. Podro showed that no basic elements of picturing (and thus no lexicon and grammar of depiction) can be identified in a principled way. He concluded that the notion of a pictorial language, however attractive it has been to many modern artists and art theorists, is simply a historical ideology within modern art.

10 Grice, "Meaning Revisited," 224. The "nesting" of intentions allows for complex, or what Grice called "background" or "sneaky," intentions; see "Utterer's Meaning and Intention," 156; "Meaning Revisited," 242; "Utterer's Meaning, Sentence Meaning, and Word Meaning," 231; and Sperber and Wilson, *Relevance*, 17–21. At one point, Grice claimed that the *absence* of sneaky intentions must be a precondition for utterer's or occasion meaning ("Meaning Revisited," 242). Though understandable, this stricture must be unrealistic. Nevertheless, "an intention which is infinitely expanded in [an internally reflexive and regressive] kind of way . . . can-

not actually exist" in functional human conversation ("Meaning Revisited," 240). Grice explored this complex phenomenon in later work (see "Logic and Conversation," in *The Logic of Grammar*, ed. Donald Davidson and Gilbert Harman [Encino, CA: Dickenson Publishing, 1975] 64–75; "Presuppositions and Conversational Implicature," in *Radical Pragmatics*, ed. Peter Cole [New York: Academic Press, 1981] 183–97).

11 Novitz, *Pictures and Their Use in Communication*, 27.

12 In addition to replacing "audience" with "beholders," this formulation adapts revisions of Grice's account of speaker's meaning formulated by other philosophers: P. F. Strawson, "Intention and Convention in Speech Acts," *The Philosophical Review* 73 (1964) 439–60; Michael Schiffer, *Meaning* (Oxford: Clarendon Press, 1972); Paul Yu, "On the Gricean Program about Meaning," *Linguistics and Philosophy* 3 (1979) 273–88.

13 The quoted phrase is Sperber and Wilson's in *Relevance*, 53.

14 Fry intimated that *Yellow House at Arles* had specifically unconscious imagistic significance for Van Gogh. But he did not explicate this suggestion in psychoanalytic terms, which he usually avoided. A Gricean model of the intentional analytics of pictoriality would emphasize consciously deliberated intentions, or at least a conscious awareness of them. By contrast, Richard Wollheim's psychoanalytic philosophy of mind identified a territory of archaic and unconscious intentions—defensively repressed intentions—in picture making, which he called "secondary meaning" (what the painter unconsciously uses pictoriality to achieve in his psychic life) in relation to primary meaning (equivalent to the picture maker's conscious and communicated pictoriality in a Gricean sense). Any realistic and robust theory of visual culture must make due (and extensive) allowance for the unconscious topography of pictoriality. See Richard Wollheim, *Painting as an Art* (Princeton: Princeton University Press, 1981); for further comments on Wollheim's model of what I have called "psychic seeing-as," the unconscious imaging that determines ordinary aspect-perception both in mundane visual perception and in pictorial interpretation, see Davis, "Freudianism, Formalism, and Richard Wollheim," in *Queer Beauty*. For the unconscious and archaic sediments of pictoriality in a picture interpreted in terms of intersubjective sexuality, see Davis, *Drawing the Dream of the Wolves*.

15 Patrick Suppes, "The Primacy of Utterer's Meaning," in *Philosophical Grounds of Rationality: Intentions, Categories, Ends*, ed. Richard E. Grandy and Richard Warner (Oxford: Clarendon Press, 1986) 124.

16 The point is made by Yu, "The Gricean Program about Meaning," 284–85, and Biro, "Intentionalism in the Theory of Meaning," 247; see also Noam Chomsky, *Reflections on Language* (New York: Pantheon Books, 1975) 60. These authors regard Grice's program as fatally circular and therefore as analytically vacuous.

17 "Utterer's Meaning and Intention," 157.

18 This account of depiction builds on my "Finding Symbols in History," "The Origins of Image Making," and "Replication and Depiction in Paleolithic Art," in *Replications*. There I failed, however, to stress the recursive and partly circular (or hermeneutically tautologous) nature of the salient recognitions and inferences; that is, to relate the intentional analytics of depiction both to the autonomic successions of vision and to the emergent circuitry of the iconographic succession.

19 See especially Noam Chomsky, *Problems of Knowledge and Freedom: The Russell Lectures* (New York: Vintage Books, 1971) 19; *Reflections on Language*, 55–68. As Sperber and Wilson put it, "The property of being a grammar-governed representational system and the property of being used for communication are not systematically linked" (*Relevance*, 173).

20 John Searle, "Meaning, Communication, and Representation," in *Philosophical Grounds of Rationality*, ed. Grandy and Warner, 214, 216.

21 Dennis Stampe, "Toward a Causal Theory of Linguistic Representation," in *Studies in the Philosophy of Language*, *Midwest Studies in Philosophy* 2, ed. Peter A. French, Theodore E. Uehling, Jr., and Howard K. Weinstein (Morris, MN: University of Minnesota Press, 1977) 43. Or, as Stampe also writes, "what makes some one single thing and not another, the object of a representation?" (ibid.).

22 Gareth Evans, "The Causal Theory of Names," in *Naming, Necessity, and Natural Kinds*, ed. Stephen P. Schwarz (Ithaca, NY: Cornell University Press, 1977) 200.

23 Stampe, "Causal Theory of Linguistic Representation," 44; cf. Evans, "Causal Theory of Names," 197.

24 Saul Kripke, *Naming and Necessity*, 2nd ed. (Cambridge, MA: Harvard University Press, 1980) 95.

25 Evans, "Causal Theory of Names," 197.

26 Michael Devitt, *Designation* (New York: Columbia University Press, 1981) 25.

27 Devitt, *Designation*, 33.

28 Stephen Schwartz, *Naming, Necessity, and Natural Kinds*, 32; and compare Stampe, "Causal Theory of Linguistic Representation," 23, and Evans, "Causal Theory of Names," 197, 202–3, 215. As Kripke has warned, his model of "chains of communication . . . hardly eliminates the notion of reference; on the contrary, it takes the notion of intending to use the same reference as a given" (*Naming and Necessity*, 80).

29 The quoted phrases and the distinction are Keith Donnellan's in "Speaking of Nothing," in *Naming, Necessity, and Natural Kinds*, ed. Schwartz, 232.

30 The quoted phrase is Devitt's in *Designation*, 26–27.

31 Other qualifications have been enumerated by Evans, "Causal Theory of Names," 201–7, and Devitt, *Designation*, 57–58. Seemingly a naming ceremony involves the speaker's intention to name, an understanding of the ceremonial institution, an "ability to use names in general," and often a sophisticated deployment of other elements of the language (see Devitt, *Designation*, sects. 2.5–2.7). But in some functional naming ceremonies these conditions would not always seem to hold.

32 The quoted phrase is Donnellan's in "Speaking of Nothing," 229.

33 Stampe, "Causal Theory of Linguistic Representation," 46–47.

34 The quoted phrase is Stampe's in "Causal Theory of Linguistic Representation," sect. 8.1.

35 The complex diagrams of the "abduction" of the agency of artworks, artifacts, and representations that have been devised by Alfred Gell (see n. 2) show exactly why these cases are not at all unusual, and why they must be salient in the social anthropology of art and artifacts. In this example, the agency transmitted by A and by B through D*a* and D*b* are crucially different *despite* the visible morphological likeness of A and B and/or D*a* and D*b*. And it is the agency of A or B (the analogy of D*a* or D*b*) that beholders care about.

36 Lest it be thought, again, that these considerations are wholly abstract, divorced from any real-world art-historical or visual-cultural context, it should be noted that recent research has highlighted intertwined issues (and conflicts and contests) of commodity branding, intellectual property, image copyright, criminal responsibility, and artistic license involved in some of the foundational picture- and object-making activities of so-called Pop Art, which engaged the conflicts in ways that had not been socially salient (or as highly salient) in earlier instants of the making of ready-mades or other art objects indiscernible from "real things": see Cécile J. Whiting, *A Taste for Pop: Pop Art, Gender, and Consumer Culture* (New York: Cambridge University Press, 1997); Michael J. Golec, *The Brillo Box Archive: Aesthetics, Design, and Art* (Hanover, NH: University Press of New England, 2008); and Anthony Equord Grudin, *Television Dreams: Andy Warhol and the History of Postwar Advertising*, doctoral dissertation, University of California at Berkeley, 2008.

37 In turn, this calibration might be taken to be part of the work of art, or what Nelson Goodman called a "symptom of the aesthetic," even though it can be inimical to some exhibitive functions and communicative purposes of depiction. Goodman's account of the "symptoms of the aesthetic" in symbol systems was not the same thing as his model of the nonnotational symbol system of depiction. For Goodman's nominalist constructivism, see *Languages of Art: An Approach to a Theory of Symbols*, 1st ed. (Indianapolis, IN: Hackett, 1968) and *Ways of Worldmaking* (Indianapolis, IN: Hackett, 1978).

38 These matters can be especially pressing in the case of real objects that change in time and space but nonetheless possess properties or histories of self-identity that should be taken, and must be seen, as irreducible—in the case, for instance, of portraits. Ordinarily portraits do not project an empirically different sitter *qua* particular human being when they are replicated and transformed (as pictures) to pictorialize his or her changing visible aspects.

39 Whitney Davis, *The Canonical Tradition in Ancient Egyptian Art* (Cambridge: Cambridge University Press, 1989). Critics of this characterization of ancient Egyptian picturing have understood me to have said that the Egyptians only repeated one visible configuration or one visual image of it. This would obviously have been impossible. Rather, the Egyptians pictorialized the world in a consistent way replicated throughout configuration and its imaging—its way of being seen. Of course, non-canonical, pre-canonical, and anti-canonical horizons in Egyptian pictoriality should also be identified. But they were pictorially intelligible, I believe, largely in relation to the canonical tradition to which they were related and from which some of them had precipitated (as Dy... to the tradition of Dx-1, Dx-2, etc.).

40 See Whitney Davis, "Archaism and Modernism in the Reliefs of Hesy-Ra," in *"Never Had the Like Occurred": Ancient Egypt's View of Its Past*, ed. John Tait (London: UCL Press, 2003) 31–60. This finding need not contradict the model of a canonical tradition in ancient Egyptian art, for the reliefs of Hesy were integral to the consolidation of that canonical tradition. But at the time of this intervention in the existing pre-canonical or non-canonical tradition, they would have been avant-garde.

41 For examples of the morphology and temporality of these pictorial structures (often threaded through with seemingly nondepictive configuration), see Whitney Davis, "Prehistoric Palimpsests," in *Visuality and Virtuality*. In the case of engraved figures superimposed on one another in prehistoric caves, it is possible literally to

see (or in some cases to touch) the sequences and transformations or montages such as those in question in this section. Arguably the palimpsests were produced not only as a function of this history of pictoriality. They were also made to pictorialize that very history as such—a more unusual function of depiction in the history of culture.

42 W.J.T. Mitchell, *What Do Pictures Want? The Lives and Loves of Images* (Chicago: University of Chicago Press, 2005); and compare David Freedberg, *The Power of Images: Studies in the History and Theory of Response* (Chicago: University of Chicago Press, 1989) and James Elkins, *Pictures and Tears: A History of People Who Have Cried in Front of Paintings* (New York: Routledge, 2001).

43 In the anthropology of art developed by Gell (see n. 2) it would sometimes be legitimate to ask specifically "what *pictures* want"; that is, what the nature and efficacy of their putative agency in relation to picture makers and beholders might be. But even here specifically human intentionality vested in picture makers and beholders eventually trumps any nonhuman agency attributed to pictures. According to Gell, human makers and beholders abduct the identity of *other* entities believed to act causally in the production of the picture, including the picture itself understood to have aesthetic power and representational agency.

Chapter 7: The Iconographic Succession

1 Arthur Danto, "Description and the Phenomenology of Perception," in *Visual Theory: Painting and Interpretation*, ed. Norman Bryson, Michael Ann Holly, and Keith Moxey (New York: HarperCollins, 1991) 209–10. Danto referred specifically to a study by R. J. Herrnstein, Donald H. Lovell, and Cynthia Cabell, "Natural Concepts in Pigeons," *Journal of Experimental Psychology: Animal Behavior Processes* 2, no. 4 (1976) 285–302.

2 Arthur Danto, "Animals as Art Historians: Reflections on the Innocent Eye," in *Beyond the Brillo Box: The Visual Arts in Post-Historical Perspective* (Berkeley and Los Angeles: University of California Press, 1992) 23. Danto cited a paper by K. M. Kendrick and B. A. Baldwin, "Cells in the Temporal Cortex of Conscious Sheep Can Respond Preferentially to the Sight of Faces," *Science* (April 24, 1987) 448-50.

3 The quoted phrase is from "Animals as Art Historians," 24.

4 To be specific, Gombrich did not fully explicate the immanent pictoriality of objects or artifacts accepted by the subject as *substitutes* and therefore usable as schemas in his sense of the term. The stick used by a child as a hobby-horse is not quite the same thing as a stone accepted by a bird as an egg if the stick *depicts* the horse. Of course, the stick need not do so. But then it is hard to see how it could be an example of "the roots of artistic form" (see "Meditations on a Hobby Horse, or the Roots of Artistic Form," in *Aspects of Form: A Symposium on Form in Nature and Art*, ed. Lancelot Law Whyte [London: Lund Humphries, 1951] 209–28, reprinted in E. H. Gombrich, *Meditations on a Hobby Horse and Other Essays on the Theory of Art* [London: Phaidon, 1963] 1–11). For further discussion, see Davis, "Gombrich and the Pictorial Schema," in *Visuality and Virtuality*.

5 Michael Podro in correspondence with the author, 1987–88. Similar descriptions of the recognitional work that gives depiction can be found in Podro's *Depiction*, 5–28.

6 "Introductory, §1," in *Studies in Iconology: Humanistic Themes in the Art of the Renaissance* (Oxford: Oxford University Press, 1939) 3–17 (quotations from pp. 5, 6);

this essay will be called "Iconography and Iconology," the title Panofsky gave to it in a 1955 reprint (hereafter cited as *I & I*). The essay was based on an earlier essay: "Zum Problem der Beschreibung und Inhaltsdeutung von Werken der bildenden Kunst," *Logos* 21 (1932), 103–19 = Erwin Panofsky, *Aufsätze zu Grundfragen der Kunstwissenschaft*, ed. Hariolf Oberer and Egon Verheyen (Berlin: B. Hessling, 1964) 85–97 (hereafter cited as *PB*). Both texts will be discussed in more detail in Chapter 8.

7 *Das Erkenntnisproblem in der Philosophie und Wissenschaft der neueren Zeit*, 3rd. ed. (Berlin: B. Cassirer, 1922) 699. For Cassirer's and Panofsky's neo-Kantian approach to iconology, see Whitney Davis, "Phenomenology and Iconology," in *Visuality and Virtuality*.

8 "Iconography and Iconology," in *Meaning in the Visual Arts: Papers in and on Art History* (New York: Anchor Books, 1955) 32, n. 7. This remark occurred in the only addition that Panofsky made in republishing the essay of 1939 (namely, *I & I*) in 1955.

9 Later in his career, Panofsky put considerable stress on what he called iconographic disjunction, the fact that motifs acquire different symbolic valences in different historical contexts—different visual cultures or visualities. But the disjunction in question here is a disjunction within *each* visual culture or visuality, which must overcome it to be constituted as a visual culture in the first place, a visuality in the ultimate sense defined by iconology.

10 Ludwig Wittgenstein, *Remarks on the Philosophy of Psychology*, vol. 2, ed. G. H. von Wright and Heikki Nyman, trans. C. L. Luckhardt and M.A.E. Aue (Oxford: Blackwell, 1980) 130, no. 60. The distinction between picture and image is crucial for understanding the relation between pictorial representations and the observer's standpoint in apprehending them; the standpoint is not *only* a function of the geometry of the visual angle. But that is a topic for another book. See Whitney Davis, "Image and Picture," in *Visuality and Virtuality,* and "Archaeologies of the Standpoint" (MS.) Research Forum Lectures, Courtauld Institute of Art, London, February 2006.

11 "Italian Art and International Astrology in the Palazzo Schifanoia" [1912], in *The Renewal of Pagan Antiquity: Contributions to the Cultural History of the European Renaissance*, ed. Kurt Forster, trans. David Britt (Los Angeles: Getty Research Institute, 1999) 585.

12 Danto, "Seeing and Showing," 3.

13 See especially Henry G. Fischer, *L'écriture et l'art de l'Égypte ancienne: quatres leçons sur la paléographie et l'épigraphie pharaoniques* (Paris: Presses universitaires de France, 1986).

14 T. J. Clark, "Preliminaries to a Possible Treatment of Olympia in 1865," *Screen* 21, no. 1 (1980) 18–41, hereafter cited as *MO*. Clark published a revised version in *The Painting of Modern Life: Paris in the Art of Manet and His Followers* (New York: Knopf, 1985), but the original publication is cited here; it was used by several early respondents to Clark, discussed below.

15 Accounts of this kind in English can be found in Joseph C. Sloane, *French Painting Between the Past and the Present* (Princeton: Princeton University Press, 1951) 178–201, and Anne Coffin Hanson, *Manet and the Modern Tradition*, 2nd ed. (New Haven: Yale University Press, 1979).

16 George Heard Hamilton, *Manet and His Critics* (New Haven: Yale University Press, 1954) 75, 80.

17 George Heard Hamilton, *Tradition and Invention in Modern Art* (New York: Abrams, 1954) 20.

18 On Privat, see Hamilton, *Manet and His Critics*, 76–78, and compare Sloane, *French Painting*, 188–91.

19 See Theodore Reff, "The Meaning of Manet's *Olympia*," *Gazette des Beaux-Arts* 63 (1964) 111–22, revised and expanded to become *Manet, Olympia* (London: Allen Lane, 1976), and Michael Fried, "Manet's Sources," *Artforum* 7, no. 7 (1969) special issue.

20 In the case of Manet's *Olympia* as described by Hamilton, the *Aufhebung* consisted in the peculiar integration (independent formality) attained in the disintegration (configuration minus pictoriality and stylisticality) manifested in the painting. Modernist formalism tried to discover the criterion for such puzzling *Aufhebungen* in Immanuel Kant's doctrine of rational self-criticism. The most influential modernist art critic, Clement Greenberg, argued that painting must critically conform itself to its medium. But Greenberg's criticism was severely distorted, often vitiated, by his conflation of medium and formality, his tendency to believe that aspective interactions can be discriminated and detached in discrete configurative registers, and his failure to take sufficient account of the ways in which stylistic and iconographic successions persist in putatively self-critical and purified (i.e., medium-specific and formalist) configurations.

21 "Manet: Modernism and Avant-Garde—Timothy Clark's Article on Manet's 'Olympia,' *Screen*, Spring 1980," *Screen* 21, no. 2 (1980) 15–25, and see T. J. Clark, "A Note in Reply to Peter Wollen," *Screen* 21, no. 3 (1980) 97–100.

22 In these exchanges, the term "contradiction" must be read in its specifically Marxist meanings: (1) to denote the disjunction between the real forces and relations of production on the one hand and cultural (mis)representations on the other hand, and (2) to characterize the immanent tensions of bourgeois class identity (that is, the tenuous relationship of the human subject to ownership of the means of production and to capital accumulation). Because of (1), the subject cannot recognize (2); equally, because of (2), the subject cannot recognize (1). While Clark gave considerable weight to this double bind as it gripped Manet, Wollen emphasized its recognizability in self-consciousness relayed by representation—that is, the supposed possibility of a political and artistic *Aufhebung* in the so-called avant-garde. Nearly thirty years later the same debate continues to obsess modernist art historians concerned to discover the criticality of modern art.

23 Alexius Meinong, *Untersuchungen zur Gegenstandstheorie und Psychologie* (Leipzig: J. Barth, 1904), and see J. N. Findlay, *Meinong's Theory of Objects* (Oxford: Oxford University Press, 1993) and *Realism and the Background of Phenomenology*, ed. Roderick M. Chisholm (Glencoe, IL: Free Press, 1960).

24 Art-Language [i.e., Michael Baldwin, Charles Harrison, and Mel Ramsden], "Manet's 'Olympia' and Contradiction: apropos T. J. Clark's and Peter Wollen's Recent Articles," *Block* 5 (September 1981) 34–43. A contemporary essay by Art-Language offered an innovative—and still virtually unique—intersection of semiological, historical, and cognitive considerations: see Michael Baldwin, Charles Harrison, and Mel Ramsden, "Art History, Art Criticism and Explanation," *Art History* 4 (1981) 432–56.

25 "Manet's 'Olympia' and Contradiction," 36.

26 Ibid. 38.

27 Ibid.

28 Ibid.

Chapter 8: Visuality and Pictoriality

1 Susanne K. Langer, "On Cassirer's Theory of Language and Myth," in *The Philosophy of Ernst Cassirer*, ed. Paul Arthur Schilpp (Evanston, IL: Library of Living Philosophers, 1949) 393.

2 I will not try to unravel definitions of "visuality" employed by historians of visual cultures around the world. For example, see Craig Clunas, *Pictures and Visuality in Early Modern China* (Princeton: Princeton University Press, 1997); *Visuality Before and Beyond the Renaissance*, ed. Robert S. Nelson (New York: Cambridge University Press, 2000); and *Images and Empires: Visuality in Colonial and Postcolonial Africa*, ed. Paul S. Landau and Deborah D. Kaspin (Berkeley and Los Angeles: University of California Press, 2002).

3 In turn, the English essay was translated into German in *Sinn und Deutung in der bildenden Kunst*, trans. Wilhelm Höck (Cologne: DuMont, 1975) 26–41.

4 "Meaning in the Visual Arts," *Magazine of Art* 44, no. 1 (February 1951) 45–50, hereafter cited as *MVA*.

5 *The Life and Art of Albrecht Dürer*, 2 vols. (Princeton: Princeton University Press, 1943); unless otherwise noted, the one-volume fourth edition of 1955 will be cited hereafter as *LAAD* (the text was not substantially changed from the first edition, but Panofsky's "Hand List" of Dürer's work was eliminated).

6 Panofsky used this conventional title, first applied in the later eighteenth century. For valuable historiographical surveys, see Hans Schwerte, "Dürers 'Ritter, Tod und Teufel': Eine ideologische Parallele zum 'Faustischen,'" in *Faust und das Faustischen: Ein Kapitel deutscher Ideologie* (Stuttgart: E. Klett, 1962) 243–78, and especially Jan Bialostocki, *Dürer and His Critics, 1500–1971: Chapters in the History of Ideas* (Baden-Baden: V. Koerner, 1986) 211–42.

7 A two-sided "preparatory drawing" for the engraving is in the Ambrosiana. The verso of the sheet was said by Panofsky to be the fair copy, and insofar as it reversed the drawing on the recto, it could have served as a working drawing for the engraving (which would, of course, have reversed it in turn). A further copy of it (not always accepted to be Dürer's) is in the Uffizi. None of these three studies, however, includes the figures of Death and the Devil.

8 Raymond Klibansky, Erwin Panofsky, and Fritz Saxl, *Saturn and Melancholy: Studies in the History of Natural Philosophy, Religion, and Art* (London: Nelson, 1964) 373. This text was prepared in the 1930s but only finished and published long afterwards.

9 *Die Kunst Albrecht Dürers* (Munich: Bruckmann, 1905); 6th ed., ed. Kurt Gerstenberg (Munich: Bruckmann, 1943), hereafter cited as *KAD*; 7th ed. (new ed.), ed. Kurt Gerstenberg (Munich: Bruckmann, 1963) = *The Art of Albrecht Dürer,* trans. Alastair and Heide Grieve (London: Phaidon, 1971). For Panofsky's dissertation at Freiburg, see *Die theoretische Kunst-Lehre Albrecht Dürers (Dürers Ästhetik)* (Berlin: G. Reimer, 1914). The dissertation did not present all of the technical details of Panofsky's researches on Dürer's theoretical studies. These appeared a year later in *Dürers Kunsttheorie* (Berlin: G. Reimer, 1915). For Wölfflin's review of Panofsky's

book, which reminded readers of Wölfflin's role in its genesis, see *Monatshefte für Kunstwissenschaft* 8 (1915) 254–55.

10 Paul Weber, *Beiträge zu Dürers Weltanschauung* (Strassburg: J.H.E. Heitz, 1900) 42–44. Weber's monograph was the principal art-historical source for both Wölfflin and Panofsky.

11 In addition to his dissertation researches published in 1914 and 1915, between 1915 and 1923 Panofsky published two major articles on Dürer's art and devoted considerable attention to the artist in his study of styles of proportioning the human figure in art: (1) "Dürers Darstellungen des Apollo und ihr Verhältnis zu Barbari," *Jahrbuch der Preussischen Kunstsammlungen* 41 (1920) 359–77; (2) "Dürers Stellung zur Antike," *Wiener Jahrbuch für Kunstgeschichte* 1 (1922) 43–92 = "Albrecht Dürer and Classical Antiquity," *Meaning in the Visual Arts*, 236–85; (3) "Die Entwicklung der Proportionslehre als Abbild der Stilentwicklung," *Monatshefte für Kunstwissenschaft* 14 (1921) 188–219 = *Aufsätze*, 169–204 = "The History of the Theory of Human Proportions as a Reflection of the History of Styles," *Meaning in the Visual Arts*, 55–107. In 1923, moreover, he published a monograph (coauthored with Fritz Saxl) on Dürer's *Melencolia I* (1514)—the engraving usually grouped, along with *St. Jerome in His Cell* (1514), with *Knight, Death, and the Devil*; see *Dürers "Melencolia I": Eine quellen- und typengeschichtliche Untersuchung* (Berlin: Teubner, 1923), *Studien der Bibliothek Warburg* 2. Here Panofsky and Saxl applied the method of the "history of types," an integral element of the general iconographical method (see Chapter 7).

12 See especially *Dürers Ästhetik*, 17–37, and *Dürers Kunsttheorie*, 78–121, 127–56, 205–9.

13 Hans Kauffmann, *Albrecht Dürers rhythmische Kunst* (Leipzig: Seeman, 1924). For criticisms of Panofsky's dissertation researches, see pp. 99, 105, 121, 145–46; for *Kunstwissenschaft* and rhythm, see p. 7. Kauffmann's opinion was buttressed by a survey of *Kunstwissenschaft* published by Hans Hermann Russack, *Der Begriff des Rhythmus bei den deutschen Kunsthistorikern des XIX. Jahrhunderts* (Weida: Thomas und Hubert 1910) (pp. 61–65 deal with Wölfflin).

14 "Albrecht Dürers rhythmische Kunst," *Jahrbuch für Kunstwissenschaft* (1926) 136–92.

15 Ibid. 136–40. Like Kauffmann, Panofsky cited Russack. But he asserted that Kauffmann had ignored the "modern" scholarship, above all the physiological aesthetics of Theodor Lipps (compare Russack, *Der Begriff des Rhythmus*, 76).

16 Wölfflin's illustration was included in the next edition of his book, published in 1943 and edited by Gerstenberg—the last edition to appear in Wölfflin's lifetime. In turn, in 1963 Gerstenberg published a seventh edition of Wölfflin's book, but he eliminated the tendentious illustration and its accompanying footnote. As this was the edition that was translated into English, the controversy has not been apparent to English-speaking readers.

17 *Dürers Kunsttheorie*, 202–7, and esp. fig. 22. Panofsky knew that a horse simultaneously lifts its left forefoot and its right hindfoot only when it is trotting; a walking horse raises its forefeet and hindfeet on the same side. Dürer probably intended, then, to portray "the regulated step of the riding-school so as to give a demonstration of perfect rhythm" (*LAAD*, 154). As Wilhelm Waetzoldt had already observed, however, in the engraving the "horse should have been proceed-

ing at a walk." In a strictly Wölfflinian vein, Waetzoldt concluded that Dürer's pictorialization of a *trotting* horse accompanied by a *running* dog had been determined by "purely artistic reasons of form" (*Dürer and His Times* [1935], trans. R. H. Boothroyd [London: Phaidon, 1950] 74). In 1943 Panofsky tried to overcome this obstacle by describing the trot of the Knight's horse as a "regulated step" or "measured gait" befitting not only the late-medieval riding school but also the proportional construction deployed by Dürer in order to depict the figures (*LAAD*, 154). But Panofsky's proposal merely exacerbated the fundamental difficulty. All such interests in the purely formal aspects of depiction would seem to support Wölfflin's contention that the perfect image of the perfect horseman, whatever he might be, constituted Dürer's primal interest in the engraving.

18 "Hör, du Ritter Christi, reit hervor neben den Herrn Christum, beschütz die Wahrheit, erlang der Märtyrer Kron!": *Dürers schriftliche Nachlass auf Grund der Originalhandschriften*, ed. Konrad Lange and Friedrich Fuhse (Halle: M. Niemeyer, 1893), 164 (27). This context had been proposed by Wölfflin's predecessor Herman Grimm ("Dürers Ritter, Tod und Teufel," *Preussische Jahrbücher* 36 [1875] 543–49; see also Weber, *Dürers Weltanschauung*, 13–18).

19 *Dürers schriftliche Nachlass*, 140 (5) (*der Reuther*), 150 (20) (*der Reuter*). Here the artist was explicitly referring to various sales of his print of 1513; no other rider could be intended. For a more recent edition of the diary, see *Dürers schriftlicher Nachlass*, ed. Hans Rupprich, vol. 1, *Autobiographische Schriften* . . . (Berlin: Deutscher Verlag der Kunstwissenschaft, 1956) 146–202 (*der Reuter* named on pp. 162 and 166; *du Ritter Christi* on p. 171).

20 In the scholarship available to Panofsky, the date of first publication varied from 1502 to 1504; it is now agreed to have been 1502.

21 See Weber, *Dürers Weltanschauung*, 17. Moreover, Panofsky did not mention that the most widely circulated Latin editions appeared after 1515; it was in this year that "the great dissemination and real popularity of the book first took hold" (ibid. 16).

22 As an example of the former type, Weber reproduced the illustration to the sixteenth chapter of a pamphlet published in 1494 (*Dürers Weltanschauung*, 31); for the latter type, he reproduced a painted woodcut produced in 1488 (*Dürers Weltanschauung*, 32, pls. 4–5).

23 For the iconography, Panofsky cited Richard Muther, *Die deutsche Bücherillustration der Gothik und Renaissance* (Munich and Leipzig: George Hirth, 1884) vol. 2, pl. 169-right (Hans Wieditz's illustrations to Petrarch) (my Fig. 7.2), and Gustav Pauli, *Inkunabeln der deutschen und niederländischen Radierung* (Berlin: B. Cassirer, 1908), pl. 18-top left (a poor replication of the same?).

24 Edgar Wind, *Giorgione's Tempestà with Comments on Giorgione's Poetic Allegories* (Oxford: Clarendon Press, 1969) 27, n. 31.

25 E. H. Gombrich, "The Evidence of Images," in *Interpretation: Theory and Practice*, ed. Charles Singleton (Baltimore: Johns Hopkins University Press, 1969) 102.

26 Sten Karling, "Ritter, Tod und Teufel: Ein Beitrag zur Deutung von Dürers Stich," in *Évolution générale et développements régionaux en histoire de l'art: Actes du 22e Congrès international d'histoire de l'art*, vol. 1 (Budapest, 1972) 731–38; for a similar perspective, see Ursula Meyer, "Politische Bezüge in Dürers 'Ritter, Tod und Teufel," *Kritische Berichte* 6, no. 6 (1978) 27–41. Variants of this interpretation had

already appeared in the nineteenth century before Grimm's insistence on the *miles Christianus* had fully taken hold. Therefore we can be justified in inquiring into Panofsky's reasons for promoting the Christian association.

27 Heinrich Theissing, *Dürer's Ritter, Tod und Teufel: Sinnbild und Bildsinn* (Berlin: Mann, 1978).

28 Compare "Das Problem des Stils in der bildenden Kunst," *Zeitschrift für Aesthetik und allgemeine Kunstwissenschaft* 10 (1915) 460–67 = *Aufsätze*, 23–31 (written in response to Wölfflin). As already noted, Panofsky's investigation of the "history of types" was launched in his study, written with Saxl, of Dürer's *Melencolia I*. It received definitive form in *Hercules am Scheideweg und andere antike Bildstoffe in der neueren Kunst* (Leipzig: Teubner, 1930) and in "Classical Mythology in Mediaeval Art" (coauthored with Saxl), *Metropolitan Museum Studies* 4 (1933) 228–80. The latter study was used as the remarks that followed "Iconography and Iconology" in *Studies in Iconology*, 18–31 = *Meaning in the Visual Arts*, 40–54. Finally, Panofsky's essay dedicated to Cassirer, "Et in Arcadia Ego," was specifically proposed as a clarification of the "inner meaning" of Poussin's painting—its *Geistlichkeit* or iconology—in light of a "history of types" (*Philosophy and History: Essays Presented to Ernst Cassirer*, ed. Raymond Klibansky and H. J. Paton [Oxford: Oxford University Press, 1936] 223–54).

29 In the essay "Phenomenology and Iconology" in *Visuality and Virtuality*, I address the difference between Panofsky's notion of *Zeit und Ort*, reified in high iconological contextualism, and Martin Heidegger's account of *Sein und Zeit*, which would generate an *existential* contextualism far removed from the *a priori* sociologism of much visual-cultural studies—a sociologism that Heidegger would have criticized for its assumption of "the They" as the grounds of any kind of formal, stylistic, or pictorial meaning.

30 Michael Friedman, *A Parting of the Ways: Carnap, Cassirer, and Heidegger* (Chicago and La Salle, IL: Open Court, 2000) 31.

31 Ernst Cassirer, *Zur Logik der Kulturwissenschaften* (Gothenburg: Erlander, 1942) = *The Logic of the Humanities*, trans. Clarence Smith Howe (New Haven: Yale University Press, 1961). On *Kunstwissenschaft*, see ibid. 122–42.

32 Rudolf Carnap, *Die logische Aufbau der Welt* [1929], 2nd ed. (Hamburg: F. Meiner, 1961) = *The Logical Structure of the World* (Berkeley and Los Angeles: University of California Press, 1967) §178.

33 Carnap, *The Logical Structure of the World*, §179.

34 Friedman, *A Parting of the Ways*, 84–85.

35 See "Die perspektive als 'symbolische Form,'" *Vorträge der Bibliothek Warburg, 1924–25* (Leipzig: Teubner, 1927) 258–330 = *Aufsätze*, 99–167 = *Perspective as Symbolic Form*, trans. Christopher S. Wood (New York: Zone Books, 1997). Perspective projection would seem to permit heteropsychological coordination because in its metric-numerical construction (and insofar as we can systematically interconvert notionally between divergent standpoints) we can *all* see essentially the *same* space from different vantages. For this reason, perspective was associated by Cassirer and Panofsky with the attainment of objectivity about nature. This view was echoed by Gombrich, who emphasized the optical mimeticism of perspective—its mirroring of the objective world even though the "mirroring" might

be a trompe l'oeil, an illusion of the phenomenal or subjective visual world. See further Whitney Davis, "Renaissance Virtuality and Modern Metaopticality" and "The Origins of Perspective" in *Visuality and Virtuality*.

36 Within the academic community and intellectual tradition that was well known to Cassirer and Panofsky, see especially Heinrich Rickert, "Zwei Wege der Erkenntnistheorie," *Kant-Studien* 14 (1909) 169–228.

37 Edgar Wind, "Some Points of Contact Between History and Natural Science," in *Philosophy and History*, ed. Klibansky and Paton, 255–64 (quotations from pp. 257–58).

38 Edgar Wind, "Experiment and Metaphysics," *Proceedings of the Sixth International Congress of Philosophy, Harvard University, September 1926*, ed. Edgar Sheffield Brightman (New York: Longmans, Green and Co., 1927) 222.

39 Unlike Panofsky, Wind urged his readers to jettison the neo-Kantian grounding of the *circulus methodicus*. In particular, he wished to avoid the Kantian antinomies by deploying what he called "the method of 'implicit determination' which defines the relation of 'part' to 'whole' in such a way that any proposition concerning the structure of the 'whole' can be tested in terms of the behaviour of the 'parts'" ("Can the Antinomies Be Restated?" *Psyche* 14 [1934] 177; see also *Das Experiment und die Metaphysik: Zur Auflösung der kosmologischen Antinomien* [Tübingen: Mohr, 1934] = *Experiment and Metaphysics: Towards a Resolution of the Cosmological Antinomies*, trans. Cyril Edwards [Oxford: European Humanities Research Centre, 2001]). This method enables the work of experimental hypothesis to proceed, because we do not need to address the entire constellation in which our instrumentations and our documentations are embedded in order to investigate the conditions of its coherence. As a logical-positivist philosopher of science noted at the time, "for anyone reared in Kantian traditions," as Wind had been, "this [approach] is revolutionary" (Ernest Nagel, Review of *Experiment und Metaphysik*, *Journal of Philosophy* 31, no. 6 [March, 1934] 164–65). Wind associated his proposals with the pragmatism of Charles Sanders Peirce, a point cited by Panofsky in *PB* (p. 94) and again in "The History of Art as a Humanistic Discipline" (*Meaning in the Visual Arts*, 14). But Panofskyan art history cannot be regarded as rigorously pragmatist.

40 Panofsky, "The History of Art as a Humanistic Discipline," 17.

41 My terminology in this paragraph might suggest that Panofsky applied Gottlob Frege's influential distinction between *Sinn* and *Bedeutung* (sense and reference): we might say that Panofskyan iconological *Deutung* or culturally-specific referentiality is Fregean *Sinn* expressed at the collective and traditional level rather than at the level of individual "speaker's meaning" or "use" (see Chapter 6). Regrettably I cannot enter into this fascinating topic here.

42 Martin Heidegger, *Sein und Zeit* (Halle, 1927) 51, n. 1 = *Being and Time*, trans. Joan Stambaugh (Albany, NY: State University of New York Press, 1996) 52.

43 See Whitney Davis, "Phenomenology and Iconology," in *Visuality and Virtuality*.

44 Erwin Panofsky, "Aussprach," *Vierter Kongress für Ästhetik und Kunstwissenschaft*, ed. Hermann Noack (Stuttgart: F. Enke, 1930) 53–54 = Ernst Cassirer, *Symbol, Technik, und Sprache: Aufsätze aus den Jahren 1927–1933*, ed. Ernst Wolfgang Orth et al. (Hamburg: F. Meiner, 1985) 115–17.

45 Bialostocki, *Dürer and His Critics*, 217.

46 Friedrich Nietzsche, *Die Geburt der Tragödie, oder: Griechentum und Pessimismus* [1870–71] in *Werke: Kritische Gesamtausgabe*, ed. G. Colli and M. Montinari, vol. 3, pt. 1 (Berlin: W. de Gruyter, 1972), §20, 127.

47 Ernst Bertram, *Nietzsche: Versuch einer Mythologie* (Berlin: Bondi, 1919) 69.

48 Wilhelm Waetzoldt, *Dürer und seine Zeit* (Vienna: Phaidon, 1935) 232–33, and see his *Dürers Ritter, Tod und Teufel* (Berlin: G. Stilke, 1936), where he reminded readers (pp. 22–23) that Adolf Hitler loved the print just as Nietzsche did.

49 Theodor Hertze, "Dürers deutsche Form," *Die Rasse* 2 (1934) 134–38.

50 Bialostocki, *Dürer and His Critics*, 378.

51 Dürer's earliest studies of the proportions of the horse, a drawing signed and dated 1503 (now in Cologne), adopted the Leonardesque pose (see Gustav Pauli, "Dürers früheste Proportionstudie eines Pferdes," *Zeitschrift für bildenden Kunst* NF 25 [= 49] [1914] 205–8). According to contemporary observers, Leonardo's horse in Milan had decayed by the time Dürer could have seen it, if it was still standing at all. For this reason Panofsky preferred to say that Dürer must have known the monument by way of drawings made by other artists or perhaps in the form of studies of the horse prepared by Leonardo himself (*LAAD*, 153; for a possible source in a drawing by Pisanello, see *Dürers Kunsttheorie*, 200, n. 2). After the publication of *LAAD*, two other appropriately-posed Italian horses were cited as possible models for the Knight: the marble relief of Roberto Malatesta on horseback (W. R. Valentiner, "Italian Renaissance Sculpture: The Tomb of Roberto Malatesta," *Art in America* 35 [1947] 300–312) and the horse of one of the three kings in Benozzo Gozzoli's fresco for the Medici-Riccardi Chapel in Florence (Henry Rox, "On Dürer's *Knight, Death, and Devil*," *The Art Bulletin* 30 [1948] 67–70). The point here, however, is not the uniqueness of the equestrian prototype. Rather it is the specificity of its pose in the pictorial images that replicated it.

52 Panofsky, *Dürers Kunsttheorie*, 200–204 and figs. 21–22 (quotation from p. 204).

53 In a beautiful pictorial demonstration, in the engraving Dürer showed that the *breadth* of the horse's hoof is equal to its height. In the lefthand lowermost quadrant of the implied proportional grid, the hoof of the raised left forefoot of the horse is placed at the upper terminus of a diagonal running from the left hindfoot hoof on the ground through the right hindfoot hoof raised from the ground (in the correction). It is equal to one-quarter the height/width of the quadrant itself (and specifically EF [see Fig. 8.10]). (Of course, while the left hindfoot hoof is placed just outside its quadrant, the left forefoot hoof is placed just inside its quadrant.) In other words, Dürer seems to be showing that the hoof in both its breadth and its height is the measure—the module—for the proportions of the entire group of horse and rider. By contrast, in the proportional study for the horse on the sheet in Nuremberg, the right hindfoot hoof "cuts over" Line E (Panofsky, *Dürers Kunsttheorie*, 202, n. 2). I would suppose that in this version of the image Dürer was trying to discover whether the hoof should touch against Line "J" (in Panofsky's reconstruction)—an attempt that the artist abandoned in both the uncorrected and the corrected hooves in the engraving. Such proportional-modular investigations, though seemingly specialized and, as it were, hard to see in a finished depiction, are not unusual in the worldwide history of art: in canonical depiction in ancient Egypt, the span of the clenched human fist seems to have been used as the module for the construction of the entire figure (see Whitney

Davis, *Masking the Blow: The Scene of Representation in Late Prehistoric Egyptian Art* [Berkeley and Los Angeles: University of California Press, 1992] and "Planarity and Its Disjunctions" in *Visuality and Virtuality*).

Chapter 9: How Visual Culture Becomes Visible

1 I must set aside an endemic—and a deeply misleading—colloquialism in art history that says that we *do* see or look at images; that is, at artworks, pictures, and other items of visual culture (or their reproductions). Images are an empirical subject matter of art history, or they should be. Indeed, in a well-defined theoretical sense they are the very *subjects* of art history: they are the noetic standpoints (usually correlated with real spatial and temporal locations) at which art-historical objects such as pictures and artworks are realized by human agents, that is, made visible to them. (As we have already seen, of course, the mere visibility of a picture or artwork is not sufficient to constitute it as recognized or recognizable in a visuality.) But such images are not the artifactual *objects* of art history: the artifactual objects in question are pictures or artworks that must *be imaged* by people. No doubt this confusion has had a great deal to do with the conflation of visibility and visuality considered here. Pictures are often visible, and every image of them (i.e., a "seeing") partly succeeds to visuality. But pictures as such are not simply relays of visuality (Chapters 6, 7, and 8).

2 Ludwig Wittgenstein, "Cause and Effect: Intuitive Awareness," *Philosophia* 6 (1976) 420.

3 Of course, these bare-minimum recognitions—of the presence of a picture, of the presence of the style of its maker, of the presence of recognizable depicted objects, and so forth—are not especially interesting from the point of view of an advanced formal, stylistic, and pictorial analysis and criticism of a painting recognized *prima facie* to be an apple-picture by Cézanne, perhaps one of several or many that have this minimum identity. But in theory, as we have seen in preceding chapters, even the mininum recognitions must be secured in successions that resolve disjunctions and reduce resistances at every step. And the question of recognition and resolution in the successions would become immediately pressing if we found an apple-picture known to be by Cézanne in which none of the apples looked like his.

4 These are not quite the same visual cultures, of course; they are different successions that precipitate from sets of likenesses that might be recognized between fruit, mountains, painted colors or shapes, and certain effects of geometrical optics. In the two successions just mentioned, imagine that these likenesses *have* been recognized by someone, constituting his visual culture (a visual culture specifically for him). In the first, someone paints pictures in the way Cézanne did. Indeed, if the person in question *is* Cézanne then the first visual culture is specifically his way of painting pictures. In the second, someone sees natural effects in the world as if *they* had been painted by Cézanne. Perhaps when he painted pictures, Cézanne saw the world (the world, for example, of bowls piled with fruit and mountains across the valley) in just this way, though probably—almost certainly—he did not.

5 For a review of interpretations of Wittgenstein's use of the term *Lebensform*, see J.F.M. Hunter, "Forms of Life in Wittgenstein's *Philosophical Investigations*," *American Philosophical Quarterly* 5 (1968) 233–43. For clarification of the philosphical issues, I have benefited from Warren Goldfarb, "I Want You To Bring Me A Slab,"

Synthèse 56 (1983) 365–82; Stanley Cavell, *This New Yet Unapproachable America: Lectures after Emerson after Wittgenstein* (Albuquerque, NM: Living Batch Press, 1989); and Newton Garver, *This Complicated Form of Life: Essays on Wittgenstein* (La Salle, IL: Open Court, 1989) 237–67.

6 See Paul Wijdevelt, *Ludwig Wittgenstein, Architect* (Cambridge, MA: Harvard University Press, 1994), and Rush Rhees, "Wittgenstein on Language and Ritual," in *Wittgenstein and His Times*, ed. Brian McGuinness (Oxford: Blackwell, 1982) 69–107.

7 This system has as much claim as any, I think, to be called a language, though it is not the same thing, of course, as what we ordinarily mean by natural language or speech (even though the complete primitive language of the builders involves speech as well as other actions and signs). Wittgenstein's thought experiment highlights the fact that the simple language of the builders is virtually a pure function of its practical social context, however limited. The complete primitive language of A and B is the language of A and B *as builders* and indeed as these builders building a building together; it is (maybe it *only* is) a language of building for building among these builders, and perhaps, as we will see, only for building a particular kind of building in a particular way. Arguably it has no application outside that strictly defined context—no functional intelligibility—despite the fact that every one of its separate elements (the words and gestures of Builder A, the building elements secured by Builder B, and so on) could readily be integrated into different complete primitive languages.

8 A fine account of Tylorian culture theory can be found in Christopher Herbert, *Culture and Anomie: Ethnographic Imagination in the Nineteenth Century* (Chicago: University of Chicago Press, 1992). A lucid treatment of Wittgenstein's knowledge of the cultural and social theory of his own generation and of the preceding two or three generations—especially theory relevant to his working concept of *Lebensform*, a term employed in anthropologies other than his—can be found in Allan Janik and Stephen Toulmin, *Wittgenstein's Vienna*, 2nd ed. (New York: Simon and Schuster, 1973).

9 In more recent years so-called cultural studies has backed away from the quasi-bacteriological concept of culture and the one-sided culturalism of cultural anthropology, though it has not fully renounced it. It tries to address cultural translocation and hybridity (another quasi-biological concept) in both historical and present-day or postcolonial situations, especially in situations of ethnic, racial, and religious diaspora and in the contemporary transnational arena of globalized commodity exchange and information flow (see especially Homi Bhabha, *The Location of Culture* [London and New York: Routledge, 1994]). At the moment, in fact, the very notion of culture hardly serves to designate anything more than the operation of conventions that have emerged between social agents in order to mediate their practical interactions and negotiations, the provisional, context-specific bond that "culture" seems to create between them—the very problem to which Wittgenstein addressed himself. This is not surprising: some of Wittgenstein's ideas about language-games and forms of life quickly passed into subsequent cultural and social theory outside the cultural anthropology that studies the supposedly shared and normative customs of ethnic groups. For example, Peter Winch's *The Idea of a Social Science and Its Relation to Philosophy* (New York: Routledge & Paul, 1958),

a Wittgensteinian treatise, had considerable influence on the Birmingham School of social theory and the "cultural studies" derived from it (see Stuart Hall, *Critical Dialogues in Cultural Studies*, eds. D. Morley and K. Chen [London and New York: Routledge, 1996]). J. L. Austin's theory of speech acts, deeply indebted to Wittgenstein's thinking about ordinary linguistic usages in the *Investigations*, has been widely adapted in models of the "performativity" of gender and other aspects of sociocultural identity.

10 Engelmann's comments were probably a bit envious; his own previous efforts to design for Margarethe had been spurned by her. For the house, see Whitney Davis, "Fitted Like a Glove: Wittgenstein's House for His Sister in Vienna" in "Archaeologies of the Standpoint" (MS.), Research Forum Lectures, Courtauld Institute of Art, University of London, February 2006.

11 Ludwig Wittgenstein, "Cause and Effect," 420.

12 Ludwig Wittgenstein, *On Certainty,* 358–59.

13 In another version, Wittgenstein wrote "facts of living" in place of "forms of life" in this sentence and gave *Lebensformen* as a variant (*Remarks on the Philosophy of Psychology*, vol. 1, eds. G.E.M. Anscombe and G. H. von Wright, trans. G.E.M. Anscombe [Oxford: Blackwell, 1980] 116e, no. 630).

14 For example, and to continue the case sketched in an earlier section, suppose that in B, C, D, and E the visible materials employed in each building are to their recognized economic value as the builders of each building are to their nationality; and suppose, then, that the "high" value of materials in this group of buildings (as opposed to the "low" value or the unknown value of the materials used in A and F) is recognized to be a function of the nationality of the builders and vice versa. But the high value of each of the buildings B, C, D, and E, however it is visible, is not visibly the same in each case, even though all the configurations have the aspect of having been made by builders of a certain nationality or nationalities—the respect of likeness that sets them apart from A and F, despite the fact that C looks like A and F (its nationality recognized, its high value can be seen).

15 In his lectures on aesthetics in 1938, Wittgenstein is reported to have said that "what belongs to a language game is a whole culture." He used the example of "musical taste"; one must know "whether children give concerts, whether women do or whether men only give them, etc., etc." He stressed that "aesthetic words," like other words, require us to "describe ways of living" in which the aesthetic judgments accompany a "complex activity" or "vast structure of actions not expressed by one judgment" (*Lectures and Conversations on Aesthetics, Psychology and Religious Belief*, ed. Cyril Barrett [Berkeley and Los Angeles: University of California Press, 1967] 8, 11). If Wittgenstein always meant *Lebensform* to be exactly the same thing as human *Kultur*, especially aesthetic culture, he did not say so consistently. But we can say that when (for example) children's concerts for adults and adults' concerts for children are held to the same canons or criteria of musical activity or musicality—when the same language-game is being played in the same form of life—we are likely dealing with the emergence of a culture. (Perhaps the children are learning the culture of musicality already familiar to the adults.) This is not to say that any culture is shared *other than* and *outside of* the playing of the game.

16 For Kubler's model, see *The Shape of Time: Remarks on the History of Things* (New Haven: Yale University Press, 1961). For comments, see Whitney Davis, "World

Series: On the Principles of World Art History" in *Visuality and Virtuality*. It is a severe defect of Kubler's theory that it models "the history of things" on games like chess or bridge. In other games, notably dice, his "rule of series" would not pertain; in dice, there is no change in the probability that I will throw a certain number at every throw. There is no doubt that Kubler conceived formal sequences in artifacts to be less like dice and more like chess, in which each move I make defines and reduces the possibilities for the next move. But this is not a rule of series. It is simply a rule of chess. More exactly, the rules of chess mean that my moves are constrained in a way that can be stated as the rule of series *for chess* and similar games. It might well be that making works of art and other complex artifacts is more like playing chess than dice. But if this is always so, Kubler did not make the case. And I doubt that it is always so. In some cases our "formal motions" (Kubler's term) in making or doing things might be like chess and in other cases they might be like dice, especially when we are *playing* chess or dice. And in some cases we might liken our motions in making to chess and in other cases to dice—accepting Kubler's rule of series in the case of chess-like making as the culture of that particular way of making things ("it's like playing chess") and accepting different likenesses, not captured by Kubler's rule of series, in other situations ("it's like playing dice"). These are matters to investigate in the historical study of forms of life and the recognized forms of likeness that emerge in them. In building a house, painting a picture, or trading goods on the market, are the things we make in sets and series like playing chess or like playing dice? Like neither?

17 Despite visible differences between Brillo-box cartons and *Brillo Box*, at least some initial observers of *Brillo Box* took it to be just like Brillo-box cartons (for full details, see Golec, *The Brillo Box Archive*). Arthur Danto's ruminations on morphological indiscernibility as a device in aesthetic ontologization were motivated in part by the putative indiscernibility, at least for him, between Brillo cartons and *Brillo Box* ("The Artworld," *Journal of Philosophy* 61 [1964] 571–84). Of course, these claims may have been disingenuous. But they were not inherently implausible, for who is to say that Danto didn't see the two objects as looking exactly alike even if other critics deny their indiscernibility?

18 Anthony Grudin has demonstrated the importance of the notion and the practices of commodity branding to Warhol's game in art; see "'A Sign of Good Taste': Andy Warhol and the Rise of Brand Image Advertising," *Oxford Art Journal* 33 (2010), 211–32. We do not need to pursue the involutions of *Brillo Box* seen as *not* the branded box of Brillo pads but as something akin to the branding of Warhol's art, and so on. (For this and other possible recursions of iconography in the *Brillo Boxes*, see Chapter 6.) As Danto pointed out, an analytic or quasi-philosophical contribution of Warhol's work and its similars was precisely to ontologize the operations of metaphor, analogy, and lifeworld in art by definitively extracting art (at least notionally and in some imaginable practices) from visible morphology.

19 I have slightly revised Wittgenstein's description of this game in order to highlight the interaction between the color terms, the deictics, and the ostensive gestures.

20 I owe the metaphor of a form of life as a "medley-like mixture or garland of practices somehow supporting or complementing one another" to Michael Kober, "Certainties of a World Picture: The Epistemological Investigations of *On Certainty*," in *The Cambridge Companion to Wittgenstein*, eds. Hans Sluga and David G. Stern

(Cambridge: Cambridge University Press, 1996) 418. The qualifier "somehow" is crucial, and remains unexplicated by Kober, though he points out that Wittgenstein's "notion of a form of life does not explain anything"; instead, "it describes, or labels, the setting in which . . . language-games are practiced." Here I have tried to give one possible explication of the visual, noetic, and social processes.

21 Stanley Cavell, *This New Yet Unapproachable America*, 41–42.

22 G.W.F. Hegel, *The Phenomenology of Spirit* [1805], trans. A. V. Miller (Oxford: Clarendon Press, 1977) 421–26.

23 Newton Garver argues this case in *This Complicated Form of Life*, 237–67.

24 The relation of real standpoints to aspect-seeing and the para-anamorphic constitution of intersubjective visual understanding in a social group or a social situation would have to be the topic of another study (see Whitney Davis, "Archaeologies of the Standpoint"). A superb treatment of essential anamorphosis in the constitution of perspective defined as the construction of intersubjective visual knowledge of the world (a visual culture or visuality) can be found in Lyle Massey, *Picturing Space, Displacing Bodies* (University Park, PA: Pennsylvania State University Press, 2008); Massey deals with relevant theoretical and practical formulations in the sixteenth and seventeenth century.

Chapter 10: Visuality and the Cultural Succession

1 Simon Blackburn, *Spreading the Word: Groundings in the Philosophy of Language* (Oxford: Clarendon, 1984); see also Saul Kripke, *Wittgenstein on Rules and Private Language: An Elementary Exposition* (Cambridge, MA: Harvard University Press, 1982).

2 For the term, see Raymond A. Dart, *The Osteodontokeratic Culture of Australopithecus Prometheus* (Pretoria: Transvaal Museum, 1957); it is independent of the accuracy of Dart's archaeology. An osteodontokeratic culture might involve communication—a simple call system like the speech or spoken natural language of the builders in Section 2—integrated with other features of the language game. Indeed, Wittgenstein assumed communication because the language game of the builders is inherently social. The assumption is not inevitable, however. Whether *Australopithecus*, *Homo habilis*, or any other hominid creature used natural language in osteodontokeratic cultural activities—what might have been a visual culture for them—is an interesting and important question. But it is not strictly relevant here.

3 Ludwig Wittgenstein, *On Certainty*, 358–59.

4 Imagine that the color-schemed buildings and dishes of food analogize the hidden order of the cosmos as a series of layers of reality, only one of which we can actually see "in real life" but which the buildings and dishes of food are designed to recall to us, to suggest or invoke. Analysis of many nonmimetic representational traditions around the world assumes or discovers visual cultures that have this kind of noetic coordination.

5 Being manifest is not the same as being *public*, for it is not clear that someone can see exactly the same visual aspect of something as someone else at the morphological level of the perceptual "quality" of its color, shape, and so on, such as the particular redness of the red in the "Choose Red" building. Wittgenstein gave considerable attention to this problem; it might have been pressing for him insofar

as he stressed the public nature of meaning and meaning (if I am right) is rooted in recursions of aspect-seeing. But here the recursion of analogy, the culturality of aspect-seeing, contributes to the coherence of a mutual form of life, and hence to its public meanings or to its meanings as public facts: to help someone else see an aspect of something we see, we can say, "it's like *this* . . . it looks like *that*." These manoeuvers will never transfer aspect-seeing (as it were *all* the aspects of an aspect . . .) to someone else. They might, however, enable us mutually to come *closer* than otherwise to the seeing of others, and at any rate to reach a point at which any differences in our "private" aspect-seeing have no public salience for anything we do in our shared form of life. (Conversely, we can be warranted in arguing that there is no such thing as "private" aspect-seeing insofar as we *always* see aspects of things in the context of a form of life usually shared with others.) We might take this to be the aspective-phenomenal face of the heteropsychological function of univocally determined noetic constructs as analyzed in Carnap's logical positivism (see Chapter 8).

6 The quoted phrases in this paragraph are David Lewis's in *Convention* (Princeton: Princeton University Press, 1961). Full analysis of the relations between perceptions of likeness on the one hand and knowledge of conventions on the other hand would be an immense task beyond the scope of this book.

7 Ludwig Wittgenstein, *On Certainty*, 21.

Index

Page numbers in italics refer to illustrations.

interdetermination, aspective, 37-42, 47-48, 54, 64, 71, 155, 172, 195, 202, 215, 233, 327; in art, 60; culturality in, 77, 337-38; definitions of, 9-10, 48, 220, 319; disavowals of, 47, 50, 64; disjunctions in, 97-98, 219-20, 253; failure of, 220; and forms of life, 283; as ground of visual culture, 274, 319; objects as symptoms of, 73; and pictoriality, 151, 155, 165, 178; totalization of, 250. *See also* analogy; aspect-seeing; life, form(s) of; likeness, forms of; pictoriality, resistance of
International Style, 77, 80
Ireland, style in art of medieval, 82

Jacob, Isaac, and Esau (Ghiberti), 160
James, William, 112, 115
Jesus (as Christ), 196-97
Jung, Carl, 291

kalos-name(s), 137, 141
Kandinsky, Wassily, 57
Kant, Immanuel, and Kantianism, 113, 230, 253, 256, 258-59, 278, 361n7, 362n20, 367n36, 367n39
Kant und das Problem der Metaphysik (Heidegger), 260-61
Kauffmann, Hans, 241-43
Kelly, Michael, 3-4
Klee, Paul, *60*, 61-63, 112
Knight, Death, and the Devil (Dürer), 234-74, *235*, *243*, *268*, *269*, 322
Kober, Michael, 372n20
Kokoschka, Oskar, 189
Kripke, Saul, 168-69
Kubler, George, 72, 296-97
Kugler, Franz, 106, 349n7, 352n21
Die Kunst Albrecht Dürers (Wölfflin), 239, 243, 267
Kunstgeschichte. See art, history of
Kunstgewerbe, 53. *See also* Riegl; *Strukturforschung*
Kunstkritische Studien (Morelli), 87
Kunstwissenschaft, 38, 41, 241, 253-54, 257, 364n13. *See also* Panofsky; Vienna School
Kunstwollen, 53-54, 71, 118, 347n19. *See also* Riegl; *Strukturforschung*

La Marche (France), prehistoric antler from, 130-31, *131*, 148
Lacan, Jacques, 255
Langer, Susanne K., 230
language:
—complete or primitive (Wittgenstein), 286-92, 312, 329-30, 336; expansions of, 300, 306-7, 329-30, 336. *See also* builders, parable(s) of the; language-game(s); life, form(s) of

—natural or spoken, 16, 58, 156-57, 160, 163-64, 167-69, 178, 190, 287, 298, 343n19, 370n7, 373n2
—pictorial. *See* formalism, Latent; pictures, language of
language-game(s), 23-24, 156-59, 169-70, 205, 290, 292-94, 297-99, 305, 328-30, 333; art as, 23-25, 300, 306-7, 371n15; family resemblances of, 320-21; and super-language-games, 306-7, 312, 329, 336. *See also* builders, parable(s) of the; language, complete or primitive; life, form(s) of
Lanzinger, Hubert, 265, *265*
Last Supper, pictures of, 196-97, 204-5
Lebensform(en). See life, form(s) of
Lee, Vernon, 88, 113-16
Leninism, 224
Leonardo da Vinci, 237, 267, 270
Lewis, David, 374n6
"Libyco-Berber" culture, petroglyphs of. *See* Flamand
life, form(s) of, 5, 11, 19, 23-24, 27-29, 33-35, 52, 220, 223, 281-82, 305-6, 312, 316, 340; according to Wittgenstein, 287-92, 305, 317-19, 330, 370n8; certainty in, 283, 340; commensurability of, 316-17, 327; family resemblance of, 316; form of, 115; human, 190, 317; nonhuman, 187-92, 317-18, 324-26, 330-31. *See also* builders, parable(s) of the; language-game(s)
Life and Art of Albrecht Dürer (Panofsky), 234, 239, 244
Life of Raphael (Vasari), 100
Life of Reason (Santayana), 115
life-form(s), 317-18. *See also* life, form(s) of
likeness: analogical, 306-8, 319, 323, 333; forms of, 5-6, 10, 34-37, 69, 70, 194-96, 280-94, 298, 305-6, 312, 316, 324-25, 330, 335; morphological, 73, 292-93, 319, 323, 333. *See also* analogy; indiscernibility; seeing-like
Link, Philipp, 236
Lipps, Theodor, 364n15
looking, close, 48-50, 120-22, 126; as close reading, 126-27, 129, 132-33, 139, 344n1; and forensics, 129, 136; and indiscernibility, 213-15; modes of, 53, 72-73, 129; and pictoriality, 156; rhetoric of, 63; and style, 79. *See also* formalism, high; reading, close; visualism
Loran, Erle, *54*, 55-57, 59, 64
Lotze, Herman, 112, 115
Luristan (Iran), style in art of, *80*, 81

Magdalenian period. *See* Paleolithic period
Manet, Édouard, 216-29, 238
Marshack, Alexander, 128-49
Marxism, contradiction as analyzed by, 223-25, 228-29